Recording Reality, Desiring the Real

VISIBLE EVIDENCE

Michael Renov, Faye Ginsburg, and Jane Gaines, Series Editors

Volume 24 :: Elizabeth Cowie
Recording Reality, Desiring the Real

Volume 23 :: Thomas Waugh
*The Right to Play Oneself: Looking Back on
Documentary Film*

Volume 22 :: Alisa S. Lebow
First Person Jewish

Volume 21 :: Malin Wahlberg
Documentary Time: Film and Phenomenology

Volume 20 :: Jeff D. Himpele
*Circuits of Culture: Media, Politics, and Indigenous
Identity in the Andes*

Volume 19 :: Jennifer Deger
*Shimmering Screens: Making Media in an Aboriginal
Community*

Volume 18 :: Abé Mark Nornes
*Forest of Pressure: Ogawa Shinsuke and Postwar
Japanese Documentary*

Volume 17 :: Alexandra Juhasz and Jesse Lerner, Editors
F Is for Phony: Fake Documentary and Truth's Undoing

Volume 16 :: Michael Renov
The Subject of Documentary

Volume 15 :: Abé Mark Nornes
*Japanese Documentary Film: The Meiji Era through
Hiroshima*

Volume 14 :: John Mraz
Nacho López, Mexican Photographer

Volume 13 :: Jean Rouch
Ciné-Ethnography

Volume 12 :: James M. Moran
There's No Place Like Home Video

Volume 11 :: Jeffrey Ruoff
"An American Family": A Televised Life

Volume 10 :: Beverly R. Singer
*Wiping the War Paint off the Lens: Native American
Film and Video*

(for additional series titles, see page 219)

VISIBLE EVIDENCE, VOLUME 24

Recording Reality, Desiring the Real

Elizabeth Cowie

 University of Minnesota Press

Minneapolis

London

The Introduction and chapter 4 were developed from "The Spectacle of Actuality," in *Collecting Visible Evidence*, ed. Jane Gaines and Michael Renov (Minneapolis: University of Minnesota Press, 1999), 19–45. Chapter 1 was developed from "Documenting Fictions," *Continuum: Australian Journal of Media and Culture* 11, no. 1 (1997): 54–66. Chapter 2 was developed from "Working Images: The Representations of Documentary Film," in *Work and the Image*, vol. 2, *Work in Modern Times: Visual Mediations and Social Processes*, ed. Valerie Mainz and Griselda Pollock (Aldershot, UK: Ashgate Publishing Limited, 2000), 173–92; and "Giving Voice to the Ordinary: Mass-Observation and the Documentary Film," *New Formations*, no. 44 (Autumn 2001): 100–109. Chapter 5 appeared in a shorter version as "Ways of Seeing: Documentary Film and the Surreal of Reality," in *Building Bridges: The Cinema of Jean Rouch*, ed. Joram ten Brink (London: Wallflower Press, 2007), 201–18. A version of chapter 6 was previously published as "Specters of the Real: Documentary Time and Art," *differences* 18, no. 1 (Spring 2007): 87–127; and "Desiring the Real, Voicing Reality in Documentary Art," published as "Dokumentarische Kunst: das Reale begehren, der Wirklichkeit eine Stimme geben," in *Auf den Spuren des Realen Kunst und Dokumentarismus*, ed. Karin Gludovatz (Vienna: Museum Moderner Kunst Stiftung Ludwig, 2005), 15–41.

Published by the University of Minnesota Press
111 Third Avenue South, Suite 290
Minneapolis, MN 55401-2520
http://www.upress.umn.edu

Library of Congress Cataloging-in-Publication Data

Cowie, Elizabeth.
 Recording reality, desiring the real / Elizabeth Cowie.
 p. cm. — (Visible evidence ; v. 24)
 Includes bibliographical references and index.
 ISBN 978-0-8166-4548-0 (hc : alk. paper) — ISBN 978-0-8166-4549-7 (pb : alk. paper)
 1. Documentary films—History and criticism. I. Title.
 PN1995.9.D6C69 2011
 070.1'8—dc22 2010030716

Printed in the United States of America on acid-free paper

The University of Minnesota is an equal-opportunity educator and employer.

17 16 15 14 13 12 11 10 9 8 7 6 5 4 3 2 1

This book is dedicated to the memory of
Celia Cowie (1947–2008), in recognition of her
vision and humanity, and for the understanding she
brought to the lives of so many of us.

Contents

Acknowledgments ix

Introduction: The Spectacle of Actuality
and the Desire for Reality 1

1 ▶ Narrating the Real: The Fiction and the
Nonfiction of Documentary Storytelling 19

2 ▶ Working Images: Representing Work and
Voicing the Ordinary 46

3 ▶ Documentary Desire: Seeing for Ourselves and
Identifying in Reality 86

4 ▶ Documenting the Real 118

5 ▶ Ways of Seeing and the Surreal of Reality 135

6 ▶ Specters of the Real: Documentary Time and Art 153

Notes 187

Index 213

Acknowledgments

This book has developed over a number of years and has benefited from help and support in a wide variety of ways. Research leave from the University of Kent, together with a matching award from the Arts and Humanities Research Council of Great Britain, enabled me to complete this project. The many Visible Evidence conferences I have participated in have been a crucible for the gestation of ideas and arguments in this book, and my thanks goes to all the organizers and fellow participants. I would like to thank Michael Renov and Jane Gaines in particular for their wonderful encouragement and timely interventions in the making of this book.

The personal support and intellectual engagement of my students as well as my colleagues at Kent have been invaluable, and though I can name only a few here, I'd like to express my gratitude to Christine Evans, Charalambos Charalambous, Silke Panse, Sophia Phoca, Dick Kennedy, Eunkwang Huh, Catherine Grant, Virginia Pitts, Aylish Wood, Murray Smith, Clio Barnard, Sarah Turner, Adam Chodzko, Peter Stanfield, Paul Allain, Frances Guerin, Cecilia Sayad, Mattias Frey, Jinhee Choi, and Lorenzo Chiesa. A number of other people have been important for their help and conversation, and I would like to thank Joan Copjec, Mary Ann Doane, Mary Kelly, Griselda Pollock, Laura Marcus, Joram ten Brink, Karin Gludovatz, Henry Krips, Predrag Padjic, Adrian Rifkin, David Bate, Valerie Krips, Alisa Lebow, Brian Winston, Caroline Rooney, Julia Barosso, and Vanalyne Green. My thanks as well to two initial readers of the manuscript, Bill Nichols and Jane Roscoe—I hope they can recognize how their comments and suggestions contributed to the final work.

My sisters, Anne Bloom and Celia Cowie, sustained me through the ups and downs of writing. My biggest thanks is to Glenn Bowman, whose support and intellectual engagement contributed significantly to the making of this book.

Introduction: The Spectacle of Actuality and the Desire for Reality

Documentary, because reality is organized into an explanation of itself.
:: Trinh T. Minh-ha, *Reassemblage* (1982)

Documentary, in presenting the sights and sounds of reality, enables reality to "speak" at the same time as it "speaks about" reality. It thus realizes the desire that cinematography inaugurated: of knowing reality through its images and sounds, that is—figuratively—of allowing reality to "speak for itself." This book examines the documentary film as a cinematic project that seeks to enable the citizen-spectator to know and experience reality through recorded images and sounds of reality. Closely linked to the development of both modernity and modernism, documentary arises as a film genre characterized by a dual assertion of the objective knowableness of the world and its claim that it gives us access to this knowledge.

Documentary's selection and ordering of the images and sounds of reality constitute an account of the world; however, it thereby becomes prey to a loss of the real in its narratives of reality. The new technologies of photography and cinema came to be seen as the proponents of an audiovisual realism that nevertheless failed to be revealing. Bertolt Brecht, in 1930, comments, "The situation is becoming so complex that less than ever does a simple reproduction of reality tell us anything about reality. A photograph of Krupps or the AEG yields hardly anything about those industries. True reality has taken refuge in the functional."[1] Brecht refers here to the debate about realism and representation, as well as about the historical and social determinations of the social reality re-presented, from which the documentary film emerged in the work of filmmakers in Europe and North America in the 1920s as an aesthetic project of

recorded reality represented. This was not the art of the everyday but the art constituted by the everyday re-presented by seeing anew, which film made possible.[2] The documentary film was an extraction from and organization of reality—a fabrication, but one that thereby brought forward a new reality. These concerns and this project continue to be the focus of much current work in documentary.

In recording actuality, however, photography and cinematography address two distinct and apparently contradictory desires. There is the desire for reality held and reviewable for analysis as a world of materiality available to scientific and rational knowledge—a world of evidence confirmed through observation and logical interpretation. The camera eye functions here not only as a mastering, all-seeing view but also as a prosthesis, an aid and supplement to our vision whereby we are shown a reality that our own human perceptual apparatus cannot perceive. The desire arising here is for a symbolic or social reality ordered and produced as a signification through which the observed can be integrated, via a discourse of recognition and classification, into a densely constituted field of knowledge, power, and techniques.[3] Documentary film is associated with the serious and has become, in Bill Nichols's words, one of the "discourses of sobriety" alongside—albeit as a junior player—such discourses as science, economics, politics, education, and the law.[4]

Yet for all its seriousness, the documentary film nevertheless involves more disreputable features of cinema usually associated with the entertainment film, namely, the pleasures and fascination of film as spectacle. As a result, there is a desire for the real not as knowledge but as image—as spectacle. Jean Baudrillard argues, "There is a kind of primal pleasure, of anthropological joy in images, a kind of brute fascination unencumbered by aesthetic, moral, social or political judgments. It is because of this that I suggest they are immoral, and that their fundamental power lies in this immorality."[5] In the documentary film, these pleasures arise not through make-believe or fictional enactment but by the re-presentation of actuality. It has, of course, been more usual to relate this dichotomy between knowledge and spectacle to the divide conventionally made between fiction and nonfiction film, characterized by film historians as two opposing traditions arising from Georges Méliès, the magician-filmmaker, on the one hand and Louis Lumière, the scientist-inventor, on the other. Fantasy is set against reality in a splitting that has been similarly applied to the televisual and the digital. Thus while cinematography, which like photography derives from the achievements of scientists as well as showmen and entrepreneurs, opened up new opportunities for visual pleasure as both knowledge and spectacle, the recorded visible came to be divided between

the objective and intellectual appraisal of empiricism's gaze and a pleasuring of the eye in a subjective and experiential engagement with the seen and, with synchronous sound after 1926, the heard.

Documentary, in recording historical reality, incites a desire for the real both as knowable, and hence mastered by our knowledge of it, and as prior to and evading our mastering of it as the radically contingent. The fascination with the spectacle of "real time" re-viewed has been an impulse in each of the technologies for reproducing reality and, as Mary Ann Doane suggests, "the celebrated rupture of the postmodern may be no more than a blip on the screen of modernity that, from its beginnings, sought the assurance of a real signified by life and pursued a dream of instantaneity and a present without memory."[6] The specter of an improper dreaming, however, threatens all the reassurances that technology appears to offer. In questioning this division and its hauntings, this book explores the ways in which actuality and documentary films involve us as desiring, as well as knowing, spectators, engaging us in the pleasures of looking. This not only involves a coming to know, and the scopophilic pleasures of looking, but also engages our identification as the subjects of the look and of the voice in documentary, as well as with the objects of the camera's— and thus our—gaze. The documentary is an embodied storytelling that, while a narrativizing of reality in images and sounds, engages us with the actions and feelings of social actors, like characters in fiction.

This book addresses the paradox that arises here—of the fascinating pleasure of recorded reality as both spectacle and knowledge—through examining the interrelationship and interdependence of the pleasures of spectacle, voice, and identification in the documentary with its project of informing and educating. We must think the actual, moving between living and dwelling as the affectual, and a becoming as a knowing constructed virtually in a transforming of the real into reality. If in this book I slip in my account between the psychoanalysis of Sigmund Freud and Jacques Lacan on the one hand and Michel Foucault's critiques on the other, while drawing upon Gilles Deleuze and Jacques Derrida as well as Slavoj Žižek, it is because each offers ways in which to think about documentary and the question of its role in re-presenting reality to a subject divided as self and other. We must apprehend the actual as a "sensible," to draw on Jacques Rancière,[7] and engage in a movement between a living and dwelling as the affectual, and a becoming a subject of knowledge that is constructed virtually in a transforming of the real into reality. The commonsense division real versus illusion is sidestepped by using Deleuze's distinction between the actual and the virtual that he draws from Henri Bergson, in opposition to the possible versus real distinction,

for the "possible" already defines the real it can become, and the real is thus causally inferred in the possible. Deleuze, by contrast, sees the movement from virtual to actual as a creation, not a realization for, "while the real is the image and likeness of the possible that it realizes, the actual, on the other hand does *not* resemble the virtuality that it embodies."[8] The actualization is a creation that produces a differentiation. In representation, Derrida argues, there is a deferral and differing, *différance*, arising in the becoming of meaning of signification that points to an absent "before" of a not-yet-meaning; it is as a real that is not textual. Lacan, like semiotician Charles Sanders Peirce, turned to a triadic rather than dualist structure in his concepts of symbolic, imaginary, and real, each a psychical relation of encountering self and other.

The desire for reality as reviewable, as a present time re-seen in an imagined future, and the fascinating pleasures of recorded reality as spectacle and as knowledge are explored in this book in relation to documentary's project of informing and educating. As a radical film form, documentary has also been a way for filmmakers to say something about contemporary and historical reality through images of it. If cinema has realized the wish to know reality through its images, and later its sounds, that is, to let it "speak for itself," what kind of speaking, and speaking about, emerges in documentary, and how are we engaged by it? These questions structure this book as a whole, and the focus of this introductory chapter will be the role of the pleasure of the specular as access to knowledge in documentary.

Documentary is also a narrative form deploying specific modes of storytelling, notwithstanding its claim to truth as nonfiction. The relationship between different documentary approaches and their narrative and stylistic forms to the kinds of knowledge and subject positions produced is explored in chapter 1. Considerations of style and form in documentary are often subordinated to issues of content and to the question of faithfulness to the reality recorded, focusing on techniques and technical advances, such as sync sound in the 1960s, which enabled the development of the "observational" style of documentary. New technology has enabled yet greater access to and veracity in the re-presenting of reality (e.g., infrared imaging and digital microcameras), while anxiety about the fake and the fabricated remains intense, as Brian Winston has clearly shown.[9] Contemporary documentary film and video, however, as well as reality television, and indeed news and current affairs programs, deploy marked stylistic devices such as slow motion, freeze-frame, and the use of striking camera angles that indicate the presence of the camera, which reflexively signal reality offered as spectacle.

Documentary as a project was defined in relation to the public sphere and to the production—and inculcation—of public values, including ideas of identity as belonging and involvement. Chapter 2 asks, how does the documentary participate in discourses of knowledge and thus reality? This question proposes documentary as not only a discursive construction but also as a constructing discourse. The documentary project constitutes reality as knowable and produces a knowledge of reality through its construction and deployment of discourses about reality. Here I draw upon Michel Foucault's account of the discursive construction of our objects of human knowledge and of the subject of human knowledge, namely, "Man," and the men and women who have come to identify as subjects of knowledge, in order to examine the epistemological work of documentary. This is explored through the example of images of work in the films of the 1930s British documentary film movement and the parallel project in the United States. What is proposed here is a certain revision of the history of documentary at this time that is developed further in relation to filming the speech, as well as the sights and sounds, of the ordinary, the everyday, that finds its first expression through the contribution of Ruby Grierson and the project of Mass-Observation in Britain in the '30s.

The identifications of documentary, that is, the ways in which we are engaged as desiring and as knowing spectators, is explored in chapter 3. Lacan's account of the position of the speaking subject within the four discourses that he identifies is drawn upon to understand the address of the documentary and the speaking subjects it presents. Equally implicated is the spectator, as addressed by the documentary and by what she "asks," of, that is, seeks from, the documentary as knowledge and experience.

There is always an excess of signifying in what is shown and what is said that is uncontrolled by the speaker—or filmmaker—that Lacan designates as the real, namely, as "unrepresentable." I explore this "real" of the documentary in relation to its factuality and its assertion of the knowability of the world in chapter 4 in relation to two films about war trauma: *War Neuroses: Netley, 1917, Seale Hayne Military Hospital* (Pathé, 1918, United Kingdom), an early silent documentary showing the treatment of World War I soldiers suffering from "shell shock," and *Let There Be Light*, John Huston's 1945 sound documentary on the treatment of the symptoms of trauma in World War II soldiers in the United States. In chapter 5, through the work of anthropologist and filmmaker Jean Rouch, I consider the surreal of reality, whereby something slips as we try to "make sense" of what we see and hear, and a little bit of the real appears, undoing subjectivity as unified, thereby engaging our imaginative remaking of our understanding in a seeing differently—a seeing anew.

Chapter 6 concludes by considering the question of time and memory and asking, what is the reality gained, or lost, in the interposing of a declared aesthetic intervention in the re-presentation of recorded found reality? Here I argue that it is in the ways that time is brought into play that documentary is also art, and it is political. Time here is both historical time and time experienced as duration by the spectator and the documentary's participants. The documentary is both a memory machine, making available present events for a future spectator's time of re-viewing, and a present tense—"speaking about the past"—in a "now time." But remembering is not simply the recall of past events; it is also the reencountering of emotions attached to those past events and their losses, and in this, it carries out a work of memorializing that is also a process of mourning and forgetting. Remembering is a space of time that is also a placing of the pastness of the past and of dwelling in the places of the past. It is the time of memory that enables the art of documentary.

▶ ────────────────────────────────────

Desiring Reality Re-presented

The desire for a reality held and reviewable had been articulated within science as well as the arts long before cinematography. For Louis-Jacques-Mandé Daguerre, however, the impetus that led him to develop in the daguerreotype a method of chemically recording the image of the world provided in the camera obscura, rather than reproducing it in a painted scene, involved a desire not only to reproduce a realistic view of reality but also to reproduce the spectacle and sensation of views in the real world, as his earlier dioramas had done.[10] The daguerreotype, moreover, also reproduces the evanescent quality of the diorama in its requirement that it be held at certain angle and thus enforces a particular position of view, for only then is the image apparent where before the surface appeared merely as a vaguely shadowed silvery screen. The daguerreotype thus produces a now-here, now-gone quality to the image (a quality also found in the painterly device of anamorphosis, where a smudge on the canvas becomes, with the next step, a skull in Holbein's "The Ambassadors"). These features suggest that Daguerre is a more important precursor of the moving pictures than Henry Fox Talbot, but it is the legacy of the latter, namely, the legacy of an epistemological realism, that theorists and critics have subsequently emphasized.[11]

With the chemical recording of the camera obscura's images, the human observer is displaced by a mechanical seer. Jean-Louis Comolli notes, "At the very same time that it is thus fascinated and gratified by the

multiplicity of scopic instruments which lay a thousand views beneath its gaze, the human eye loses its immemorial privilege; the mechanical eye, of the photographic machine now sees *in its place*, and in certain aspects with more sureness. The photograph stands as at once the triumph and the grave of the eye."[12]

The overturning of the classical optics of the Renaissance, and with this the decentering of the classical subject of vision, had begun well before the development of photography through the work of Joseph Nicéphore Niépce, Daguerre, and Talbot in the nineteenth century. The camera obscura had been the privileged metaphor for the observer's relationship to the external world, a relationship in which vision is knowledge, and knowledge is seeing.[13] The human eye, however, is now shown to be a limited organ, misleading and imperfect in its observations, and human vision becomes instead a realm of the fallible. A subjectivity of sight comes to the fore at the same time and as a corollary of a heightened scientificity or objectivity of apparatus. Comolli writes, "Decentered, in panic, thrown into confusion by all this new magic of the visible, the human eye finds itself affected with a series of limits and doubts. The mechanical eye, the photographic lens, while it intrigues and fascinates, functions also as a *guarantor* of the identity of the visible with the normality of vision."[14]

Photography, then, concludes the separation of the subjective, human viewer from the new objectivity of mechanized observation.[15] Knowledge of the world is no longer equivalent to human perception. The observer of the camera obscura becomes instead the consumer of an already recorded and reproduced view. Does not the active creation of knowledge through vision, observation, now become displaced by a passive reception of knowledge through vision? Here is perhaps the most pernicious of obfuscations befalling photography and cinematography in this ideological privileging of the active—reminiscent of the Protestant "work ethic"—versus the passive, derogatively correlated with inactivity. Yet vision always remains an active process of cognition, and one is never a mere observer overlooking. Certainly we cannot act upon what we see in the image or interact in the same time and space and with those we listen to, but this is not equivalent to inactivity, for our imaginative engagement with the seen and heard is a mental response and interaction. We require, therefore, a complex understanding of our desire to come to know and thus in some sense experience, possess, and be possessed by images of past reality, experienced in "now time."

If the "referential" is no longer a domain that is knowable through the physical senses and preeminently through sight, nevertheless the demand for such a referentiality—and with it a realist imperative—continues to be apparent and indeed is central to the emergence of

photography and cinematography that now become, as Comolli suggests, guarantors of the real. Subjectivity was simply a hurdle that could be overcome by mechanized modes of vision; thus Mary Ann Doane concludes, "We are faced with the strange consequence that the cinema, as a technology of images, acts both as a prosthetic device, enhancing or expanding vision, and as a collaborator with the body's own deficiencies,"[16] for it only succeeds as an appearance of continuous movement because of the limitations of the eye.

Vision may no longer be viewed as the site of understanding, but the conflation between the eye as a mechanism of sight and the mind or brain as the location of the comprehension of the visible nevertheless remains compelling—as shown by the use of "I see" for "I understand" and its extension in the exhortation "you see" puncturing our everyday speech by which we invoke the wish and demand for understanding from our addressees. There is a compelling believability in seeing, and we still want to have the evidence of our own eyes—even while "knowing" the fallibility of our sense of sight.[17] Located here is the central paradox concerning our perception of the world: on the one hand, the knowledge that the senses deceive and on the other, the sense of knowledge that our bodily perceptions afford us and of knowing the world through its smells, sounds, textures, and temperatures, as well as sights.

Translated as a mental understanding, this sensory knowledge becomes a representation to the mind through the work of memory, that is, the matching up of this new sensory information with the learned understanding derived from previous sensory information. A gap, an aporia, exists between sensory knowledge or stimuli and sense itself. The sense of certainty of our sensory experience opens us to the disavowal of our knowledge of the limitations of our senses, that is, to the uncertainty of their sense making. The camera obscura, displaced as the metaphor for a centered subject of knowledge, now plays to this desire. As an apparatus of overlooking, it offers the pleasures precisely of the separation of the body as site of vision and the object of sight, presenting a panorama of the seen world, or so it seems, as one gazes upon the curved dish of its screen in which friends, relatives, or strangers stroll, unaware of one's look.[18]

The fixing of such a scene through photography expands the fantasy arising here, that is, of reality beyond oneself but graspable and available to be held in an image. The process of recording fulfills the wish for reality reviewed but also brings with it the question of how far the mechanism of recording intervenes on reality to transform—and pervert—it. The problem or possibility that the image lies as well as tells the truth is an issue in theology as well as in philosophy. It is also the locus of anxiety and,

thus, of a repeated returning to the recorded image to ascertain its truth or falsity. This dilemma posed by the photographic image is also the locus of *ambivalent* desire for the true image and for the image that truly shows the world evidentially, that is, as confirming reality in its meaningfulness and as we already know it to be. Documentary film inherited both this anxiety and ambivalent desire; as recorded actuality, it figures both in the discourse of science, as a means of obtaining the knowable in the world, and in the discourse of desire, as a wish to know the truth of the world, represented by the question invariably posed to actuality film, is it true? In that question is a further one, namely, do I exist? The latter is a question that is addressed to an other from whom I seek and desire a response. This is the questioning that psychoanalysis has sought to understand.[19]

The pleasure of the visual and the desire for the real were joined directly with the science of the visible in the stereoscope.[20] The stereoscope is, however, paradoxical in its mode of representation. It does reproduce the vision of the human eye very closely, unlike the photograph and cinema, and the realism and sense of tactility of the stereoscope image can be very vivid. As Jonathan Crary observes, "No other of representation in the nineteenth century had so conflated the real," so that "even as sophisticated a student of vision"[21] as the scientist Hermann von Helmholtz could write, in the 1850s, that "these stereoscopic photographs are so true to nature and so lifelike in their portrayal of material things, that after viewing such a picture and recognizing in it some object like a house, for instance, we get the impression, when we actually do see the object, that we have already seen it before and are more or less familiar with it . . . No other form of representation in the nineteenth century had so conflated the real with the optical."[22]

One nevertheless must initially concentrate hard on bringing into focus the stereoscopic scene, while the eyes held close to the viewing glasses are excluded from any peripheral vision beyond the encased images. As a result, the viewer of the stereoscope is also made fully conscious of the means of production of the viewing process itself. It is here that, Jonathan Crary has argued, the observer is "disciplined" in being subject to the viewing process effected by the apparatus. The stereoscope thus fails to be fully phantasmagorical or "properly" illusory.[23]

The photograph, like the painting, can, of course, be seen at a glance, singular and framed—memorializing—while it, and its reality, can be held close but separate, that is, it can be fetishized.[24] In contrast, the stereograph presents a doubled image, undistinguished and indistinguishable as an object but that thrusts us into its reality. The disjuncture of the stereograph lies not only in its three-dimensionality but also, and

in some ways more strikingly, in the lack of a single point of view—a focused scene in the photographic or painterly sense. Instead the eye must roam the view so that it never fully converges as a homogenous view. To perceive the appearance of three-dimensionality, whether in a reproduced scene in the stereograph or in the world directly apprehended, requires a cognitive process—primarily of memory—in order for the spatial relationship to be understood. What the stereoscope makes apparent, therefore, as the viewer attempts to bring the scene together, is the very incoherence of vision.[25] It is thus indeed the case that, as Crary says, each observer is transformed "into simultaneously the magician and the deceived."[26] This is also the structure of disavowal described by Freud, in which the subject knows very well the truth but all the same believes its opposite, but where the *substitution* of fetishism, of a reality framed and cut out that monocular perspective affords, is missing.[27]

Documentary film similarly bears the marks of the disjunction between the film and the reality recorded, whether as fragments from a larger *absent* world figured here only partially, or because the voice-over narration poses the images as objects of view rather than a simply unfolding reality. This gap in representation between the reality presented and the reality absent introduces the real in Lacan's sense of an unrepresentable that is nevertheless apprehended; here, it is the real of an irreconcilable difference between representation and the before of representation.

The Pleasures of the Spectacle of Reality

Spectacle is part of a long tradition of popular forms such as the circus or the magical acts of traveling fairs.[28] It is thus opposed to the scientific; the "sight" is viewed not for knowledge but for sensation, which has increasingly been associated with the nonintellectual. But spectacle is also a feature of the high culture of the upper and middle classes in the West, exemplified in development in the eighteenth century of the "Grand Tour" in Europe as the necessary completion of a wealthy European and North American young man's education, whereby the viewing of the sights themselves and their visual appreciation was the mark of a gentleman. At the very least, spectacle is a feast for the eyes. We consume the world through our look, appropriating it as meaningful; pleasured by its colors and shapes, we nevertheless form it into social or philosophical meanings or an aesthetic experience. Sightseeing later became commonplace for the bourgeoisie in the nineteenth century, and in the twentieth century for people more generally, whether of objects, places, or peoples.

The visual as spectacle was also central to discourses of the sublime in the eighteenth century, both in relation to an aesthetic experience of landscape, and in relation to the represented in art. What is invoked in the notion of the sublime is, in contrast to the beautiful, the power of the image or the seen that is experienced as awesome or terrifying, insofar as it is a sensible experience that lies outside sense or meaning. The experience of the sublime arises as a pleasure out of the pain of terror as the mind masters the senselessness. For Edmund Burke, the terror of the sublime is to the mind as exercise is to the body, forcing reason to comprehend the senseless.[29] Immanuel Kant places the experience of the sublime in the failure of the imagination to grasp or encompass a phenomena—to represent it to the mind—which leads reason to recognize and conceptualize a beyond-representation: "Sublime is what even to be able to think proves that the mind has a power surpassing any standard of sense."[30] The sublime here is thus a certain limit to representation and to sense, which is overcome not by sense-making but by the apprehension of its very limits, that is, of senselessness as such. The problem of the sense, or non-sense, of the experience of the seen continues to exercise discussions of the visual. The expansion of visuality in the nineteenth century through mechanical reproduction opened up new vistas for visionary pleasures but at the same time posed the dilemma of whether vision was for spectacle or for knowledge, a division between a subjective and experiential engagement with the seen as opposed to an objective and intellectual appraisal.

Spectacle, characterized by a sheer pleasure in looking, is typically cited as the key and initial element in cinema's popularity and fascination for audiences rather than, and in opposition to, narrative. In *The Struggle for the Film*, Hans Richter presents a version of the many "urban myths" about the responses of audiences to the first projected films. His story is set in 1923 and involves a Jewish emigrant to Palestine:

> He had few possessions, only an old projector and a single ancient film. With these he installed himself in the poorest Arab quarter of Jerusalem. His film ran for several months. The audience never failed him; indeed, he noticed many faces that returned again and again. One day by mistake the last reel was run first. Surprisingly, there were no complaints. Even the "regulars" failed to stir. This intrigued the cinema owner. He wanted to find out if anyone objected, and if not why not, so he ran all the reels in any order. No one seemed to mind. "Why?," he wondered in some amazement, and asked one of his oldest customers. It turned out that the Arabs had never grasped the plot, even when the film was shown in the right order. It was clear that they only went to the cinema because there one could see people walking, horses galloping, dogs running.[31]

The foundational role of spectacle for cinematic pleasure was quickly disavowed, however. Instead the pleasures of cinema have become defined as constituted by narrative and the standard account of film history is that the thrill of the spectacle of actuality in the new form of imaging gave way to the pleasures of narrative in the fiction film and its more successfully illusionistic world. In Crary's terms, the fiction film is more fully phantasmagorical as—especially in American cinema—the processes of production became hidden in order to sustain more effectively the illusion of a real world up there on the screen, complete, whole, and integral. In contrast, the actualities of early film invariably betrayed its processes of recording, making the viewer aware of the camera's look that has preceded her or his own, revealing its "disciplining" of the spectator. Spectacle suspends story in favor of the view and of viewing as a process for its own sake, and it is this role that Nöel Burch sees as an alternative to the narrative cinema that subsequently became dominant.[32]

Tom Gunning has described early film as a "cinema of attractions" characterized by a showing rather than a telling.[33] Such showing is marked through a display or performance that acknowledges the viewer, notably through the recurring employment of looks at, and thus direct address to, the camera, and hence by extension to the anticipated future film audience, which disturbs the establishment of narrative illusion. In acted film, this might create a complicity of gaze in the sharing of a secret or a joke with the spectator, who is thus drawn into the fictional narration, albeit not as a narrative illusion.[34] In the early actualities,[35] such as travelogues and "topicals," "showing" is not quite the same. The look at us so often recorded in these films may be one or all of three different looks—a gaze at the camera as an extraordinary machine and a wish to see it functioning, or a gaze at the cameraperson, or a look at an imagined future audience. This last look is less likely in the earliest actualities but quickly became a feature, as marked by the tendency of people in films to wave at the camera—a tendency especially disconcerting in World War I film footage of what we would at first perceive as lines of forlorn and desperate refugees walking past the camera, but who, when they suddenly turn and smile or wave at us, transform their relationship to us and disrupt our understanding of their victimhood.[36] The disjunction arises not only because the spectator becomes aware of her look as well as becoming the—imagined—object of another's look but also because such a look rivals the spectacle that is the "topic" of the actuality, for the camera's gaze is narratively undercut when all the bystanders appear uninterested in the scene around them and instead are avidly watching the camera. The look back at the camera disturbs the actuality shot by reversing

the object of fascination from inside the scene to outside. What must be distinguished here is not an opposition between spectacle and narrative illusionism but one between a filmic pictorialization—whether acted or actuality—that solicits and addresses the spectator's look for whom it "performs" and a spectacle that confronts or surprises the spectator in her or his looking.[37]

The spectacle of reality involves an entertaining of the eye through form and light, and an entertaining of the mind in the showing of something known either as familiar, or in a new or spectacular way, or something not yet known that thereby becomes the known. The world shown in the actuality or documentary film is presented as knowable, and the terms of its knowability are organized by the film, not by reality. The scenes of reality are posited for our view by their selection, framing, and combination; the spectator is invited to look and, even without titles or voice-over, to thereby understand the seen. The particular knowledge of a documentary film confirms the knowableness of the world in general. What is conjoined is the pleasure that Freud called "scopophilia," or the satisfaction of the wish to see and that, as curiosity, is closely associated with the wish to know or "epistephilia," with an identification as the subject of knowledge.[38]

Curiosity is central to the scientist's project of knowing the world and to the scientific use of optical devices, including film, in order to "see" what the human eye cannot. For both Eadweard Muybridge and Etienne-Jules Marey, in their development of ways to record physio-logical movement imperceptible to the human eye, optical devices became prostheses for human sight, enabling us to really know the *moving* object of view, which for Muybridge was the human and animal body. Such curiosity was equally but less pruriantly satisfied by the highly acclaimed British series filmed in the 1920s *The Secrets of Nature*, which used microscope and time-lapse cinematography to reveal the unfold-ing processing of nature. In curiosity, the desire to see is allied with the desire know through seeing what cannot normally be seen, that is, what is normally veiled or hidden from sight. Of course, when such a desire is associated with pleasure rather than with science, that desire is usu-ally termed voyeurism. Two processes can be discerned: First, there is the process of overturning the physical barrier to sight, or that which prevents knowledge, with all the violence this can imply. Here, desire is attached to the barrier or veiling rather than the hidden, which therefore cannot wholly be distinguished from nonphysical barriers, namely, moral and social prohibitions. Second, there is the desire to see what is hidden and the knowledge thereby afforded. What may be desired in this coming to

know of the hidden is the already known, as in the repeated viewing of the now-familiar but still forbidden body of the woman-mother in voyeurism. Alternatively, there is the pleasure and wish to see or be shown the unfamiliar. In documentary films, the unfamiliar of the seen has been associated with its sensationalism, a "cinema of attractions," presenting the exotic and the horrific, as well as the bizarre and unusual, including the eroticism of the sexually strange of other cultures and peoples.

Two contradictory desires can be involved in this encounter with the unfamiliar: either a mastery of the new and unknown, or a repeated encounter with the impossibility of mastery, of knowledge, and of sense-making. The latter, which as noted earlier might also be called the sublime and is therefore not necessarily simply satisfying, is also the experience Freud names as the "uncanny" and can be related to Lacan's notion of the real.[39] Curiosity here implies a seeing without the subject itself being seen or being the object of inquiry, involving a fantasy of mastery. Such pleasure is clearly afforded by documentary film notably, as has been widely discussed, in the "observational" film where, as a "fly on the wall" the spectator-camera intrudes or roams with impunity (depending on how one evaluates this) through the scene.[40] This pleasure in overlooking and overhearing the scene is heightened whenever an action not normally seen in public is shown in a film, or when someone exposes their feelings or thoughts on film accidentally or without apparent premeditation, which we are therefore led to read as "real." Such moments may also be comic or embarrassing and, when caught on home video, have become the material for television comedy shows. A version of such shows in the 1960s was called *Candid Camera*, and the form currently broadcast is more accurately named *You've Been Framed*.

The lure of the spectacle of the hidden revealed has also become a feature of much "serious" documentary and factual television. A new subgenre of the broadcast factual film has arisen in the editing of footage from the video cameras of the police and security firms as well as recordings of medical procedures in hospitals. In the 1990s, the public concern at the commercial marketing of these recordings led to the withdrawal of a number of such video releases in Britain. In contrast, *Police, Action, Camera* (made by Carlton for the independent broadcasting channel, and first aired in 1994, *Cops* in the United States is a similar format) is featured as a factual program about police work, its claim to seriousness supported by the presence of Alastair Stewart, a regular ITV news broadcaster, who introduced it until 2007. Such programs' visual material nevertheless offer a highly entertaining mix of specular pleasures. In *Police, Action, Camera* we are shown police video footage

from surveillance cameras on motorways and railroad crossings in which motorists and bus and truck drivers all take horrendous risks with their own and others' lives. We are invited to condemn the criminal stupidity of such drivers as we watch—voyeuristically—with the same view as the hidden camera. Later the skill of police drivers is demonstrated in a series of video recordings of car chases, all shot from within the following police car, giving an immensely exciting visual experience with the added pleasure of not only being with the "winners," since the police always caught the drivers, but also being on the side of the law. In video footage of police collaboration with rescue agencies, the prosthetic function of film is again foregrounded, but now it is electronically recorded video that "sees" not in relation to light but to heat as a helicopter pilot, flying at night and using a heat-sensing "camera," "sights" the still-living body of a man who has fallen into the River Thames and guides police and rescue workers to him. Subsequently we are shown the video footage from the same kind of "camera" that is guiding firefighters responding to a huge inner-city blaze to the hottest spots of the fire and to areas about to become engulfed in flames. The fascination with the spectacle of actuality here follows the tradition established by the early actualities, such as the Warwick Trading Company's *Fire Call and Rescue by Fire Escapes* (1899) and Edwin S. Porter's *The Life of an American Fireman* (1903).

The pleasure of the specular as access to knowledge is central to the recent development of "undercover" filming using hidden microcameras carried by investigators disguised as customers, supporters, and so on. We expect or hope to see those filmed expose themselves as liars, as heartless, or as corrupt. The clandestine footage heralds access to a greater or underlying truth about the event or topic, while the—then inevitably—poor lighting, sound, and vision connote veracity. The Channel Four series *Undercover Britain*, broadcast in 1995, developed this approach using "ordinary" people, often themselves formerly on the receiving end of the situations they now investigate, and thus combining the investigative with the autobiographical in a form of video diary.

The Samson Unit, made for the "Dispatches" documentary slot for Channel Four in the UK by an Israeli production group (broadcast in 1994), investigates the crack Israeli undercover army group, the "Samson Unit," documenting the soldier's work as spectacle and performance. It raises important questions about not only their role in Israel's struggle to combat terrorism within its borders, and the potential for error and brutality in its occupation of the West Bank/Palestine, but also the effects of their hazardous work adopting false personas and disguises on the men themselves. The film shows the men initially in training, then undertaking

a daylight undercover action, and then making a night raid on a house in the occupied West Bank as they attempt to capture suspected Palestinian gunmen. It focuses on individual men as they make preparations and shows their nervousness before the attack. The poignancy of these scenes, however, contrasts with the emphasis on the spectacle of the attack through the use of small infrared cameras fixed to a number of the men on the raid. The documentary thereby creates the expectation that we will see not so much the hidden but the normally inaccessible, at the same time giving a subjective sense of "being there" with the men as they undertake the action. The cameras, placed below eye level, while allowing us to see in the dark, nevertheless record little intelligible action, but the images do *connote* realism very effectively in a way now more familiar in fiction film. The privileging of—and our pleasure in—our audiovisual senses as access to knowledge that the documentary itself subscribes to is then questioned, however, when it is revealed that the Palestinian man killed in the raid—shot after failing to respond to repeated calls to halt, which we hear on the film—not only was not a gunman but also was, in fact, deaf. Unable to hear, he became a victim notwithstanding the military procedure of warnings and despite the soldier's declared aim to maim, not kill.

The past decade has seen significant changes in the broadcasting of recorded reality, for what is apparent in trawling the television channels is the explosion in "factual filming" forms. The docusoap emerged as a format from the serial observational documentary of Paul Watson and Franc Roddam's *The Family* (BBC, 1974), based on *An American Family* (Craig Gilbert, 1972, broadcast on U.S. Public Broadcasting Service [PBS] 1973), when Watson's *Sylvania Waters* (BBC, 1992) became reworked in the UK show *Airport* in the mid-1990s as cheap television.[41] U.S. formats include *Ace of Cakes, American Chopper, American Hot Rod, Miami Ink, Deadliest Catch, Ice Road Truckers,* and *Truth, Duty, Valour*. Reality, that is, ordinary people, are part of programs such as *The Oprah Winfrey Show, The Ricki Lake Show,* and *The Jerry Springer Show*, as they have long been in quiz shows. Now, however, reality television—"popular factual programming"—haunts documentary as its other, in what John Corner has called our "post-documentary culture of television" in a reference to hybrid factual versus entertainment forms that produce "documentary as diversion."[42]

The extraordinary stories of peoples' real lives and adventures fascinates, whether circulated through picture magazines, television talk shows, or reality programs. Corner makes a valuable distinction in his use of the term "post-documentary" to signal the relocation of a set of practices, forms, and functions that center on an "emphasis on microsocial

narrative and their forms of play around the self observed and the self-in-performance,"[43] with attendant pleasures in observing the gap between being and seeming. The "selving" that we observe, that is, the observation of a "true" self emerging from the performance, which was the object of direct cinema documentary is now packaged in the reality game show format created by *Big Brother* (Endemol). Such a show does not simply divert our attention but rather engages the spectator to entertain the possibility of different ways of being the self and being with the other, engaging forms and processes we commonly call "identification." As Annette Hill observes in her study of audiences, "Being a factual viewer means taking on multiple roles, as witness and interpreter, and occupying multiple spaces, between fact and fiction."[44] These multiple roles are explored more fully in chapter 3.

The new mediations of ways of "seeing others" and "seeing things," including the Internet, and the interpenetration of public and private via the Web are a reconfiguration, or perhaps a reversal, of the privatization of the personal and the family in the transition from traditional society to modernity. Documentary has always struggled to differentiate itself from the simple factual of news, current affairs, and information programs, as well as from the popular factual—whether this was the "topicals" of early cinema or the "infotainment" of the later Pathé newsreels and now reality television. The project of a "democratic civics" that Corner refers to may no longer be a focus of documentary, but its role as journalistic inquiry and exposition remains. At the same time there has been a resurgence in documentary as a project of radical interrogation, sometimes seen in cinemas or broadcast, such as *Bus 174* (José Padilha, codirector Felipe Lacerda, 2002, Brazil), but more often circulated in the parallel public sphere of the Web.

The concern to distinguish the serious as the "proper" factual from mere fun sustains the dichotomy that the documentary project—as the "drama of the doorstep"—introduced.[45] Paul Watson's recent UK documentary *Malcolm and Barbara: Love's Farewell* (produced by Granada for ITV, broadcast 2007) nevertheless shows that the importance of the story triumphs over reality even for a filmmaker who has become notable for his attacks on reality television.[46] This important and heart-rending documentary continues the story of Watson's earlier film of Alzheimer victim Malcolm and his wife, showing his deterioration and last hours after slipping into a coma but not his death on camera, as the film implies, and as claimed in pretransmission publicity. We see the most intimate moments of dying, yet this is a duration that the documentary cannot convey, bound as it is to measured time of the program slot. ITV

commissioned a review by media law firm Olswang, which concluded that while the filmmaker had not deliberately misled the broadcaster, the "misunderstanding arose from the ambiguity in the language used by Paul Watson to describe his filming and his film, and also the ambiguity of its final scenes."[47] In the following chapter I turn to this question of documentary's fictions and the drama of reality.

Narrating the Real: The Fiction and the Nonfiction of Documentary Storytelling

> *From the moment they become film and are placed in*
> *a cinematic perspective, all film-documents and every*
> *recording of a raw event take on a filmic reality which either*
> *adds to or subtracts from their particular initial reality*
> *(i.e., their "experienced" value), un-realizing or sur-realizing*
> *it, but in both cases slightly falsifying and drawing it to the*
> *side of fiction.*
> :: Jean-Louis Comolli, "Détour par le direct—Un corps en trop"

"How can we be sure that what we are seeing is true and not fiction?" is the question that haunts documentary. If documentary, as Grierson defined it, is "the creative treatment of actuality,"[1] Brian Winston asks what is "the nature of the 'actuality,' or reality left?"[2] And what is the nature of the fiction that Comolli argues arises from the "slightly falsifying" process of the re-presentation of recorded reality?[3] The factual cinema that emerged in the 1920s and that, following John Grierson, came to be called documentary was characterized by two central concerns: firstly, an opposition to the dominant mass cinema of fictional narrative; and secondly, a concern not with mere recorded actuality but with documentary as, in Grierson's words, "a new art" of filmed reality in a presentation or *performance* of recorded reality that brought the spectator to an understanding of her world anew. Documentary, as the creative treatment of reality, is a new art.

For early documentary filmmakers such as Grierson, Dziga Vertov, Robert Flaherty, and Pare Lorentz, narrative was central; what was excoriated was fiction. Yet Grierson's hostility to the fiction film, in particular the Hollywood fiction film, was not that its events and characters were imaginary but that these films, or most of them, lacked realism. Grierson attacked what he saw as Hollywood films' unrealistically happy

endings, false romanticism, and sensationalizing.[4] Neither narrative nor even fiction, however, were simply eschewed by these filmmakers while the question of manipulation and fabrication that was a central concern continues in our current debates about documentary and about forms of knowledge about reality for a society. This chapter explores documentary storytelling as nonfiction and the ways it is distinguished from fictional cinema. It argues that this is not an epistemological or philosophical distinction but is a discursive effect arising from the assertion of a differentiation, the terms of which are formed and transformed historically.

Documentary is the re-presentation of found reality in the recorded document, its truth apparently guaranteed by mechanical reproduction of that reality in what has come to be known as its indexical relationship to the original. It is closely linked to the development of modernity, for the documentary asserts itself as the genre of the objective knowability of the world. Dai Vaughan argues, "What defines a documentary as such is the way we approach it: the fact that we look to its images as records of the specific, not as envisionings of the possible."[5] In its desire to show the real, however, the documentary becomes prey to a loss of the real in its narratives of reality. It is a loss we cannot mourn but anxiously return to, that is, it is a loss of a reality imagined *before* its fall into mediation, interpretation, narration, and presentation. Charles Baudelaire, in his critique of the nineteenth-century project of realism in art, identified such an anxiety when he suggested that the realist seems to say, "I want to represent things as they are, or rather as they would be, supposing that I did not exist, that is, the world before my intervention."[6] The new visual apparatuses that emerged in the nineteenth century appeared to offer a mechanical realization of this desire, yet each also paradoxically figures the anxiety about the nature of our apprehension of reality that is central to realism in art, reintroducing the problem of truth.

The idea of a truly observational filming has haunted cinema from its beginning, giving rise to the desire for an unlimited access to reality in unmediated recordings of actuality, as if through the camera we may create a record of everything that an all-seeing God might have surveyed. With the development of lightweight 16mm cameras, which could be easily handheld, together with portable sync-sound in the late 1950s, the documentary filmmaker could at last move freely, following events and people at will.[7] The observer-spectator could now see and hear for herself, as if she were there. But "seeing for ourselves" in documentary is actually ourselves seeing through another's eye, for we adopt as our own the look of the camera that has gone before us and that has selected and organized the space and what is seen. Our access to photographed reality remains

partial insofar as the camera necessarily views this and not that (mise-en-scène), frames (*mise-en-cadre*), and hence cuts out from the wider ongoing contingency of the world just this scene, this event, this action, and this person. Nevertheless, such scenes, events, and actions—caught by the camera as they happen or discovered as "found reality"—include indiscriminately contingent elements of noise, activity, and objects, confirming them as reproduced through a process "in the making of which," as Bazin observed, "man plays no part."[8] Bazin's concern, however, is not with film's ostensible "objectivity" but with the understanding enabled in audiences by its re-viewing.

Recorded reality re-presented is a reenactment of the past as a making present again of places, people, and events, to an audience, but because it is extracted from ongoing reality, it thereby distorts by becoming exemplary, standing in for but also excluding—as unrecorded—other views and other people. To open up into meaningfulness, however, the recorded reality and its sounds and voices must, like the photograph, be captioned, becoming placed and grounded through titles or voice-over. It becomes documentary in that it is narrated through selection and ordering, in an emplotment, but thereby gives rise to an anxiety about what is lost of the real in this process of meaning making. Epistemological or philosophical distinctions cannot resolve the anxiety that the use of such dramatic devices arouses concerning the deformation they perform upon recorded reality.

▶

The Illusion of Reality

The moral—and political—requirement to distinguish between the real and illusory is central to modern Western culture and is part of a privileging of the serious over illusion, the imagined, and fantasy, which are usually assumed to be the domain of fiction. This very division, and its correlation of illusion and fantasy as equivalent, was challenged by Sigmund Freud at the turn of the century when he formulated the psychoanalytic theory of the unconscious, in which fantasy and dreams are central.[9] For the subject, the unconscious and fantasy are very real psychically and produce real effects. Lacan has subsequently extended Freud's challenge to the simple division of reality versus fantasy through his tripartite distinction between the real, the imaginary, and the symbolic.[10]

In Western philosophy it is Plato's allegory of the cave that articulates the demand for a distinction between the real and the illusory, which is central to modern theories of ideology whereby the real must be extracted

from behind or under the cloak of a veiling illusion such that, for Karl Marx, the real relations of power are uncovered.[11] In the 1960s, Louis Althusser, drawing on the work of Antonio Gramsci, allied the account of ideology and false consciousness in Marx to Lacan's concept of the subject as formed in an imaginary relationship through a miscognition of itself as unified, whole, and ideal.[12] This miscognition arises for the subject in what Lacan termed the "mirror stage," when the infant recognizes itself as imaged and thus identifies, perhaps when seeing itself in a mirror or by the voice or touch of the other through which the child is addressed as a unified whole. In identifying, the child is constituted as a subject and as a body with boundaries. Yet this also involves a misrecognition, Lacan argues, for the image identified with is the child as a whole, a unity that contrasts with the child's experience of itself as uncoordinated and a series of parts. The image is an ideal, but in the process of identifying, the child is alienated from this ideal self, as an other it seeks to be, and Lacan calls this relation to a unified and whole ideal "the imaginary."[13] It is this imaginary that, for Althusser, provides the form of the subject's lived relation to society. Through this relation, the subject was brought to accept as its own and to recognize itself in and identify with the representations of the social order. The subject is thus "interpellated."[14] That social practices address us and so interpellate us as subjects for their discourse is clear, and we can speak of the subject of medicine and the subject of law. Yet Althusser's emphasis on miscognition implies that the subject's identification is with a false image of unified subjectivity, implying that such a mistaken identification can be rectified and an alternative—true— subjectivity will emerge in its stead. For Lacan, on the contrary, it is neither a matter of perceptual error nor a matter of a false image but of a splitting that accompanies the very possibility of imagining, that is, of having an image of one's sense of embodiment. This splitting immediately divides the human animal in its bodily experience from its image of itself, split between an imagined and idealized unity and an experienced incompletion. Two different and contradictory knowledges arise, to each of which the subject is equally attached. The divided subject, however, is no more a truth, or a lie, than the unified subject and certainly cannot be the goal of a radical politics.[15]

Lacan's concept of the imaginary cannot support a theory of ideology as a mask that is covering over and hiding a truth and reality that lays behind the (mis)representation, and that can be revealed by peeling away the distorting mask of ideology. On the contrary, Slavoj Žižek has argued, while ideology may appear as a mask, there is nothing behind the mask. What is supposed to lay behind the mask is constructed by the discourse

that proposes its masking, not a reality distorted by the masking. Instead, in his famous reversal, Žižek refers to reality as such as "fantasy," as a construction that "manages" the real.[16] The fundamental fantasy is that of "the" world, as obvious, as a fact, and as knowable, and thus as a reality guaranteed by the symbolic order of law, science, all the discourses of sobriety that thereby distinguish the "merely" imagined as "a" world. It is these discourses that constitute—in Lacan's terms—"the Big Other." The brute awfulness of "the real world" (as both humdrum and cruel) is often contrasted—as Grierson did—to the wishfulness of imagined worlds of Hollywood's dream factory. However, this is a false opposition, for the awfulness of the world of reality is always preferable to the unrepresentable, unbearable terror of "a world" of the real. We can, nevertheless, take a distance from ideology, from the imaginary, but such a place must, Žižek argues, remain "Unoccupied by any positively determined reality—the moment we yield to this temptation, we are back in ideology."[17]

▶

The Fiction and the Nonfiction of Documentary

These terms are not simple opposites, nor are they equivalent to real versus nonreal, factual versus nonfactual, and true versus false, for while documentary is called factual film, fiction is not simply nonfactual. Fiction denotes a genre or category of literature, also termed "the novel," that is a narrative work of imagination. The earlier meaning of the term, now obsolete, referred to the act of fashioning or fabricating an imitation of nature; thus painting, as a mimetic art, was a "human fiction." The related meaning of fiction as feigning, deceit, and dissimulation on the part of someone also became obsolete with the emergence in the eighteenth century of a new form of literature that presented the imaginative invention of events and characters narrated—fashioned—in words but in which the imagined incidents and persons are presented without the intention to deceive. This came to be termed "fiction." Such works were distinguished from the "romance" in that they were, in the words of the nineteenth-century critic Edmund Gosse, "a sustained story which is, indeed, not historically true, but might very easily be so," involving as a genre the analysis and criticism of contemporary life.[18] This new kind of literature, represented by the work of Richardson and Defoe for example, was not a distinct form in the sense of the difference between free verse and the sonnet, nor was it a new material form, as with cinema. These works were hybrids based on the work of, at least, the essayist, the epistolary, and the dramatic. They are part of an assertion of a new and

serious use of the imaginary in literature that is opposed to the unreal-
ity and unseriousness of romances and fairy tales; indeed, both Defoe
and Richardson presented their works as true accounts, as documentary.
Defoe's *A Journal of the Plague Year*, published in 1722, is a reconstruc-
tion of events several decades earlier, combining the factual, in its careful
descriptions drawn from contemporary oral accounts and in its con-
temporary statistics and recorded information, with the invented in its
fictional narrator-character, who reflects on his own position within the
pestilence-ridden London he has chosen to remain in. Defoe's book would
thus appear to be a forerunner of the documentary, not the novel, and
Patrick Keiller's film *London* (1994) presents a comparable work of docu-
mentary sounds and images narrated fictionally, as a chronicle of a year
in the life of Britain's capital seen through the eyes of Keiller's imaginary
protagonist, Robinson—in a reference to Defoe—but whose insights and
responses are reported to us by an unnamed and unseen narrator, voiced
by Paul Scofield. *London* contrasts with the current hybrid form that
also draws on invention, namely, the docudrama, for in the latter what is
central is not the inventions introduced nor the use of reenactment, but
the way the events are presented within a frame of narrative causality that
produces a novelizing (I return to this later in the chapter).

Fiction and novel—in the sense of the modern novel—came to be
taken as synonymous terms so that by the nineteenth century the writer
Henry James could declare, "The only reason for the existence of a novel
is that it does attempt to represent life."[19] The literary arguments here
reflect contemporary cultural debates and the new claims for realism
by writers. Fiction in the novel, therefore, is not nonfactual or without
truth—it may include many facts, as well as statements with truth value
that we might accept as true.[20] "Fiction" is thus a hybrid of the nonreal
and the real, as an imagining of the actual—for example, in the devel-
opment of the documentary novel in the 1930s that was influenced by
cinematic documentary.[21]

The term "nonfiction" appears to be more recent, perhaps arising
with the development of public libraries, for the *Oxford English Dic-
tionary*'s (OED) first recorded use is 1867, in the annual report of the
Boston Public Library, to distinguish between "fiction and non-fiction"
writing, and the OED consequently defines it as simply "prose-writing
other than fiction."[22] Paul Rotha, the British film theorist and documen-
tary filmmaker, was clearly drawing on such a distinction when, as early
as 1931, he referred to "non-fictional film."[23] While fiction is a genre
within imaginative writing, nonfiction encompasses a very wide range
of forms of "narrative depiction of factual events,"[24] including not only

scientific writing but also biography. The success of the term "documentary" in English signals, however, the wish to distinguish a certain kind of nonfiction work on the model promoted by Grierson, namely, the creative, that is, narrative, treatment of actuality. What is the nature of the fictionalism thereby introduced and with what consequences for truth value and knowledge? Does documentary film nonfiction, as Branigan has suggested, deploy narrative differently to fiction?[25] Does this produce a fictioning of reality? Is truth determined differently in fiction and nonfiction?

The distinction between fiction and nonfiction does not exist in the text itself—whether written or audiovisual—but in the authorization that is provided for the text by the writer or filmmakers and by the publisher, exhibitor, or broadcaster. There is no style that distinguishes the factual from the fictional while both narrative focalization and omniscient narration or nonfocalized narration are found in each. If, like fiction, the documentary is defined as not intending to deceive, then it requires an assertion in this regard by its producers that the events and actions shown—the film's world, in fact—are actual and real, in such a way that enables the reader or viewer to know "for certain" whether what they are watching is offered as fiction or nonfiction. This may be directly stated by the opening credit titles, or through voice-over or titles within the film, or by direct speech, but where no such assertion is made, such as in Frederick Wiseman's films, it must be made clear at the point of exhibition or broadcasting of the film to ensure, as Carl Plantinga argues, that it "mobilizes relevant expectations on the part of the audience."[26] Of course, certain visual and narrative styles are more likely to be encountered in nonfiction, and our knowledge of the conventional use of such styles supports the assertion of nonfiction or may draw us to assume the work is nonfiction in the absence of an extratextual statement.

The illocutionary role of such an assertion is complex. Trevor Ponech states, "A belief is verbally expressed, along with a certain kind of 'illocutionary force,' namely, the intention that the hearer acquire or maintain a like belief," that what she is seeing and hearing is nonfiction.[27] This allows for a "non-fiction stance" by filmmakers and audience toward the represented in the film,[28] so that whatever the actual status of the filmed material—it may include reconstruction or re-enactment as well as actuality footage—we are asked to view this as nonfiction because it presents an ordering of images and sounds that, if not recorded actuality, references reality. It is about "the world" and not "a world"—to draw on Bill Nichols's distinction here.[29] The possible uncertainty surrounding the veracity of documentary film is not dispelled by this definition of

nonfiction works, for the filmmakers might be lying, or might be themselves mistaken, or might have been deceived by the participants. The assertion of nonfiction involves, moreover, several different claims by the filmmakers as communicators: that what is being shown should be treated as nonfiction statements—both linguistic and nonlinguistic—about the world that are not intended to deceive; that what is shown is truly reality; and that what is being asserted about what is shown is true because it is corroborated by the *evidence of the filmed reality*. The truth of the nonfiction work arises not through being recorded reality, however, but through the argument it makes in presenting the statements of others—experts, witnesses, participants in the events—directly through interviews or, in observational documentary, as overhead. Peter Lamarque and Stein Haugom Olsen acknowledge that language organizes our experience of material reality "without thereby creating it"; nevertheless, that organization constructs how we view and understand reality, transforming its "thingness" into "something."[30]

Truth, therefore, is not a quality or meaning that is immanent in reality; rather, it is an effect of human discourse. Material reality—the trees outside—are not true, they simply are. The "true meaning" of reality lies not in what we see and hear, or touch, but in our understanding of reality organized through our symbolic systems, preeminently through language. The truth of reality must be spoken, or presented, in documentary: as a result the term "truth" is a way of categorizing statements of meaning and description about the world, in contrast to the false. In secular societies, truth is established through argument supported by evidence, which becomes "fact" by its deployment within a discursive argument[31] (hence Foucault's case for truth as power discussed in chapter 2). The facts, in fact, cannot speak for themselves. Rather, we make them "speak" by our contextual knowledge and understanding within specific institutional and social frames so that, for example, while Rodney King's brutal wounding was recorded on video by George Holliday, the "facts of the matter," namely, whether this was unlawful or lawful police violence, became an issue of interpretation and one that, although judicially resolved, remains rightly contested. This is not to argue, as postmodernists might, that objective reality it is nothing more nor less than what we *say* it is. Knowledge in modernity is not subjective, it is not simply relative; nevertheless "objectivity" itself is a construct of thought in relation to materiality.

Speech is a symbolic system by which we address an other. How, then, does what we say about the world become understood as true, that is, what guarantees it? We might say that truth is really just a way we have of speaking about what we agree on—cognitively recognize—and

what we find persuasive. This returns us to Immanuel Kant's view that truth as a statement is an intersubjective act, involving a rationally communicable cognitive orientation.[32] Lacan's discussion of truth, drawing on Kant, addresses the intersubjectivity involved, for he suggests that in speech, "the signifier requires another locus—the locus of the Other, the Other as witness, the witness who is Other than any of the partners."[33] For while one cannot feign the act of feigning, one can lie about telling a lie, but in doing so one posits a truth knowable somewhere else, by some other who is witness to the lie *as* a lie and thus also to the truth of the lying speech. This Other is Truth's witness, since for who else but this Other does one pretend to lie? Certainly not the duped addressee who believes the lie (which it is not) and therefore fails to know the truth. Lacan concludes, "Thus Truth draws its guarantee from somewhere other than the Reality it concerns: it draws it from Speech. Just as it is from Speech that Truth receives the mark that instates it in a fictional structure. The first words spoken decree, legislate, aphorize, and are an oracle; they give the real other its obscure authority."[34] Such speech is that of the Master, one of the four discourses outlined by Lacan, and discussed more fully in chapter 3.

That something regarding truth is at stake in speaking is suggested as well by theories of truth, notably what is termed the "Performative Theory of Truth," which argues "that ascribing truth to a proposition is not really characterizing the proposition itself, nor is it saying something redundant. Rather, it is telling us something about the speaker's intentions. The speaker—through his or her agreeing with it, endorsing it, praising it, accepting it, or perhaps conceding it—is licensing our adoption of (the belief in) the proposition."[35]

Documentary, similarly, is performative in asking us to believe it as nonfiction, but in each case the question arises of whose intention it is: who wants me to know this and why? The corollary is that there may arise as well anxiety at the loss or absence of a guaranteeing speech that does not also imply the possibility of the false.

Lacan's assertion of the fiction of truth and his claim that "every truth has the structure of a fiction," is not saying that truth is illusory (i.e., false) but that it is part of the symbolic system, in opposition to the "real." He writes, "The fictitious is not, in effect, in its essence that which deceives, but is precisely what I call the symbolic."[36] Lacan draws here on the work of Jeremy Bentham, who argued that "a fictitious entity is an object, the existence of which is feigned by the imagination, feigned for the purpose of discourse, and which, when so formed, is spoken of as a real one."[37] For Bentham, Colin Tyler writes,

Fictions and fictitious entities are required for any language and consequently any thought beyond that of "the brute creation." Judged by the standard of utility, discourse using propositions that only referred to real entities would be too cumbersome when compared to the circumspect use of some propositions that refer to fictitious entities. Without such propositions, there could be no widespread medicine, no art, no poetry, no engineering, no chemistry or other sciences, and while there could be none of the present linguistically based judicial corruption, similarly there could be no possibility of an uncorrupted system of law, rights and justice. In short, some legal fictions, like some legal fictitious entities, may be justified on the ground that their careful use tends to bring a net utilitarian benefit.[38]

We must draw upon just such a sense of the "fictitious" in relation to the nonfiction of documentary and its deployment of "fictitious entities."

Documentary, however, in showing recorded reality, asks us not only to view it as nonfiction, as not made up or not real, but also to view it as happening a particular way, where what is shown is *phenomenologically independent* of what is asserted linguistically. The documentary filmmaker asserts that not only what she says but also what she shows is not imaginary, and the illocutionary force of this is dual: the viewer is asked to take not only a nonfiction "attitude of belief toward this situation" but also the attitude of a "natural interpreter" of the audiovisual, a stance distinct from the belief that the filmmakers intend what they say in the film to be believed as "how things stand in the world." Indeed a question arises as to how far all that we see and hear is intended by the filmmakers as a communication act, and a meaning. In his discussion of nonfiction, Ponech does not give any defining specificity to the audiovisual of nonfiction because images and sounds of reality, and therefore reference to the historical world, appear in fiction film as well. But documentary—as a term referring to audiovisual nonfiction—is different from nonfiction literature and radio, which each describe to us the seen reality, or marshall its voices. In documentary film, sights as well as soundsof reality are seen and heard that are a record of their occurrence in time and space independently of specific statements by the film-makers, or interviewees. For we make sense of the uncontrolled, the polysemic, in documentary as well as the organized and narrated. As Ponech summarizes, drawing on Charles Sanders Peirce's notion of the index (discussed shortly), "By virtue of its natural indicator elements, the cinematic, audio-visual artifact is always related to some real situation, about which it preserves a selection of information."[39] But, as Plantinga argues, "The showing may not involve an assertion of a specific propositional content,"[40] and the asserted proposition may not relate to all the information the audiovisual

offers. The "this," the sights and sounds, is never fully intended for us by controlling authors or fully interpretable, but instead, as "found" reality, it is always in excess of the documentary's narration. Documentary is an organized statement, an "utterance" of the recorded audiovisual, but it can never fully determine—as might be done with a conventional sign system such as language—the meaning of the utterance, for there is always some aspect that exceeds the intention of the filmmakers, which we refer to "reality." In this lies the specificity of documentary as nonfiction. This "reality" is neither true nor false; rather, it is a real that bears upon us as a brute insistence, and it is the nonmeaning real, and not simply meaningful reality, that documentary as audiovisual nonfiction enables us to encounter.

▶ ───

The Fake in Nonfiction

The classical aim of pictorial art as the production of an illusion of reality[41] was challenged by the development of the still images of photography and by the moving images of cinema, each of which mimics perception, effecting a certain deception of the eyes and thus of the mind. Film—as images and sounds in time and space—is mimetic, like photography from which it derives; but it is also, like drama, mimetic in its showing of performed actions and events in time and space. At the same time, film is diegetic, a form of telling: it narrates like literature. Film is not fictional in the sense of fashioning an imitation in the way that painting was considered a "mimetic fiction," rather, it registers the image of the original, albeit by a complex chemico-electrical industrial and, now, digital process, producing—to recall Bazin's words—an automatic copy of reality.[42] Film not only indicates the reality it records but also is caused by that reality. The American philosopher and logician Peirce characterized the photograph's relationship to reality as indexical and thus as signifying about the reality it is a trace of. In his theory of semiotics, Peirce presents the sign as tripartite—as icon, index, and symbol—whereby each form of sign is a representation of an object. The icon demonstrates the qualities of the object through a drawn image, or a diagram, and so on. An index demonstrates the influence of its object, for the mercury in a thermometer responds to the warmth or coolness of the atmosphere, organized to rise in a container in relation to calibrated markings that enable these two qualities to be measured; nevertheless, we do not *see* the heat. The bullet hole indicates the action of the *absent* bullet. Similarly, we do not see the time a clock tells; we can only read the measurement of time the

clock's mechanism is calibrated to record. The photograph also shows us what it points to—reality, thus it appears to be both iconic and indexical. Its iconicity (its status as an iconic sign) rests, however, not in the image of the objects we see within it but in the object that the photograph is; the qualities demonstrated are those of the object *photographed*. Peirce makes clear that the icon is not simply the object but a rendering of its qualities, for the representation is clearly differentiated from its object. He saw photographs as indexical as a result of their physical connection to the objects they show, "having been produced under such circumstances that they were physically forced to correspond point by point to nature."[43] This indexicality seems to guarantee photography and cinematography's truth to reality, for indices, Peirce asserts, "furnish positive assurance of the reality and the nearness of their Objects."[44] In the photograph, the "dynamical object" is light, and what the photograph demonstrates is the influence of light reflected from objects that either produces a change in the light-sensitive silver salts or, now, triggers the digitally coded registration of this information. The thermometer does not indicate the source of the heat or cause of its absence in the indication of coldness, but only its effect. Similarly, a photograph shows the effect of light reflected, namely, the images formed by light bouncing off objects; this does not guarantee the nearness or the nature of the reality of the objects imaged, but only the nearness and reality of reflected light.[45] The indexicality of recorded still and moving images points to images formed by light but not to the nature of their reality or truthfulness or context. The optical recording of sound is similarly indexical—as an image of modulated light waves corresponding to the sound waves of speech and noises (replaced by magnetic tape from the 1950s)—but its status as evidential of the real has been different in that, as speech, it provides testimony in words and thus in a symbolic language.

For Peirce, only the symbol has what he terms "thirdness," that is, the triadic relationship he requires for the signification or meaning made possible by language: an object, a sign, and an interpretant.[46] The symbol functions as a sign in being interpreted as a reference to its object. A symbol thus denotes primarily by virtue of its interpretant—in language, the word translates the object into a sign in the mind. Its sign action (semiosis) is ruled by a convention, a systematic set of associations that ensures its interpretation: for example, natural language or certain forms of cross as a conventional reference to Christianity. Nevertheless the icon and the index signify; they communicate something about the object they refer to. Peirce refers to indexes as "natural signs" because they arise from the nature of an action and are produced by it, so that stepping through mud

or snow will leave the imprint of the feet, paws, or claws that make that action. Its meaning, that is, our interpretation, is not similarly natural but depends on our learned knowledge about the world.[47] Although the photograph does not index the reality of our world of objects, people, and actions but only the action of light reflected, it is a sign of more than the action of light because of the relationship we interpret as existing between the light reflected and the objects the light is reflected off. Like the bullet hole that bears visual witness to the passage of the bullet, the photograph signals an event: it is a sign of contingent and ongoing reality from which it has been cut out and cut off spatially and temporally. That it also bears the imprint of that reality does not engender meaning any more than looking at reality.

The photograph or film's excerpted reality also points to a reality *not excerpted*, which we cannot see and is therefore "missing," as well as the reality *unexcerpted*, that is, unfilmed, whole, and without loss, thus not only unrepresented but also unrepresentable.[48] In recorded film, therefore, we do not have a direct and full access to either contemporary or historical reality, for a process of signification that is also a mediation is necessarily introduced in the temporal transpositions its recording produces. Nevertheless, it is this possibility that both photography and film allows us to envisage, namely, that of an incontrovertible evidence. It was just such *evidence* that was the concern of the makers of *Spanish Earth* (Joris Ivens, 1937) when they showed to cinema audiences the brutality and horror of the aerial bombing of Madrid by Franco's fascist insurgents and its devastating effect on ordinary people, the civilians of the Spanish Republic. Ernest Hemingway's voice-over tells us, "Men cannot act before the camera in the face of death." Later his narration discovers for us in the wrecks of some planes the names of their manufacturers and the identity papers of their pilots as German and Italian, demonstrating the involvement of these states in contravention of international law. While the amateur photographs and films recorded by German soldiers during the World War II, like those more recently at the military prison of Abu Ghraib in Iraq,[49] were personal mementos, once discovered, they can be mobilized as visual testimony to crimes in international law as well as testify to the fetishistic desire for precisely such an evidential record on the part of the photographers. The photograph—or audiovisual recording—as evidence, is mobilized then by a discourse of law, of ethics, or of psychology in order to bring the image to speak its "truth." It becomes narrated in the transformation of the document into the documentary as a presentation of the facts and the testimony of participants in the events and actions shown. As Philip Rosen has argued, what is required

to transform the fuzzy indistinct film footage of the assassination of the John F. Kennedy is the explanation by the commentator Bill Ryan, which produces coherence and sense from unmediated, unorganized reality, and thus it becomes documentary.[50] At the same time, the reality of the document is appealed to, proven in this example by the very fuzziness of the image. The *meaning* of the events of September 11, too, was not immanent in the images and sounds, for while it was clear that planes had hit the tower blocks of the World Trade Center, understanding this in terms of cause was more difficult, and television reporters at the scene struggled to imagine its causes in the absence of information that would only come later. The images and sounds are conventionally marked and read as authentic, but their veracity does not produce meaningfulness.

▶ ───

The Reality and the Illusion of Documentary

Cinema is the projection of a series of still images that have been recorded consecutively through a continuous but intermittent exposure of photographic film at a speed of at least fourteen frames per second so that, when projected at a similar speed, the eye perceives them as images of moving people whereas they are really moving still images of people. It is in this apparent movement that the cinema presents a dissimulation, a "feigning" of reality, for although the people we see and the actions they undertake are not imagined—that is, are not a mental construct—but are real, and the images that reproduce that reality as photographically recorded are real, these people are not present to us. Only their image is present. While stories of early spectators *deceived* by cinema's images abound, these miss the point, for as soon as such spectators are fully appraised of the nature and origin of these images, they stop looking behind the screen for the real actors (if they ever did). We are no longer in ignorance, as were the prisoners in Plato's cave, yet we respond in certain respects to cinema's images as if they are reality, that is, we respond with belief.

Modern technology has given us an array of prosthetic devices that enable us to transcend time and space. Communication devices—the telephone, two-way radio, the Internet, and the mobile phone—involve a "doing" in an exchange of words and, now, images in a present "real" time but separated by space. They are interactive. Live broadcasting— radio and television or Webcam—is an overhearing or overseeing in the present or "real" time, but unlike theater or the football match, our embodied relationship is different; separated geographically, we are cognitively in two spaces, here and there, while physically located in one place.

Recorded reality overcomes the separation of both space and time: we can experience the seen and heard now, in a present tense of seeing and hearing, and in any place. We can "recover" past sounds and images that become displaced in time and space, as we listen to Mozart, or the Rolling Stones, or review our photographs and family films.

We do not consider the telephone as deceiving us when we speak to friends and family and hear the replying sounds as their voices. Nonetheless, we do not hear anyone's voice, for while to our ears the noises emanating from the resonating diaphragm in the telephone receiver are the same as the voice of the person we believe is at the other end of the telephone line, in fact that voice, as sound waves resonating in the air, has become a series of electromagnetic signals. The telephone reproduces the voice of our interlocutor in the "real time" of our conversation—and our interaction, albeit mediated, is real; it is an experience in reality. By contrast, it is the "over there and elsewhere" of images and sounds that we cannot interact with but yet are present to us, that raises the question of our relationship to them as reality.

"Real time," "historical time," "actuality," and "event," are all terms that we use to mark out the temporal difference between the experienced present, the "now" time, and its later encounter in remembering—through our own memories and through prosthetic devices of audiovisual recording. Our encounter with past "real time" arises, on the one hand, through its indexical traces in diverse forms of material record arising in the same temporal moment, such as the clock stopped at the moment of the bombing of Hiroshima or the water marks left after Hurricane Katrina. The photograph indexes time as the instant of the camera's shutter opening and closing, but it neither measures that time nor records it. Cinema's record of movement is a series of still images, but time may be indexed within the image by the angle of the sun, the style of clothes, and so on. On the other hand, we encounter the past in the present through its re-presentation in the written accounts of those present within that "now time" or, in the case of film, in the recording of past sights, sounds, and words experienced in viewing as "now time." We "flashback," which in film produces a particular fiction or "as if" effect.

The term "flashback" was first used in the nineteenth century in the novel, in the sense of a memory coming upon one in a "flash."[51] It was later also used to refer to the experience of trauma victims of a "return" of a visual or auditory memory of the traumatic event—as with the World War I soldiers who fell victim to "shell shock"—or, more usually, a memory that is charged with the painful affect of the traumatic event but does not ostensibly appear to be connected. The flashback emerged early

in cinema as a means of referring visually either to earlier story events we have seen in the film or to a time prior to that of the film's events; it may show events remembered by a character, or it may convey information independently of a character, as an "objective" flashback.[52] As a cinematic device, the flashback transgresses the spatio-temporal coherence of dramatic, mimetic performance, breaking the diegetic illusion of continuous time and space and making apparent a controlling "narrator." It introduces a specific fictionality, distinct from the fiction of the story as such: the fiction that the past can be *re-seen*, while unmarked as such as past—for there is no past tense to audiovisual recording. This is the fiction embodied in the flashback as a subjective remembering, for not only is the remembered imaged instead of thought but it is also shown in the same way that we see and hear the diegetic present time of the film; thus we see and hear the subject in the past of her remembering. The past as *remembered* thought as image is given an equivalent *cinematic* reality to the represented present. The subjective flashback is always potentially unreliable, as deceiving—as in Hitchcock's *Stagefright* (1950)—or as a misremembering, but what we see does not cue us to this possibility. While the nonsubjective or "objective" flashback always breaks the illusion of the diegetic world as continuous in time and space, the fiction that both it and the subjective flashback constitute in cinema is the fiction of seeing and hearing across time. The present tense of images and sounds of the past time of the diegesis are seen in the present time, present tense of the film's story.

The documentary film's recording of reality re-presented is not usually considered a flashback, yet it, along with newsreel footage, constitutes an audiovisual archive of past reality, a public form of memory that we may appropriate as our own to become how we remember. The fiction of archive footage as flashback is the past time present again audiovisually, which we experience as our "now time" of affective encounter.[53] In Spike Lee's *When the Levees Broke: A Requiem in Four Acts* (2006), the archive footage edited with interviews merges with the remembered accounts given by the participants, just like the flashback in fiction film.

This fiction effect, like the ontological paradox of the cinematic image that has exercised philosophers and film theorists, arises not because film is an illusion, for the images are optically real, but because although we are separated in space and in time from the images—the *absent* but *real* objects, persons, and places we see engage our belief such as to produce real emotional and mental responses. It is as if the scenes and experiences we watch are happening right now and are not merely past events. We are not spatially present to the events, however, and this

is a central element in our affective response. The images of the attacks of September 11 on the Twin Towers in New York City and the horror of the many people trapped as each building became engulfed in flames and then collapsed like a house of cards was available to viewers across the United States and the world as it was happening in real time, yet our spatial separation was not compensated for by an auditory interaction, as it was for those relatives and friends speaking by—mainly mobile—phone with those trapped. While the events were not happening to us, for we were not physically present to them but instead safely in our homes or places of work, we still may have felt anguished horror, terror, fear, pity, and loss because we imagine what those trapped might be experiencing and we react emotionally in our imagining, as if it were ourselves. Moreover, it is just such a spatial separation that can produce trauma, as it did for many of those relatives and friends and viewers overseeing the events. For what may be brought into play, unconsciously, is of a past infraction that is now remembered—flashed back to—in the experience of imagining a possible future infraction.

Documentary gives rise to emotional responses that, insofar as they are related to nonfictional events, are therefore viewed as proper and appropriate in contrast, for example, to the views of Gregory Currie and of Kendall Walton, summarized by Peter Goldie, that responses to fiction involve *quasi-emotions* and not real emotions, "involving make-beliefs or imaginings rather than beliefs, and make-beliefs do not have the same connection to action as do beliefs." Goldie notes that the problem with this division of emotional response "is that our response to real life non-actual events would *also* be consigned to quasi-emotions: we would only have quasi-emotional responses to accounts of things that have happened in the past, or to things that we imagine, remember, daydream, hypoth-esize, and plan."[54] Goldie instead proposes a distinction not between fiction and reality but between our emotional response to actual events that we experience and nonactual events that we experience imagina-tively as thought. Our anxiety in relation to an anticipated meeting, for example, involves the thought of the meeting that is imaginatively expe-rienced. What is involved is a *representation* to oneself of the possible future actual event in the now time of lived experienced. He argues that our engagement with narrative explains our engagement with nonac-tual events, and this is achieved "through imaginatively adopting two kinds of perspective that the narrative involves": between the thoughts and feelings of those internal to the narrative, its protagonists, and the external perspective of the narrative discourse. "If all this is right," he says, "then there should be much in common amongst our emotional

responses to non-actual events, *whether fictional or real life*, and to the extent that there are differences, these should be explainable"[55] (emphasis in original). Documentary engages us with the nonactual because it is a representation of a past time and of a place not present to us as we watch and listen, offering a space and time for our imagining and for our thinking and feeling.[56]

Fiction engages the reader in a complex relationship that the phrase "willing suspension of disbelief" has traditionally summed up[57] and has been held to give rise to the "paradox of fiction" whereby events are treated as "real" and "true" by readers or spectators because they are emotionally compelling, although imaginary.[58] Inversely, documentary—like the narratives of history—is treated skeptically by spectators and viewed as possibly untrue or as falsified reality. Paul Ricoeur notes, "Historians address themselves to distrustful readers who expect from them not only that they narrate but that they authenticate their narrative."[59] In factual cinema it is not enough that the words and images are compelling, for we may remain skeptical of the claims for truth and objectivity not only insofar as the evidence adduced is found unconvincing but also because we are uncertain of our own ability to evaluate the evidence for the authenticity of the account presented—in other words, we fear being duped. Paradoxically, however, we may take a stance of skepticism because the nonfiction's showing is both compelling *and* convincing; it is felt to be emotionally real but, unlike in the case of fiction, our emotional response presents us with the question of action in relation to the conviction the documentary has given rise to—evidenced by our response—and, not wanting to take responsibility for the ethical demand for action arising, we question the evidence.

Our subjectivity as readers or spectators of nonfiction is similarly engaged when we are confronted by evidence and argument that counters our knowledge about the world—what we take it to be like (a question of verisimilitude)—or the validity of our beliefs. The sociologists Paul Merton and Karl Lazarsfeld, analyzing factual radio programs in support of the war effort following America's involvement in World War II, observed, "It is already well-known from related fields of investigation that listeners cannot readily assimilate information and attitudes if these are not already tied into their backlog of experience" and asserted "evaluations evoke skepticism and doubt." However, facts "which integrate and 'explain' a course of events" allow the audience to draw their own conclusions, albeit guided implicitly by their cumulative force."[60] The subjectivity of our encounter with documentary is the focus of my discussion in chapter 3, while here I want to consider the question of

documentary verisimilitude in relation to its claim to be a nonfictional narration of the world.

▶

Documentary Emplotment and Verisimilitude

What distinguished the new genre of fiction was not that it involved imaginary persons and events but that these events and characters and their actions could have occurred, for they are recognizably likelife as it was lived by readers. We might recall here that Bazin did not see the documentary film as the only form of realist cinema; rather, like Henry James, he recognized the power of the fiction to represent human experience through storytelling and constructed narratives. Realist works must produce in their reader or viewer a sense of recognition of the world they portray as lifelike, as verisimilar. It is because the material and external world is not meaningful—it just is—that an impression of verisimilitude must be produced by nonfiction as well as fiction in order that we may apprehend the represented reality as realistic, that is, as like what we *expect* life to be like and thus believable.[61] The term addresses our *expectations* about the world, and these derive not only from factual or scientific knowledge but also from our knowledge of what is held to be culturally normal for our community. Verisimilitude is thus an effect of our social knowledge that is culturally as well as historically specific in relation not only to how our world appears but also about our human actions in the world, and thus it partakes of the "natural interpretation" discussed earlier where the cause or motivation for the observed phenomena is understood through knowledge of the nature of actions on the world. In presenting "the" world, documentary assumes audiences will comprehend it in the same way we understand our everyday reality, which is to say, in terms of our expectations about the world. The poor, for example, must appear properly poor in whatever way an audience may currently recognize poverty. Verisimilitude depends as well on the way in which we understand human activities in terms of goals or intentions; thus people standing together in a line become comprehensible as a queue once we understand that they are waiting to enter a cinema—that they are there *for* something—although this meaning is only available if we understand the cultural convention whereby waiting groups of people form a line, a self-imposed order of access to the cinema.

We expect, nevertheless, to assess the world of nonfiction differently than a world of fiction, bringing to bear a different schema for comprehending it *as* nonfiction. In a discussion of observational documentary,

Comolli argues that within *direct cinema* a whole range of exchange, reversal, and inversion activity is set up between what might be called the reality effect (the impression of the experienced, true, etc.) and the fiction effect (sensed for instance in common expressions like "too good to be true," etc.).

In contrasting a "reality effect" and a "fiction effect," Comolli distinguishes between two different ways in which spectators respond that each relate to cognitive schemata of "believability": the first is the movement from immediate belief to a questioning evaluation of the truth of the represented, and the second is the movement to the suspicion that it is acted for the camera, either as faked or as reenactment. Direct cinema as such only presents a more extreme case, however, of a process arising with every instance of recorded reality.[62] Yet the "normal expectations" we draw upon to understand people's appearance, actions, and behavior may not equip us to make sense of what we see and hear, and thus we misread and misunderstand. Or, recognizing that our expectations are not being met or the people and their behavior are recognized as unfamiliar and as "unlike us," the gap in our understanding that thereby arises may open us to the terror of the not known as the unknowable, giving rise to fear and denigration of the difference of the unfamiliar as a threat and the different as inferior.

What is required is a documentary narration by which the threads of causality can be revealed so that actions become motivated and the contingent of reality and the unknowableness of the unknown is organized into knowledge. Documentary thus draws upon the modern novel's development of verisimilitude as a motivation given by the narration that produced a new approach to plot, that is, verisimilitude as the ordering and organization of events and actions as logically caused and in relation to which characters are shown reacting with psychologically motivated intention, in contrast to the use of coincidence or the intervention of the supernatural in the earlier romances.[63] As Peirce observed, "Time is the form under which logic presents itself to objective intuition,"[64] for the after is assumed to be a consequence of the before, dispelling the discontinuity of the event, of the instant. It is plot, however, that creates (fiction) or discovers (nonfiction, historical writing) causal connections through its construction of the temporal relations of knowledge of the human agents involved in the events. Plot orders the way in which knowledge of events and actions comes to be known. On the one hand, it orders information about events that its characters or social actors receive, thus providing motivation for their actions and reactions and thereby their performance in mimesis or in reality. On the other hand, diegetically through direct or implied narration, plot orders the information its reader or viewer receives about the

events and actions and thus about its social actors' or characters' motivations, creating suspense through withholding or delaying information. Plot organizes our coming to understand, which may involve it presenting a disordering of the story's chronology of the events and actions, creating connections by the juxtaposition of events in relation to the motivations of characters we hear or infer from what we see.[65] Where plot in fiction is the a priori design of causality, and it must feign being uncontrolled, in documentary the causal connections are always constructed afterward. By its narrating, the documentary presents an explanatory frame that establishes terms for understanding the reality it shows independently of audiences' expectations, producing causal connections, albeit with argument and evidence, and thus a time of a before and an after of the event or action. But in thus transforming the arbitrary and contingent of lived experience into the knowable, documentary makes reality both realistic and less real. In contrast, the fictional plots of Italian neorealism that fail to fully provide causal connections appear more like reality.

Where fiction refers to nonactual imagined events, narrative is simply the positing of causal relations between events that may have been real or invented so that a beginning, middle, and end (like wars) is proposed, with actants who bring about changes in an originally stable situation. These processes of narrative are common to history writing, and to related forms such as biography and autobiography, as well as to fiction, but this does not make history fictional (though it may still be so). The accounts of origin that explain things as caused, as opposed to being arbitrary and uncaused, are aspects of the discursive order of a culture, whether understood as the actions of a god or, alternatively, as in our contemporary society, the discourse of science that proposes material observable causes (e.g., earthquakes arising from the geological action of Earth's crust moving). In each case, events are understandable because they are taken as caused. Indeed, it is the definition of narrative as a series of events in a cause–effect chain that excludes many forms of imaginary representation from being properly narrative, especially myths and fairytales, not only because they contain magical interventions as "uncaused" but also because they are accretions of juxtaposed and combined actions lacking a connecting relationship, that is, lacking precisely the plot of the novel or, to use Paul Ricoeur's term, the emplotment of the narrating voice of historical writing. Indeed, it was as a narrative form that the documentary distinguished itself from the actuality film and the travelogue that preceded it.

Drawing on Hayden White's analysis of historiographic discourse, William Guynn argues that this "suggests that the strategies by which historians or novelists make sense of the world, whether it is conceived

as real or imaginary, belong first of all to the literary craft, to the art of fiction-making." As a result, Guynn asks, "Are we not justified in suspecting that within cinema the discourses of fiction and nonfiction share many basic signifying structures?"[66] Narrative as a rhetorical form is not equivalent to fiction: rather, it is a form of representation that produces specific determining conditions of reading, of meaningfulness, and all forms of social discourse involve a certain narrativity.[67] This does not make all narratives equivalent, however, for what must be considered is the discursive structure in which the narrative is encountered and in relation to which its meanings are organized. Hence we can differentiate a story of detection, whose meaning is organized through its narrative operations of deduction and evidence, from one that, while also having this form of narrative, has its meaning determined by its insertion within a series of further discourses—as is the case with a prosecuting attorney's summation in a court of law. What is involved here is not a distinction between true and untrue stories but a question of the different relationship constituted by the text for the "reader" in relation to the knowledge of its discourse. In this more limited sense, narration is the unfolding of knowledge where the spectator's knowledge in relation to the events and actions presented is set up wholly by and within the text. The *text* gives, or withholds, information, and constructing enigmas or posing questions that only it will answer (though it may desist from doing so). This will be the case whether the knowledge concerns "real" events or not, past or present. A documentary film will be narrative not only because, as in the classic documentary, it is heavily "recounted" with a voice-over telling us the story of coal or of truants, for example, but also because the film has established its own terms for the knowledge it will convey and the story it will construct. Its status as discourse is constituted not as part of negotiations between union and management in the coal industry, not between school and parents over truancy, but as representation within cinema and television as discursive institutions. Derrida's term for this is "artifactuality." He writes, "Actuality comes to us by way of a fictional fashioning" that is undertaken "through intervention at the level of what is called framing, rhythm, borders, form, contextualization."[68]

▶

Documentary Novelizing

Stephen Heath and Gillian Skirrow, in their analysis of the British television documentary *Yesterday's Truants*,[69] argued that at one level television initiates the permanent arena of communicationality, and

at a further level, it proposes to communicate this or that in this or that program . . . between the two, as the juncture of their realization, it maps out fictions, little dramas of making sense in which the viewer as subject is carried along—in which, indeed, the individual becomes "the viewer," the point of view of the sense of the program. Summoned as citizen into a world of communication to receive particular communications, the individual must be held into the program, *entertained* as well as occupied. Hence the organizing movement of *Yesterday's Truants* with its scenes, its rhymes, its multiple times, varied yet narrated into coherence through the basic idea, the fascination with identity, with the lives of the truants.[70]

Heath and Skirrow characterize this "organizing movement" as a "novelizing" that arises not in a reconstruction or reenactment, not in the imagined, but in the deployment of plot, and this forms the discursive structure for the documentary.[71] Film combines both mimesis and diegesis in its material signified: diegesis because the camera's recording of the events, actions, and words *directs* the way we see the performance, and the manipulation of shot scale, in cutting from long shot to close-ups, organizes *how* we see and come to know in a "narration"; mimesis because actions and speech recorded are re-presented. In documentary, the role of plot in relation to diegesis and mimesis is changed. The actions, events, and speech we see and hear did not arise as a result of relations of cause and effect constructed prior to their recording—they are not "plotted," but contingent. They may be responses to the situation of recording and to the documentary's questions, and they may be scripted in a certain sense—planned into the documentary, rehearsed through discussions with the researcher or filmmaker, or written by the expert witness who is presented, but they are nevertheless authored by the speaker and are not mimesis. Of course, while a speaker or social actor may enact her words recorded at an earlier time in a repetition, a form of "playing oneself," it remains authored by the subject who speaks. Werner Herzog's films, such as *Little Dieter Needs to Fly* (1997), are documentary involving reconstructions in which the documentary protagonist plays him or herself, but they are also fictions, since Herzog invents events and motivations. The documentary protagonist may also introduce some fiction, that is, lie, but this would remain documentary, since though lying is a pretense, it is not a performance of lying. While the social actor's words are not "plotted," they can be understood as having been "emplotted," to use Ricoeur's term, in the creation of a narrative of the self, as an agent, and as psychological subject in the world. Such emplotment is a "telling" of oneself as the story of one's identity that at the same time produces a splitting of the subject between an I who narrates and the self in a remembered past or

in the present and who is spoken about.[72] Emplotment here will involve not only a causally structured account in a "sense making" but also the construction of perspective—of how I see myself and how I act so as to offer myself to be seen in the way that I desire, drawing on a rhetoric of performance implicitly (the jokes, smiles, shy looking away, etc.), which is also a performing of the self.[73] Emplotment in this sense, however, not only is never conscious but also is subject to unconscious thoughts, feelings, and wishes.

"Reality" television depends on strategies of novelizing even where the outcome is not known in advance, as with *Big Brother*, since the situation of the participants is organized to produce drama: not only the drama of a game show in the risk of being voted off by audiences and housemates, but also the drama of their interaction over the many tasks they are set, juxtaposed with the revelations by participants in their direct address to "Big Brother" (i.e., the camera) as they respond to questions or put forth their views. Such "reality" television makes, rather than finds, the reality it shows, yet it is not fiction. Dramatic reenactments, however, may not involve such "novelizing," instead restricting the performances to the actions and events of documentary evidence without a narrative "arc" of suspense or pathos.[74]

Narration (diegesis) discovers for us the causes—the motivations—of characters and events. The simplest documentary plotting presents a temporal relationship of before and after, as seen in both *War Neuroses* and *Let There Be Light*, discussed in chapter 4, which present stories of illness and cure. However, where in *War Neuroses* the causes of the men's hysterical symptoms are not explored, *Let There Be Light* presents the "back stories" of the men—of human psychological need. In *Hoop Dreams* (Steve James, 1994) it is the comparison between the successes and setbacks of two young African American basketball players as they seek to win educational opportunities through their sporting skills that constitutes the films narrative plotting. Documentary film editor and writer Dai Vaughan has suggested, "What defines a documentary as such is the way we approach it: the fact that we look to its images as records of the specific, not as envisionings of the possible."[75] Yet by narrating its images of the specific, of reality, in relations of causality, documentary also narrates an envisioned possibility of other outcomes and other narrations of causality. Errol Morris's *The Thin Blue Line* (1989) presents a "whodunnit" in its exploration of two opposed accounts of the murder of a policeman, one given by Randall Adams, who was convicted of the crime, and another given by David Harris, whose testimony convicted Adams. It is through its selection and arrangement of its information from

interviews with the police, prosecutor, judge, witnesses, defense team, and archived transcripts—documentary evidence—and its juxtaposition of these with reenactments and fiction film footage, that the film makes its argument. The question of innocence or guilt is left suspended, unanswered, at the film's opening—as it was in Fritz Lang's fictional *Beyond a Reasonable Doubt* (1956)—and then explored not merely by interrogating the evidence but also by a series of hypotheses figured through the different presentations of the reenactment of the murder and by scenes "quoted" from fiction films that illustrate, or question, the claims and thus the motivations of the social actors, the film's "characters." In the course of the documentary, the plausibility of the younger David Harris is gradually undermined, and at the film's closure, the words of Harris in the film's now time confirm the film's view of him. Randall subsequently, and in part because of the documentary, secured a retrial at which he was acquitted of the crime.

A different emplotment arises in *Capturing the Friedmans* (Andrew Jarecki, 2003), concerning whether crimes had been committed at all. It presents the accounts of the police, and of the young men whose evidence against Arnold Friedman and his youngest son, Jesse, led to their conviction, alongside their denials and that of other family members. Jarecki drew upon the extensive home movies made first by Arnold and later by his eldest son, David—now a famous and popular children's birthday-party clown, "Silly Billy"—including David's filming of himself in a video diary, of his family's response to the arrest of Arnold and Jesse in 1989 on charges of sexual abuse, and of their acrimonious interactions.[76] The case against Arnold was initially in relation to child pornography he had purchased by mail order, but as a result of the police investigation, a number of the young boys he taught computing in his home subsequently made complaints of rape against him and Jesse. Both denied the charges, and David, with his other brother Seth, strongly supported Jesse and their father while their mother—devastated at discovering his secret homosexual pedophilia—was not certain that her husband was not guilty, while she was desperate to save her son.

The home movies are visible evidence of a happy family, but this account is questioned, just as Michelle Citron, in her film *Daughter Rite* (1980), used her family's home movies to question the "story" her filmmaker father seeks to tell in them. Jarecki's film explores the family's crisis as much as it narrates the tragedy of Arnold and Jesse's conviction through its interviews with Jesse, David, and their mother, Elaine Friedman. The interviews with the police investigators and some of the boys who gave evidence against the Friedman's, together with another boy

who denied that anything had happened, furnish strong indications that the boys were drawn by the police to falsely accuse David and Jesse, and Jarecki became convinced of their innocence. The film itself remains impartial, while focusing on ambiguities surrounding Arnold's pedophilia in particular and the possibility that Arnold had abused his own sons—as he seems to admit in relation to, first, his brother as a child and then with two young boys on Long Island. Jesse firmly denied any abuse, as does Arnold's brother, who remained his passionate supporter.

Jarecki has been criticized for not making clear his belief in the Friedmans' innocence. Debbie Nathan—who had corresponded with Arnold and who was a consultant for the film—wrote in the *Village Voice* that following its screening at the Sundance film festival, Jarecki "was struck by how they [viewers] were split over Arnold and Jesse's guilt. Since then, he's crafted a marketing strategy based on ambiguity, and during Q&As and interviews, he has studiously avoided taking a stand."[77] Jarecki's film does defer the issue of the truth, of whether Arnold and Jesse were guilty, but in doing so it engages us with the problem not of a miscarriage of justice, which at the time of the film (as with *The Thin Blue Line*) remained undecided in a court of law, but of how we might come to believe in their innocence or guilt in relation to the highly emotionally charged crime they were accused of. To Jesse and David, Arnold was a wonderful father; to his school students, he was an inspiring teacher; to his wife Elaine, he was transformed by the revelation of his pedophilia from a cold husband who devoted himself more to his sons than to her to an object of hatred who had by his actions brought tragedy upon his family, especially Jesse. The film cannot produce incontrovertible evidence because it is not a question of who committed the crime but whether a crime was committed at all and thus of the truthfulness not of witnesses but of purported victims. The film is not ambiguous but, lacking the evidence, it also does not assert what the director clearly believed, and leaves Debbie Nathan's forthright defense of Arnold to state the case. Instead, the film engages us in evaluating what we learn in relation to our assumptions, anxieties, and prejudices. For example, Jarecki withholds information that might clearly color our views and understanding by delaying revealing it until very late in the film: Arnold's brother's homosexuality. Or the choice between two views is left open to us, as when we hear the police investigators commenting on David's film of his brothers joking, apparently carefree, on the morning of Jesse's sentencing, which they interpret literally, or rather conventionally, as inappropriate levity given the gravity of the case and as a sign that Jesse feels no remorse. But of course he has no reason to be remorseful if, as he avers, he is innocent of the crime, and instead we may

infer that humor relieves for a moment the awful tension he feels.[78] We may believe in Jesse and David's love for their father, but can we believe in the man who inspired it? Can we hold a contradictory view of Arnold as a good citizen and father but also a sexual pervert who has admitted to child abuse in the past? It is not the truth of sexual desire but the pain and tragedy of sexual desire amiss that infects all his family that is documented in the film and is an enduring image over the figure of David's "Silly Billy" clown.

Documentary film never ceases to be a documenting of reality, all its "deformations" notwithstanding, insofar as it sets out a contract with its audience by its self-declaration as a documentary. Its particular fabrications do not thereby make it not nonfiction. The documentary film was never an ontological fact; it has always been a project, a polemical assault on the nondocumentary, however this has been defined. It is a polemic that is formed within the specific discourses of its time—for example in the 1920s, the debates published in *Novy Lef* that developed Russian formalist's concern with "facticity" as it defined this, in a focus on the materiality of the world, and an emphasis on utility and constructivism in form and content. John Grierson, drawing on these debates, was concerned with the education of the new citizen. What these polemics produced was a struggle around representation, of what should be filmed, that is, what should be "seen," and how it should be shown. This struggle addressed a contingent world in which discourses, as well as their representation, became changed as a result. That struggle and its potential for transformation are explored in the next chapter.

[2] *Working Images: Representing Work and Voicing the Ordinary*

This chapter introduces two questions that are central to this book: First is the question of the representability of everyday life and the project of "voicing" the ordinary as not only subjective testimony but also art— that is, as a sensory experience that is emotional and aesthetic. Second is the question of how the sounds and images of work, workers, ordinary people, and their activities signify as facts and as historical information. How has documentary film produced such discursive definitions and thus such defining discoursing? The focus here will be images of work in 1930s documentaries for these raise the question not only of the representability of work as a material visualization but also of its characterization within our modern society, that is, the social and economic role of work and the representation of work as embodied labor. Film can reproduce images of laboring, but "work" is an economic and social concept and hence must be signified as such to distinguish it from human activity that is held to be nonwork. This chapter considers the ways in which documentary images can be understood to work discursively and the ways in which documentary's "voicing the ordinary" disturbs discursive hegemony in documentary. The exploration of the role of speech is continued in chapter 3, and I return to the possibility of speaking the ordinary as art in my concluding chapter.

Modernity and its industrial processes of production transformed the conditions of both work and the visual, expanding enormously the scope and scale of productivity through labor as well as the imaging of the world through photography, cinematography, and video. The achievements of modernity have, however, been viewed with ambivalence. A conflict was—and continues to be—perceived between the new possibilities offered by these developments in modes of production and imaging and the dehumanization produced by modernity's regulation and

exploitation of the worker and the gaze through mass industrial processes. Cinema was embraced as a modern visual technology while excoriated as the proponent of a visual realism that was ever less real in the artifices and illusionism it deployed in its storytelling. Modernism, as a movement in visual arts, architecture, and literature, challenged tradition in culture and society and in our ways of seeing, but it also opposed the alienation arising with modernity and "the loss of reality, which makes experience every emptier and reality itself ever more impenetrable."[1] Film and the photograph, as simple records of reality, do not in and of themselves produce an understanding of reality; instead, Brecht observed, "True reality has taken refuge in the functional."[2] Modernism, in demanding that we see anew, developed the new visual technologies of modernity to produce a new seeing that would also be, it was argued, a truer "seeing" or understanding. The documentary film, as a new cinematic form that emerged as a project of filmmakers in the 1920s in Europe, with related developments in North America and elsewhere, was a product this movement. These filmmakers sought to oppose the perceived illusionism and deceptions of the fiction film, but they did so as an extraction from and organization of reality—as, in fact, a fabrication, but a fabrication that thereby brought forward a new reality.

The new "documentary" form of film was part of an opposition to cinematic practices as these had developed since 1896. The recording of reality in the "topicals," travelogues, and newsreels that constituted a large part of early cinema (and that subsequently remained widely popular) came to be supplanted after 1907 as the dominant commodity of cinema, and the following decade saw the emergence of the feature fiction film, with its staging of spectacular scenes and historical enactments as well as its specifically cinematic storytelling through forms of editing such as cross-cutting and the close-up. This was accompanied by the appearance of theories about film, both as a new form of art and as a popular medium, while artists and filmmakers began exploring its formal possibilities in the development of avant-garde experimental film practices.[3] Film, as a new discursive practice, became differentiated by both filmmakers and film theorists as an art form distinct from either theater or literature; they saw it as being more than merely pictures with stories and more than a mere copy of reality—not only mimetic but also diegetic.[4] At the same time, a new concern with reality and its representation emerged in the 1920s whereby film became a medium not only of visual experimentation but also of social criticism and of social renewal and education. In the new Soviet Union, the Russian formalists, writing in *Lef* and *Novy Lef*, together with filmmakers such as Esther Shub and

Sergei Eisenstein, debated the nature and role of the "fact film," while Dziga Vertov developed newsreels and, in 1929, made *Man with a Movie Camera* as an experiment with filmed reality. A comparable project emerged in the work of other filmmakers in Europe, seen in Alberto Cavalcanti's *Rien que les heures* (*Nothing But Time*, 1926), Joris Ivens's *Misère au Borinage*, (*Poverty in Borinage*, 1932/33) and Jean Vigo's *A propos de Nice* (*About Nice*, 1930), as well as in the United States, seen in Paul Strand's *Manhatta* (1921).

Drawing on these concerns and his own interest in the social role of film art, the young Scottish cinephile and social scientist John Grierson went on to promote these new approaches to filming reality as both an art form and a means by which the citizen might come to learn about the world. Grierson distinguished two key aspects in this approach to filming reality. First, "Documentary, or the creative treatment of actuality, is a new art with no such background in the story and the stage as the studio product so glibly possesses. Theory is important, experiment is important."[5] It was a new art in its use of the poetics of cinema—namely, montage editing, camera framing, and movement—and also, after the introduction of synchronized sound, of music. Grierson, in arguing for documentary as an art form, is distinguishing it from mere reproduction, following the example of the Soviet filmmakers, and seeks by this phrase to emphasize not a manipulation of reality but an expressive presentation of recorded reality by the filmmaker.[6]

Second, documentary might be the "drama of the doorstep," showing to the citizen the world and herself not mere recordings of scenes from real life but a creative and dramatized representation of reality.[7] Grierson saw in the documentary film a form that could not only inform and enlighten but also engage audiences; his aim was to make a drama from the ordinary to set against the prevailing drama of the extraordinary and to bring the citizen's eye in from the ends of the Earth to the story—his own story—of what was happening right under his nose. Such an aim can also be seen in the approach taken by Germaine Dulac in her work on newsreels in the early 1930s, following her avant-garde and surrealist films, including *The Seashell and the Clergyman* (1928, with Antonin Artaud). She writes,

> This kind of cinema [newsreel] is the great modern educator or society. It brings together the most diverse intelligences, the most varied races, and by a magnetic current, it throws a girdle round the earth. It can show every cinemagoer the intimate details of the life in foreign countries and the human beings behind the official face of historical tradition and imagination . . . Seen this way, the cinema becomes an individual experience, enabling us all

to live something instead of imagining it. Classes and races meet in the cinema without intermediaries. Emotions, gestures, joy—humanity rises above its individual characteristics: as the sight of other human beings brings understanding, it helps to destroy hostility.[8]

Grierson stressed, in a manner reminiscent of Lukacs in "Narrate or Describe,"[9] the importance of distinguishing between a description that recorded merely the "surface values of a subject" and a "method which more explosively reveals the reality of it. You photograph the natural life, but you also, by your juxtaposition of detail, create an interpretation of it."[10] Here Grierson follows the Soviet documentarists of the 1920s who similarly acknowledged the role of the filmmaker. Vertov filmed "life taken by surprise," but this was only raw material—it took on significance in the process of montage—and Sergei Eisenstein's *The Battleship Potemkin* (1925) was for many years listed as a documentary film.[11]

Grierson described the alternative cinema that documentary made possible in his essay "First Principles":

> (1) We believe that the cinema's capacity for getting around, for observing and selecting from life itself, can be exploited in a new and vital art form. The studio films largely ignore this possibility of opening up the screen on the real world. They photograph acted stories against artificial backgrounds. Documentary would photograph the living scene and the living story. (2) We believe that the original (or native) actor, and the original (or native) scene, are better guides to a screen interpretation of the modern world . . . (3) We believe that the materials and the stories thus taken from the raw can be finer (more real in a philosophic sense) than the acted article . . . Cinema has a sensational capacity for enhancing the movement which tradition has formed or time worn smooth. Its arbitrary rectangle specially reveals movement: it gives maximum pattern in space and time.[12]

Emphasizing film's specificity as sounds and images in time and space, Grierson also anticipates Bazin's later comments on the capacity of film to see anew for us. Documentary as a filmic form, in Grierson's account, not only shows us the world as it is but also tells its stories. The project of documentary was thus paradoxical, for this new form was both proclaimed as factual—as true to reality—while also asserting the need to reveal (i.e., narrate) a truth found not in the simple image of reality but in an understanding of it. Moreover, documentary not only communicates or conveys statements, meanings, and views in its narrating with images, sounds, and language but also constitutes these through its own processes of representation. Thus documentary film, and later broadcast television and video, presents us with reality as knowable, in a production

of specific discursive modes for knowing reality through the construction and deployment of discourses about reality.

Documentary is, therefore, a "discursive practice" in the sense given to this term by Michel Foucault, for it is not only a discursive construction but also a constructing discourse. A discursive practice, Foucault argues, "must not be confused with the expressive operation by which an individual formulates an idea, a desire, an image; nor with the rational activity that may operate in a system of inference; nor with the 'competence' of a speaking subject when he constructs grammatical sentences; it is a body of anonymous, historical rules, always determined in the time and space that have defined a given period, and for a given social, economic, geographical, or linguistic area, the conditions of operation of the enunciative function."[13] Discourse here is not talk but a speech or writing authorized because it conforms to the set of rules by which the speaker can be recognized as authoritative, namely, the rules by which what is said is recognized as appropriate and hence as "knowledge" as defined by the norms constituted by the discourse. In this sense, discourse "speaks" the subject, whereby, Rudi Visker argues, "rather than document the originality of thinking subjects, it binds them to a set of rules which makes their thought and their originality possible."[14] As a practice, discourse does not function simply as reference or expression; rather, the objects or phenomena it describes and accounts for are brought into being by the discourse as such.[15] Thus the concept of the "deserving poor" arises, distinguished from the "undeserving" in the discourse of nineteenth-century philanthropy. The approach Foucault proposes in *The Archaeology of Knowledge* is, Visker argues, primarily "a systematic reflection on the epistemo-logical conditions which made it possible for what was said from a particular point about human beings *to be said*."[16] Visker suggests that it is, rather, an archaeology "which simply questions 'things said' with the aim of determining 'what it means to them to have come into existence' and thus seeks 'the law of what can be said.'"[17] It is "an analysis which reveals a 'systematic organization' [*systematicité*] in thinking and speaking which is neither logical nor linguistic, but discursive in nature: an order of discourse."[18] How, then, does documentary participate in the construction of discourses of knowledge and of reality as not only the "said" but also the "shown"? Documentary discourse, in re-presenting objects, persons, and their actions as seen and heard, performs these phenomena as knowable; its object is knowability itself, not by a system of signs (as in language), but as reality re-presented in a "showing" that is a "telling" in its manipulation of the camera's seeing through editing, with its own recognizable "regularity" and its own rules by which its "documentariness" is acknowledged

and authorized. The fake or "mock" documentary, which puts forward fictional events or acted scenes as documentary, thereby confirms its rules in breaching them. Medical discourse, too, cannot distinguish fabricated data from the genuine except by a reexamination of the data and its collection, and the problem of modes of description of scientific experiments and their results has been an issue since the work of Robert Boyle.[19] The anxiety regarding the genuineness of our discourses of truth is nowhere more apparent than in the concern that documentary filmmakers adhere to guidelines for authenticity.[20] At the same time, documentary presents specific discourses, together with the objects of knowledge of those discourses, and it is the easy or uneasy relation between each that figures the particular knowledge-truth that arises through its discursive constructions. It is here, Foucault argues, that power arises.

The seen and heard are no longer subject only to a linguistic description but appear before us, requiring a "fit" between the expository discourse and the observed world.[21] Film's documentary discourse consists, therefore, not only in the words said—which might be available within other discursive forms, such as journalism, historical narration, and so on—but also in its discursive address and in the "architecture" of spectatorship arising from that address, which produces a specific objectifying subjectification in the documentary's particular combinations of sounds and images, words and actions, and times and spaces.

In *Archeology of Knowledge* and *The Order of Things*, Foucault sought to resolve the problems arising with what he refers to as "a history of the referent," of what "madness itself might be"[22] in the ways it was spoken of that he undertakes in *The History of Madness* and its "archaeology of alienation,"[23], characterized by Visker as an "*archè-ology*" that "related a history in which an original self-presence was alienated from itself."[24] Instead, Foucault now argues, "For the enigmatic treasure of 'things' anterior to discourse," archaeology substitutes "the regular formation of objects that emerge only in discourse."[25] There is no essence of madness, or of the subject, that exists prior to the violence of the naming and describing of discourse. Does not Foucault, Visker asks, also thereby jettison "the problematic which it tried to express"? There is, he argues, a cost to Foucault's approach:

> To define discourse independently of things or, as he later puts it, to "conceive discourse as a violence which we do to things . . . as a practice which we impose on them" is a way of preventing it from being trivialized by being regarded merely as the expression of a pre-given "order of things.'" And to search in this practice it imposes on things for the "principle of . . . regularity" of the events of discourse is a way of thinking an "order of discourse"

which does not supervene later, but comes about in and by that discourse. But the price to pay for this *demarche* would seem to be that, instead of (for example) "undermining the order of psychiatric discourse," such an archaeological concept of order can only describe it and, indeed, even seems compelled to legitimate it.[26]

Foucault addresses this issue in his later work, to which I will turn shortly, nevertheless Visker's critique remains very important. Foucault not only opposed approaches within the history of ideas that seek origins but also sought to demonstrate the discursive *conjuncture* through which a new discourse comes to operate. "Archaeology," he says, "analyses the degree and form of permeability of a discourse: it provides the principle of its articulation over a chain of successive events; it defines the operators by which the events are transcribed into statements."[27] It addresses crises and change because through them can be shown "what, in these crises, could be given as an object of discourse, how those crises could be conceptualized in such an object, how the interests that were in conflict throughout these processes could deploy their strategy in them."[28] A discursive practice is characterized not by an adherence to rules but by its formulation of objects of knowledge in relation to the field of "strategic possibilities" that these rules, or norms of stating, institute.[29] These "strategic possibilities" exist as a result of, and not prior to or despite, the rules. Rules are thus not authorized, but they themselves authorize and define. The rules of discursive practice enable meaning to arise rather than to delimit given meanings. The new emerges not against but with the rules, and the conditions of possibility the rules enable, because of the discontinuities within discursive regimes.[30]

Discursive practices produce meaning and definitions; such knowledge disciplines, in that it forms and traces the knowable and the knower, both the subject of knowledge as well as the object of knowledge even when these are one and the same. Each society, Foucault suggests, has its own regime of truth, "that is, of the types of discourse it accepts and makes function as true; the mechanisms and instances that enable one to distinguish true and false statements; the means by which each is sanctioned; the techniques and procedures accorded value in the acquisition of truth; the status of those who are charged with saying what counts as true."[31] Within the discourses of modernity, truth is taken to be embodied in scientific discourses, that is, those that lend themselves to evaluation and demonstration and not in, for example, oracles or the word of God. There is a constant "demand for truth, as much for economic production as for political power,"[32] yet while it is the object of widespread consumption and diffusion, truth is produced and transmitted under the dominant

control of a small number of political and economic apparatuses, such as universities and the media. Notwithstanding such control, however, truth is also an object of contention and social confrontation—of ideological struggle. Foucault challenged the assumption of simply true or false ideas, knowledge, and ideology. "Truth" in a society is the knowledge—the statements—that count as true; how statements become formed and authorized is the concern of his later studies of the clinic and the prison. As a result, Foucault argues, "It's not a matter of emancipating truth from every system of power (which would be a chimera, for truth is already power) but of detaching the power of truth from the forms of hegemony, social, economic, and culture, within which it operates at the present time. The political question, to sum up, is not error, illusion, alienated consciousness, or ideology; it is truth itself."[33] The statements of historical discourse do not represent a history; they enact it by authorizing actions and institutions as the events—and the forces for the events—of history. It is in its operation as discourse that power is produced, but this is achieved not through the imposition of rules on subjects and their activities but through power's ability to define objects of knowledge, such as the active or working subject, as a result of conforming to discursive rules. The particular form of power Foucault is concerned with here is "truth," or the knowledges "produced only by virtue of multiple forms of constraint";[34] rather than defining the rules, this power is defined by them. Knowledge thus implies and produces power, but the production of power, and the wielding of any such power, is not the cause of the discursive construction but the outcome. This power, as distinct from force, arises from the authorization produced by the discourse and not by the speaker; the power of discourse arises not from the agent or agency but from the relation of subjects to the discourses that "speak" them. Žižek notes that the subject produced by discourse is not only "the result of a disciplinary application of knowledge-power" but also "its *remainder*, that eludes the grasp of knowledge-power."[35]

Foucault, summing up his work in 1982, declared that his goal was not the analysis of power or the writing of histories of power; rather, it "has been to create a history of the different modes by which, in our culture, human beings are made subjects."[36] He outlines three "modes of objectification" that he sees as involved in this process. The first mode of objectification arises from "modes of inquiry" that take the status of sciences, seen in the discourses on "man," emerging at the turn of the nineteenth century of philology, economics, biology, and so on, that attribute to humans the identities of the speaking subject, the laboring subject, or the breathing subject. The second mode is the objectivizing of the subject in what Foucault calls the "dividing practices," whereby the subject

is either divided within herself or divided from others in a process of classification (e.g., the asylum and the mad, the hospital and the sick, and the prison and the imprisoned). The third mode of objectification, which was the concern of Foucault's work at the time, was "the way a human being turns him—or herself—into a subject," specifically "how men have learned to recognize themselves as subjects of 'sexuality.'"[37]

Foucault's focus of analysis and critique in his work was indeed objectivity itself, the rationalism of the Enlightenment, and the objectivization it enacts that produces a subjectivizing subjection. To observe is to view within a particular frame of discursive knowledge so that what is "seen"—that is, what is addressed within the scene by being described or recorded and subjected to measurement, calculation, and rendition—is determined by that discursive "perspective." To be "objective" is to act or observe as other to and separate from the observed. The "observation" constitutes knowledge insofar as it conforms to discursive practice, that is, as an account of the object observed in a manner appropriate to the specific discourse of "knowingness"—for example, the observation of the effects of gravity. Observation leads to an account of the object produced as knowledge. For this to become a relation of power, or of "mastery," the observed must become implicated by acknowledging as a locus of knowledge defined as truth the other who observes her; through this objectification her "subjectivity" is defined, produced, and thereby, to use Althusser's term, interpellated. By contrast, gravity cannot be mastered, though we can defy it.

For Foucault, objectivity arises from observation, and the human gaze is the paradigm for this observation by which the seen is the object of a will to know that thereby masters the seen, objectifying it as knowable in terms of the regime of the truth of the discursive regime of observation. Documentary, as audiovisual recorded observation, would seem to be equally subject to Foucault's critique of objectivity, but two caveats can be introduced here. First, as emphasized earlier, a discursive regime is not a unified order of regulation but a field of possibilities in relation to both continuities and *discontinuities*. Second, his account of the visual observation that produces the "truth" of madness both acknowledges other forms of observation and implicates the subjectivity of the object of observation. In *History of Madness*, Foucault commented,

> I tried to write a history, the most rational possible history, of the constitution of a knowledge [*savoir*], of a new relation to objectivity, of something that could be called the "truth of madness."
>
> Naturally this doesn't mean that, using this new type of knowledge, people were able actually to postulate criteria that could reveal madness

in its truth; no, rather, what they did was to organize an experience of the truth of madness linked to the possibility of an effective knowledge and shaping of a subject that knowledge could be known by and know.[38]

Madness becomes mental illness, and the mad person becomes an object of knowledge as a result of a three-fold conjunction: there emerged a new ideology of reason that could characterize madness as a degeneration not from reason but from an essential humanness. Peter Miller observes, "Madness for the classical age had entailed the notion of an eruption of animality" in the emergence of unreason.[39] At the end of the eighteenth century, Foucault argues that "one sees emerging the general lines of a new experience in which man, in his madness, does not lose truth but *his* truth; it is not the laws of the world which escape him, but he himself who escapes the laws of his own essence."[40] This period saw changes in the state's management of the dangerous potential for disorder arising from "displaced" persons, that is, the indigent, the unemployed, and the mad, which led to the creation of the asylum as a place of containment of the mad as distinct from the incarceration of the indigent in the poorhouse. There also developed the new discourse of medicine, which enabled a differentiation of actions and behaviors as illness, albeit mental, rather than as unreason or the irruption of the animal in the human as a counternature, giving rise to the new medicalized discourses of psychiatry and psychology. In this process of differentiation, widely different behaviors are brought together as a genre with the common causality of degeneration, inherited or as a result of circumstance, by which the subject lost herself to herself. Madness became understood as a fundamental alienation of her intrinsic truth as human, her essence.

In constructing the mad as the object of knowledge, the new discourse of psychiatry at the same time constructed the human as the object of knowledge—of what it means to not be mad and to be human itself. Foucault demonstrates here the historical specificity of both the discourses and the objects of these discourses and, thus, of scientific knowledge. The category of the objective and neutral observer who sees in the behavior of a person her deviation from the normal or the sane was constructed on moral and judgmental norms by which the madwoman became responsible for, and thus guilty of, her madness and—in order to be cured—she had to be brought to acknowledge this.[41]

In *Madness and Civilization*, Foucault refers to two kinds of observation of the mad: In the first, earlier form, "such observation did not, basically, involve him; it involved only his monstrous surface, his visible animality; and it included at least one form of reciprocity, since the sane

man could read in the madman, as in a mirror, the imminent movement of his downfall."[42] Such a classical regime of truth did not construct madness as an object of enquiry and thus as subject to knowledge; it was simply a condition. By contrast, the second form of observation, arising with the new regime of the asylum that characterized, Foucault argues, the work of the English Quaker Samuel Tuke, was "deeper and less reciprocal." It developed as both a will to know the nature of madness (i.e., all its visible signs read as symptoms) and the bringing of the mad to know her madness, to see herself as she is seen and known by the observing of psychiatry. The psychiatrist was the source of the knowledge of her madness, and her cure depended on her surrendering herself to this knowledge. She had to recognize (identify) herself as mad: "The madman is obliged to objectify himself in the eyes of reason."[43] Foucault does not account for why the mad man or woman should feel so obliged, since the procedures he describes are only the prompt and not the cause. It is Tuke, quoted by Foucault, who appears to offer an explanation: "Even more efficacious than work, than the observation of others, is what Tuke calls 'the need for esteem': 'This principle in the human mind, which doubtless influences in a great degree, though often secretly, our general manners; and which operates with peculiar force on our introduction into a new circle of acquaintance."[44] Can we not discern in this "need for esteem" the grounds for that division of the self, the "dividing of the subject," which Foucault here terms "alienation"? Is this esteem not the gaze of the other imagined? Foucault chose not to explore the first kind of objectifying gaze he identifies insofar as it was—at least in relation to madness—superseded. As Martin Jay notes, "With characteristic rigor, Foucault thus resisted exploring vision's reciprocal, intersubjective, communicative potential, that of the mutual glance. *Le regard* never assumed for him its alternative meaning in English as well as French: to pay heed to or care for someone else."[45] This was not an oversight, for as Jay suggests, "wherever Foucault looked, all he could see were scopic regimes of '*malveillance.*'"[46] His focus was on the subjectivizing objectivity of institutions of knowing and knowledge for which the gaze was a *metaphor* as much as it was the means. Foucault never resolved the question of the uncaused subject, resorting to a grammatical uncertainty in his use of the passive tense. Moreover, reciprocality—as in Foucault's own example— is a form of identification and of empathy. It is a further element in the world (rather than empire) of the seen and not an alternative to the disciplining gaze. This view guides my approach here and my later discussion of identification in chapter 3. For Foucault, objectivity is a myth, and in psychiatry, "it was from the start a reification of a magical nature, which

could only be accomplished with the complicity of the patient himself."[47] But what complicity might the mad be able to engage in? In what way is it the consequence of the order of knowledge? The moral responsibility that Tuke invokes requires, as Foucault shows, a subject of reflection and of self-reflection or reflexivity, as an agent of reciprocity, which defines the sane more readily than the insane. Indeed, Foucault's book is concerned not with madness but with the discourses that constructed insanity as a modern form of subjectivity and that may or may not coincide with a human experience and performance of the self.

In his 1982 account of his project, Foucault no longer referred to discourses but instead referred to modes and practices, and in so doing, he elided the role of discourse as disciplining. Yet it is this notion of disciplining in his early studies that made Foucault's work so influential, if controversial. The very term, and its role in his analyses, especially of the prison, implies constraint; however, discursive constructions produce resistance as well as compliance, and they are incomplete and subject to time, while they also enable. At the same time we must also read the other story in Foucault's work, of how the person is subject to or is an agent responding to the requirements of the discursive regime.[48] In *The Care of the Self*[49] Foucault showed how the person in the classical period might perform himself as a sexual subject in relation to the procedures and actions proper to his time. In this unfinished project, James D. Faubion suggests, Foucault became interested "in ethics and in that reflexive exercise of power through which human beings can, if always within limits, undertake to envision and to revise themselves."[50] The history of such practices will no longer be only genealogical, or a history of the will to know; instead, other forces and relations are involved, Faubion suggests: "One of these latter—though Foucault mentions it only rarely—is the *volonté de vérité*, the 'will to truth,'"[51] a will not strategic, as in the will to know (*savoir*) as an objective knowing, of the other (who may also be the self), but as curious. The will to truth, though often conflated with the will to know, becomes related to ethics as the speaking of truth; we might understand this as a truth of being in doing, performing *this* in contrast to knowing that I am *that*. It is our actions within a pattern of conduct that commit us "to a certain mode of being, a mode of being characteristic of the ethical subject."[52] For Foucault, Paul Rabinow, suggests, "the goal—the mode of being—of ethics" is "as historically constrained, practical assembly and disassembly."[53]

With this history, Foucault avoids the problem of the alienation he posits for the insane and for the imprisoned, for example, but he has not resolved the problem his earlier work also gave rise to, namely, the possibility of another subjectivity outside of, or before, such disciplining. In

this new emphasis on practices, the role of vision and the visible and of the objectification and disciplining he saw as arising from these—and that have been especially influential in discussions of documentary film and the relations of power—are displaced. Where Foucault discusses the regulatory nature of practices, Judith Butler introduced the term "performative," citing Nietzsche's claim in *On the Genealogy of Morals* that "there is no 'being' behind doing, effecting, becoming; 'the doer' is merely a fiction added to the deed—the deed is everything." She continues: "In an application that Nietzsche himself would not have anticipated or condoned, we might state as a corollary: There is no gender identity behind the expressions of gender; that identity is performatively constituted by the very "expressions" that are said to be its results."[54] Butler subsequently drew on J. L. Austin's work on performative speech, though—informed by the work of Foucault—she rejects Austin's assumption of a "free subject of speech" who is the author of her act of speech. What Butler draws from Austin is the nonnecessity of an "inward" performance to accompany the "outer" performative. Thus, when the liar promises, the promise remains promised, regardless of whether the action promised by the act of the promise is undertaken or not. It is a move to formulate identity against the polarity of control versus the controlled: do I make or cause myself and my identity, or am I made or caused by factors—social or biological—outside of my control? Instead, the "interiority" of subjectivity is displaced to be an effect of the performativity that is undertaken without any "inward act," that is, in doing this I do not think or reflect that I am doing something that "makes" me; I just do it, but in doing it I become "made." The reverse is true, for I cannot enact myself by thinking of doing something. Lying, however, is also an instance of the splitting of the subject between the promiser and the liar. To lie, to promise in bad faith, is indeed an "inward" act that takes account of the other for whom the performed promise is a lie. "In all his work," Deleuze suggests, "Foucault seems haunted by this theme of an inside which is merely the fold of the outside."[55] We are made before we make, yet being made, or subjectivized, by the social apparatus (*dispositif*) is also an unmaking because of the folding in of the outside twists and snags.[56]

Proposing documentary as a "discursive practice" is, therefore, to understand this not only as a scopic mode involving a disciplining that is normalizing but also as a practice that engages us—"hails" us—as agents and not simply objects of our "subjectivizing" in that reflexive ethics that Faubion refers to and that involves what he suggests might be called "a will to become."[57] In his concept of the "distribution of the sensible," Jacques Rancière provides a related account to that of Foucault's discursive regime, namely, of the way in which knowledge, or the broader meaning arising

with Rancière's notion of the "sensible," is the system of "self-evident facts of sense perception that simultaneously discloses the existence of something in common and the delimitations that define the respective parts and positions within it. A distribution of the sensible therefore establishes at one and the same time something common that is shared and exclusive parts."[58] There is an ordering of the sensible, of that which is capable of being apprehended by the senses, both material and intellectual, in a distribution that orders the set of possibilities and modalities of what is the visible and the audible as "self-evident facts," as well as what can be said, thought, made, or done. It apportions places and forms of participation in a common domain or world, thereby establishing the modes of perception within the sensible order. There is a process that relates the sensible encountered, the apprehension of the evidence of the sense to the self, and the sense, understanding, of the "givenness" of the senses such that they are facts. Rancière's concern is not with the origin but with the enaction of distribution, and not with the political as origin, but its performance as a continual "doing," and thus as contingent. It is with his concept of "dissensus" that Rancière identifies action and change across the sensible.[59] Dissensus as such does not produce change or involve disagreement; rather I understand it as the contingent apprehension of the unincluded, of an evidential that is apprehended but not authorized as the factual self-evidential. It is experienced as the inadmissible, the unsayable, and thus is immediately spoken. Dissensus names the process of a fissuring of the sensible order made possible not by a "perception" of a new "fact" but by the perception of an incompleteness. With his notion of the "sensible," Rancière is already opposing the "distribution" that separates art and politics, the thought and the felt, not so as to make them the same, but to enable an understanding of the possibilities of each as dissensus. Such an understanding is central to my discussion in the following while I also relate the gap in the sensible that is dissensus with Lacan's concept of the real that similarly arises not before but after symbolization.

In the following discussion, I explore this in relation to the working subject spoken by documentary discourse and the ways in which the voicing of the ordinary by documentary disturbs the subjectivizing of objective discourse, introducing a "dissensus."

▶────────────────────────────────────

The Nature of Work

Work is not an entity, a thing, or an object. It is a concept, an abstraction that distinguishes and defines a portion of human activity and interaction.

Work is the labor we do that is not play or recreation. It includes not only physical labor distinguished from the exertions of sport but also so-called mental labor, or intellectual work. Work is serious; it involves a focused and directed activity with an intended and planned outcome constituting a material or cultural benefit. Work, therefore, produces value. Work is labor we do that produces a living. Human societies as economic, political, and cultural entities are characterized by their relation to the amount of work in time and effort that producing a living requires. Depending on the amount of time and effort, a community may have more or less nonsubsistence work time—more or less time for nonwork activities or culture, which we call leisure in modern societies, or for producing an economic surplus that it can trade. The organization, and thus control, of access to work, the use of tools and resources for work—both human and material—and the surplus that can be produced are central to the story of human societies and their discursive institutions.[60] The owner of the means of production can collect the value of her own labor and the surplus value of her employees' labor. This, of course, is capitalist economic production. The surplus value of our work is hidden, in Marx's famous words, and the wage or salary paid does not necessarily correlate with or reflect the amount of surplus value produced. Rather, in a free market, labor is valued just like any other commodity in terms of demand and supply. Therefore, work is, for most of us, waged work; we no longer work to live but to earn a living, an income, which we expect to enable us to purchase more than the bare essentials for life, that is, we expect it to allow us to consume as well as produce a surplus. But because money can earn as well, paradoxically people can make a living from money itself, as "unearned income" in the tax office's language. In contrast, large amounts of labor are expended in activities that are neither within the domain of leisure nor within the domain of the waged economy, for they do not produce an income for the worker (e.g., housework and parenting)—that is, they are not economically productive in capitalist terms.

As a category of labor, work thus depends on a series of distinctions that are both economic and social (e.g., in the discourse of economics, the product may be material, such as food, steel, or ships, or immaterial, such as a service). "Work" is also constructed by state apparatuses, thus while the discourse of economics may be socialist or capitalist, governmental discourse—realized in the laws enacted by the state, such as maximum hours and minimum wages—defines work. In addition, the discourse of medicine, in adjudicating on disability, thereby also produces definitions of fitness in relation to definitions of work, while legal discourse in relation to human rights and equality must define work in order to define

inequality. Feminist discourse draws on the discourse of gender rights to challenge inequality in wages, producing a new definition of work as nongendered—now extended, mostly, to the armed services. At the same time, feminist discourse challenged traditional definitions of labor by and within the family, not only demanding the recognition of housework as equal to conventional paid labor, but also challenging the definition of male labor earlier in the twentieth century as earning a "family" wage, in contrast to female labor, which did not.

▶ ───

Representing Work

Work is a process, a physical activity in time and space. Cinema, as a medium of representation, for the first time captured this process of work as motion, that is, as the transfer and transformation of energy into movement and action. Cinema's invention drew upon the experiments of Muybridge and Marey, who each developed devices for rapid photographing of humans (and animals) in motion, enabling its analysis.[61] Film can record human labor and activity, but the pertinence of what we see—precisely its communication *as* process and not merely as the play of color, movement, and sounds—must be signified in addition. Bearing an indexical trace of the movement and actions of people and animals, film *shows* physical exertion as movement, but it cannot thereby tell us about the process of work involved. Rather, the cinematographic recording must become "a film," an organized series of sounds and images in time and space that can signify intentional actions within a larger frame of interaction. The process of work is transformed from duration, a continuing doing, to measured time through an ordering, which introduces the narration of a commencement or beginning and a completion of the act and its outcome as an endpoint, thus introducing cause and effect. Documentary film not only reproduces the actions recorded by the camera but also, in its selection and ordering, produces a statement or discourse that constitutes those actions as knowable.

For actions and activities to be understood as work, a documentary film must characterize them as such, drawing on conventional definitions either explicitly or implicitly, depending on the extent to which the anticipated audiences are assumed to share or be familiar with these definitions, thus distinguishing them from other actions that are deemed not to be work (e.g., clothes washing as personal care rather than a paid service or walking as leisure activity rather than the work arising as part of delivering the mail). Documentary, too, produces definitions of work.

In his film *Spare Time* (1939), for example, Humphrey Jennings describes this as the time we have for ourselves between work and sleep.[62] The voice-over heard at the beginning informs us that the workers whose spare time activities we will see are drawn from three industries—steelmaking, textiles, and coal mining—so we infer that the steelworkers are not paid for the time they give to playing in the brass band. To represent "work," a film must engage not only with images of work in the already-organized definitions of economics, politics, unionism, or whatever but also with its own processes of representing and defining. The artist, filmmaker, and activist Hans Richter articulated the dilemma of film and realist representation for filmmakers in the 1930s, writing,

> If the forces that determine men's destinies today have become anonymous, so too has their appearance. The cinema is perfectly capable in principle of revealing the *functional* meaning of things and event, for it has *time* at its disposal, it can contract it and thus show the development, the evolution of things. It does not need to take a picture of a "beautiful" tree, it can also show us a growing one, a falling one, or one swaying in the wind—nature not just as a view, but also as an element, the village not as an idyll, but as a social entity.[63]

It was as a social entity and not simply as image that Luis Buñuel sought to convey the reality of a lived experience in *Las Hurdes* (*Land without Bread*, 1932), in which he documents the circumstances of life and death in the communities in the Hurdes Altas region of Spain, notorious for the poverty of its land and people. By a strange irony in the context of Richter's admonition quoted earlier, Buñuel, in order to travel in the area to film *Las Hurdes*, obtained official permission by claiming it would be a "picturesque" documentary about the area. Taking notes over a period of ten days, Buñuel then recaptured these observations on film very closely: the goats, the beekeeping for the wealthier neighbors of Hurdes Bajas, the malaria-carrying Anopheles mosquitoes, a child sick with diphtheria, a funeral party carrying the coffin for miles over the hills because there are no churches. But these images cannot as such show what Buñuel also observed, a "land without bread, without songs."[64] The images remain obstinately enigmatic without the voice-over narration. How else could it be conveyed how precious goats are and how vulnerable they are to the dangers of the sheer mountain cliffs? Or that transporting the beehives to the mountains for the summer is a dangerous and risky journey for the men and animals carrying the bees? We see a harsh but awesomely beautiful landscape, yet we cannot see the physical and economic difficulties of scraping a living from this same landscape until it is conceptually, and not only visually, observed for us. The visible must be articulated as evidence.

In a sequence showing men preparing some ground for planting, we can see the human labor involved and probably recognize its agricultural role, but we can see neither the scale of exertion required nor the difficulties involved in order to produce a crop. We cannot necessarily anticipate either abundance or scarcity for these farmers. This, however, is central to the workers themselves, for while the work may be the same as that of thousands of other peasants, here in Hurdes Altas, the return on that labor is very small and may not be enough to feed a family. The work of these men must, therefore, be understood and defined not only in terms of its physical labor but also in relation to the scale of return on that labor.

Buñuel sought in this film not only to inform audiences of the shocking conditions of work and existence of the Hurdanos, but also to challenge our casual acceptance of such circumstances by refusing to appropriately causally account for them. The dry, matter-of-fact voice-over explains what we see but does not fully make sense of it for us, while it introduces strange juxtapositions of facts and social phenomena, a surrealism, in fact (discussed further in chapter 4). In challenging us to consider how we construct our sense of reality and how we find meaning in the facts and thereby interpret the film, Buñuel produces not merely a "surrealist documentary" but rather a film that both exposes radical injustice *and* critiques the discursive forms that naturalize that injustice— the filmed travelogue of the exotic and the sociological research studies that document as "other" the communities and lives they examine.[65]

The documentary film is not only an assemblage of facts and of a filmed reality but also an interpretation that may draw upon established understanding, or it may challenge such "interpretations," renegotiating established and conventional meanings.

▶ _____

The Quality of Work

Work must not only be signified as such but also be contextually placed and qualitatively defined. Work, or workers, might be heroic in the face of physical hardship or muscular in terms of demands for endurance and strength, as in *Coal Face* (Alberto Cavalcanti, 1935). The hardship endured might be represented as victimization (industrial sweat shops) or as ennobling and natural (peasant labor). Skill and craft might be emphasized, as in *Night Mail* (Harry Watt and Basil Wright, 1936), or the focus may be the machines, rather than human labor, that enable mass production, and the worker portrayed as just one element in the industrial process. This might be celebrated in an embrace of the modern and of

American methods and efficiency (e.g., in *Berlin—Symphony of a City* [Walter Ruttman, 1928]) or countered (as in Robert Flaherty's *Industrial Britain* [1931–32], which emphasized craft).

The first decade of cinema saw the development of the American economic philosophy of Taylorism and the detailed division of labor in assembly-line production adopted by Henry Ford, which deskilled workers, reducing the role of the individual worker to a small number of specific and delimited tasks. (It was also adopted by the developing film industry; however, there the division of labor led to specialization and increased skills in many areas.) Work in the twentieth century was, therefore, been under continual redefinition in terms of the skills—if any—involved and the kinds of activities required. At the same time, workers, through unionization, have successfully intervened in the definitions of work in the regulation of employers' practices (e.g., opposing so-called casual labor and the definition of what constitutes a "normal" working day or week in the demand for overtime payments for hours beyond these). This success has, however, been represented as a danger, namely, that the power of the unions restricts the free market and hinders economic development and is antidemocratic (e.g., in the claim that the 1926 General Strike in Great Britain overrode the democratic processes of Parliament). Thus the definition of work is also part of an ideological as well as economic struggle. (The role of the infrastructure of "unearned" income for the economy and work has been relatively unrepresented, though it is no less crucial.) Indeed, fear of popular unrest and strikes led to censorship of these topics in British feature films so that, before 1945, workers and the unemployed were rarely the subject of such films except as comic or benign elements in the story. By contrast, in the United States, both blue-collar and white-collar workers and their vicissitudes were regularly shown in the movies, and not always as part of a love story with a happy ending. As Hollywood films constituted 80 percent or more of all films screened in Britain in the 1930s, British audiences more often saw images of North American workers, while it was John Ford who filmed industrial life in Britain in *How Green Was My Valley* (1941), which adapted Richard Llewellyn's novel on coal miners in Wales at the end of the nineteenth century, though it could have as easily been set in the 1930s.

Instead it was in documentary films and actualities that images of work and workers might appear. Such images were popular topics for early actualities and formed a genre called "industrials," while workers were a focus of the new "documentary" film movement conceived by Grierson and first realized in his 1929 film *Drifters* about herring fishermen in northeast Scotland. *A Day in the Life of a Coalminer* (Kineto

Production Co., 1910, made by courtesy of the L. N. W. Railway) is a typical example of an early "industrial," while *Coal Face* is a central film of the documentary movement's concern to image Britain to itself, focusing on coal as one of the foundational industries for British manufacturing and trade. The two films, separated by just twenty-five years, nevertheless present very different portrayals of colliery workers and the working of the mines. In their differences is told the story of both changes in coal mining and the history of its representation, for it is in the specific filmic discourse of each that social knowledge and understanding are organized and through which the individuals portrayed are produced as workers.

A Day in the Life of a Coalminer presents scenes from a Northumberland colliery in the north of England. The film opens with a miner saying good-bye to his wife and child at the garden gate, firmly locating waged work as an activity of married men and fathers. At the same time, this scene institutes a narrative structure of events and action related in temporal order while it also introduces a fictional level not only insofar as the scene is clearly staged for the camera but also because the focus on an individual worker and his family "novelizes" the social reality as "their story." Although the penultimate scene shows the miner returning in the evening, this personal focus is not sustained, for we do not see the collier in the main part of the film. Instead typical scenes from a day's work at the pit head and down in the pit and are shown, commencing with the men collecting Davy lamps, which an intertitle briefly explains, and traveling down in the lifts to work the coal seams. We see shots of coal moved on the rail wagons, of coal pushed by hand, and of some men hacking at the coal face. (This raises some questions of fictionality, given the problem of lighting such a scene underground, yet the shot appears extremely realistic in terms of pit props, coal seam, and general conditions). Other shots show work above ground, collecting the coal wagons from the lifts and pushing them to the sorting area. This work is done by both men and women, with the latter introduced by an intertitle as the "Belles of the mine" before being shown in a collective posed photoshot that is not accorded to the male workers. Scenes are filmed in long shot with a single, fixed camera position, and movement is by social actors toward or away from the camera or across the frame, and the relation of the spaces shown to each other is not made clear. All the elements of the process of coal mining are presented: the men lowered in the lifts, hewing the coal, its movement up above ground, the sorting of the coal on rollers, and its transfer to the locomotive trains that will transport it to the fireplaces of the nation—or at least a middle-class nation, as imaged in the film's final shot of another home, where a maid adds coal to a brightly

burning fire and the family moves closer to enjoy its warmth in a cozy scene of parents and children. This is not, of course, the family of the coal miner of the film's title and opening scene. The film shows exemplary events, but it does not tie these up into a seamless reality. Instead events are very much displayed, in Gunning's sense, in a "cinema of attractions." The film focuses on social actors, allowing shots to remain where someone is looking straight into the camera, thus including an acknowledgment of the filmmaking process within the scene. Moreover, the coal miners are shown as wage earners, in a scene of the men—but not women—forming a queue to collect their weekly paycheck. Here arises the first of two moments in the film that function, I suggest, in the manner of the "punctum" described by Roland Barthes.[66] As one man steps away from the booth and walks toward the camera, he examines the contents of the envelope, checking the amount and, perhaps, the deductions for food, rent or other charges that he might owe to the mining company. This action of scrutiny transforms the scene from simply showing the miners being paid, to one—equally factual—showing the payment to involve the issue of the sum as sufficient or insufficient. The second "punctum" involves a woman worker, perhaps around thirty years of age, with a strikingly plain face who is caught in medium-long shot for a few moments, as her smile becomes a broad span of gums and teeth that will contrast with the image of the "Belles" conjured immediately after by the film's intertitle and the subsequent shot. Then suddenly her expression changes, her smile disappears and is replaced by a worried stare, while behind her a boy looks first at her and then at the camera. What disturbs the film at this moment is the woman's disturbance. It is given no motivation, but it interrupts the film and the spectator's look, a look that initially consumed the scene as a spectacle—of a working-class lass displayed for our view; her open smile appears naïve, as if she is as innocent of the camera as of her uncomely looks. The boy's look mirrors the spectator's, and his expression—which seems to be a wry or mocking smile—affords comment within the film on the woman. He thus functions as a kind of surrogate for the spectator and with whom we collude in our gaze. Of course, he cannot, in fact, see the woman's face, but we may transpose onto the boy a response as if he, like us, were looking at her, a projection plausibly supported by the thought that, certainly, he must have known her as a fellow worker. Nevertheless, any subsuming of the boy's look to our own remains, precisely, a projection. The woman's change of expression thus seems a response to our gaze and view, a sudden realization of the camera *as* gaze, and a look from elsewhere that she is suddenly alarmed by in a moment of consternation and, perhaps, self-consciousness.

A Day in the Life of a Coalminer (1910). A woman mine worker smiles, then frowns, observed by a boy behind her, and the camera catches a moment that becomes, in the film, a Barthesian "punctum."

The film displays rather than narrates, despite its framing story. But these displays are not simply "viewings" but "views" in the sense that they include a perspective. *A Day in the Life of a Coalminer* is a kind of museum tour of the industry involving a series of exemplary scenes. We learn nothing of the process of mining (e.g., the erecting of pit props or of the process of work, including the dangers of mining, notably emphasized in the later *Coal Face*). The workers are exotic—especially the women in

their femininity—for little is explained of the work except that it is physically hard labor (e.g., the women are seen working in pairs to carry what may be pit props and pushing along the wagons of coal for sorting). The film thus discursively constructs the women as not only workers but also as female and thus objects of sexual scrutiny. Here, for both a modern audience and, perhaps, for a contemporary audience in 1910, there is the pleasure of reality revealed, caught unawares in the atypical picture of women's physical laboring in an industrial setting (as opposed to the more typical agricultural and domestic-service setting).

Coal Face, a film of similar length, adds not only sound to the picture of coal mining but also a specific discourse through which it constitutes an image and definition of the miner as worker and as employee within the industry as well as of the importance of coal as a foundational industry for Britain and her empire. It is a highly organized composiition of sequences of reality filming of scenes at the colliery, workers' homes, and images of the wider role of coal not so much for the individual consumer but rather in the larger context of Britain's world trade in shipping and the steel industry in providing both gas and electricity to turn the wheels of industry as wind, water, and steam had in the past. Directed by Alberto Cavalcanti, it was edited by the painter William Coldstream, with verse by the poet W. H. Auden and music by Benjamin Britten. The film is exemplary of the British documentary movement of the 1930s, as formally experimental, combining a poetic and lyrical montage of sound and image representing the sweat and toil of work underground as men tramp to the swelling chorus offscreen. As socially committed, it also shows the interrelation and interdependence of the men as a community, whether at the coal face or transporting the boulders of coal. *Coal Face* is concerned with fashioning a new image of the manual labor of the coal miner as muscular rather than brutish; as heroic endurance in the face of appalling working conditions underground; and as tragic when the dangers of that work bring illness, injury, maiming, and death. The film enacts the inclusion of the coal miner in the image of British industry and empire and extends to this group of workers the idealization of physical labor and manual exertion, as well as the ethic of work, which were part of, for example, the sports and fitness movements of the early twentieth century. Edgar Anstey, another member of the documentary film movement, has described their desire to see "the working man . . . as a heroic figure" and to celebrate "the ardor and bravery of common labor."[67] In a more intimate moment, originally filmed for Flaherty's *Industrial Britain* and included again in this film, we see a couple of men take a break to have their "snap," consisting of sandwiches and a drink,

eaten where they rest their tools, at the coal face. Robert Colls and Philip Dodd have described this as "a moment when the male body absorbs attention without regard to its function . . . [F]oregrounded on the left of the frame in the blackness—lit and shot from above—is a radiant face and body of a miner."[68] This moment is held for some seconds; appearing stylized, it displays and images the miner as a "noble body," such that, they argue, "concentration on the splendor of male working-class bodies (a simple complement to a matching obsession with their animality) fixes such men's concerns and competence and ratifies the distinction between mental and manual labor."[69] This image, however, is Flaherty's—the steel-workers are similarly "displayed" in *Industrial Britain*, but that film also emphasizes the skill of craftwork and not simply the brute strength of the workers represented. These scenes are part of a wider image making, and a related mode of representation can be seen in, for example, the wartime paintings of Graham Sutherland or Stanley Spencer, and Henry Moore's drawings of coal miners. This aim of "ennobling" labor, while no doubt also involving an intellectual condescension and a masculine narcissism as well as a fetishization, nevertheless opposes the 1920s image of miners as a threat to the nation (following the General Strike of 1926). *Coal Face* was produced as national "propaganda," or promotion for Britain and her empire, and its inclusiveness rewrites images of work and workers as part of the social consensus of "new Britain."

Coal mining is presented not only as a national industry but also as a matter of communities, workers, and their families dependent on the mine for their homes—often owned by the mine company—and their livelihoods, as the voice-over states. The film works on a number of levels that interrelate to produce a satisfying filmic discourse and a document of fact and information. This film, more than any other, has given us the image of coal mining in that century, most visibly and monumentally with the image of the winding tower at the pit head but also the slag heaps, the ponies pulling wagons, and the sweating men doubled over wielding pickaxes and mechanical hammers to hew the coal. Only the last of these images is part of *A Day in the Life of a Coalminer*, while the women and the other pit head workers are now gone. Absent, too, is any direct address by the workers themselves; not only—as in *A Day in the Life of a Coalminer*—are the workers silent, but also the looks at the camera, and thus address by social actors seen in *A Day in the Life of a Coalminer*, have now been banished, while the frugal intertitles of the first film have been replaced by an expansive voice-over narration in the second. The miners are presented primarily as a *body of workers*, and while union banners and marching bands are absent, they might easily be added, in

contrast to the particularity of *A Day in the Life of a Coalminer*, which focuses on individuals and groups of individuals. *Coal Face* articulates an image and meaning for coal mining, organized as an aesthetic audiovisual experience through the rhythm and pace of its sound and image editing. *Coal Face* is, nevertheless, not simply discursively closed, as later critics have often argued. The replacement of the miners' voices by the chorus and music, as well as by the rhythmic marching, stands in contrast to the organizing statements of the voice-over. These elements are antinaturalist in a way similar to Vertov's juxtaposition of images in *The Man with the Movie Camera* (1929) and are not fully contained by the film in the way that the later *Night Mail* integrates the poetic and the functional within its story of the nighttime mail train.

As Andrew Higson points out, the Griersonian documentary project "tried to hold together profoundly contradictory tendencies."[70] For Grierson and Rotha, Higson notes, the task of documentary—"the public service which it is the duty of cinema to perform"—is the "teaching of citizenship" and the transformation of the spectator into "a thinking, reasoning and questioning member of the community." Nevertheless, Higson says, the form of the documentary film can, "by situating the discussion in the text itself," once more place the spectator citizen "outside the public sphere"—passive, albeit enlightened.[71] Moreover, he argues, Grierson's many claims for the documentary film, and the state or quasi-state funding he secured, tend to imply that a single "public interest" can be served, masking the extent to which the public sphere is a contestatory space in which not all social interests have an equal voice and "consensus must be negotiated or acquiescence imposed." Higson concludes by characterizing the Griersonian project in Foucauldian terms, as an "effort to produce and regulate an official public sphere, an attempt to discipline public life."[72] In Grierson's words, "it was, from the beginning, an adventure in public observation,"[73] involving, as Rotha put it, "presenting one half of the populace to the other."[74] This meant, Higson argues, that "the public must be educated, they must comprehend the values of citizenship, but they must also be observed, surveyed, analyzed, categorized—that is, they must be policed."[75] It is not, however, the documentary of the 1930s that most exemplifies the practices of surveillance but our own century and the growth of video surveillance.

The documentary film movement was certainly part of the debate around and struggle for political consensus in the decade after the 1926 General Strike in Great Britain. The incorporation into the public sphere of the working classes—and, of course, of women following the enfranchisement acts after the World War I—was a social-democratic project

that opposed the traditional class and gender structures and the vested interests of owners in maintaining an excluded class. No doubt this project and its impetus was partial and incomplete, and certainly it is in large measure subordinate to the continuing elitism and hierarchy of the dominant business interests in Britain in the 1930s, so well summarized and satirized in *Peace and Plenty* (Ivor Montagu and B. Megarry, 1939) and *Hell Unlimited* (Norman Maclaren and Helen Biggar, 1936). Moreover, it was a project of inclusivity rather than class revolution. Yet that this itself was revolutionary needs to be more fully acknowledged. The 1930s was a period of contestation around the boundaries and modes of a widened public participation, of the redefinition of the citizen as more than the male bourgeois, and involved the redefinition of the ownership, and hence role, of knowledge.

Coal Face is part of this redefinition, for it articulates the image of Britain as inclusive of the miner and his manual labour. It effects, in Rancière's terms, a change in the distribution of the sensible, of the relations between the visible, the sayable and the thinkable, through its montage of sound and image. The coal industry is no longer simply a matter of mines and owners but also of the men and their families who live, and die, by coal, and the miner is thus redefined as a key image in the representation of the role of coal for Britain and her empire. This was also the image in the 1910 actuality, *A Day in the Life of a Coalminer*, but there the miner was represented in his and her particularity, whereas in *Coal Face* the miner and his sacrifices are a universal and a component of the success of the British empire. Its appeal and address are to "one Britain" that it envisages and thus gives image to, and its aim is consensual, but at the same time, it is defining the terms of that consensus and that image. The notion of a state of responsible and informed citizens would now include the worker, producing a redefinition of the "national interest" as more than the interests of the economic elite. As a result, the position of the owners as employers without responsibility toward their workers or the country would be in question. This redefinition can be seen with hindsight to lay the basis for the wartime national collective interest and the postwar nationalization of the coal industry. Andrew Higson indeed notes, "There is no denying that such films do extend the boundaries of permissible discourse, the boundaries of the representable, and that in this extension, working-class figures are indeed often placed at the centre of the diegesis—though rarely as active subjects. The system of looking constructed for this cinema, however, suggests a very different reading, since in many ways it situates the spectator as a bourgeois outsider, looking in on this other class as spectacle. From this perspective, the working

class are effectively captured—held in place, tamed—as the objects of a benignly authoritative gaze."[76] The project of inclusivity does not simply "tame," however; rather we may understand it as also a rewriting of the "dangerous, unknown other," as familiar, as *Heimlich* (in contrast to the *Unheimlich*, the uncanny), enacting a process of recognition of the other(s) as part of "one Britain." In *Enough to Eat?* (Edgar Anstey, 1936), sponsored by the Gas, Light and Coke Company, scientists and the state are charged with a duty to enable good nutrition, but this is not—yet— national government policy, while the spectator as citizen is addressed in terms of not only her duty to eat better or to encourage others to do so but also as an agent who can act to bring this about through knowledge. The working-class poor are victims of poverty but not of ignorance in the film, for it demonstrates by interviews and statistical graphs that poorer housewives do know what foods are important for their families, thus showing its own concern to portray them as subjects of knowledge, which we can understand as its ideological aim because the cause or source of that knowledge is not shown. This is in contrast to, and perhaps in contradiction with, the claims made by the film for the scientific understanding it presents, for the women's knowledge is just asserted by the (male) voice-over. Observation and testimony as evidence are central to this film, but the public school youths as well as the urban working-class kids are objects of its scrutiny. In contrast to the nineteenth-century informants of Henry Mayhew,[77] the women interviewed are participants in the modernist project of understanding and achieving good nutrition rather than being recipients of philanthropy's voyeuristic concern. Action is undertaken not only through charitable handouts but also through local government initiatives funded by local property taxes, as also seen in *Housing Problems* (Arthur Elton and Edgar Anstey, 1935).

Insofar as documentary as a mode in the 1930s is exemplary of and a player within the discursive struggles and redefinitions that were arising with the emergence of a new post–World War I modernity in Britain, the spectator is addressed as an agent as well as subject of these meanings, that is, she is addressed as a social agent and a subject within a specific historical conjuncture.[78] Films such as *Enough to Eat?* do not simply "know" for and on behalf of the spectator;[79] they also demand a spectator who comes to know. The modernist role assigned to science and knowledge is as a performative "act" whereby scientific knowledge is an imperative for change and human progress, and to be informed about matters of science implies taking action in relation to that knowledge. Moreover, there is an assumption on the part of filmmakers of widely different views in the 1930s that to see is to be impelled to act and that film

can function as visual evidence.[80] These views are not simply naïve and misguided, as too often we—as later theorists—may assume but attest to the power of the moving images and sounds of film and to the determining role of historical conjuncture for the production and consumption of film, which has been perhaps most important for documentary film.

The People Who Count (Geoffrey Collyer, 1937), by its very title, was part of this new discourse and its debates, but it presents a quite different account of work, working, and workers. Like *Coal Face*, this 16mm sound film made by the London Co-operative Society is "propaganda"—in the sense used by John Grierson—for an informed and committed citizenry. Its address—to "the people who count," namely, ordinary workers—is similarly inclusive but it is also partisan, for the film promotes the project and ethics of the cooperative movement as opposed to private ownership and capitalist modes of production. It is not, therefore, apparently consensual; it does not address or appeal to "one Britain" as *Coal Face* seems to. The film opens with a series of questions posed by the voice-over narration by A. V. Alexander, a Labour and Co-operative Party Member of Parliament: "Who will achieve a higher civilization and how will they do this?" It will be achieved by cooperation, Alexander replies, and this is illustrated by egalitarian images of cooperation in nature, sport, and industry. Describing what is needed in the world—peace and prosperity—over shots of street scenes, in a reprise of *Workers Leaving the Lumière Factory* of 1895 (Louis Lumière), and images of a woman worker at a milk-bottling factory, the voice-over asks again, "Who will achieve this ideal state? The answer is all around us, in offices, factories, shops." The film sets out three groups of persons to give answers—men and women workers, mothers, and wives. "Workers" included men and women, for we have just seen images of women workers. The categories of mothers and wives are two further groups of workers, unlike the related but, here, not necessarily comparable categories of "husbands" and "fathers."

The People Who Count is also an advertisement for the co-operative society retail movement, and specifically the growing retail development of the London Co-operative Societies. Through a brief reenacted history, viewers are directly encouraged to support the movement and its ideals of worker cooperation, while the success of the movement as a retailing enterprise is shown in the modern new department stores being built by the London Co-operative Societies, especially Royal Arsenal and the Woolwich Co-operative Societies, and in the numerous stores taken over and reopened as cooperative ventures, as well in the range of services offered, including dentistry and ophthalmics. What is sought, however, is

not simply shoppers and consumers for the new complexes and services but supporters of the cooperative ideal; it is this that is being "sold," rather than goods and services as such, and it is women's participation, both as workers and as consumers and primary purchasers for the family, that is solicited in the film. It is here that the film offers a new discursive construction of the worker, specifically the woman worker. This worker, whether she has a paid job or is running a household as a wife and mother, consumes, and she does so in bright new stores in which she is offered the latest and newest goods and services at excellent prices. The film shows a different London emerging with the modernist architecture of the new stores in the remodeled high streets. The department store was not, of course, a new concept in retailing, but its origins and early development was as a middle- and upper-class facility. The cooperative movement's successful entry into this form of marketing organization thereby extended it to a wider class and made it part of the transformation of consumerism in the 1930s fueled not least by the emergence of cheap food as the result of changed techniques in world agriculture, which freed a portion of the ordinary worker's wage for other kinds of purchasing. (The international slump in prices for food and raw materials did not always lead to cheaper prices, as producers resorted to dumping of food and other practices in an attempt to keep prices high; the cost of food was lowered, instead, by the increased productivity of new methods that created a greater return on investment.)

The film exemplifies its themes through the example of a store taken over from private ownership, describing the reopened premises as being efficiently organized and a pleasant place to work and shop in. This, we are told by the voice-over, is the result of people working for themselves in their own cooperative business. The camera cuts between high-angle views and medium shots of a ladies' clothing department before cutting to a medium close-up of a young woman who speaks directly to the camera. This is the only inclusion of direct address by a social actor within the film, as a result her voice is in marked contrast with the male voice-over of Alexander. The woman's speech might have been scripted and rehearsed, yet her halting way of talking and awkwardness in front of the camera confirms her as real and ordinary and not an actress. She says, acknowledging the problem of believability, "Although it's almost too good to be true, but . . ." and goes on to affirm that it is really the case that her working conditions have improved since the store became run by the cooperative movement. She describes the better relations with colleagues, better pay and hours, and the better relations with customers based on equality and service, not servitude. In these brief words,

the shop assistant defines what matters to her as a worker and a woman, while the film illustrates her words with shots of women at work and at leisure and shows staff and customers enjoying as equals the open-air rooftop restaurant.[81]

Women at work was also the focus of a wartime propaganda documentary, *Five and Under* (Donald Alexander, 1941), which, like *Coal Face*, speaks for the subjects it presents, but unlike that film, it fails to represent the women and their achievements inclusively, as part of making "Britain" great, or as war workers, victorious. The film centers on working mothers and their children, but its concern is not with women as workers and their achievement but how their primary responsibility for child care prevents them from being workers enough for the war effort. At the same time, as working mothers, they are represented as failing their children. The solution the film presents is child care, but it poses a further question: how to ensure good mothering? Its answer is for the children to become weekly or monthly boarders at nursery homes in the country—with air, light, and the "proper" care of professionals. Women as workers—including as mothers—are not addressed. Instead, care of children becomes the work of *other* women, while their mothers' work in the factory or elsewhere is simply assumed. The difficulties of separation for both the mother and her child are shown in a scene where a visiting mother is not at first recognized by her small daughter, but such problems are quickly passed over by the film's emphasis on the greater good for the child of its improved environment, away from its mother's poor housing and so on and on the greater good of the national war effort itself. Like *Enough to Eat?*, the aim of *Five and Under* is to promote intervention to ensure children receive the proper nourishment of mind and body, light, and air, but in this film, it is at the cost of mothering.

No discourse of women as workers emerges in the film, except as necessary to the war effort, and the contradictory view of women's position in the labor force in relation to their role as mothers that emerged in the nineteenth century with industrialization is maintained. Yet in postwar Britain, despite the returning soldiers who reentered the workforce, there was a shortage of labor, leading the government to seek to retain women in the workforce. Not only, however, was the wartime provision of nurseries quickly eroded, but the wages for women's work were too low to enable mothers to afford paid child care. Meanwhile, the new definitions—and requirements—of mothering were "professionalizing" the role of women as mothers. Through the work, for example, of John Bowlby,[82] the earlier government-promoted concern with hygiene and diet, healthy environment, and sport and play, was augmented by an

emphasis on the mother–child relationship and the psychological development of the child in its first years. As a result, nurseries for children came to be seen as a second-best provision and a last resort, since the child was deprived of its biological mother's attention and psychological interaction. The second wave of feminism, the women's movement of the 1960s, was undertaken by the children of these mothers, who demanded solutions to the contradiction rather than the choice imposed on their mothers of one or the other.[83] It was through documentary film that feminists sought to explore and expose these contradictions; for example, Connie Field's *The Life and Times of Rosie the Riveter* (1980) showed the way in which in the U.S. women war workers had to fight for equal pay for equal work and then lost their jobs to the returning men. At issue, however, was not only a patriarchal discourse seeking women's return to the home but also a wider and more complex arena of contestation regarding work as such, family lifestyle, and the ghost of war trauma. All of these remain current concerns.

▶

Working Images

Such films produce and organize meanings of work and workers at particular historical moments. They do not only record a process of labor; more importantly, they constitute ways of *viewing* the worker and, hence, also produce an identity for laboring. Moreover, it is not only what is included but also what can be inferred as excluded that determines this identity. The history of labor in these films is a history of the terms through which laboring is thought and the limits of these terms. If these images are not simply facts of a past reality that we can consume as history, and if they are not true and meaningful by virtue of the reality recorded, what is their value or role for us? It is precisely as constructions that we can read *historically*, inasmuch as work and workers are conceptualizations of human labor and its social and economic value.[84]

The analysis here has centered on the specific national context of these British films, but their filmmakers were part of, and influenced, a worldwide development of documentary. In the United States, this led to the films made for the Works Project Administration promoting the New Deal and its measures, and to documentary storytelling in Grierson's sense; but while Pare Lorentz's *The River* (1938) presents a closed discourse that solves the problem of water for, and not by, the farmers, in Joris Ivens' *The Power and the Land* (1949)—which follows the style of his work in *Spanish Earth*—we are shown a community of dairy

farmers who work together to draw upon governmental support to bring electricity to their farms, thereby not only ensuring the freshness of their milk through refrigeration but also transforming their work and leisure with electrically powered light and machines. *The Power and the Land* shows the diverse activities on the farm, but the arduous nature of agricultural labor is explained by the controlling voice-over. It is defined as a communal project not only of family but also of neighbors. The film's discourse of labor is evidential but also ideological—of giving to and taking from the soil, one's community, and the nation—its voiceover asserting that "one man alone can't change things." Proper labor and the due return on labor are defined in relation to the new technologies of modernity that free time or increase the return on the time of labor. Shown not as victims but as empowered workers, the farmers are an image of America working together, yet we never hear their voices; instead the film speaks for and of them.

There lies in all these films stories of meanings and thus identities that continue to move us—that is, to interpellate us—and we can find ourselves addressed not only as working subjects but also as sons and daughters of workers. Alternatively, these identities and meanings may be the basis for a critique through which we institute—or represent the desire for—other identities and meanings. These are both fundamentally aesthetic functions. Documentary—film, video, broadcast and satellite television, and the Internet—not only reflects the discourses arising in the public sphere but also is itself a discourse constructing and defining what we take to be the "public."

▶

"They Speak for Themselves": Giving Voice to the Ordinary

Giving voice to the ordinary is associated with Mass-Observation, the project for "Anthropology at Home," which was cofounded by Charles Madge and Humphrey Jennings along with Tom Harrisson in 1937.[85] This developed Madge's idea of ordinary people "speaking for themselves."[86] It is this idea of social and political engagement with the voice, and its role for documentary's discursive constructions, that I want to consider here in the context of the 1930s documentary project.

What is voiced, first and foremost, are the views of ordinary people. The "voices" of Mass-Observation were primarily writings—diaries, in fact, rather than recordings. In film, it is also an embodied voicing that can engage us emotionally—a poetic voicing. It is through the work of Ruby Grierson that I will explore the emergence of a documentary voice

of the participant and its dramatization (an approach that reemerges in the documentary dramas of live broadcast television of the 1950s in Britain and the filmed television docudrama of the 1960s). She became involved in documentary film through her older brother John Grierson but worked primarily for Realist and Strand (two independent associations of filmmakers), collaborating with Edgar Anstey and Arthur Elton on *Housing Problems* and with John Taylor as codirector with Ralph Bond on *Today and Tomorrow* (1936) and director of *Today We Live* (1937).[87] All these works share certain distinctive characteristics, forming a strand in 1930s documentary that sought to include the voice of ordinary people as well as the images and stories of the everyday.[88] It is our desire for and pleasure in the "ordinary" and the problem of verisimilitude that arises in seeing and hearing the ordinary that are my focus here. A number of interrelated questions arise: of what is being sought in the voicing of the ordinary, and insofar as this is a desire for testimony as the truth of experience of the "ordinary" person, what kind of access to the "real" of peoples' lives is being offered? As a corollary, the question also arises as to the representability of this "ordinary" through recorded language, sounds, and images, for this "voicing" is always a construct of the documentary discourse as an audiovisual medium. In addition, there is the question of the moment of the historical conjuncture of the speech and its recording and the discursive construction of the time of its reception, both in terms of different audiences (i.e., class, nationality, age, race, and gender) and in terms of different historical times of audiences—the 1930s or the 1970s or the twenty-first century. What notions of real and unreal, of verisimilitude and the nonverisimilitudinous, and the genuine and the false arise for audiences as a result?

Mass-Observation, declared Jennings and Madge, "does not set out in quest of truth or facts for their own sake, or for the sake of an intellectual minority, but aims at exposing them in simple terms to all observers, so that their environment may be understood, and thus constantly transformed. Whatever the political methods called upon to effect the transformation, the knowledge of what has to be transformed is indispensable. The foisting on the mass of ideals or ideas developed by men apart from it, irrespective of its capacities, causes mass misery, intellectual despair and international shambles."[89] In their preface to *May the Twelfth: Mass-Observation Day-Surveys* (1937), Jennings and Madge write, "These fifty Observers were the vanguard of a developing movement, aiming to apply the methods of science to the complexity of a modern culture." The Observers were ordinary people drawn from a wide range of social and working backgrounds, of whom Jennings and

Madge note, "A large proportion of them have already shown themselves able to write really useful reports. Prof. Julian Huxley has written of some of these that they 'would put many orthodox scientists to shame in their simplicity, clearness and objectivity.'"[90] Nevertheless, while observers were asked to note details of dress and other characteristics, which might be related to gender, class, job, and family, there is an the aspect of Mass-Observation that delivers not only "objective facts" but also the facts of subjectivity (e.g., facts about how families save will at the same time tell a story about how families desire—or fear—in relation to the future that their saving looks forward to). Indeed, Madge and Harrisson later asserted that "Mass-Observation has always assumed that its untrained Observers would be *subjective* cameras, each with his or her own distortion. They tell us not what society is like but what it looks like to them."[91]

What seems a quite romantic concept of "the untrained observer" undercuts the strident empiricism promoted by Huxley's comment, introducing a profound epistemological questioning of modernity's knowledge structures. It is such subjectivism that makes the Mass-Observation material so rich in anthropological terms while at the same time limiting its role as "proper"—that is, objective—social history. It is as if, not heeding the division that Jonathan Crary has argued arose between the disciplined observer and a subjective gaze, the camera is no longer the prosthesis enabling true, or truer, observation but rather—in the reference to the camera's distorting lens—a metaphor through which the subjectivity of vision is articulated. A different discursive construction arises in both Mass-Observation and some of the films of the documentary movement, one that can be understood as oppositional to the hegemony Crary has assumed for the discourse of disciplined observer.[92] The subjectivity of "speaking the ordinary" emerges in relation to a social project arising in the 1930s that sought to enable a wider enfranchisement of views in constituting the "voice of Britain." New aspirations and thereby new definitions of agency are being invoked in relation to subjects as citizens susceptible to the subjectivity of aesthetic, emotional response.

▶

The Vision and Voice of the Ordinary

Giving voice and image to the ordinary—the anthropology of our own culture—is clearly not straightforward, but both Mass-Observation and filmmakers like Ruby Grierson were concerned with authorizing the ordinary rather than authoring the everyday. Observation necessarily involves distance, a controlling vision of the observer over the observed,

and thus a separation, with the assigning of the status of object and "other" to the observed. Documentary films, however, are a specific and particular *performance* of the specular through film as discourse, and they cannot be simply aligned with or made equivalent to the surveillance and control of the scopic regimes of the prison or of medicine, to take two of Foucault's studies. As argued in chapter 1, the documentary film does not simply control the terms for its own reading but draws understanding conventionally through its verisimilitude. The documentary film must either successfully produce in its viewers a sense of the realness of what it shows, through enabling a recognition of the ordinary as really real, because familiar; or, alternatively, it must motivate its strangeness so that we understand its unfamiliarity as a mark of its reality.

Housing Problems (Arthur Elton and Edgar Anstey, with Ruby Grierson, 1935), a film widely discussed in terms of its ideological and aesthetic role for 1930s documentary and social history, notably poses issues of verisimilitude and of the role played by the ordinary men and women who voice their stories of slum housing. The problem of shocking living conditions is to be solved by the provision of new housing by the local authority that provides "proper" conditions as defined by planners and architects (e.g., in terms of space and natural light, of running water and sanitation for each unit for rent, in collaboration with the gas and electricity utilities [the gas service was a partner in the film's production]). In this film, encouraged by Ruby Grierson, those living in the slums tell their own stories of their dreadful living conditions.[93] Are these people only the objects of our eyes and ears (i.e., figures to be observed)? What is the role of the words and character of their speech—its enunciation and phrasing and of the mise-en-scène of their speaking? Their speech and statements are accompanied, indeed enclosed, by two voice-overs from speakers who each remain unseen: one, anonymous, speaks in received English while the other is Councillor Lauder, a local Labour Party politician and chairman of the Stepney Housing Committee. Thus, far from having their own say, the words of the "slum dwellers" might seem to serve simply to confirm the truth of the problem of slum housing articulated by these two authoritative voice-overs, while the formal framing of the informants, it has been argued, distances us from them, preventing identification.[94] Yet although the film's concern is primarily with the "bigger picture" of housing regeneration, the inclusion of the views of "ordinary people" is not fully assimilated into this. Rather, I suggest, a certain strangeness in relation to the film overall is produced by these testimonies for, notwithstanding the familiarity the film evoked in audiences from the community around Stepney when it was shown by the filmmakers, a problem of verisimilitude

arises—seen in both contemporary comments and in the responses of many modern viewers of the film in relation to the address of some of the informants. Mr. Norwood, for example, speaks quite formally to camera, seated before his bureau arrayed with the decorative objects typical of any home of the period, and a large mirror above. He appears unnaturally posed, and as if speaking from a prepared script, thus as contrived and therefore unconvincing. As John Corner observes, "Modern viewers of the film sometimes register uneasiness at what they believe is the uneasiness of the speakers. Certainly, and not surprisingly, most of the participants look and sound a little awkward in their performances. But to be cued by sympathetic embarrassment of this kind into an interpretation of the speaking as somehow inauthentic, perhaps even the result of directorial management (thereby illegitimately 'set up'), is to be oneself a victim of the ideology of spontaneity, of modern television naturalism. Indeed the very awkwardness of non-professional performance in *Housing Problems* can be seen as a guarantee of communicative honesty."[95] The "strangeness" may be read as either indicating inauthenticity or, on the contrary, the truly authentic. The undecidability here poses back to us our demand for the authentically real and its impossibility as anything other than the verisimilar. Mr. Norwood's home is not scrutinized by the camera to reveal its inadequacies in a modernist concern to adduce visual evidence; instead it is his bureau that represents his home (of just two rooms, with no separate kitchen, and no toilet or bathroom), while we might infer that his ambitions for a different kind of home are figured by the overmirror and ornaments. His style of address may be understood as the formality of someone unused to public speaking; moreover, this contrasts starkly with his words, which tell the story not only of physical inconvenience but also of unhealthy and unsanitary conditions causing illness and death and of his children whose lives were cut short and whom, we can imagine, will be commemorated in the infant mortality statistics.

Mrs. Hill, in contrast, stands on the staircase of her tenement to describe the conditions that she points out, the camera cutting away to give visual evidence for her claims for the dampness, the single-toilet facility shared by many families, and the vermin in the walls. What is striking is not, or not only, the visual evidence but her mode of speech, circling round to repeat herself, most noticeably as she reiterates the awful structural condition of the building: "The whole house is on the crook," she says, to which the strange angle of the staircase bears witness. It is a rhetorical device giving emphasis to her words not only because she may fear her words and the scenes she points to are unconvincing but also because in this way she gives drama to her account. She places herself as

well as a social subject of speech—for her rhetorical style is part of the London East End community's form of storytelling—and as a psychological subject of speech, for whom perhaps, we may infer, the particular offense of the crookedness of everything in the house overruns all the other horrors of her housing.

The testimonies in *Housing Problems* exceed their proper role as "realistic" and introduce an imagined space of other stories. For example, Mrs. Atribe, in voice-over, relates how nice her new home is with its modern stove and boiler for washing clothes, over images of her new home. The anonymous commentary anticipates her next words as "All the same, Mrs. Atribe will never forget the rats in the house she had before," and she then tells us of the day in her old home when she discovered a large rat and of her husband's efforts to capture and kill it, giving us a drama of event and action and not simply of the horror of rats and the disease and danger they represent, which thus remains only implicit. What emerges, I suggest, is a social reality not fully contained by the film's documentary discourse, a voicing of the ordinary that exceeds the bounds of the structures of cause and explanation, problem and solution, that the documentary enacts, reintroducing contingency.

The films Ruby Grierson contributed to each show a concern to give voice to the people they show. *Today We Live*, for example, is about three communities who are seeking funding to build local community centers.

Housing Problems (1935). Mrs. Hill describing the shocking state of her building, says, "The whole house is on the crook."

While scenes are clearly organized for the camera, as in *Housing Problems*, the film is also inclusive of dissenting views, such as the unemployed miner in South Wales who consistently objects to the project of building a center, arguing that it will not provide them with jobs, which is what they really need. In *Give the Kids a Break* (1937), on which she worked as assistant director to Donald Taylor, the opening sequence of the teacher addressing a class of Glaswegian schoolchildren is clearly acted and scripted for the camera. The scene differs, however, from the usual enactments in 1930s documentaries, such as in *Night Mail* or *BBC: The Voice of Britain* (Stuart Legg, 1935), organized as it is with diverse and diverting shots of the children at their desks—a girl knitting and some boys playing a game—as the teacher makes a joke about the spelling of a particularly unpronounceable Scottish location. The schoolteacher has set the children the task of writing about what they would like to do on a holiday, and the film shows the accounts they produced, evoking the imagined spaces desired and anticipated by each child, which are realized in the more, and less, organized scenes of activity and play of children on holiday that follow. The Glasgow charity that organized these summer vacations for the city's children is represented not by a singular figure but through a group meeting where the planning and arrangements for the trips are discussed. The film is a record of these holidays as well as an advertisement for this work and an appeal for support. Organized separately for boys or girls, with camps for Jews, Catholics, and Protestants, the images of the tents and the boys lined up outside, as well as the scenes of breakfast and preparing meals, might recall similar shots from Leni Reifenstahl's *Triumph of the Will* (1936). Here, however, the low-angle shots and close-in framing that cuts up the scene presents boisterous anarchy rather than organized athleticism. The tone is one of play and playfulness rather than discipline (e.g., in the series of long-held shots of a teacher with some boys walking down to a beach, some straggling behind, others striding on arm in arm, and another who bends down to pull up his sock over and over again). Exuberance and freedom are suggested in these scenes. The film certainly offers a spectacle, but one of children experiencing pleasure and fun rather than as objects of a controlling observation. The children do perform, however—not only through organized games and activities but also in three set pieces of filming. In one, a small boy entertains a group sitting around him in a tent, singing and performing in music-hall style "Roamin' in the Gloamin'." In another, a girl regales a group of friends with a comic story, acting all the parts; her broad accent is both familiar and estranging so that it is the non-Glaswegian spectator who is "strange," or other, to this scene as she tries to follow the girl's account of

naughty children and animals. A third performance is shown when, following a collective song, a young boy steps up to sing unaccompanied, in a voice rich, melodic, and more powerful than his slight and slender frame would lead us to expect, "Misty Islands of the Highlands." Though he acts as an experienced performer, with his arm on his hip as he leans back to project his voice, we are reminded of his youth when his hand drops periodically to tug his short trousers back up around his waist.

Give the Kids a Break continues to have the power to delight and move us. Something is documented here, as in *Housing Problems*, that is more than the propaganda of a small Glasgow charity or argument for slum clearance. The films record and observe but also enable a sense of the social actors, allowing them to have their say as well as to speak to us through their gestures and actions and by the intonations and characteristics of their speech. In this, the films engage us with people not as "victims" but just as ordinary, yet also in its presentation in each film, it is an ordinariness that touches us poetically.

The possibilities for film that Ruby Grierson's work suggested were not realized until several decades later, in the work of the British "Free Cinema" filmmakers, and in the development of the interview and its "vox pop" or "man on the street interview" forms that are both now

Give the Kids a Break (1937). Boys are ready for the morning wash.

Give the Kids a Break (1937). We overhear the girls chatting.

central to documentary, and in the overheard of direct or observational cinema. It is in the video-diary format that her legacy, and that of Mass-Observation, is most clearly realized and continued as access television through the BBC's *Video Nation* in Britain, enabling members of the public to present their ideas, projects, and activities on video, via the Web and television.[96] In the next chapter, I explore the identifications arising in documentary and their relation to its forms of address.

[3] *Documentary Desire: Seeing for Ourselves and Identifying in Reality*

The identifications that, in the fiction film, are dismissed as vicarious, illusory, and ideologically dangerous are, in documentary, both permitted and proper to its project. Explored here are the ways in which the documentary film, no less than the fiction feature film, offers mise-en-scènes of desire and of imagining that enable identification even while, or rather because, it asserts itself as real. As spectators of documentary, we bring with us not only an understanding of the conventions of the novelistic, as well as of the "factual," but also a desire for reality represented and a desire to find that moment that is not only real and factual but also "true." Indeed, the demand for the distinction these terms imply itself constitutes a *desire* for a certainty of the knowable, of the world as testable, producing a split between two domains: one of proper, true, knowledge and a second domain of improper, untrue fabrications. Such a "wish to know" (epistephilia) the truth of the world both seeks an answer and is a questioning: is this really so, is it really true? The splitting produced by this opposition between true and false inaugurates an uncertainty and becomes the locus of anxiety in which another question is posed, one that is addressed to the other from whom we seek and desire a response in relation to not only the truth of the other or the world but also the truth of ourselves as subjects. This chapter draws on the understanding offered by psychoanalysis to explore the specific ways that documentary engages this questioning address and the interrelation that thereby arises of desire, knowledge, and identification in the sounds and images of the documentary with the ethics of desiring, knowing, and identifying.

Knowledge, as Foucault articulated so clearly, is not just there; rather, it is what is recognized as knowledge by a community, that is, as having a specific or specified use value for a community, such as the

knowledge of the effects of different plants, or of the understanding of light, or the knowledge of poetry, or of politics. As the way a society knows and organizes its knowing, its ordering of knowledge institutes a discursive regime by which the kinds of statements that count as knowledge are determined. Knowledge is independent of the subject as an objective understanding of the world, while at the same time, paradoxically, it is always for a subject, since it only exists insofar as it is known by someone, in the same way that Peirce defined the sign as always implying an addressee. The knowing of knowledge, which we speak of as something we possess, is both instrumental—we know how to change a flat tire—and something that has value and currency as a commodity that, for example, I trade in as an academic, for it is acquired only by learning. The coming to know of knowledge is, by contrast, a process. The world as a knowable entity, "reality," is constructed by the subject through its encounter with externality in a mastering that is also an acknowledgement of its mastery over us or as something we submit to. The tools humanity has fashioned are honed not just to fit "reality" but also to transform it in an imagining of the world otherwise.[1] Knowledge, by making the material world "make sense," is at the same time a construct that wards off the emptiness of meaning of contingent reality. Science declares the knowability of the world, foreclosing the real as meaninglessness, and as such is, for Lacan, a form of sublimation.[2]

What is our fascination with facts? How does documentary address us with its facts and with its desire to represent true reality? Merton and Lazerfeld, in their analysis of responses to government propaganda, note, "We observed at once an interest in detailed circumstantial facts. Facts are in the saddle . . . Facts, not the propagandist, speak." They suggest that "the concrete incident, rich in circumstantial detail, serves as a prototype or model which helps orient people toward a part of the world in which they live. It has orientation value."[3] Their example is a radio program on merchant-shipping convoys that explained in great technical detail how the speed of the convoy is determined by the slowest boat, thereby implying a further, and subjective, meaning, that the merchant marine willingly place the collective good over individual good. The sequence was most effective because "the facts, not the propagandist, speak," and they conclude, "The voluntary drawing of conclusions has little likelihood of the disillusionment which so often follows the propaganda of exhortation."[4] Audiences are engaged by the facts and become agents in relation to this knowledge, drawing further inferences, such as "surely my sacrifices do not match theirs,"[5] but in film, this is a *showing* rather than telling.

Documentaries invoke and require identification; this is a cognitive process and a matter of knowledge, for we must identify their facts and recognize their meanings. In this we are positioned by the documentary's discourse of reality, identifying as the subject addressed, as one who knows and comes to know, which involves both seeing for oneself the truth of reality and identifying with the seen and with the objects of knowledge and of the camera's observation—other people and other subjects. Our relationship to knowing is as rational and objective persons, while also involving an emotional engagement with the seen and heard that is often also called identification. Such identification is not all of a piece, however. Rather, it involves a number of distinct psychical and, for documentary film, cinematic processes that engage us as both knowing and desiring subjects. Indeed it might seem that the term refers to processes either too multiple or too vague to be useful, and both philosophers and many film theorists prefer to talk of emotional response rather than identification. This gives rise to new problems concerning the concept of emotion or of affect as a feeling or experience and in the opposition implied between emotion and rational understanding. While identification is a contested concept and process, it is nevertheless the term most of us use to refer to the way we feel for and about other people and ourselves.[6] It is also a concept that has been central to both psychoanalysis and theories of ideology, for we are our identifications. The approach I adopt here is to view identification as naming a number of processes that are both interdependent and singular, which may also be, at the same time, contradictory.

How does documentary engage us in identifying? Documentary informs us of the world, offering us identities in the images and stories of other lives that it presents that become fixed as known and knowable through its account and explanation of the world it shows. It thereby reassures us that our own, different identities are equally knowable, engaging our desire for the certainty of our knowable and known identities. Our identities are both visible attributes (e.g., red hair, brown eyes) and our personal characteristics (e.g., shy, proud, clever, insightful, gay, black); these are distinctions that are both social and psychological. It is this intermixing that I am exploring here.

Identity arises in relation to two distinct cognitive events centered on the senses but that are also an imaginative engagement: The first is the recognition of the self as an entity, a bodily differentiation between what is me and what is not me, and thus other, which Lacan describes in his account of what he termed "the mirror stage" as the acquisition of an image.[7] The second is the recognition of attributes and qualities of the

thingness of the separate self and the other that arises through the address of others and becomes the experience of "me-ness," of an identity as son or daughter, child or adult, or as naughty or nice that one embodies, and in recognizing this one also comes to enact this identity for these others.[8] Identity is experienced subjectively as a feeling that "I am this," where "this" might be shyness, but it is also inextricably an identification, for shyness is a quality objectively recognized by me as mine.[9] It is a quality that I may also identify in other people, giving rise to the sense of being like or the same as others, but this is distinct from becoming the other.

Identifying, and the identity it makes possible, never ceases as we transfer to others our relations to the emotional figures of our childhood and seek new ways of becoming the image of ourselves given to us by those figures. What is the role of our encounters with the imaged and explained lives of others in documentary, and is it distinct from fiction? In documentary, people speak to us, and we are engaged by their address, that is, by how their speech positions us as addressees. Through its stories, documentary presents mise-en-scènes of desire and of possible outcomes hoped for in the contingent reality shown that engage us as desiring subjects. Storytelling, whether in literature, theater, or film, is also one of the discursive practices of imagination through which we may envision ourselves as subjects of desire and feeling. Whether in Freud's language as the fetish, or in that of Proust as the *madeleine* of his memory, or in the imagery of Hitchcock's Madeleine and her coiled lock of hair and her posy of red rose buds in *Vertigo* (1958)—obsession and desire are *figured*, performed, and given substance in gesture, action, and objects in mise-en-scènes of fantasy. Identification, however, is with the place occupied by the character, or the person participating in the documentary, in relation to another object or person; it is a relation of desire, of wishing, not as but as if. One's own desires are played out through these figures of "identification" and not as them.

The pleasure of the "information" documentary film arises with an identification with the other of knowledge, understood as taking the place of the other in relation to knowing, and the pleasure of coming to know as a mastering the world. There is a desire for knowledge, a wish to know, founded in the wish to know the desire of the other. A further pleasure arises from the recognition that the other knows and thus I can know, the inverse of which is the pleasure of the reassurance that, for example, science or scientists know, and they know for me.[11] Similarly, the charity worker is helping others "for me," and the emergency services are rescuing "for me"; they are invested magically as "doing it" for me, not as a gift to me, but as a separated part of me "over there," an idealized

self who would fulfill my ego ideal demands as I might wish to help and rescue others. Equally they fulfill the wish to be helped and rescued. It is such pleasurable reassurance that documentary *narration* makes possible, in contrast to the images and sound bites of the news report. This is, of course, a matter of imagining and of fantasy in the sense understood by psychoanalysis of the world available to be mastered, to become what we want it to be, and of the contingent real made over into knowable reality and thus available to change, to desire. It is a matter of believing— because the other does—that the world can be mastered. "The other who knows/does it for me" is part of "magical" thinking, or fetishism, in the understanding given to this by Marx as an alienation, or in Freud's terms, the splitting of the ego arising with *disavowal*.[10] Žižek asks, "Is the primordial version of this substitution by means of which 'somebody else does it for me,' not the very substitution of a signifier for the subject? In such a substitution resides the basic, constitutive feature of the symbolic order: a signifier is precisely an object-thing which substitutes me, which acts in my place."[12] A certain disavowal is involved in this relation to documentary in which, as Freud showed, two knowledges or beliefs are held at the same time.

In documentary, we also encounter behaviors by which we may be recognized by ourselves and by others as subjects of (as well as subject to) an imaging and imagining through which we enact being and our being for, that is, our desiring, whether as ambitious or erotic. It is a form of discourse through which we undertake that "care of the self" Foucault explored in his third volume of *The History of Sexuality*, of performing oneself within the world of one's others.

▶──────────────────────────────────────

Vision

Cinema produces both a subjection of objects to its gaze and a subjection of the spectator to a gazing that is separate from her and has gone before to organize the space and the seen for the spectator's look. This mechanical record stands in for the look of the filmmakers, but functioning prosthetically, its images will offer both more and less than the human eye it replaces. In 1936, Walter Benjamin commented, "The audience's identification with the actor is really an identification with the camera. Consequently the audience takes the position of the camera."[13] Such a looking appears in fiction film to be no one's, that is, it is "objective," only becoming subjective when it is marked as someone's (e.g., the camera's place of viewing is shown in the following, reverse shot, to be that of

a character). The camera operator's look is not part of the fictional world imaged, however, and it carries no moral responsibility; everything is staged, play-acted, for the camera.

The documentary camera's gaze allows us to "see for ourselves" in an identification with the camera as objective and disembodied. We take the camera's look as our own in a wish to see.[14] But if we are brought to remember that this is also the filming subject's look and he or she is a participant in real events unfolding in historical time, then it becomes understood as embodied and can no longer be an "objective" gaze when our knowledge of the context of filming gives rise to moral questioning. Instead, the uncanniness of our prosthetic devices becomes palpable. In Alain Resnais's *Nuit et brouillard* (1955), for example, we see the transport wagons and the many people being herded aboard—the young, the old, the sick, the families and friends—among whom we may discern anxious faces. This is real, but also partial, for there are no images of the horror of the journey endured by these involuntary travelers or of the terror they will shortly experience in the gas chambers. The camera's look as objective observer with which the viewer so readily aligns herself is here the optical viewpoint of a Nazi cameraman, perhaps an officer overseeing their inhuman transportation. Understood as such, it becomes an embodied gaze and subjective point of view that, we may surmise, takes pleasure and satisfaction in them as evidence of the Nazis' successful achievement of their obscene desire for a "Final Solution" and the Third Reich's inglorious aim of a cleansed race. It is a look that we will want nothing to do with. Instead, the objectivity of these images as found reality now seems profoundly compromised.[15]

Yet these images also record living people doomed, each recognizable; among those faces boarding the trains, behind the camp wires, or in the ghettos, there might be found friends, neighbors, and most hauntingly of all, relatives who could be recognized—or imagined—not only as parents or brothers and sisters but also as the grandparents or great-grandparents of children born long after. Objectivity opens onto a subjectivity through our imaginative capacity as we slip between identification and disidentification and, perhaps, back again.

Is it not the face, shown in extreme close-up, that breaks into the documentary's observing gaze, foreclosing its distance? Without even the speech of the social actors as a "character," the close-up can draw us to identify on the basis of being what we see, in a confusion of self and other that has been termed infantile transitivism, from the observation that a small child, seeing another fall and, hurt, start to cry, will itself also start to cry though not in any pain. Lacan took this term from the work

of Charlotte Bühler in order to describe the process of what he termed the mirror stage when the child takes others as its imagoes, giving rise to the formation of the ego as such and the emergence of subjectivity in the human animal. The transitivist identification with the image of the face supports the adoption of the social actors in the documentary as stand-ins for ourselves within the scene.[16] But, whether fiction or documentary, the movement of the camera and thus of the narrative in the shift from close-up to medium shot of the figure, for example, or to the object of her glance, breaks the viewer's absorption in the image of the other and opens her to the chain of signification, of causality, and to the movement of desire for the next, different image. Meanwhile, the face is something that gives rise to meaning, but when we interpret a face as expressing sadness or happiness, it is the person and not the face we understand as experiencing these emotions. Our faces communicate, yet our bodily expressions are not straightforwardly readable, for is the expression a smile or a grimace? Is the laugh an expression of merriment or terror? The eruption of a laugh that is incongruous—that is, out of sympathy with—the context is both very common and disturbing to those who hear it, becoming read as a levity that denigrates the response of pain and sadness that is experienced and recognized by others as appropriate. The body responds here not to symbolic reality and conventional readability but to a real that is outside signification. Gilles Deleuze and Félix Guattari have questioned the assumption of a transparent, or fixed, meaning in facial expression, describing this as the construction of a "facial machine" and instead they ask not what a face *means* but what it *does*. It is as virtual or thought, Deleuze argues, that the face engages us: "There is, at some moment, a calm and restful world. Suddenly a frightened face looms up that looks at something out of field. The other person here neither as subject nor object but as something very different: a possible world. This possible world is not real, or not yet, but exists nonetheless: it is an expressed that exists only in its expression—the face, or the equivalent of the face."[17] Through the other's face I become aware of a world experienced by the other, which thus becomes a realm of possibilities and of a virtuality, whether this is "a world" of fiction, or "the world" of contingent actuality. Deleuze's example here is what he distinguishes as an "intensive" face, a term he draws from Bergson, which experiences or feels something intensely, implying a change from calmness to an agitation, whether delighted or terrified, infusing the face momentarily. It is a response to the world "out there." What is introduced is the domain of the other, and a third joins the two of the gazer and the face. We may then not only speculate as to the possible world that the face registers in its change but

also identify as "that's me," experiencing a horror or a pleasure that we recognize—or misrecognize—in the face we see as well as anticipating the actualization of the world invoked, whether as fictional or documentary actuality. In contrast, Deleuze distinguishes the "reflective" face: not strongly marked in its physical manner of expression and even bland or enigmatic, it does not refer me to a possible outward world that acts upon the face but to an inner "world" of thought and of reflection that is continuing (rather than fleeting) and inaccessible to our view and our independent confirmation of it. Seeing the face—intensive or reflective—we imagine. Reflection for Deleuze is something in the world that forces us to think, not of an object of recognition, "but of a fundamental *encounter* . . . It may be grasped in a range of affective tones: wonder, love, hatred, suffering."[18] Encountering the face as a reflective face is to be brought to think about the other's thinking. In cinema, a film will show the reverse field of the social actor's look or cut to a new image that "answers" our questions, and her face resumes its individuation, filling up the meaning to produce what Deleuze has called the "movement-image." But if the reverse field is withheld, delayed, or itself ambiguous, it becomes a "time-image." Joan Copjec writes, "The close-up discloses a de-predication of the subject, an emptying out of personality. The face, then, withdraws from the represented space, retreats into an 'other dimension,' as Deleuze says."[19] Richard Rushton thus argues, "When confronted by a face, whether reflective or intensive, we must re-coordinate our view of the world and subsequently our actions in that world . . . The face, more than anything, makes us approach the world anew."[20]

In his account of the face in close-up[21] Deleuze draws on Bela Belázs's discussion to argue that "the close-up does *not* tear away its object from a set of which it would form part, of which it would be part, but on the contrary, *it abstracts it from all spatio-temporal co-ordinates*, that is to say it raises it to the state of Entity."[22] It is "de-territorialized," Deleuze insists, but is this separating out not also part of those processes of fetishization, of a certain sublimation, and of an imagining—projection—onto the other whose face I encounter, in a re-territorializing? For if, as Deleuze suggests, the face as an affection-image has the qualities of Peirce's concept of "firstness," in being experienced as a positive qualitative possibility in the natural world, we must inquire as to how this becomes actualized as thought. Peirce writes,

> The idea of the absolutely first must be entirely separated from all conception of or reference to anything else; for what involves a second is itself a second to that second. The first must therefore be present and immediate, so as not to be second to a representation. It must be fresh and new, for if old

it is second to its former state. It must be initiative, original, spontaneous, and free; otherwise it is second to a determining cause. It is also something vivid and conscious; so only it avoids being the object of some sensation. It precedes all synthesis and all differentiation; it has no unity and no parts. It cannot be articulately thought: assert it, and it has already lost its characteristic innocence; for assertion always implies a denial of something else . . . Only, remember that every description of it must be false to it.[23]

A subjectivity remains in our encounter with the face and with the world that exceeds the "reflection" Deleuze appeals to, for our encounter always produces an unassimilable remainder in our response of something apprehended but for which every description is always insufficient.

In documentary, the face extracted by the telephoto lens or zoom is observed: exemplary and enigmatic, it must be held long enough to set in train an engagement that might entail the ecstasy of Eisenstein, the "feeling-thing" of Epstein, and the affection-image of Deleuze, as it is in certain shots in Wiseman's films or in *The Nightcleaners Part One* (1975), discussed in chapter 6. But what of the long-held shot taken close up of the *speaking* face encountered as documentary interview or direct-to-camera speech? Do we not respond at one and the same time to the face extracted and to the person's story? The face and the voice each address us, but these are not identical and engage us in different ways.

Together with the image, the speech of social actors in the documentary, whether direct to camera or in relation to an interlocutor within the film, is central to producing identification. It is an engagement that is sensual and cognitive, for voice is experienced as sound, in an embodied voicing of tone, cadence, and rhythm that produces both a haptic and cognitive relation to the heard, as well as speech and thus language as a conceptual system.[24] In the documentary film, there are two different times of address: the present of the recording with its interactive address between the participants themselves and between them and the filmmakers, and the future of the re-presentation of the recording and its—unknown—listeners. For all the "you knows" interjected by the speaker, the spectator's questioning "what do you mean" is never heard. In documentary we overhear and oversee the world we are shown, addressed indirectly by the participants and by the particular selection and organization of the overseen and overheard—an observational cinema—or we are addressed directly. The speaking subject, whether as overheard, as voiceover, or as the embodied voice in close-up—the "talking head"—introduces questions of authority, authorship, and of agency and interlocution.

Addressed directly, we are invoked as spectators for the world

shown—whether through the voice of a narrator off-screen (voice-over), or by a presenter or interviewer who is seen as well as heard—and by the participants interviewed, where it is made apparent that the speaker is addressing statements to be heard by a future anticipated audience. Indeed, most interviewees are preinterviewed and often rehearsed.[25] However, the speakers will often forget this as they become caught up in their telling, and even in their re-telling, of their story in a transferential relation with their interlocutor. The narrator addressing us directly may appear onscreen, as in diary films, and in testimony, and investigative documentaries (also termed "performative" in a reference to the role of the filmmaker investigator), or be heard as a voice off-screen, unseen. Where the interaction of the interviewer or filmmaker with the participants on-screen is heard, she is not always seen, while a speaker we see may become an off-screen voice (e.g., as the camera follows an exchange of views among a group, or when the speech of an interviewee is edited as voice-over to photographs or archive footage related to the subjective account being given).[26] Trinh T. Minh-ha observes that "interviews which occupy a dominant role in documentary practices—in terms of authenticating information; validating the voices recruited for the sake of the argument the film advances (claiming to 'give voice' to the people); and legitimizing an exclusionary system of representation based on the dominant ideology of presence and authenticity—are actually sophisticated devices of fiction."[27] Speech is thus not only a matter of the said and of the statement itself but also of the authenticity and authority of the speaker. The disembodied, expository voice-over narrator of classical documentary is simply there; often unnamed and unexplained, it has become referred to as a "voice of god," yet its authority and objectivity as our guide is not authorized within the documentary (e.g., through being an expert, or authoritative figure within the social context, such as a doctor). Documentary direct address therefore involves a hierarchy of voice whereby the disembodied, unauthorized, expository voice-over has authority over the seen and heard within the film, in contrast to the subjective and embodied personal telling of "experts" and of the "ordinary people" interviewed. The voice-over is also a voice-off, better termed, Michel Chion suggests, as the "acousmatic," where the source of the voice is not shown or known, and it is this possible indeterminacy of the voice from elsewhere that can haunt documentary.[28] Untied to a body, the voice-over penetrates us as both of the image and more than the seen. Minh-ha introduces such an indeterminacy when she says, in her film *Reassemblage* (1983), "I do not intend to speak about, Just to speak nearby."

Overheard speech between the social actors appearing on screen in documentary engages us, Bill Nichols argues, as observers in a relation to the seen and heard similar to that of fiction film.[29] Such overheard speech is not performed for the documentary as an address to the film's future audience, although if the speakers are aware that it is being recorded, they may try to tailor and shape their speech in relation to this dual address. Overheard speech may be partial, just snatches of conversation—perhaps because of difficult filming conditions that are thus indexed by the incompleteness of the recording—but it is more usually the result of editing. In observational documentary, the images can be an equal partner with the overheard speech, or even dominant, whereas when direct address is dominant, the image becomes subordinate to speech, inverting the image track's privileged position as the discourse of truth and reality that both observational documentary and the fiction film assert. Of course, in observational filming, the overheard of direct life is subordinated to the process of editorial selection by the sound recordist and editor, under the direction of the filmmaker and her anticipation of the likely events and actions that may arise. Nevertheless, the fiction is that in *Hospital* (Frederick Wiseman, 1970), we see it as Wiseman saw it, just as Robert Montgomery, in the part of Marlowe, claims we will see it as it happened to him at the opening of his film of Raymond Chandler's *Lady in the Lake* (1947). Our relation as addressee changes with each form of speech, the implications of which is explored later in this chapter in relation to Lacan's account of the four discourses.

▶ ─────────────────────────────────

Documentary Novelizing: Being Seen and Heard

The emplacement of the viewing subject is also secured by the devices—and pleasures—of the "novelistic," discussed earlier in chapter 1. In presenting a narrative of cause and effect, the documentary creates the certainty of a knowable world, centering the spectator as subject of (but also thereby subject to) this certainty. The world presented must, nevertheless, be believable: to sustain our belief in its claim to reality, it must be like what we expect the world to be. It must conform to the way in which we conventionally see and understand the world and human actions within the it. The "believability" of the documentary world—its verisimilitude—is produced when it is recognizably familiar, thus it is in some sense the same as the world we already know. The documentary film, therefore, presents the knowable world not only, or necessarily in order, to enable us to know the world as the new but also, and as often,

to enable us to know the world as familiar and to find again our known objects. As Heath and Skirrow observed, "The novelistic is a veritable process of identification in a quite simple sense of finding, reviewing, staging, voicing *identifying* in terms of lives, multiple times fused in that basic vision which supports the whole viewpoint definition: viewpoints, people, the world seen sympathetically—the novel, initial apparatus for the novelistic, knows its major development in the nineteenth century as a vehicle of sympathy—as it happens, seen for you and I, as you and I, the fictions of this world, see it."[30] The participants in documentary become "characters" through its dramatic narration, not as spoken by a voice-over but instead as "found" by the camera, such as Jackie Kennedy's anxious glove twisting in *Primary* (Albert Maysles and D. A. Pennebaker, 1960). Through interviews or moments of speech direct to camera, we are given character "point of view," that is, we are given the subjective and internal thoughts and feelings of its social actors. Such sequences, I argued in chapter 2, however scripted and selected they may be, enable real people as social actors to tell their own stories and to give their own account. Through their speech, we can be brought to share their view of the events and to put ourselves in their place in the world that the film is showing us. We become involved with the lives and problems of the social actors we see and hear so that we are moved by their stories.[31]

Our engagement might engender a feeling of pity, arousing our sympathy *for* their suffering, yet such a response also firmly separates us from the misfortune they endure. Sympathy is conventionally seen as a more rational emotion that involves judgments about the people whose plight is revealed to us.[32] Empathy is taken to be a stronger emotional engagement, where we are drawn to feel *as* the victims and not simply for them, and thus it is often valued as a more ethical response. The *identification* it bears witness to, however, is not straightforwardly—or perhaps at all—altruistic. Kaja Silverman, in her account of her dilemma when confronted by the pleas of homeless beggars, analyzes her distress as specular, that is, as a problem of identification and not of reasonable distribution of charity. With great honesty, she confesses, "What I feel myself being asked to do, and what I resist with every fiber of my being, is to locate myself within bodies which would, quite simply, be ruinous of my middle-class self—within bodies that are callused from sleeping on the pavement, chapped from their exposure to sun and rain, and grimy from weeks without access to a shower."[33] Such bodies, she avers, cannot pass for "ideality" in our culture; they are, in Kristeva's terms, abject, and it is such an abject identification that Silverman finds herself rejecting here. The specular of identification Silverman refers to is one described by

Freud as identification with the idealized image I am or have been—the ideal ego. At the same time, there is an identification with the ideal image I could or should be—the ego ideal—which is an image addressed to me by the other, and thus voice is equally important. Indeed, the difficulty Silverman identifies here is also that of address and of what the other wants of me, namely, to be the other to his or her wanting, the one who can give, yet whose giving will never assuage the wanting. In identifying with Silverman's account, I come to recognize my own similar resistance, but it arises from an earlier identification that I also resist. It is an identification as lacking, as wanting, producing an irruption of the real. For this reason, most cultures establish a decorum around begging involving proprieties of appeal and response. Silverman's account relates her embodied encounter with the other, whereas documentary offers us mediated encounters, raising the question of what decorum and what resistances these might engage.

In a British news broadcast on the war in former Yugoslavia in 1992, a short documentary item was included showing an interview with a refugee. In the film, a Croatian housewife, describing her experiences, speaks tearfully about the freezer full of food—her homegrown or homemade produce—that was abandoned as she and her family fled their home. This detail draws us to identify, to have the same feeling of loss, not because we are the same or have had the same experience, but because we can take up the same position as her in relation to loss. The full freezer is a sign of plenty and of her role as provider, a role we might identify with, whether housewives or not, but its provisions are now spoiled or stolen, and the sign that supported that identity is lost. Moreover, in its place there arises the image of a usurper enjoying what is rightfully hers (or ours). Identification as empathy arises, rather than simply pity or sympathy, for we become engaged on our own behalf in the injustice, with all the grief and anger we might feel if we had lost what sustains our identity as providers. Identification is with a position in a narrative of loss, and our feelings are not only for the Croatian housewife but also for ourselves and our own losses, whether for those already experienced or those that might happen and are feared as a potential threat. Identification here engages the trauma, the real of subjectivity, of the possibility of overwhelming loss, not of one's life simply, but of what makes life worth living. Such events presented as unmediated, as "news breaking," are traumatic, as demonstrated by tragedies such as the Hillsborough soccer disaster, discussed later, or the terrifying sight and sound of the attacks on the New York World Trade Center on September 11, 2001, or on London's subway and buses in 2005. What is required is an account

of the "why," that can make sense of the events or, as in the latter, the displacement onto the heroism of the rescuers, and the stories of escape, of how overwhelming loss can be contained as just *this* loss, which they—al-Qaeda—caused.

The identification arising here is not the result of a judgment, but in order to be sustained, it will require the support of evidence of the believability of the social actor (e.g., that the housewife was unjustly deprived) in order to accord with conventional expectations (verisimilitude). The people in the documentary must appear properly deserving and to be properly, that is, fully, innocent victims insofar as their poverty or starvation is not caused by themselves, and their need must be justified for empathy to arise, that is, so that we can have such a wish for them. The woman who is seeking in vitro fertilization treatment may seem less deserving if she is unmarried or already the mother of five children. *Their* wish, in order to become *our* wish, that is, for us to identify, must be "reasonable."

Documentaries afford us another pleasure in identifying, for through them we can engage in situations in which we feel for others in order to assure or reassure ourselves that we are caring people. We thus fulfill a certain ego ideal demand that we are "nice" and that we can be touched by human suffering and by the causes and claims of others.[34] For this we require victims, the less fortunate, for whom we can feel.[35] Again, they must be properly helpless as well as voiceless, or at least voicing only their plight and suffering, and must not make an overt demand for help. Nor should they be able to provide a sophisticated analysis of their circumstances and its causes, or else they will rival the film and its spectator as knowing subject.

The documentary novelizing that is central in reality television docusoaps such as *Airport* or *Hotel* enables us to "dwell with" the space of a contingent real time of others' lives as they act and react to the people and events around them. That these are like a fictional soap opera serial should not, however, deceive us into supposing that audiences see no difference, nor is this difference guaranteed as one of reality and truth versus fictional unreality. Each can be a time and place for imagining the nonactual. Hill cites a viewer's comment that "I think I get more passive . . . when I watch news . . . while I watch more actively when I watch docusoaps, that is I try to think more about what the relationships between the participants are like . . . while the news is like taken in, worked on."[36] The reality, whether in *Big Brother*, *Wife Swap*, or *Would Like to Meet*, is contrived through a preset format and by the criteria for selection of the participants, so that the "spark of reality" sought is provoked rather than found, and thus it is plotted. Nevertheless, the reactions

remain contingent rather than scripted, and a specific drama of suspense arises (e.g., in the 2007 series of *Celebrity Big Brother*, the question of how Jade Goody will react to the negative press she is receiving when she emerges from the house after being evicted for her references to race). What becomes demonstrated to us is the messiness of human action and reaction provoking the question "what would I do?" Where shows such as *Supernanny* instruct, *Wife Swap*, in contrast, puts its social actors in situations where they may—or may not—learn for themselves from their swapped roles.[37] We may recognize our own behavior and see the problems it may cause, or what we see and hear begs as many questions for us as it answers, challenging us in our assumptions (e.g., about racism, and our choices in relation to gender roles in the family).

Reality television engages spectators to encounter their fears and anxieties through identification with its stories but, while they may be resolved for the child in, for example, *Children's Hospital*, they might not be for another, different child—*your* child. Such anxiety is produced neither by neoliberalism nor by capitalism as such, though modernity with its emphasis on progress through the control of the physical world and the application of science has presented the fantasy of managing "risk." This, however, has only made us more acutely aware of "free-floating anxieties," that is, fear that is held to be unjustified.

The willingness of members of the public to be filmed—whether in more ostensibly serious observational films, or in docusoaps and daytime talk shows, and reality show contests—attests to a wish not only to see and hear but also to be heard and seen. The desire to "have one's say" is to address an other both present—the talk show host and the studio audience—but also the imagined, though unseen, spectators of the broadcast program. Here might also be involved that process that psychoanalysis understands as transference, in the confessing to the other as one who can forgive, as priest, or understand, as therapist or judge. The other here is both a fantasized and powerful other and the fickle other of the media and television audience. The reality game shows thus satisfy an exhibitionism in being subject to a look from the other that thereby recognizes the participant with all the possible *valuing* this might give rise to, namely, the lure of celebrity. This satisfaction may arise not only for the contestant herself but also for spectators identifying with the other as heard and as seen in place of ourselves. As one viewer comments to Hill, "It's very ambiguous . . . I see it as a bad side of me that I enjoy watching people getting exposed to difficult things . . . Somehow I don't think they should take advantage of my bad side, because it's in all of us in some way, some little bit of malicious pleasure."[38] That shows such as *You've*

Been Framed and talk shows are enjoyed for the confessions and humiliations revealed certainly makes us sadistic voyeurs, though this may also include a certain masochism to the extent that we identify with the exhibitionist victim. Hill, drawing on her data, suggests that, for viewers, "the experience of watching a factual program can feel like being in a dream, working through what is real or not, occupying a space between fact and fiction, participating in the constructed real world of the program, and also reflecting on the nature of this real world and how it has been recreated for us to watch.[39]

▶

The Temporality of Identification

Our identifications constitute a palimpsest of our interactions with others, sedimented over time, for new identifications never erase earlier ones but continue, disorderly and often in disagreement. They remain copresent, yet not necessarily consciously "felt." Freud placed these temporally as archaic and to which we might regress in his concept of disavowal, of two knowledges that are opposed but continue to be held at one and the same time, and thus offers a different way to view this copresentness. Henri Bergson also addressed the issue of our experience of the world—the immediate data of consciousness—which he defines as duration, a temporality characterized not by measured quantity but by the quality of the succeeding elements "each permeating the other and organizing themselves like the notes of a tune, so as to form what we shall call a continuous or qualitative multiplicity with no resemblance to number."[40] Each note might be differentiated, one coming after another, thus temporally spatialized, but the music heard has qualities not of the *sum* of the elements but of their experience. This contrasts with quantitative multiplicities, such as a herd of goats, which are homogenous, being all the same thing, and yet distinct in being differentiated spatially. Qualitative multiplicities are heterogeneous and continuous, that is, without the juxtaposition of "before" and "after," except retrospectively in memory. One example given by Bergson is especially pertinent to my discussion here for it involves the feeling of pity that, Bergson argues, begins with our putting ourselves in the place of others and feeling their pain. This sets in motion a series of other responses, such as a feeling of horror at being drawn to experience the other's pain, that might lead to us avoiding such situations or to helping—since we might find ourselves in the same situation. Bergson concludes, "The increasing intensity of pity thus consists in a qualitative progress, in a transition from repugnance to fear,

from fear to sympathy, and from sympathy itself to humility."[41] While the account of the emotions suggested by Bergson is not without difficulties, what he describes here is a heterogeneity of feelings producing an intensification, from pity to a complex response of sympathy, but this is neither a juxtaposition that implies causality nor a negation of one feeling by the other. The feelings are continuous with one another; they interpenetrate one another, and there is even an opposition between the feelings.[42]

It is such a "qualitative multiplicity" in our experience of the world that documentary can present us with. Neither fixed nor unfixed but continuing and interpenetrating, since, as Bergson notes, "We instinctively tend to solidify our impressions in order to express them in language. Hence we confuse the feeling itself, which is in a perpetual state of becoming, with its permanent external object, and especially with the word which expresses this object."[43] We actualize our responses, as "this," and then as another "this."

Identifying is thus an encounter with the world and its representations that becomes an identity, as a "this" arising from an experience of duration. This encounter is experienced in relation to an externality that addresses me, such as the other who is the object of my pity and through whom I know myself in my feelings. In speech, we encounter both the measured time of pasts and futures and duration in the continuing moment of speech that engages us. We are not only addressed but also are addressing the other and thereby anticipating—imagining—an interlocutor.

▶

The Address of Documentary

Documentary film is associated with the serious, and what is seen and heard is taken to be knowledge and its spectator is posited as a subject of knowledge who will come to know. Aligned with the controlling discourse of the titles or voice-over within the documentary film, or with the documentary investigator who may figure directly in the film, we identify with the "other" of knowledge, a position of mastery, and are interpellated as members of the community of knowledge. The spectator, however, may take up the position not not only of the discovery of knowledge, in an identification *with* the scientist, but also of coming into the knowledge *of* the scientist and thereby to know what has already been organized as knowledge, so that through the documentary I become, or am affirmed as, a member of the knowledgeable culture, identifying with the place of address as the site of a coming to know of knowledge. As one

viewer explained, "I think if you watch documentary, you kind of put yourself in a kind of ignorant point of view, you know, you kind of believe in the documentary. You're ready to believe in everything."[44]

In documentary, therefore, identification is not only with the seen and heard but also with the position of addressee of the documentary as a narration, a telling, through the speech it presents, both on-screen and off-screen, as voice-over. At the same time, as spectators, we address the documentary with our desire, demanding knowledge: we want it to know the world for me and, therefore, know me. It is a demand for identity. Knowledge is sexy. What is involved is a communication act, but for the sender the addressee is the place of the other in which the addresser is heard and, therefore, finds herself known in her discourse, in her subjectivity. Identity is always outside, with the other, and it is in my relation with the other that I learn who I am and what I should be. In speaking, my discourse constitutes me as a subject for another, whom I address. Lacan describes this encounter as involving one of four discourses, each producing a specific subject position and a social bond and thus a certain "becoming." The schema of the four discourses that Lacan presented in his 1969–1970 seminar enables us to understand address as not only a one-way interpellation—being "hailed"—but also a relation that is an interdependency of the kind Hegel describes in the master–slave relation, an account to which Lacan continually returns.[45]

Each of the four forms of discourse—the hysteric, the master, the university, and the analyst—involves the same set of terms but played in a different relation to each other.[46] The schema enables Lacan to describe the relation of knowledge as well as desire in subjectivity. It is a highly abstract but dynamical account of the *production* of subjectivity as a social bond, both of the subject to itself and to its others, which Lacan also calls love. Being abstract, the schema can be deployed in relation to any kind of discursive statement, and here I will draw on it to understand the production of effects of subjectivity by documentary that, with its hierarchy of knowledge, its centering of the reality of social intercourse and asserted certainty of "facts" and "truth" seems to offer itself in relation to Lacan's first pair of terms: the master and the university. The second pair, of analyst and hysteric, are, however, no less important in the understanding they enable of the complexity of our interaction with the knowledge—the discourse of the university and of the master—that documentary engages us in. What Lacan emphasized is not only that these four discourses always implicate each other—hence the analogy with the master–slave relation—but also that subjects move between them and, indeed, are a palimpsest of these shiftings.

In speaking, Freud showed, we are driven by a truth, even if it remains unknown to us. In "hearing" we seek to know what "you really mean." The starting point of speech is a subject who has something to say, but in what is said there is always a certain failure to truly say what we mean, which keeps us talking. There is also always something more in what we say than what we mean, a "truth" that we are not conscious of but is also part of our messages. The four discourses articulate this something more and this failure in speech, but as a form and not a content for speech and thus, in the words of Paul Verhaeghe, an "empty vessel."[47] Each discourse is a communication whereby an *agent* addresses an *other* to a certain effect, a *product*, in the addressee—an understanding, which might produce a responding action. If one tells one's child to work hard at school, and she produces good reports, one's message appears to have been successful. If, however, the child produces a series of failures, one might say the message has failed. Psychoanalysis, on the contrary, sees this as equally the product of the message, and indeed as an answer. Moreover it is an answer to a truth in the message that the addresser can never fully know and therefore verbalize, namely, the truth of her desire, which Lacan characterizes as a certain *impossibility* in our communications. As a result, the *product* is always in some manner "off the mark," in an *inability* to "get it right" because the truth of the other's desire remains enigmatic.[48] This unknowable truth is the motor and starting point of each discourse

<center>

Impossibility

Agent \rightarrow Other

\downarrow \downarrow

Truth // Product

Inability

</center>

Impossibility and inability in communication.

The same four terms are found in each discourse, always occurring in the same order, but which starts from a different position within this communication model: S_1 = master signifier; S_2 = knowledge; $\$$ = divided subject; a = the object cause of desire, *objet petit a* (this is the object in its lostness to the subject, the concept is explored further in chapter 4).[49]

The discourse of the master is the starting point, founding the symbolic order (i.e., the possibility of speech and the constitution of the speaking subject as such).[50] There is no simple hierarchy here; Lacan writes, "We are dealing with a relationship of weaving, of text—of

fabric" and thus the final discourse, of the analyst, neither completes nor resolves the structure.[51] The agency each discourse refers to is not a person but a subject position in relation to another subject. Each of the following three discourses effects a 90-degree turning of the elements in the master discourse in a relation that is circular that rebounds and returns to this point.

Discourse of the Master

$$S_1 \rightarrow S_2$$
$$\uparrow \qquad \downarrow$$
$$\text{\$} \quad // \quad a$$

Discourse of the University

$$S_2 \rightarrow a$$
$$\uparrow \qquad \downarrow$$
$$S_1 \quad // \quad \text{\$}$$

Discourse of the Hysteric

$$\text{\$} \rightarrow S_1$$
$$\uparrow \qquad \downarrow$$
$$a \quad // \quad S_2$$

Discourse of the Analyst

$$a \rightarrow \text{\$}$$
$$\uparrow \qquad \downarrow$$
$$S_1 \quad // \quad S_2$$

The four discourses.

The discourse of the master is of a subject without division, a performance of coincidence between the saying and the said in a performative speech act: "I am (master of) myself," as the master signifier and the commanding dimension of language. As such, it is a disavowal of the division, underneath which is the truth of the subject of this discourse, namely, the desire to be undivided.[52] The slave's master of classical antiquity, like the absolute monarch of early modernity, such as Louis XIV, each exemplify for Lacan the signifier as master insofar as it signifies itself.[53] The master signifier S_1 tries to join with S_2, knowledge, but this, as another signifier, itself divides the subject, and the product is the object lost—the *objet petit a*, which is inaccessible to the master, but truth as $\text{\$}$, under S_1, is of her subjectivity as necessarily divided. Here, knowledge is the other of the agent's address, the knowledge that the master knows, sustaining the master's masquerade as the "one who knows." It is the doctor's patient, the professor's students, or the master's slave—in Hegel's analysis—who confirms by their own lack the master as knowing, but the knowledge inheres in the other. Thus, "the university has an extremely precise function . . . with respect to the master's discourse—namely, it's elucidation."[54] Moreover, "the master's knowledge is produced as knowledge that is entirely autonomous with respect to mythical knowledge, and this is what we call science."[55] Lacan acknowledges the specificity of his account here when he notes, "In societies that we call primitive, insofar as I describe them

as not being dominated by the master's discourse . . . it is quite likely that the master can be located by means of a more complex economy."[56] The documentary, in reducing the world to an object of its knowledge, is the discourse of the Master, addressing us as knowing the facts of reality and of reality as factual and thus incontrovertible. As spectators, we lack the knowledge we will come to know, thus affirming the documentary as knowing for us, that is, as the master.

When the schema is shifted 90 degrees counterclockwise, the divided subject is in the place of the agent, and the other is the master signifier S_1, producing underneath knowledge as its effect, namely, knowledge of the master as divided. This is the discourse of the hysteric, where in the position of truth is lack, *objet petit a*, that is, the truth of her desire as unsatisfiable desire. The discourse of the hysteric addresses the other as the master, as the one supposed to know, demanding an answer to the truth of her being. It is a demand for that "master signifier" that might fix meaning and identity. Knowledge here is enjoyed by the master, who is supposed to know, but S_2, knowledge, or the product, is inaccessible ($//$) in relation to *objet petit a*. The discourse of the hysteric addressed to the master as the one-supposed-to-know both makes and also breaks the master in that, desiring unsatisfaction, it is the desire to *not* know, and thus for the Master not to really know. The master as other knows, but he does so *for* another, but the hysteric always questions this, thereby finding him wanting and insufficient—in a word, castrated. The hysteric reveals to the master his division for what the hysteric demands is the knowing, which is an enjoying—jouissance—but this is "impossible," and she becomes the motor of knowledge's, and the master's, failure. Thus her address, rather than supporting an authoritarian logic of the "subject supposed to know" as the subject who knows on my behalf, is on the contrary, as Žižek notes, "productive of new knowledge: the hysterical subject who incessantly probes the Master's knowledge is the very model of the emergence of new knowledge."[57] For the hysteric, in declaring "this is not it," "any particular configuration of objectivity and knowledge is inadequate."[58] Each discourse is at the same time a *defense* against an enjoyment—in the sense of possession without lack—which would otherwise undo the agent's very subjectness as always divided by lack and thereby keeps desire intact: the desire not for something but to go on desiring.

The only way to avoid the "castrating" discourse of the hysteric is to change one's game by stepping back from the discourse of the master in a ninety-degree shift clockwise in favor of the discourse of the university, a qualified form of discourse of the master in which one can deploy logical argument as a knowledge that does not appear to be one's own but

is there for anyone. Knowledge is the agent, addressing an other as *objet petit a*, producing underneath the divided subject $, while the truth, S_1, is inaccessible. Take, for example, the form of argument that proposes that if x is true then y is true. Here, a social discourse—logical argument—authorizes the truth of the statement. In medicine, as a discourse of the university, the doctor may, on the one hand, speak as the master: "x will cure you," as undivided and incontrovertible, and, on the other hand, as the university, for medicine does not yet have all the answers. In mastering the discourse of the university, one may seem to speak as if the master, but this remains conditional insofar as new forms of logical arguing and knowledge may arise. Lacan, however, points to the difficulties that are now arising for the discourse of the university: "By virtue of the increasingly extreme denudation of the master's discourse"[59] and in that the university's knowledge is increasingly becoming a performative, "know this," as an absolute of the demonstrable factual. It thus places itself in the discourse of the master while disavowing this, since it is simply "facts" that the university speaks.[60] However, such "factuality" is an effect of the discourse of the university and thus must remain liable to question.

Documentary asserts the world as knowable, but its audiovisual discourse also presents the question of how to know, and therefore it deploys the discourse of the university, of logical argument, evidence, and "facts" rather than asserting a truth. Yet in this it also avers to another discourse, that of the master, which might guarantee its own. But it cannot defend itself against the skeptical spectator who, addressing in the discourse of the hysteric, will find the discourse of the master as always wanting. Claiming to offer the truth about reality, documentary suffers the anxiety of failure and of being found wanting in its answers and in its truths. Its very persuasions are evidence of its own insufficiency. Any failure to be "properly" documentary—too much fiction in reenactment, creative editing, or a lack of perceived "balance" and impartiality—places all documentary at risk of rejection as faked or as "propaganda." The appetite of audiences for reality television, the contemporary form of "qualified reality," for example, is frequently described as regressive, as indicating audience gullibility, or as a morally reprehensible preference for illusion over true reality, for the prisoners should *want* to be freed from Plato's cave. But the viewer of programs like *Big Brother* does know it is a performance and not a discourse of truth, of the master, but nevertheless things happen that we may interpret as unintended and unacted (e.g., Jade Goody's angry, bullying, responses to fellow contestant and Bollywood actress Shilpa Shetty that made reference to her as Indian).[61] In such moments what is produced is a kernel of the real, and this is not the same

as or the sum of the documentary's many statements or the reality show's avowed claims. For Jade Goody, was it not that something in her experience of Shilpa Shetty's difference in the context of this *Big Brother* series was unassimilable and inexpressible?

The fourth discourse is arrived at by a 90-degree shift clockwise from the terms from the discourse of the university. This is the discourse of the analyst, and here the abstraction of Lacan's schema is apparent, for the agent in the discourse of the analyst is not the embodied voice, the person or personality, whom one visits with costly regularity and who is too often, Lacan points out, the discourse of the master or the university. The agent is *objet petit a*, the lost object and cause of desire, and the other it addresses is the divided subject $, which produces, unconsciously, the master signifier S_1, with knowledge as the truth inaccessible as such to the subject addressed. It is the discourse that obliges the other to take her own divided being into account. Verhaeghe writes, "This impossible relationship from *a* to divided subject is the basis for the development of the transference, through which the subject will be able to circumscribe his object. This is one of the goals of analysis. It is what Lacan has called 'la traversée du fantasme,'" the traversing of the fundamental fantasy.[62] The analyst within the analytic relation does not function as an agent in the discourse of the analyst, for as object cause of desire, signifying lack, it eliminates her as a subject. She can only function as such for someone, her analysand, in the time—as duration—she is sustained in as addressing the other as lacking. Knowledge is in the place of truth; it is the knowledge of the subject's relation to lack, her enjoyment, but this is inaccessible as such to the subject addressed, although its effects are what the analytic relation can explore. It is here that the person of the analyst comes into the picture. The agency of the analyst as cause of desire may also, therefore, be undertaken by a work of representation—art or documentary—if its address to the viewing subject thereby confronts her in her division as a subject.

The discourses, moreover, as Verhaeghe emphasizes, do not produce fixed positions of subjectivity; instead there is an interchanging as agent and other through the different interrelationships of the four terms and their disjunctions. The teacher, for example, may move between the discourse not only of the master and of the university but also of the hysteric in addressing another as master, all within a few breaths. But, confronted by her students' demand to know, she may retort, "What are you asking to know?" thereby engaging the other's lack and, therefore, desire. Her address becomes the discourse of the analyst. Indeed, it is this moving from one discourse to another that makes possible the discourse of the

analyst for, Lacan says, "there is an emergence of analytic discourse at every passage of what the analytic discourse allows us to highlight as *the break through from one discourse to another.*"[63] It is a knowing, though not necessarily consciously, of that which determines the fundamental fantasy that organizes one's desire, a knowing that shuns sense—the discourse of science that, Lacan says, "leaves no place for man."[64]

What contribution to our understanding of documentary does an analysis of its forms of address within Lacan's schema enable? Documentary presents an array of speaking, which may be more or less contained, and containable, by its narration, its framing, of its speech. Such speaking involves statements, discourses about the world, which the documentary might present in a hierarchy or in a dialogic relation of interaction. We remain here in the realm of the signified, of argument, and of knowledge debated. What must be considered, in addition, is how we are engaged by the address of the discourse and in the movement between forms of address, including our own address in our demand to know, which asserts the hysteric's skepticism.

Documentary addresses us in its images and sounds as "coming to know" through a showing that is always also a telling that asserts its truth as master; but as spectacle, it may confront us with movement untied from causality, as a contingent real in the discourse of the analyst. Documentary also presents speaking subjects who may address us as one who knows (master, which here is a speaking of the symbolic institution of state, law, etc), who can present us with the facts (the university), or who is demanding to know (the hysteric). The shiftings between these might, however, give rise to that emptying out of signification that is the discourse of the analyst, *objet petit a,* as cause of desire. Here, while the spectator is addressed as the other, there is no subject or agent of the discourse.

Lacan's schema thus sidesteps the power relation in Foucault's concept of discursive formations, in which the discourse of medicine or psychiatry subjectifies persons, making them known and knowable to themselves and to its institutions through its categories. Lacan's schema addresses the formal relation instituted by communication and the social bond thereby arising not through what is said but through the agency and interpellation of saying. Yet is not such a social bond found precisely in the "reciprocity" Foucault saw arising in what he termed "classical" observing, "since the sane man could read in the madman, as in a mirror, the imminent movement of his downfall"?[65] The medicalization of madness thus defends the scientist against the real of the other's *objet petit a.*

The radical potential of documentary does not, therefore, lie only

in the knowledge presented, in formal strategies such as the overthrow of the dominant, master discourse of the classical voice-over in a democratic dispersal of address among many voices, or in the presentation of a hesitation or undecidability regarding what is presented. Rather, something radical is made possible in insofar as a circulation between the forms of discourse and their address, including that of the spectator, arises. A temporality other than that of the time of the documentary is thus introduced.

In the classic British documentary *Enough to Eat?*, the discourse of the university, of objective, scientific, knowledge, explains nutrition, but a different voice is introduced through the account by an "ordinary housewife," who explains what she buys for her family and what she would buy more of if she could afford it. The housewife knows, the voice-over tells us, the right foods to give her children, but she does not address us in the discourse of the university; she just tells us what she does. The film's assertion of her knowledge thus begs the question of how she knows, introducing the discourse of the hysteric and, in this shift, the discourse of the analyst. In *Housing Problems*, the tenants also speak for themselves, but here, I argued in chapter 2, the voice-over never fully frames their speech and its images, which thus escape the film's organizing discourse. Instead, we may ask, you're telling me this, but what do you really mean by your story told three times or your tale of the rat? What are you asking of me? Their speech hystericizes. Each film's statement—of good nutrition or of housing—as a necessary social requirement for citizens is the discourse of the university, but as argument and not as truth and thus as questionable. For one might identify with the position of knowledge, of the film and its experts, or with the citizens deserving of help—as I might be. Or one might reject the demand to recognize the other as like oneself, that is, deserving.

Disaster at Hillsborough (made by Yorkshire Television, United Kingdom, and broadcast in the documentary series *First Tuesday*, 1990)[66] focuses on the question "how did it happen?" and, its correlative, "who is to blame?" It examines the sequence of events that led to the terrible deaths of ninety-six people—children and adults—and the many injured from suffocation and crushing in Sheffield, England, at a soccer match in 1989. This occurred as a result of a surge of supporters entering the already full area for standing spectators—the "pen"—pushing those at the front against the wire fence that had been erected to prevent pitch invasions by separating them from the players. The documentary addresses us in the discourse of the university, presenting the forensic analysis undertaken by the inquiry team to determine the truth of how

Disaster at Hillsborough (1990). The position of each person in the "pen" is identified, recorded, and analyzed, and the data was then mapped to produce a digital schema of the death trap produced by the extreme overcrowding.

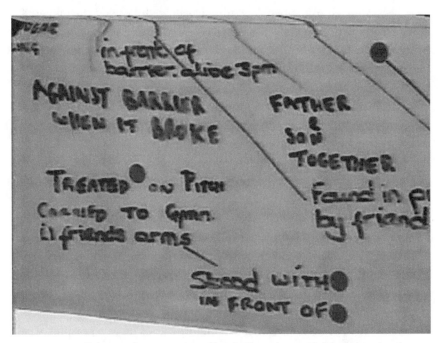

Disaster at Hillsborough (1990). Detail of the board on which information is recorded about each fatality and injured person.

and why it happened. The scientific investigation establishes the time line of the disaster, mapping in detail the placement and movement of spectators, which the film presents through animated diagrams of the stadium and the path taken by the supporters, edited together with shots of the now-empty stadium entrances and archive film of both the supporters anxiously waiting to get in before the start of the game and the subsequent chaos as those inside become crushed as the area filled to 50 percent more than its capacity. We also hear archive recordings showing the confused response of the police on the pitch, who cannot reach the victims behind the barrier, while the police chief at the stadium continued to believe he was watching a pitch invasion. These are juxtaposed with the scientific evidence from the analysis of the inquiry team, including calculations of the pressure created by the surge of incoming fans in relation to the numbers of persons in the pen—those who died and those who were injured. The visual and auditory evidence indexes a "truth" of the fatal errors of judgment, while the failure of the senior police officers to realize what would happen when the fans waiting outside were finally allowed to enter the stadium or understand what was happening to those in the "pen" constitutes the key dramatic arc of the film. This thereby also shifts its discourse to that of the hysteric, for the film questions not the evidence but its meaning, in the question as to how the event could have been allowed to happen. The film was made following the inquest, at which a jury returned a verdict of accidental death for the victims after being warned by the coroner against a verdict of unlawful killing unless they were satisfied that individuals (i.e., the police) were recklessly negligent in their actions. The question of the culpability of the police in their failure to manage the crowds coming to the soccer match remained for the victim's families, however, and is presented in the film through the accounts from survivors talking not so much of their own survival but of those that they could not save, and we understand the disaster no longer as a series of facts about a stadium and the policing of crowds but as a scene of human action and reaction and of unbearable tragedy. A police officer (in medium close-up), having stated earlier that the events had been preventable, now—and ostensibly without emotion—describes what he saw: people's faces turned blue, their tongues hanging out as they are pinned against the fences. There follows the account of Brian Doyle, who survived by climbing the fence and then tried to pull others out of the pen but "it was hopeless, it was like they were stuck together, just screaming for help." He then describes when a woman's hands he was grasping went limp: "It's the feeling of watching the life and color going out of them and you can't do nothing about it—helplessness, helplessness—and anger"

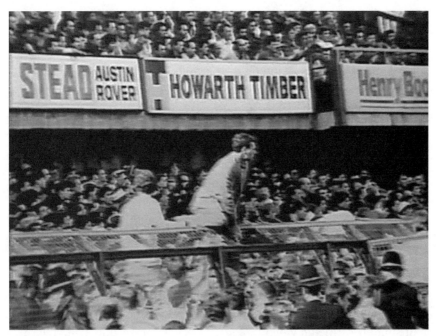

Disaster at Hillsborough (1990). Television news footage of fans beginning to escape over the fence as others are crushed, while the game continues to be played.

Disaster at Hillsborough (1990). Brian Doyle speaks of his anguish at failing in his struggle to pull a woman to safety up and over the fence.

(the camera cutting from medium to extreme close-up). To the police responsible for the crowd management at Hillsborough stadium in 1989, the soccer fans were a dangerous other liable to riot and thus requiring control, and it was this desire on the part of the police that brought about the disaster, notwithstanding that they did not desire the disaster itself. The scientific evidence presented only makes more terrifying the failure of the symbolic order, for there is no master signifier that holds meaning in place, and we are confronted with the inability of rational knowledge to defend against the real. This movement between discourses also opens us to the discourse of the analyst, in an acknowledgment of the real made possible by the film's own work of mourning through memorializing those lost on the stands at Hillsborough.

Spike Lee's *When the Levees Broke* similarly centers on trauma in the question it addresses to Americans as to why New Orleans was abandoned to the destructive aftermath of Hurricane Katrina. The film does not explore this through scientific evidence, however, and focuses instead on personal accounts from its interviewees juxtaposed with archive and contemporary still and video footage. These are powerfully edited with a carefully constructed music track that adds an emotional "voice." The film's enunciation "knows" for us the truth of what happened, namely, the abandonment of the poor—both black and white—of New Orleans in the chaos of the aftermath of Hurricane Katrina in 2005, for which its images and words are evidence. It is only when this discourse is interrupted that we are engaged by a real of impossible trauma in the— hysteric's—question "what am I, for you?" The issue the film engages is not the why but the meaning of the "when" the levees broke and thus not why there was no proper preparation for the evacuation or shelter for those without the means—the ill, the disabled, the old, and the citizens without transportation—in the city but a truth: you are not citizens worthy of protective measures by your government. This traumatic real of the other's desire is made palpable by the film's devices of melodrama in its heightening of tension, its contrasts, and its reversals insofar as it can never bring about the catharsis of an ending. The stories of rescue never fully displace other stories of those for whom it did not come, or for whom it came too late, and the impassioned testimony of survivors contrasts with the descriptive, and often defensive, accounts of the journalists, academics, police, and politicians. Montages of still images of the devastation and its victims fix and memorialize in the manner made familiar by the powerful photographs of Dorothea Lange, Walker Evans, and colleagues working for the U.S. Farm Security Administration in the 1930s, while archive video functions as the evidential for the

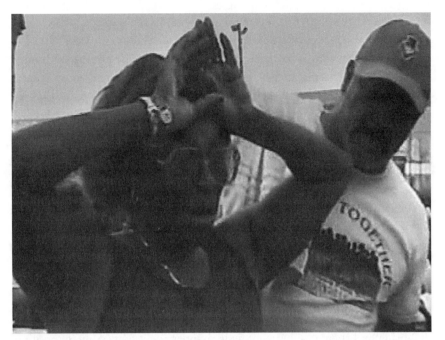

When the Levees Broke (2006). "Day Three": The observing camera captures a woman's distress.

When the Levees Broke (2006). "Day Three": Our position is reversed when a woman addresses us and the camera reporter.

interviewees' descriptive and factual accounts. In the sequence "Day Three," the voice-over of Eddie Compass (former New Orleans chief of police) introduces the next three shots showing the vast number of homeless residents gathering at the Convention Center, accompanied by quiet piano music, conveying a "then" time as the camera zooms, pans, and tilts to capture the objectified abjection of victim-survivors who never address the camera. The film cuts back to Compass, and then to New Orleans newspaper editor David Meeks, who reports the desperate plight of a disabled former employee he came across there, before cutting again to archive footage but now, in the next five shots, the camera operator or the news reporter is addressed directly, first by a man (five seconds) shouting "no food, no water," then in three brief shots: of a woman; a man; a man and woman (one second each). The following shot (fifteen seconds) is of another a woman, seen in medium close-up who articulates the unfolding tragedy of many when she demands for her mother, who is eighty-three years old and lying on the floor with a heart condition, that "she needs help to get out of here." The film here effects a rapid tempo of editing and then a longer shot as it changes to a "now" time of action with her speech and its discourse shifts from descriptive—as knowledge, thus of the university—to the direct address it remediates of a demand for help that we know is not being answered, hence challenging us with the question "what are we to you that you do not help us?" Here erupts the real. Is it not the very melodrama of *When the Levees Broke* that enables us to approach this?[67]

Capturing the Friedmans, discussed earlier in chapter 1, presents statements by the family, lawyers, policeman, and purported victims, presenting alternative views that enable different versions of the guilt or innocence of Arnold Friedman and his son Jesse. The evidential here begs further questions, or it in some way appears questionable, prompting us to ask, "You are telling me this, but is it really so?" Thus we take up the position of the hysteric in relation to different speakers who address us as master or the university. The certainties avowed by Arnold's brother and by his sons Jesse and David, and their unconditional acceptance of Arnold's declaration that "nothing happened" in the computing classes, are opposed by Arnold's wife. But is she wrong? She tells Jarecki that her sons have idealized their father, as she had her own father, despite each father's betrayal, for they were each, she now says, "a rat," concluding that "peoples' visions are distorted." Her sons saw her as abandoning their father, while she felt betrayed by his deception and could no longer trust his word. If Arnold was a victim of prejudice against homosexuality, then in marrying Elaine she became another of his victims who, like

the young boys he writes of, was never acknowledged as such by him or her sons. How far was Arnold still in denial? David says that his father spoke of it all being over in a year, of how crazy it would seem later, and Jesse recalls feeling he had no idea of what they were doing. We see in David's home movie footage the family discussing the trial, then next Arnold, embracing Elaine, saying, "Here's Mommy and Daddy, showing affection," but Elaine pulls away, asking, "I should have affection for you—why? *Tsuris* [trouble] is all I ever got from you," to which Arnold retorts, "That's not all, you've got other things." Is he not demanding here that she continue to support his self-image as the good provider, husband, and father to which his sons subscribe? David, instead, will accuse his mother of "manipulating my father" and calls her "crazy." When their lawyer suggests that Arnold plead guilty to help Jesse, Elaine insists he do so, even though Arnold continues to vehemently assert that he is not guilty of the crimes for which he is indicted. Yet he is not simply innocent, for his standing as a father and teacher rests on the lie of his sexuality— his homosexual pedophilia—that first brought the police investigation. Jesse is, I suggest, as much as Elaine, a victim of his father's lies and his father's inability to take responsibility for his actions, most poignantly demonstrated when, as Jesse recounts, Arnold turned to him and asked what he should do. "I wanted him to make the decision . . . I remember feeling like a really young kid kinda looking up to him saying, 'You know, Dad, I want you to be my Daddy.' I would have been really, really proud of him if he had said he would have gone to trial and decided to plead 'not guilty.'"

The film "speaks" in its assemblage of these different voices and their discursive address, presenting us with a discourse that is desubjectivized and that fails to act as an agent whether of truth, knowledge, or doubt. Rather, it functions as the analyst, in an emptying out of meaning that poses to the spectator the issue of her desire in relation to the truth of the desire of the other, whether this is Arnold, David, Jesse, Elaine, the police officers, or the various boys who testify in the film.[68]

In each of these documentaries we are opened to the discourse of the analyst insofar as what is at issue is not only "what happened" but also the truth of the desire of the participants, the social actors and the filmmakers, and its meaning for those engaged by their actions. In the next two chapters, this real of desire that is an unspoken and unspeakable in speech is explored in relation to trauma and its documentary representation, while the imperative of the nonsense of the real that was the focus of the surrealists is considered through the documentary work of Jean Rouch.

Documenting the Real

*No matter how different the subjective responses, trauma is
due to the intrusion of the raw facticity of facts that bypass
any principle of pleasure or reality and by the haeccitas of
loss before any loss or absence can be acknowledged.*
:: Max Hernandez, "Winnicott's 'Fear of Breakdown'"

Trauma is outside memory, and outside history. It is the unrepresent-
able, and thus, writes Max Hernandez, it is "the unrememberable and
the unforgettable."[1] The excess of signifying that arises in what is shown
and what is said that is uncontained and uncontrolled by the speaker—or
filmmaker—is designated by Lacan as the real and as an "unrepresent-
able." Psychoanalysis and cinema were contemporaneous developments at
the end of the nineteenth century, but while the developments of Etienne-
Jules Marey and the Lumières were directed toward established modernist
goals of science and knowledge in relation to observable phenomenon,
Sigmund Freud was developing an understanding of the human mind
and its vicissitudes in relation to what was not observable—the uncon-
scious. This chapter explores the ways in which factual film—reality
re-presented—with its assertion of the knowability of the world, may also
be a document of the "real" in Lacan's sense through two documentaries
about war trauma, *War Neuroses: Netley, 1917, Seale Hayne Military
Hospital 1918* (Pathé, 1918),[2] an early British silent film showing the
treatment of World War I soldiers suffering from shell shock, and *Let
There Be Light*, John Huston's 1945 sound documentary on the treatment
of the symptoms of war trauma in World War II soldiers in the United
States, made for the U.S. Army Signal Corp Pictorial Service.

 For the human subject, the unconscious and fantasy are very real
psychically and produce effects in reality, and it was to dreams and to

remembered fantasies that Freud turned to discover the ordering and disordering of the drive and desire and their repression that organizes the human psyche. The account of subjectivity and desire proposed by Freud and Lacan is drawn upon in the following analysis of the dual desire for the documentary real. Lacan developed Freud's challenge to the simple division of reality versus fantasy through his tripartite distinction between the real, the imaginary, and the symbolic, and this is outlined here in order to explore the appearance of the traumatic real alongside the imaginary and symbolic spectacle of knowledge.

The Spectacle of the Real

The contagion—as it was often perceived—of shell shock was a contingent reality threatening the war effort of the allies and enemy alike in World War I, while equally undermining the theoretical premises of both traditional physiological psychology and the new psychoanalysis of the Freudians. As a result of the need to treat these men, psychiatric medicine in Britain and elsewhere was fundamentally challenged and transformed. Freud's view of the unconscious as consisting in thoughts or wishes that are unacceptable in some way and therefore repressed came to have enormous significance for understanding the war neuroses of soldiers in World War I, largely, it has been argued by Martin Stone, as the result of the article by the psychologist and anthropologist W. H. Rivers, "Freud's Psychology of the Unconscious," which appeared in the *Lancet*, the main British journal of medicine, in 1917. For Freud, the repressed is not lost but instead continues to bear on the psyche through mechanisms of return: in dreams, termed by Freud the royal road to the unconscious; in slips of the tongue; and in symptoms, notably the hysterical symptoms of Freud's first patients and of the shell-shocked soldiers of *War Neuroses*. But Rivers's account, Martin Stone suggests, is a very partial and reduced version of Freud's theories in plundering psychoanalysis for its psychodynamic concepts like repression, the unconscious, and the notion of mental conflict while nevertheless centering his etiological account on the emotional world of the battlefield rather than tracing the origins of the hysterical and anxiety states associated with shell shock back to the patient's infantile sexual impulses.[3] Stone also argues that it was the large numbers of doctors who became familiar with nervous disorders while working in army hospitals with shell-shock patients that opened psychiatry to new theories, and in the 1920s, several of the standard textbooks were revised to include enlarged sections on the neuroses together with

references to psychoanalysis. As a result, the theoretical orthodoxies of asylum-based psychiatry were overturned while the new of forms of psychotherapy helped developments in treatment that were enshrined in the 1930 Mental Treatment Act in Britain that promoted outpatient clinics and voluntary treatment.

If conventional psychiatry acknowledged the unconscious, Freud's view of the unconscious as formed from repressed *sexual* wishes, arising, for example, from the Oedipal complex, now seemed inadequate to understand the hysterical and neurasthenic symptoms of the stricken soldiers. Freud addressed these questions by initially positing a conflict within the ego between aggressivity and self-protection that gave rise to war neuroses. Later, he reorganized his view of the role of the drives and sexuality to propose his most debated and notorious concept, the death drive, an incontrovertible element of the psyche that accounted for the compulsion to repeat unpleasure in the obsessive return to the traumatic event and for self-aggression, which characterizes traumatic neurosis.[4]

Lacan has extended Freud's challenge to the simple division of reality versus fantasy through his tripartite distinction between the real, the imaginary, and the symbolic. None of these terms relate straightforwardly to what is commonly termed everyday reality, while it is in his concept of the "real" and its "enjoyment" (jouissance) that Lacan incorporates those phenomenon of human suffering that Freud saw as a death drive. What then does Lacan refer to in this concept of the real, and how is it distinguished from his other two concepts, the imaginary and the symbolic? None of these terms maps onto our commonsense notion of everyday reality.[5] Instead, through these distinctions, Lacan shows how the human subject, the ego, emerges in a relation of interiority to exteriority through which the child represents itself to itself and to its others—its parents. It is the middle term, "the imaginary," that names the organizing process for this moment when the child comes to experience itself as an object distinct and separate from the other significant objects in its life, the mother's breast or bottle and the milk it obtains and the child's own excretions. As noted earlier, Lacan termed this the "mirror stage," the mise-en-scène for the precipitation of an I of the ego in the recognizing and identifying with the image as "that's me" but where the image is now both the child itself and other to it as an image *of* itself. The child *imagines* itself. Before this, the human infant has been a bundle of experiences of satisfactions and needs. The satisfaction of need—of, for example, hunger—arises externally, while the need as such arises internally.

The child's cry of discomfort as a result of its hunger becomes a call of demand to be fed when the child connects the sense of satisfaction

obtained by suckling with the activities of those caring for it. This call of demand inaugurates fantasy, the imagining of the future satisfaction that will be obtained when the breast or milk arrives; it inaugurates signification, for the child communicates by its call and does so in relation to something experienced as absent that the child wishes to have made present to it—the breast or milk. Retrospectively, the domain of need becomes the "real," the "before" of the fantasizing of the object of satisfaction in the imaginary. It is, therefore, both quite material and unrepresentable. In fantasizing, the child is representing the object to itself and to the other—the mother—through its cry, which designates the absence of the breast to child and its demand for it to be made present again. The before of need is a primordial real that involves absolute and unmediated deprivations, but it also involves absolute satisfactions.[6] The infant is not yet split by an apprehension of itself as needy and satisfied, and it is, therefore, also prey alternately to annihilation and to enjoyment that, once lost, Lacan termed "jouissance." In the imaginary, the subject demands and thus imagines—which is also to say, it fantasizes and thus represents—a possible satisfaction. But, while the breast or milk will satisfy the physical need, the mental relation to demand now established is never fully met (i.e., the mental image of need), and therefore loss and deprivation is assuaged only at this moment and not forever. Nevertheless, through fantasy, the child can imagine things otherwise, and while its satisfactions will always be partial, it thereby subdues the terror of unrepresentable loss and annihilating deprivation. It is by imagining things otherwise that the child engages with the external world, to which it poses its demands and, later, seeks to make it respond to its demands. Fantasy covers over loss and absence. The "imaginary" is the domain not only of fantasy, however, but also of social action and interaction—reality in fact.[7] In the symbolic, Lacan's third element in his tripartite division, the subject's relation to its losses is transformed by its acceptance of loss as an absolute principle. Whether termed castration or lack, what must be apprehended is lack in the other and not just lack in the subject itself; in the symbolic, the subject identifies as lacking and as at some level forever sundered from the possibility of absolute satisfaction. The "symbolic" is the social law as it organizes our relations and interrelations of desire, that is, our relation to everyday reality.

▶ ——————————————————————————————

Desire and the Real

The documentary voices reality through organizing its sights and sounds, but the space and time of the contingent reality recorded will nonetheless

exceed the factual it is claimed to represent and, as a result, may engage us in an imaginative speculation outside the givenness of the so-called factual and its immediacy. Walter Benjamin suggests, "No matter how artful the photographer, no matter how carefully posed his subject, the beholder feels an irresistible urge to search such a picture for the tiny spark of contingency, of the Here and the Now, with which reality has, so to speak, seared the subject."[8] We desire evidence of something real separate from the orchestrated view of the photographer or documentarist, but as a result, we may at the same time become aware of what is not represented. That is, we become aware of not only what is off frame and out of sight but also what is felt to be unexplained and inexplicable in the reality shown, negating its givenness—its radical contingency. This is not only unrepresented but also, more radically, unrepresentable. Here we encounter the contingent and the uncaused in reality, which Peirce saw as requiring a philosophical understanding for, as Mary Ann Doane notes, "The real, for Peirce, is not something sensed or vaguely felt. It exists as an insistence, a compulsion, an absolute demand."[9] Peirce states that "reality is insistency. That is what we mean by 'reality'. It is the brute irrational insistency that forces us to acknowledge the reality of what we experience, that gives us our conviction of any singular."[10] Doane makes a further connection—particularly relevant to my discussion here—when she observes that the place of force here is the same as in Peirce's account of the index, which, Peirce says, "takes hold of our eyes, as it were, and forcibly directs them to a particular object."[11] This insistence in reality and its unrepresentability is addressed by Lacan as the "real," and our apprehension of the "real" is in our encounter with this contingent, ephemeral, brute reality that just keeps happening, uncaused, which while it may be named "fate," nevertheless remains unapprehendable as signifying—it is "senseless" within our everyday common sense or rationality. The obviousness of reality becomes uncanny when our look that finds and possesses the world through images in a logic of knowledge and understanding is put into question. We encounter that which undoes reason. Freud's exploration of this in his discussion of the uncanny[12] is drawn upon by Lacan in developing his concept of the real. He terms the encounter with the real the "*tuché*," drawing on Aristotle's term for chance involving persons as agents of rational thought.[13] In confrontating certain moments in recorded actuality—whether in film or the photograph and stereograph—that separate out from the continuous scene, like curdled milk, and question the givenness of the image with a questioning "is it," we apprehend the real. Lacan writes, "The function of the tuché, of the real as encounter—the encounter in so far as it may be missed, in so far as it is essentially the missed encounter—first presented itself in the history

of psychoanalysis in a form that was in itself already enough to arouse our attention, that of the trauma."[14]

What sustains the subject, holding her back from the abyss of loss, and of the real, is her *objets petit a*; Lacan introduced this term in developing Freud's concept of the object of the drive to account for the way in which the subject becomes enabled to desire as opposed to being prey to drive. Its *objets petit a* signify for the child the separateness and alterity of the other and hence their loss to the child. Such an object is something that was experienced as part of the subject but is now separated from it yet can be imagined as returning to her (e.g., the mother's breast or milk). The *objet petit a* is not, however, this "breast-returned," or that which would make the subject whole again and is thus the object of fantasy and desire. Nor is it the breast, or object, lost; rather, the *objet petit a* is the "breast-lost," the object in its lostness—that is, it is the breast insofar as it is missing, and it is thus a sign representing the subject to itself inasmuch as the subject experiences itself as lacking. As such, it is the *cause* and not the object of desire, for it signifies the object as separated, now absent, but able to be made present again. It is a monument to that process of separation in which the unsatisfaction of need is represented through a deprivation in relation to the object constituted as missing. It is what Lacan terms "the Thing" (*das Ding*) that can only be "refound" in "another thing" (*autre chose*), *objet petit a*, namely, Lorenzo Chiesa notes, "the sublime object that represents it (its lack) at the foundations of the unconscious."[15] Sublimation, which Lacan defines as a change *in* the object rather than—as for Freud—a change *of* object, is not a special transformation of the drive but the mode of the drive as such.[16] The sublimated object stands in place of the Thing but cannot replace it; thus sublimation reiterates the object-lost.[17] In Lacan's account, the *objet petit a* has a paradoxical role; it has a kind of borderline function that confounds any simple division of representation into a fixing and unfixing of the subject. This object both replaces—as a stand-in—and signifies lack, which is the role Freud gave to the fetish in his later discussions, where he places the formation of the fetish substitute as arising in a disavowal that produces a splitting of the ego but where the "disavowal is always supplemented by an acknowledgement."[18] The *objet petit a* arises as a framing—in the sense of cutting out—of reality for the subject, enabling it to represent itself and its losses and thus cross from the realm of the real to the domain of the imaginary. The real is thereby constituted retrospectively as the before loss. If the *objet petit a* secures the subject as subject, it does so insofar as the *objet petit a* is what falls away from the subject so that it is itself a little piece of the real; it signifies but is unsymbolizable.

The "desire for the real" is the repeated return to the *tuché* in reality whereby something in the representation figures an absence by which the possibility of presence is affirmed while yet restating loss (absence itself, *objet petit a*). In both *War Neuroses* and *Let There Be Light*, this "real" is not the war and the death and destruction it wrought but the *unrepresentatability* of war for the subjects of the film, the shell-shocked soldiers, and for the audiences as the viewing subjects of the films. While the focus of *War Neuroses* is the bodily symptoms of the men, *Let There Be Light* presents the men's own accounts of their war trauma.[19] The real in each film is not narrated as such but can be apprehended in the discontinuities we can come to understand between the shown the spoken and between the discourse of medicine and psychoanalysis.

War Neuroses: Netley, 1917, Seale Hayne Military Hospital 1918 is an early medical documentary of the treatments in two British hospitals in 1917 and 1918 of soldiers with shell shock displaying hysterical symptoms in response to posttraumatic stress. It is both visible evidence and a spectacle of knowledge in its *display* of knowledge categories organized by the discourse of psychological medicine of the time—identifying the men's physical symptoms within medical categories. Presenting a narrative of cure, the film also offers an array of visual "pleasures," both of visual "attractions" and of knowing through the visual. In contrast to the knowability of reality and its pleasures, the film also figures the real in its images of the grotesque contortions produced on the bodies of the soldiers. These images present both the medical symptom and the filmic representation of the disturbed and disrupted minds of the soldiers and are thus fully symbolic and symbolizing. At the same time, however, they signify an unrepresented that is also unrepresentable, namely, what is absent—the war itself and the trauma it precipitated in the men. While the embodied symptoms are displayed for the camera, the war is referenced in the battle reenacted in the English countryside in the film's coda, performed by a group of "cured" men. We may nevertheless discern here in the replaying a presentation of the subject's relation to trauma, that is, to the real.[20]

In *War Neuroses* the real is our apprehension of the unrepresentablity of the unrepresented of the war for the men to which their physical symptoms attest. It is not a physical trauma that produces such symptoms and the more diffuse depression, anxiety, and nightmares; nor is it simply the fear of death, rather it is when something in the "assault" that is the psychological horror of the battle trenches is unassimilable, unhandleable, unrepresentable, and hence something of the "real." It will include the apprehension of the desire of the other—the war machine—as

annihilating. Hysteria, whether the bodily conversion symptom of what is now called posttraumatic stress disorder, or the neurotic symptoms of hysterical identification, is a response to the trauma of the lack in the subject and in the other. As a result, physical trauma, as in the experience of war, is not the cause but the occasion for the hysterical symptom, a moment when the traumas of reality become the trauma of the real. It is not the new event as such that produces the hysterical symptom but insofar as it connects to an earlier event not itself remembered as traumatic in a deferral or relay that Freud termed *Nachträglichkeit*. Drawing on Freud's insight here in his concept of the real, Lacan nevertheless opposes the implication of causality from a past to the present in his term *tuché*, chance, in the encounter with reality experienced as the real.

Trauma is a subjective, individual, but also unknown experience. How, then, can we come to know trauma, that is, how can its unrepresentability be represented? In the accounts of trauma, Cathy Caruth argues that what returns to haunt the victim "is not only the reality of the violent event but also the reality of the way that its violence has not yet been fully known."[21] What is involved is "the unbearable nature of an event" and "the unbearable nature of its survival."[22] Trauma thus produces the subject, and it is its history, but in the sense of time as duration, of the subject enduring, rather than a story that can be told as series of events in a causal relationship. Such a story and experience of trauma as one's history can only arise when a certain traversal of trauma is undertaken, which enables a forgetting of trauma as it becomes something knowable in its narration, as suggested in *Let There Be Light*.

For Jean Laplanche, the concept of *Nachträglichkeit*, or "afterwardsness," as he translates Freud's German,[23] is central to understanding the workings of time and memory, that is, the way in which a significance or meaning to the past—as events or facts of an individual's history—only arises subsequently through later events and experiences. Laplanche argues that what is involved is not a repetition or activation of a memory but is a matter of *translation* in relation to a message experienced as enigmatic. The first message is the adult's—from the past of his or her unconscious desire—addressed to the child and its future knowing; it intrudes or penetrates, "seducing" the child. Laplanche thus reintroduces sexuality into the understanding of trauma but as not yet structured in the child.[24] Rather it is a seduction without meaning, and it is in this very senselessness that trauma inheres and engenders a process of becoming understood as a translation and a narrativization. "History" is constituted in this process, in which the event of trauma, the enigma of the other's message, becomes identified and narrated. History and storytelling

is the other of trauma. It is the absence of, and thus the need for, such a narrativizing that produces the encounter with the real for the subject and for the spectator.[25]

War Neuroses was made under the supervision of Dr. A. F. Hurst (later Sir Arthur Hurst) and Dr. J. L. Symns and produced by Pathé Fréres. In Britain, Pathé made a number of war documentaries for cinema release, and this film follows a common style with its scenes of men at rest or involved in ordinary activities. There is no indication that this film was intended for the general public, however, and certainly its address appears to be the medical profession and the military, for the medical terminology used in the intertitles to describe each man's condition is highly technical and the same as that used by Hurst and Symns in their article in the *Lancet*. A silent documentary, the organization of its images and text present an illustration or a demonstration of a process and an argument—the cure of shell-shocked servicemen brought home from the trenches of the battlefront in Europe.

The film shows the servicemen displaying a variety of kinds and degrees of shell shock, in particular paralysis of limbs or loss of sight where no organic cause is evident (i.e., hysterical conversion symptoms). The term "war neuroses" refers to both the hysterical symptoms shown in the film and more generalized conditions of chronic anxiety, sleeplessness, and nightmares. The first group of symptoms was most typically exhibited by the ordinary soldiers, and it is they who are shown in the film, while the latter group of symptoms were experienced by officers and are, of course, less easy to visually document.[26] The film exhibits these symptoms in moving pictures in the tradition established by the French neurologist Jean-Martin Charcot, with whom Freud had trained, who recorded the symptoms he had identified as distinguishing hysteria in his patients at Salpêtrière from 1875 in a series of photographs that were published in a number of volumes from 1876. The film, which continues to be screened to medical students, thus functions as evidence of the physical symptoms of the men and the nature of their paralysis and motor incapacity, addressing us in the discourse of the university. It is now also historical evidence of the discourses of psychiatry of the time, both of the modes of determining the etiology of disease and of the changing discourse of psychiatry in its incorporation of a psychological approach in the use of suggestion and thus seeing the men's symptoms— precisely, war *neuroses*—as the result of mental rather than physical or neurological factors.[27]

The film demonstrates the successful treatment of the soldiers through a "before" and "after" form of presentation of the men's

symptoms and their alleviation, showing their improvement and cure over subsequent days or weeks. Treatment was by physical therapies, shown in the film, involving the manipulation of limbs, and the use of techniques of suggestion—not shown—that involved implanting in the patient's mind the certainty of his cure. This was achieved by the preparatory assurances of nurses invoking the curative powers of the doctor or officer, followed by a session with the doctor or officer in which he affirms that the soldier will shortly be cured. Psychoanalytically, suggestion is understood as involving a transferential relationship to the doctor as father figure in a role of authority, which in the film, unheard and unseen, is the discourse of the master, the master signifier, that remains offscreen and veiled.[28]

The film incorporates the novelistic in its story of cure, narrating both the story of the doctors who cure and the stories of the cured servicemen themselves. We are shown a man in a wheelchair, oblivious to his paralysis, whom we next see walking and supervising basket making, his prewar craft. Other men with various disabilities and symptoms, including hysterical blindness, deafness, facial tics, and walking difficulties, are shown and then seen again, cured, walking, talking, and no longer convulsed by muscular spasms. Cured, the men are shown tending the hospital farm, digging, and plowing. A narrative world is thus introduced of work and of the lives to which the men, now healthy, can return. Comedy is introduced as well when we see the soldier who, though now cured, still cannot dig properly and who instead becomes the hospital librarian, for as a civilian he had been a bookseller. The film's medical account of cure is followed by scenes of celebration as the men organize a party, prepare food, and construct an oven in which to roast a whole pig.[29] This novelizing realizes the truth of the discourse of the university and its implicit functioning as the discourse of the master, but in doing so, it begs the question—is it really so that these men are cured? What emerges in this questioning that both the film and the spectator may entertain is the discourse of the hysteric.[30]

An uncanniness arises in relation to these images and the process of documenting that claims for the film the meaning of the images, specifically, the notion of cure. This is most palpable in the film's conclusion in which the newly cured men reenact themselves as soldiers moving out of trenches to attack the enemy under shell fire, implying the successful abreaction of the trauma of shell shock. At the same time, the coda displays to medical colleagues and to the military authorities in charge of the hospitals the effectiveness of the treatments shown. The film's visible evidence functioned, therefore, for the discourses of both psychiatric medicine and governmental agencies, not only the war office, but also

the Ministry of Pensions. The curing of the men was vital to the national interest not so much in relation to the war effort, for most of the men would not return to active military service, but in relation to the cost of medical care for the men themselves and in relation to public morale and to the relatives of men suffering shell shock, as well as in relation to postwar costs of disability pensions. Two hundred thousand men were discharged from service during the war as a result of disability due to war neuroses, while at least eighty thousand shell-shock cases passed through army hospitals. The development of outpatient facilities after the war was a direct response to the flood of over a one hundred thousand cases of ex-servicemen experiencing a range of mental and physical symptoms of war neurosis, which reached a peak in 1922. Martin Stone reports that the Ministry of Pensions was forced to set up more than one hundred treatment centers in an effort to cope with the situation, and even as late as 1939, on the eve of World War II, the ministry was still paying out two million pounds a year to victims of shell shock.[31]

The military reenactment presented is striking for its successful filmic realism (i.e., verisimilitude) in portraying a battle—for example, it carefully creates the effect of smoke trails from falling mortar shells, although many of those used in the World War I produced no such smoke trails, which had made bombardment difficult to portray visually in film.[32] *War Neuroses*, however, is also an extraordinary document of remembering by the formerly shell-shocked infantrymen. The men enact themselves as soldiers moving out of trenches to attack the enemy under shell fire; they thus play out the scene of trauma that had caused their bodies to act outside of their intellectual knowledge and control—producing their hysterical symptoms. The battle replayed is consciously acted for the camera in a participation that anticipates the work of Jean Rouch as well as reality television. The reenactment is an enactment of their cure, signifying the successful abreaction of the men's symptoms of trauma. But whereas earlier the horror of their war experiences was signified—albeit by displacement—in the hysterical symptoms the men displayed, it is now absent in their performance of *successful* soldiering. The place of the unconscious is figured by this absence, as repressed, just as it was absent in the medical account of their bodily symptoms. At the same time, the real of trauma is figured in the picturing of cure that is the mimetic double of the source of the disorder—the battle. The *reality* of war is given representation, but only *fictionally*, and our cognizance of this introduces the uncanniness of the *tuché*. The war that is referenced here is not only a documentary reality. It also functions as a metaphor for the scene of a psychological encounter for the men—of the trauma of

War Neuroses: Netley, 1917, Seale Hayne Military Hospital 1918 (1918).
Soldiers, currently patients, reenact preparing to go into action on the battlefield.

the real in an "afterwardsness." Two knowledges jostle side by side: the
before of the men's traumatization through war that is represented *after*
as cured in the enacted battle. The fiction of the battle, now successfully
endured, thus refers to a reality that is also the real of trauma, producing
an oscillation between two realities, for the cure never fully displaces its
cause—the war—that itself is used to signify the cure, and the "after" of
symbolization never fully displaces the "before" of the real. This mock
battle serves terrifyingly well, therefore, to demonstrate trauma's relation
to the real and the symbolic, for the "before" of the real is the *effect* and

not the cause of the "after" of symbolization, for the war is a product of the civilized democracies of Europe.

It was from *War Neuroses* that the British artist Douglas Gordon appropriated the "found footage" that constitutes his video loop *10ms−1* (1994). Gordon uses the case of a soldier diagnosed with "hysterical pseudo-pseudophypertrophic muscular paralysis," who, prior to treatment, walks with a severely arched back that he is unable to bend, and hence he cannot lie down without falling. Gordon refilmed and slowed the man's painstaking and deliberate movements, both echoing the work of Marey and Muybridge and undermining it, for this movement that is endlessly repeated can never reveal a scientific truth of the body. Instead, it engages the real of the body but no longer through the particularity of its specific historical context. Exhibited in a gallery, the silent video is initially extremely enigmatic for the title, which refers to the speed at which an object falls under the pull of gravity, explains little. *10ms−1* is part of the collections of the Tate Modern in London and its note on the work suggests, "watching it can be at once compelling, frustrating and strangely voyeuristic." Gordon is quoted as saying, "You can see that what is happening on screen might be quite painful—both physically and psychologically—but it has a seductive surface. What do you do—switch off or face the possibility that a certain sadistic mechanism may be at work?"[33]

The soldier's repetition of war trauma in his bodily conversion hysteria symptom is appropriated by the filmmaker (and spectator) in a re-performance marked by sadism in making this soldier live again only to relive the real of his body abstracted as rhythm and duration in a performance of electronic repetition. Moreover, it is a process in which redemption is excluded. The passing spectator who stops, her attention caught by the movements, may recognize that the filmed material is from another era and may speculate on the cause of the man's bodily distention and the context of the original recording: was it a "freak" show, part of an acrobat's performance, or a medical case study? An uncertainty concerning the visible signified (i.e., about what it really shows) is set in play together with the fascination of the repetition and motion and its horrible pleasures. For it is as if my look causes the film's reenactment over and over again while my body cringes in involuntary empathy. The real here makes strange representation as such, repeating the uncertainty of the doctors treating the many shell-shocked soldiers of all nationalities regarding the truth of the body's speech in the hysterical symptom and their anxiety—like the documentary's—as to what is faked or fabricated and what is real. An uncertainty that is reiterated by Gordon, who has

War Neuroses: Netley, 1917, Seale Hayne Military Hospital 1918 (1918). The sequence used by Douglas Gordon of a man with "hysterical pseudo-pseudohypertrophic muscular paralysis."

questioned whether the man is played by an actor, and by audiences of both *10ms–1* and the original film.

Our access to the real and to the uncanniness of war arises not from the reality recorded in *War Neuroses* but from the film's recorded reality through a poetics of repetition and it is this that Gordon has drawn on. The "found object" of appropriated footage is already discursively constructed. Its context, however, is medical knowledge. *10ms–1* is a work exhibited in the gallery space, the authorship of which lies in the way it re-contextualizes the fragment of recorded reality and, making the poetic the dominant aspect,[34] it constitutes a seeing of the recorded reality anew and engages the spectator to consider her own relationship to repetition as form and as symptom. Each film, therefore, engages us in the politics of representation.

▶

Let There Be Light: "One Thread, Death and the Fear of Death" (voice over)

The title of Huston's film, a quotation from the Bible,[35] clearly sets out its agenda. But if the light to be found is an escape from the darkness of

war trauma, it is through the medical (i.e., psychiatric) intervention of the doctors at New York's Mason Hospital for military personnel. The shell shock of *War Neuroses* has become, in 1946, a "psychoneurotic disorder" for these former combatants. Commissioned by the U.S. Army Signal Corps in which Huston held the rank of captain, the film was intended for general release both to inform the public about the distressing psychological difficulties many of the returning soldiers may experience and to allay fears about this by showing it as curable and as part of a normal human response that can be understood and helped. The military authorities had second thoughts after it was completed and withdrew the film from a screening at the Museum of Modern Art in New York; it was then suppressed until 1980, when, after heavy lobbying by Huston and others, it was finally permitted to be screened at the Cannes Film Festival in 1981. The grounds for this censorship have never been revealed, but Huston confirmed that he had obtained signed permissions from all the men participating, and his view was that it challenged the "warrior myth" of the armed services too deeply.[36] But perhaps Martin Scorsese is nearer the problem when he observed, "It's a propaganda film that undercuts its own propaganda."[37]

The film's reputation came to be based on the few accounts of those who had seen it at previews, notably James Agee's review in the *Nation* in 1946, where he praised it strongly for its powerful presentation of the anguish of the men. It, like *War Neuroses*, is often doubted as documentary, as the men were suspected of acting or being rehearsed, despite the asserted claims in the film to the contrary.[38]

The enduring power of the film, which so impressed reviewers like Agee at the time, are the interviews with the soldiers and their discussions in the scenes of group therapy. It is a classical documentary (indeed, propaganda) film with, at times, highly stylized and poetic imagery—achieved by Stanley Cortez's chiaroscuro lighting effects—and a use of nondiegetic music for dramatic effect. This is, however, in sharp contrast to the direct speech of the men that is very much like the overheard, observed scenes of Frederick Wiseman's *Titicut Follies*, *Hospital*, or *High School*. It is here that we apprehend the unrepresentable real, notwithstanding the film's powerful and sympathetic narration of the medical program and its view of the psychological basis for the men's condition as well as its sensitive presentation of the curing and progression to health of the men we come to know.

Like *War Neuroses*, *Let There Be Light* shows the men before and after treatment, but now the role of the unconscious is directly acknowledged and the past of the men is addressed in order to treat their present

Let There Be Light (1945). A soldier, being interviewed by a doctor, haltingly speaks of his distress. While African Americans were treated together with white Americans, including in group therapy and recreation, segregation in the U.S. Armed Forces remained until 1948, although all officers were trained together from 1942.

Let There Be Light (1945). Servicemen in group therapy.

condition. Both hypnosis and the drug sodium pentothal were used to bring memories to the surface of the soldier's mind, and suggestion was used to assure him that he would, upon awakening, now walk or talk. Remarkably, as Richard Ledes has argued, the approach of the doctors draws on Freud's concept of *Nachträglichkeit*, in taking the view that an earlier event is the support of the current trauma.[39] Doctors in the film emphasize the need for "an experience of safety" arising in childhood that, if not met, provides the emotional context that enables subsequent events to be experienced psychoneurotically.[40] Group therapy sessions explore family experiences while becoming forums for the men, and the camera, to demonstrate their cure through their self-understanding and awareness and their readiness and fitness for civilian life.

The men speak for themselves, but it is a speaking constrained not only by trauma but also by their status as servicemen within the hierarchy of army doctors participating in—and thereby performing for—Huston's documentary. Yet it is these very circumstances of constraint that enable us to hear more clearly their encounter with the real, and this is never resolved or contained for them or the spectator by their cure or the film's narrative of restitution and redemption for the men and for the United States.

[5] *Ways of Seeing and the Surreal of Reality*

A certain loss is always entailed in representation. Indeed André Bazin, for whom realism was central to valuing cinema as an art, nevertheless observed: "Some measure of reality must always be sacrificed in the effort of achieving it," for the more real it appears, the less it signifies the contingent reality it is the record of.[1] Similarly, Lacan notes that something must be lost—broken away—in the making of what he termed the *l'homellette*, the little man-child, in a punning mix of omelette and *homme*. For each is made in the breaking of eggs, that is, for the child, in its separation from the placenta that becomes the first in the long line of separations involved in the emergence of subjectivity in the human animal.[2] Such losses are not viewed with equanimity, however. If the vision machine that is cinema engages our desire for the really real in the photograph or documentary film, then it also gives rise to that anxious search for "authenticity" that Baudelaire spoke of[3] and that seems assured but has—imperceptibly—been sacrificed. Like other forms of art, documentary is concerned with the transformation of the ephemeral and the transitory into the significant through re-presentation, and it, too, anxiously commemorates as loss what is not preserved, recorded, and remembered. Documentary, as a result, is haunted by the specter of uncertainty and doubt, both regarding the putative contingent reality it never quite captures, and regarding the sense, the comprehending, of this (incomplete) reality it presents us with. The documentary evidential is materially both referential and in excess of the referential it invokes, both as sign and as the real. Representation, Derrida has reminded us, both makes absent as it makes present, and it makes nonsense as it makes sense, or meaning, in differing and deferring. Something here is always left out of account but this left out of account is itself an effect of representation. But this is not all. We may desire not only the lost reality but

also the losing of reality that documentary's failure attests to. Because it is missing, we are reassured *it was (really) there*.[4] Similarly, in Freud's account of fetishism, the mother is attributed a missing penis, which is then refound in a (magical) substitute.

Serge Daney identifies a certain disavowal in Bazin's view of realism, for his cinema of transparency avows a gain in reality, while he acknowledges there is always something necessarily lost between reality and its representation that produces what Daney calls a "tiny difference," which he identifies with the cinema screen that acts as both a window onto reality and yet bars us from the reality to which it gives us access. Daney relates this difference of the screen to another that Bazin discusses: "Of course a woman who has been raped is still beautiful but she is no longer the same woman."[5] Such differences are all the difference, however—not only for cinema, and more significantly for the woman raped, but also for the one who apprehends this difference. For Bazin's choice of metaphor reveals the issue of sexuality and of sexual difference as central to what is lost between reality and its representation. Uncertainty arises in relation to a difference that cannot be seen but only thought—and feared. Daney observes,

> The obscenity perpetrated by the rape of reality cannot fail to send us back to the rape of the woman and the screen, the hymen. The fundamental ambiguity of the real is the uncertainty regarding virginity: the tiny almost nothing that changes everything. The attachment to representation, the taste for simulacra, a certain love for the cinema (cinephilia), all derive less from ontology than from obsessional neurosis. It is in the very essence of the latter to clothe itself in the former. One is reminded of Freud's comment that "The predilection felt by obsessional neurotics for uncertainty and doubt leads them to turn to those subjects which are uncertain for all mankind and upon which our knowledge and judgments must necessarily remain open to doubt."[6]

If a woman's virginity or sexual probity is subject to doubt, then it is because her desire and her being as subject of desire are doubtful for the other of her desire. What is engaged here are processes of fantasy and of a fetishism in which answers can be supplied and guaranteed by the presence over there (on the woman) of what is absent. But what might be taken to be absent (in Freud's later account of sexual fetishism, the mother's penis) was never there, and it is this possibility that is most terrifying. Bazin always acknowledged the cinema image as unreal while valorizing its realism for enabling the possibility of human understanding. Yet it is when we are brought to apprehend the undecidable of the missing and the rupture this enacts in our representations that we may understand

differently our relationship to our fantasy constructions. How then might the documentary engage us in such an apprehension? In Chris Marker's essay film *Sans soleil* (1983), he presents a meditation on the cultural fetishes—including ethnographic film—by which we sustain ourselves in the face of the undecidable. At the same time, the film problematizes any easy assumption of a distance from such fetishism that documentary usually affords us by its use of its voice-over narrator. A narrator reads letters from the filmmaker, drawing us into the filmmaker's subjective perspective as we see his images, but we hear his words through the relay of a woman's voice-over that repeatedly tells us, "He wrote." This separation makes apparent the fiction of every documentary narration that presents an unseen voice-over separated from its documentary sounds and images, making each strange. It introduces a questioning of the givenness, the reality, of the images that are, nevertheless, documentary recordings by Marker. The author spoken of by the voice-over, however, is a fiction, for his letters were written by Marker, and never posted. Their status as "true" is undecidable.

This chapter explores ways in which documentary film may engage us in the surreal of reality, whereby something slips as we try to "make sense" of what we see and hear, and a little bit of the real appears, undoing subjectivity as unified, engaging our imaginative remaking of our understanding in a seeing differently, a seeing anew. Marcel Mauss observed, "The Aristotelian categories are not indeed the only ones which exist in our minds, or have existed in the mind and have to be dealt with. We must, before all else, compile as large as possible a catalogue of categories; we must begin with all those which we can know that mankind has used. Then it will be seen that in the firmament of reason there have been, and there still are, many moons that are dead, or pale, or obscure."[7] Here, Mauss invokes both science—the discourse of the university—and, through a metaphor, its limits. It is to the dead, pale, or obscure moons that I now turn in a consideration of forms of knowing and not knowing and to explore the relationship between the documentary evidential and surreal of reality—the realm of dreams, of imagination, and of the irrational that are central to the surrealist impulse.

World War I, with its specters of the real and their aftermath in the symptoms of war neurosis, was a key influence for many surrealists, notably André Breton, who worked with soldiers suffering from shell shock, and Jacques Lacan, for whom the concept of the unconscious in Freud's work became central.[8] The permeability of reality, dream, and imagination that was central to the surrealists is the focus of my discussion here, together with the ways in which their juxtaposition

came to be felt in the encounter with not only artworks but also with everyday reality and its documenting, such as in Buñuel's *Las Hurdes*. Anthropologist and filmmaker Jean Rouch has commented, "For me, as an ethnographer and filmmaker, there is almost no boundary between documentary film and films of fiction. The cinema, the art of the double, is already the transition from the real world to the imaginary world, and ethnography, the science of the thought systems of others, is a permanent crossing point from one conceptual universe to another."[9]

It is through the work of Rouch that I will explore the surreality of reality in this chapter. Rouch trained as an engineer in the late 1930s, becoming an anthropologist and filmmaker after World War II. He has produced a body of work that is an extremely important contribution to cinema as well as anthropology, but which is also controversial and challenging as a result of the way in which he sought to dissolve the boundaries conventionally imposed on these domains. This has led to a certain compartmentalization of his achievements between his scientific ethnography, including his films of visual record, his documentaries, and his "ethno-fiction" films. Rouch, however, saw his contribution in all of these activities as being informed by his early encounter with surrealism that influenced all his subsequent scientific, intellectual, and creative work. He recounts in many interviews his discovery in a library of two issues of *Minotaure*, one about the Mission Dakar–Djibouti, the cover of which was a "reproduction of a Dogon painting in red, black, and white." The other had a cover by Giorgio de Chirico, and Rouch comments, "I was very impressed by that. And I will remember all of my life the photography in that one issue—I think it was by Griaule—of the Dama masks dancing on the terrace. It was something very strange." He continues, "It was the same that was in the paintings of de Chirico, the same as you find in the first paintings of Salvador Dalí, in Max Ernst, in the collages. It was this way to 'jump,' to 'imagine.' And in the middle of that there was this strange ritual that nobody could understand."[10]

The juxtapositions that Rouch encountered were for Breton central to his 1924 "Surrealist Manifesto," where he cites Pierre Reverdy's declaration that "the image is a pure creation of the mind. It cannot be born from a comparison but from a juxtaposition of two more or less distant realities. The more the relationship between the two juxtaposed realities is distant and true, the stronger the image will be—the greater its emotional power and poetic reality."[11] This is not a juxtaposition brought together by the mind as a comparison but a juxtaposition that imposes itself on the senses and brings about an imagining.[12] The juxtaposed realities must be encountered and not invented, and the strength of the resulting image

is not inherent in the "found" realities but in the subject who apprehends the juxtaposition. For the surrealists, the found object's re-contextualization produces a tension, an impropriety, and an incongruence that disturbs rationality and prompts associations that may be unconscious a well as conscious. The "found object" (*objet insolite*) is both a material entity encountered by chance and contingent on an arbitrary moment and context, and an image as it is grasped imaginatively by the conscious or unconscious mind.[13] Surrealism here is directly materialist as the physical encounter with objects, natural phenomena, and human actions through which imagining arises.

Ethnography is the study of "found cultures" and of the role of a culture's appropriation of "found objects" in its philosophy, belief system, and social practices. Function is to be deduced not from the qualities of the object but from the qualities of its use and its deployment as "found." The ethnologist encounters the world she will observe as always unknown, that is, as found—whether so-called pristine or not—and thus subject to a process of coming to understand through her "imagining." As a result, Marcel Griaule emphasized, documentation is the first and foremost method and activity.[14] For James Clifford, however, "the surrealist moment in ethnography is that moment in which the possibility of comparison exists in unmediated tension with sheer incongruity. This moment is repeatedly produced and smoothed over in the process of ethnographic comprehension. But to see this activity in terms of collage is to hold the surrealist moment in view . . . Collage brings to the work (here the ethnographic text) elements that continually proclaim their foreignness to the context of presentation."[15] The incongruity of the found juxtapositions and their strangeness exists not in the objects or practices as such but in the context of their apprehension, both the context of the ethnographer's or spectator's cultural difference, and the context of a documentary representation, which will always produce a new moment of juxtaposition and potential incongruity.

The way in which Rouch sought to think outside of and in opposition to the division between material reality, rational empiricism, and logical thought, and dreams and poetry as nonlogical thought is suggested in two stories that Rouch returned to in interviews and his writing. Rouch tells of his professor of engineering, Albert Caquot, describing the discovery of a new understanding of stress resistance in building materials and relating how an engineer consultant—having inspected a bridge and the current weight of traffic using it—realizes from his calculations that the bridge should collapse. But learning that it is ten years old and that over this period there had been a steady increase in the weight of trucks

from five tons, to seven tons, to ten tons, he conceived the idea "that the material could resist successive stresses by adapting its resistance to the new tensions demanded of it. He does some experiments and discovers the theory of 'resistance to successive stresses.'"[16] This engineer was Caquot himself, and Rouch comments, "I was thus trained by people who were great researchers and who were, at the same time, great poets, because this resistance to successive stresses is nothing less than poetry."[17] For Rouch, then, thinking is an act of progressive imagining in relation to observed phenomena (the documentary, whether written or filmed) that is not simply and conventionally logical. It is a kind of thinking that is of the same order as poetry in making leaps of association.

In a second story—and one that evokes Mauss's words cited previously—Rouch recalls the observation of Griaule (who supervised his thesis) regarding Dogon thought systems, which give great importance in their mythology to the star Sirius and the two companions stars they ascribe to it. Griaule commented that what was remarkable was that Sirius does indeed have a companion star, but it is not visible to the naked eye. Rouch reacted by declaring, "Well, then, they can't see it," for which he was called an ass by Griaule.[18] What he understood by Griaule's retort was that he, Rouch, was reasoning within his own thought system and not the Dogon system, whereas for Griaule the companion star's reality was its existence within the Dogon religion. Rouch explains, "It's not renouncing our Cartesianism; it's considering the possibility that, beside our Cartesianism, beside our so-called scientific explanations, there are others. To ignore them means that we have an imperialist attitude."[19] Sirius's companion star (Sirius B) was not observed until 1862 but had been predicted earlier as a result of observation of the aberrant trajectory of Sirius and has now been accepted as being a "white dwarf" or "dead" star. Rouch speculates that "it was necessary for the Dogon observing Sirius to introduce an element of disorder, a companion, which determines both the anomalies of the Sirius' trajectory and the anomalies of the [Dogon] creation myth."[20] It is in holding together or juxtaposing these two approaches to understanding a natural phenomenon that Rouch makes possible a greater understanding of each.

The journal *Documents*, founded in 1929, presented the new ethnography of Griaule and Michel Leiris emerging in France, and drawing on their work, the journal took examples from all aspects of culture and made connections appear where they were least expected. Its cofounder, George Bataille, was associated with the surrealists, although he was expelled from Breton's circle after disagreements. In Bataille's contributions to the journal, the object was not art but evidence, not literature, but

documents. It was a way of writing, Dominique Lecoq has suggested, that was capable of overturning the code of branches of knowledge without constituting in itself a closed, complete body of knowledge. Thus Bataille "called upon philosophy, ethnology, economics, psychoanalysis, not to borrow their results but to open up the notions they defined in new, illegitimate, unacceptable directions."[21] The object and material reality, as referential and as the documentary evidential are mobilized in ethnography, collage, artwork, or film, but as represented, they are also displaced from their referential purposefulness. There is a change brought about by our imaginative understanding that Breton called a *"mutation de rôle."*[22] Evidence and the factual constitute the materiality of the documentary representation, therefore, not only as a content but also as a form.

In its critique of rationalism and its narratives of causality, surrealism deployed the materially evidential to produce unexpected connections that demand we re-assess our assumptions about the fact in its traditional, proper place, as a result of its new, improper, re-placing. Lecoq concluded that "if logic masks the gaping inadequacies of the logos, Bataille, in impelling *Documents* to expose all the contradictions, chose both to uphold logic and to remove the mask."[23] It is this double move that Rouch's cinema, too, upholds. What arises is a "seeing anew" in an estrangement through which the everyday and the taken for granted is re-presented. The documentary evidential as recorded actuality is materially referential but, because brute reality is contingent and ephemeral and because it is something that just keeps happening uncaused, it also exceeds the referential it invokes. While it engages us to make sense of and to comprehend it as factual, the documentary evidential can also open us to the absence of meaning and the factual's appearance as uncaused. The unrepresented as the unacknowledged, unexplained, and inexplicable in the contingent reality shown negates the documentary givenness of the images and sounds we see and hear, and as a result, we may apprehend not merely the unrepresented but also the unrepresentable. This "real," in Lacan's sense, while unrepresentable, nevertheless bears on us, palpable but unspeakable. Like slips of the tongue or jokes that we make in our everyday lives, which Freud analyzed as the "return of the repressed" of the unconscious, the real can be felt as the contingent, the uncaused, in reality.

The surreal, David Bates has argued, must be understood not as a type of image (or object) but as a type of meaning or, rather, of nonmeaning, contradiction, ambiguity, or veiling of meaning, enigmatic in fact.[24] It appears whenever we encounter the absence and thus failure of meaning that, much as nature abhors a vacuum, we seek to fill, yet for all the answers we may offer, we cannot be certain which, or that even any,

are true. The surrealist work—text, object, or image—deploys reality to engender our encounter with what is in reality but is more than "reality." For example, the found incongruities arising from natural but absurdist juxtapositions that arise in Diane Arbus's work and that jar and reverberate, challenging our expectations of verisimilitude. A different "more than reality" is experienced in relation to the visual traces of the unconscious we may encounter, suggested in Brassai's *Rolled Bus Ticket* (1932), an "automatic image" that is documentary evidence of an unthinking action that betrays a psychological state to which the object bears no necessary or mimetic relationship.[25]

In the documentary surreal, we are grasped by the evidential as enigmatic signifier. Held by its unmeaning, we engage the traumatic, but spurred to make sense, we embark on a process of translation through which we produce an account or interpretation that "works." Nowhere is this process made more necessary, and with more diverse interpretations, than in Luis Buñuel's film *Las Hurdes*, discussed earlier in chapter 2. The images alone could not show what Buñuel also observed, a "land without bread, without songs," yet despite the voice-over narration, they continue to be obstinately enigmatic. The work—and poverty—of *Las Hurdes* is presented without placing its story in a wider context through which we can understand causes—it is not explained as either natural and God given or the result of the peasants' ignorance, or solely due to the calumny of the exploiting classes of government, church, and landowners. Failing to identify causes for the dire condition of the people of Las Hurdes, the film's epistemological stance is scandalously neutral; it states just "the facts" in its dry and unemotional voice-over without making "sense" of them (e.g., in an account of the justice and injustice of the plight of the Hurdes people and ways in which this might be rectified).[26] The life of the *Hurdanos* is "made strange" by the film because, unexplained, it is inexplicable—how and why are these people without work and land from which they can produce enough food to eat and without access the medicines and education of modern society? The hardships that the film relentlessly states are senseless and absurd in the perspective of modernity's progress—they are surreal. Thus while many have seen this film as in sharp contrast to his earlier films made with Salvador Dalí (*Un chien andalou*, 1928, and *L'Age d'or*, 1930), Buñuel insists that in filming reality he was remaining within the spirit of surrealism and says that although these first two films are "imaginative" and *Las Hurdes* is taken from reality, he believes "it shares the same outlook."[27] The voice-over narration both informs and, dry and inexpressive, is a parody of "objective" documentary observation, presenting scenes and information that raise more

questions than are answered, which appear inappropriate or digressions, and offering facts about what we see in which the shocking implications—for example, a child dying of diphtheria—are never acknowledged. The "strangeness" of the found reality the film and its voice-over make apparent the nonsense of reality, and thus Buñuel challenges us to consider how we construct the sense of reality and how we find meaning in the factual, that is, how we interpret it and the failure of meaningfulness. Is not the film's banning by the Spanish government of the Second Republic (1933–36) perhaps evidence of its power to disturb the complacencies of progress and knowledge of modernity?[28]

The documentary evidential of cinema is first and foremost a space and a time. It is a mise-en-scène of action, reaction, and becoming. This is the ground of the present tense of film that nevertheless includes its becoming past as record. Film always shows both a now and a then, so that the reality it re-presents—whether fictional story or documentary—is temporally inherently doubled. What is involved in documentary film surrealism is a "found" mise-en-scène that brings into the same space what is not "normally" adjacent, opening up associations and oppositions, and inciting a certain horror, or pleasure, at the improprieties. Cinema as the art of the double and of dreaming enables a surrealism as well as a realism in its recording of reality. In Rouch's ethnographic films of record as well as in his documentary fictions, a surrealism arises through how we come to see, as well as what we see, in the process of our apprehending the juxtaposing (collaging) and not only in what is juxtaposed.

The found image or object is encountered in an experience that, whether brutal or beautiful, is equally captivating. Rouch has spoken of the importance for him of de Chirico's paintings, where the juxtapositions open the spectator to latent or potential meanings arising both in the cultural—and conventional—connotations of the depicted and in the spectator's cognitive and emotional response to these *conjoined* connotations, which thus spur further associations. Describing de Chirico's lighthouse imagery, Rouch says, "This was an architecture of dream" through which, though wakeful, the spectator will herself come to "dream,"[29] but as a kind of daydream. Rouch asserts, "I've never considered craziness to be pathological, and I always considered it normal to dream. I've always been a very good dreamer; I've even written poems from my dreams."[30]

For Breton, surrealism was "the resolution of these two states, dream and reality, which are seemingly so contradictory, into a kind of absolute reality, a *surreality*."[31] It was not only the external world that might provide "found objects" but also manifestations of the mind's

involuntary—unconscious—workings, and Breton drew upon Freud's account of the unconscious and dreaming. Breton also developed processes of "automatic writing" as forms of "controlled possession" to access the unconscious that can be uncovered or revealed in reality. The dream or image can be read and analyzed. It was Freud who gave voice and significance to dreams as the "royal road to the unconscious" and asserted the reality of fantasy and the imaginary in human psychology. Yet he was an ambivalent figure for surrealism, for Freud also pathologized the unconscious and constituted psychoanalysis as a science and a hermeneutics.[32] Rouch himself has said of Freud, "I saw that he was not a dreamer himself but was rather exploiting dreams—like Karl Marx."[33] Freud's project was deeply rationalist but, in what Freud termed "the navel of the dream," he affirmed that there was a certain element in the dream that was uninterpretable.[34] Here, as well as in his concept of disavowal, Freud affirms the way in which our relationship to knowing, to the factual, and to the rational is doubled and contradictory. Similarly, Breton sees the contingent in the found object and image, which, as objective chance, is also ambiguous so that, while it might be recorded and analyzed, it retains a core of mystery or uncertainty. In his concept of the real, Lacan drew on the insights of surrealism (with which he was closely associated in the 1930s) while developing Freud's idea of an "unplumbable" element in the unconscious.[35]

To Rouch, like Luis Buñuel, dreaming was a form of reality not simply experienced in sleep, in which one is other to oneself in a form of doubling.[36] "The dream is just as real, maybe more so than reality. It's what I tried to do . . . jumping between the two."[37] It is such "dreaming," the imaginative play of the conscious and the unconscious, that Rouch brings to his documentary work. While the observing camera's eye sees for the filmmaker it, unlike the filmmaker, sees indifferently, and Rouch, as cameraman for his films, always acknowledged that objectivity and its correlative, subjectivity, are each introduced by the intervention of the filmmaker. Rouch described his work of "direct cinema" as involving a filmic attitude in which he is attuned to catching "the most efficacious images and sounds," to "film-see" and "film-hear" by knowing the limits as well as the possibilities of his camera, its lenses, and his sound recording equipment, as well as framing, camera movement, and editing in the camera—he calls it "film-think."[38]

Rouch, however, also adopted the idea of a "participatory camera" from Robert Flaherty,[39] involving the people he filmed closely in the process itself, to produce—in Rouch's words—a "*cinè*-dialogue," where there is no longer object and subject and "knowledge is no longer a stolen

secret" later to be consumed in another place, at another time, by another culture.[40] The discourse of the master and the university are no longer only on the side of the filmmaker, the representative of the West; instead, there is a circulation. Knowledge and the master signifier are also spoken by the participants, while the filmmaker, thus addressed, answers with the discourse of the hysteric. This collaboration is both a work of transference and countertransference in which filmmaker and participants variously may seek to provide what each understands consciously or unconsciously to be what the other wants (desires) from them. Rouch commented, "Currently I am at the point of reflecting on my own role as a taker and giver of doubles, as an eater and shower of reflections . . . to clarify these roles in relation to the self of the ethnographer and ethnography itself."[41] Rouch is no longer an observer–camera but a participant who is in a form of trance, for "the camera becomes a magic object that can unleash or accelerate the phenomena of possession" because it leads the filmer onto paths he would otherwise never dare to take, "guiding him to something that we scarcely understand: cinematographic creativity" in a form of automatism.[42] In filming *Tourou et Bitti: Les tambours d'vant* (Tourou and Bitti: The Drums of the Past, 1971), Rouch suggests that the *"ciné-transe"* he experiences played the role of the catalyst in bringing about the possession of the dancers.[43] Rouch based his concept of the *ciné-transe* on the Songhay–Zerma theory of the person as split, "founded on the notion of a 'double' or *bia*, who represents shadow, reflection, and the soul, all at the same time" that exists in a parallel world of doubles that is also the place of the imaginary.[44] This *bia* is tied to the body but may temporarily leave the body during sleep, in dreaming, or when awake in a state of imagination or reflection; it is the process that occurs in possession, but here the *bia*, having been replaced by the spirit or god, is preserved in a protective fresh skin. The magician may voluntarily project his double, who can then journey to the land of the doubles in order to guide or defend the community (though this is not without danger). The sorcerer, too, can project his double, but here the purpose is for evil—to cause death by stealing the *bia* of victims. Rouch is possessed and thus separated from his *bia* in the *ciné-transe* and also, like the sorcerer, a hunter of doubles, while at the same time he is like the magician who directs his *bia* and returns the double—the filmed images—in a process that contributes to the community.[45] Both cinema, as a world of doubles, and Rouch's role as filmmaker-magician, were recognized by the Songhay–Zerma in their invitations to him to film their procession ceremonies, notably the *hauka*. The camera is a magical other double, through which a world and an audience not present but imagined is addressed not only by Rouch but also by the participants.

Cinema—whether documentary or fiction—is a production of a performing for others, a being seen and heard.

Rouch brings to his filmmaking his awareness of surrealism's concern with the split and multiple subject and retains a hesitation between rational and irrational explanation in his claims for the *ciné-transe*. Indeed, he emphasizes that, for the Songhay–Zerma, the two worlds are so interpenetrated "that is almost impossible for the uninformed observer to distinguish the real from the imaginary in them. 'I met Ali yesterday' can just as easily mean 'I really met Ali yesterday' as 'I dreamed about, I thought about, Ali yesterday.' And when the observer gets used to this gymnastic, he disturbs the real as well as the imaginary."[46] Rouch's documentary fictions are, therefore, perhaps themselves special forms of *holey*, the Songhay term for cult performances, and of possession in performing as one's double. The reality given to the world of the imaginary is not a delusion but a certain kind of knowing or knowledge relationship that parallels Freud's notion of disavowal, of knowing and not knowing, or of two knowledges that each contradicts the other that he saw as central to the splitting of the psyche.[47]

In *Les mâitres fous* (The mad masters,1955), Rouch viscerally confronted audiences with the paradoxes of making sense of the reality we engage in as subjects and as spectators of his films. The film presents the juxtaposition of modernity—colonial British—and tradition in this *hauka* possession ritual of Songhay–Zerma migrants from French Niger in Accra, British Ghana. It is a documentary rather than simply a record, for it also presents the context of the migrants in Accra and their work and introduces individuals who we will later see in the possession ritual, and the film then returns to this "normality" at the end. Moreover, Rouch concludes with the claim that, in the mastering performed by *hauka* adepts, the participants have "resolved, through violent crises, their adjustment to today's world," and thus Rouch redeems the horrific scenes of the ritual. The possession rite is a weekly event, repeated just like their encounter with colonial modernity is repeated, and many of the spirits take the form of colonial figures—the governor-general, and so on. The film aroused considerable criticism on its first viewing and continues to powerfully divide viewers as to both what we learn in the film and how we should understand the behavior of the *hauka* adepts. The problem of interpretation makes palpable something of the real, which the ritual itself also engages in relation to the process of possession. Tracing these problems of interpretation makes apparent the film's surrealism.

The ritual is undertaken within a carefully staged mise-en-scène, motivated by the forms taken by the spirits on entering their human

"horses." A termite hill is painted to represent the governor-general's palace, with a crude wooden likeness of him standing over the ceremony and patterned cloth representing the Union Jack flying overhead. There is also a cinema poster for three films, including *The Mark of Zorro* (Mamoulian, 1940).[48] All these are kinds of "found objects," the redeployment of which produces a change of role, a *mutation de rôle*. Like all *holey* ceremonies, it is highly theatrical and may seem abjectly comical or satirical to outsiders. Indeed, the ritual has been interpreted by many—including the British authorities—as a parody of, and thus as also a resistance to, colonialism, but while the *hauka* spirit world is peopled at least in part by colonial figures, this is not simply a self-conscious intention, since it is the spirit that chooses the adept (i.e., the master) and not vice versa. Moreover, many of the spirits do not lend themselves to this interpretation (e.g., the truck driver and train engineer); here the *hauka* are possessed by the spirits connected to the new powers of technology. The eating of the dog, which breaks a taboo of the British colonial powers, enacts not mockery but an overcoming and absorption of that power, for the *hauka* show that the adepts are stronger. Previously it had been pig that was eaten, as this was something that, since the *hauka* adepts were also Muslims, was forbidden to them. More importantly, Rouch emphasizes, these were "powerful new gods who most certainly are not to be mocked."[49] The ritual's mimicry bears witness to the Songhay–Zerma encounter with the otherness of not only French and British colonialism but also Islam and North African and Arab culture.

To read the ritual as motivated, whether consciously or unconsciously, by anticolonialism is to offer a Western psychological explanation that contradicts the role claimed for it by the community itself. As Paul Henley shows, drawing on Rouch's ethnography, the *hauka* are one of six *holey* sects, all of which associate spirits "with alterity, exemplified by various ethnic Others with whom the Songhay have come into contact at certain moments in their history."[50] The *holey* spirits are invoked to help protect or are consulted over problems for which their remedy is sought. Rouch's voice-over interpretation of the ritual can be related to the "healing" role of the ritual shown in the film in relation to the adept who confesses a transgression to the priest—that he has slept with his friend's girlfriend and subsequently has been impotent for two months—and is later possessed as "Major Mugu." After the ceremony finishes, the voice-over claims that he is cured and that his girlfriend is "very happy" as a result. Commenting upon the influence of *Les mâitres fous* on Jean Genet and on his play *Les Nègres* (*The Blacks*)

Les mâitres fous (1955). An adept possessed by his spirit, "Major Mugu," is helped by a nonadept.

Les mâitres fous (1955). A man carries the dog that later is killed and eaten.

Rouch observes, "Possession, after all, was the original theatre, the idea of catharsis."[51]

What characterizes the spirits is that they are otherworldly and thus "by very definition will behave in abnormal, outlandish ways."[52] The breaking of taboos marks the spirit as nonhuman and unrestrained by any rules. Henley suggests that the Songhay have looked to exotic others to provide the models for the spirits because, "in Lévi-Strauss' celebrated phrase with regard to Australian totems, these powerful Others are 'good to think with,' not about the nature of human beings, but about the nature of spirit beings."[53] Rouch said, "There's an attitude of both mockery and respect in *Les mâitres fous*; they're *playing* gods of strength." As a result, Rouch suggests, the *hauka* were "a fascinating model to follow" for young Africans, as "people who are afraid of nothing," just like the Europeans who do whatever they want, including breaking the taboos of others.[54] Here he proposes what might be a self-conscious motive, yet it is an indirect model, for it can only be imitated through becoming possessed in a performance of unconsciousness.

What seems to be acknowledged through the *holey* sects is an otherness or an alterity, which enters the community but which the community cannot direct or control, whether this is nature, incoming neighbors, or Islam. The power of the other is signified in the deployment of its signs but nevertheless superseded by the superior power of the spirit that is demonstrated by the inversion and transgression performed by the spirit through the *hauka* adept. The ritual presents an intermixing of elements that remain distinct in a drama of their very juxtaposition, a conjoined image of embodied self and spirit, of power and weakness, where both the abject and taboo are celebrated and valorized. The boundary of self and other is permeated as meaning and identity slip between, for the adept both is and is not the spirit, partaking in the spirit's power and disowning it as much as he or she is disowned by it. Rouch comments, "It was like Buñuel's attitude to the church. You cannot feel sacrilegious if you do not respect your opponent. What the *hauka* did was very creative and implicitly revolutionary, just as the authorities feared."[55] Henley's use of the term "thick inscription" to refer to film's capacity to show a detail and level of information that cannot easily be contained by explanatory voice-over is, therefore, especially appropriate in viewing *Les mâitres fous*.[56] It should be added, however, that the "meaning potential" arises not only from the complex and multiple reality recorded but also in its juxtaposition across the film and its impact upon audiences as shocking and unassimilable within conventional (Western) understanding. As important as what we see is what we hear. The soundscape of the film

includes much of the direct sound recorded, with the incantations of the *hauka* audible, as well as the single-stringed instrument used to call down the *hauka* spirits. Rouch had sought to translate the speech, but the glossolalaic mix of French and English made this impossible. DeBouzek describes how Rouch, having worked closely with one of the members of the cult on an interpretation of the events and recorded speech, "decided to set his notes aside, doing the final voice-over without a written script. According to him, that first narration was part of his own 'possession' by film, part of his personal *ciné-trance*."[57] The soundscape of the film is complex: At times it presents Rouch's voice-over alone, but more often it does so with the directly recorded sounds and speech audible in the background. However, at a number of points these are more audible, becoming dominant (e.g., during the incantation over the concrete altar or during the dancing when the music becomes clearly heard). Rouch's voice-over during the possession ritual both describes and explains, but he also reenacts as he adopts the voices of the possessed dancers and the spirits that possess them. The pace and tone of his voice shifts, appearing perhaps to be as possessed as the dancers themselves in this strange further doubling whereby the spirits, and the possessed, speak through Rouch as if—or indeed—he, too, is possessed. This is in marked contrast to his voice-over where he is offering an explanatory description (at the beginning and end) and where he speaks over the insert of shots of the British governor, troops, and the opening of the state government.

Rouch observed, "Every sort of force has attacked them [the *hauka*] and me for filming them—the colonialists who don't like the portrait, African revolutionaries who don't like the primitivism, antivivesectionists who don't like the sacrificial murder, etc."[58] In the trance, the adepts are indeed "inhuman," for they are *hauka*, but they are still able to resume themselves as very much human, as Rouch shows in the film's postscript. Is it not a Western gaze and its ideas of the world that can give rise to the fear Rouch claimed was experienced by the Senegalese director, Blaise Senghor? In Rouch's account, as he emerged from a public screening in Paris, Senghor felt that others in the audience looked at him with the thought that here's "another one who is going to eat a dog!" Such a gaze sees the possession ceremonies of the *hauka* as typical of all West African behavior, and it assumes a unified subjectivity to such "dog eaters" in contrast to the clearly doubled world of the *hauka* in which we are witnessing a theater of performance that is unscripted or, rather, scripted by the *hauka* and not by the adepts. It is the spirit who eats the dog, not the man. The practice of possession and the philosophy of human and nonhuman it responds to undoes our sense making of this

film—we cannot produce a logic of cause and effect with reference to verifiable evidence. Prerana Reddy has argued that it is by exposing the constructedness of Western rationality that the *hauka* "were making the most effective critique of all,"[59] but it is a critique "found" by the "Western" viewer—who might also be Nigerian and Muslim and not simply white and Christian.

It is not the *hauka* adepts who are irrational; rather it is the spirits who are outside human sense who are "unreasonable" in acting outside the decorum of what is proper, expected, human action. What is held to be rational is more often a matter of verisimilitude, an action being either what we expect as likely or being properly (i.e., with due propriety) motivated. The film juxtaposes two different orders of verisimilitude that are two different contexts of understanding in a collage that does not produce a mixing; that is not a dialectic that can be resolved into synthesis; and that is not a dialogic encounter. The informed, anticolonial Western viewer can recognize that the ritual is a performance in which the performer is neither consciously acting the part nor mad, but is acting on behalf of another and nevertheless is confronted by another non-sense that touches more closely the real. For who or what is this other directing the possessed?

Possession, like the automatic writing of the surrealists as well as hypnosis and suggestion, opens the person to forces she is not self-consciously directing. In each case, what we have is an observable phenomenon for which unverifiable explanations or understanding are offered. In Songhay–Zerma philosophy, the possession ceremony is a performance in reality by a possessing spirit that displaces the double of the medium in order to enter the medium's body and mind and who is therefore now other to herself. The anthropologist understands its benefit as arising in the relationship to the spirit whom the community can consult and receive advice from. For psychoanalysis, the possession is equally real—but as an effect of the processes of the unconscious in which a kernel of non-sense remains that Lacan calls the real.

Rouch describes how disturbed he and the others involved in the filming were after recording the possession ceremony and that he said to Damouré, "We really made a bad film, it's very cruel."[60] They decided to go out the next day to see what the participants were doing, and at Damouré's suggestion, this became the epilogue, producing a closure for the filmmakers. Rouch also tells the story of his friend Tallou, who was very shocked by what he had seen and declared, "Everything is fake. All this is fake,"[61] to which their driver answered that Tallou should be careful or the *hauka* would take revenge. Two weeks later, Rouch says, Tallou

was possessed. What is shown here is not only Rouch's own uncertainty as to the propriety of what he had seen and filmed but also the powerful impact of their experience of the ceremony. Rouch accepts the reality of the possession rites and his own "possession" during filming—and thus of a certain "strangeness" of the self to itself—without resolving in this film, or in his later comments about the film, what such possession implies for the person and for our notion of the person.

Rouch documents the otherness, the strangeness, that penetrates everyday reality and the social practices arising that enact our relationship to this real in reality, thereby involving us as spectators in an encounter with the strangeness of not only the other but also ourselves. In *Jaguar* (1957), Rouch similarly documents performances that engage the issue of the impact of modernity, colonialism, and migration—now, however, as a conscious form of enactment and thus as fiction but one improvised and played by nonactors, drawing upon their own lives and cultural practices to perform a story of migration and return. Control, as Rouch emphasizes, is thus ceded to the actor-participants, and the film documents both the story and their performance.[62] It is an imagining that draws on both Western culture and African culture, made vivid in Rouch's *Moi un noir* (Me, a Black, 1958), where the "characters"—taking the names of American film actors such as Edward G. Robinson, Eddie Constantine, and Dorothy Lamour—perform their own stories as the doubles of both those they might wish to be and the selves they are. In *Petit à petit* (1968–1969), which Rouch later made with his African collaborators from *Jaguar*, the surreal of reality is not only that of a non-Western culture for the European but also that of the Western culture for the non-European, while in *Chronique d'une été* (Chronicle of a Summer, 1960) Rouch brought his camera to Paris and its "strangeness." In such films, Rouch brings together what is logically unconnected in a free association always drawn from social reality but never unrelated to an imagining that may also be unconscious.

[6] *Specters of the Real:*
Documentary Time and Art

Specters belong to the Real, they are the price we pay for the gap that separates reality from the Real.
:: Slavoj Žižek, *The Metastases of Enjoyment*

A specter is . . . a trace that marks the present with its absence in advance. The spectral logic is de facto a deconstructive logic . . . Film plus psychoanalysis equals a science of ghosts . . . a trace that marks the present with its absence in advance.
:: Jacques Derrida, speaking in the film *Ghost Dance* and quoted in his and Bernard Stiegler's *Echographies of Television*

What is central to the aesthetics of documentary is the temporal disjuncture introduced between the real time of the event and its presence again in the filmed record that can be understood as spectral in the sense proposed by both Žižek and Derrida.[1] If to Walter Benjamin's question (albeit rhetorical) whether "the very invention of photography had not transformed the entire nature of art"[2] we answer yes, it is not only because of its mechanical reproduction of the world—which is the focus of his concerns—but also, and as significantly, because of the specific figuring of time that the photograph and film present us with. The instant image, "snapped" by the camera with the "touch of a finger," would now suffice "to fix an event for an unlimited period of time. The camera gave a posthumous shock, as it were."[3] In this chapter, I consider the question of time and memory, and I will argue that it is in the ways in which time is brought into play that documentary is also a political art. Time here is both historical time and time experienced as duration.

The moving image and its accompanying sounds remake our relation to the time of the represented as one of simultaneity, in a present

tense of seeing, but it was not until broadcast television that the real time of transmission was also the real time of viewing. Early television, transmitted "live," was a medium that, like the telephone but unlike film, was not a record and thus there was only the passing and not the pastness of its sounds and images.[4] In the digital, the present of events can be both transmitted and recorded. Experienced in and as the ongoing of digital "real time," events are no longer separated as instants but are instead a continuous stream in the doubled world of an other;[5] made available by Webcam or mobile phone, they can be returned to as remembered.[6] "Real time" is our encounter with simultaneity while geographically separated. We are present in time but not in space with those we chat to online or on the phone. "Real time" is "now" time, lived and experienced time, endured rather than calculated, to draw on Henri Bergson's distinction between measured time and time as duration. Digital real time and its transmission by the World Wide Web, by telephone, and by satellite offers not only interaction but also immersion as we become identified in the unthought of doing and being that is the ongoing experience of the other of the Webcam.

The new forms that are emerging in the virtual space of the digital are discursive structures that also instantiate an array of possibilities for engaging with and in the digital. The mobile phone is perhaps the most important example, for it now gives us at one and the same time always-available simultaneity any place at all (almost) and memory in the images we send and may record. These are images not only of ourselves but also of what we see and are part of, that is, our ongoing reality. We want this to be present to the other who is our interlocutor and to make present to ourselves here the other's gaze elsewhere that we imagine as we listen to her reactions to our visible missive.

Our "here" is actual, as geographical and spatial, and virtual, as thought—in Charles Sanders Peirce's terms[7]—and as the "here" of me, myself, as desiring subject. For Deleuze, following Peirce, it is only the "event" that is actual, whereas the remembered and the anticipated (i.e., the past and future) are thought, imagined, and virtual. In making simultaneous the image of the actual and the virtual image or remembering, the digital engenders not new desires but a new temporality for the articulation of our desiring.[8] The digital image passing between endures as a separated part of me that I can hold, copy, and give (send) as virtual. The voice has never undergone a similar fetishization; is the said and heard more on the side of the actual, more rooted in the contingent and tied to the instance of utterance—a duration—as a passing present such that, reheard, it bespeaks absence as loss and not as made present again? The voice unembodied, like the gaze, is encountered as *objet petit a*, the

uncanny.[9] The mobile phone—as voice and, now, image—nevertheless produces connectivity all over the place, which, when recorded, may become by awful chance the documenting of an event. We may remember the phone calls by terrified students during the Columbine High School massacre and realize again the anguished separation felt by the hearers, who were unable to help or protect, or the recorded messages sent by victims trapped in New York's World Trade Center on September 11, 2001 that movingly speak of life, addressing futures of which we now know they are not a part. More recently, London's 2005 subway bombings became documented by mobile phone cameras showing images of surviving passengers walking in darkness back though the tunnel toward the station and medical care, while the carnage of the train carriage and its dead are an unseen horror escaped.

Two kinds of time are thus figured in documentary: a "now" time of a present speaking and acting, for insofar as film *shows* rather than *tells,* it does so as an ongoing present that unfolds before our eyes. And as past time, for the recording of "now" time anticipates—imagines—a future audience for whom this "now" time will then be a "past remembered." Writing of the "liveness" of television, Derrida observes that it also "works like a kind of undertaker, recording things and archiving moments about which we know a priori that, no matter how soon after their recording we die, and even if we were to die while recording, *voilà,* this will be and will remain 'live,' a simulacrum of life."[10] It is a pastness that for the audience is unmarked, its time appearing as just contemporary, or a continuing time—a duration. However, as Derrida notes, "there is no purely real time because temporalization itself is structured by a play of retention or of protention and, consequently, of traces: the condition of the possibility of living, absolutely real present is already memory, anticipation, in other words, a play of traces. The real-time effect is itself a particular effect of 'différance.'"[11] It is in measured time that causality and narrative come into play, in a past that foreshadows the present as its future, which we will fully know only once past as we determine—that is, speculatively construct—its causes and consequences. Here is historical reality. Everyday reality, however, just is. It is without history until remembered, and recollected.

▶ ──

Documentary Time and Place: Remembering and Memorializing

"Forgetting is a property of all action," wrote Nietzsche in *Uses and Abuses of History*, where he poses a being, and the happiness it makes

possible, as the "unhistorical," in contrast to one who cannot forget and who "no longer believes in himself or his own existence; he sees everything fly past in an eternal succession and loses himself in the stream of becoming."[12] Such a person cannot know happiness: "There is a degree of insomnia, of rumination, of the historical sense, through which living comes to harm and is finally destroyed, whether it is a person or a people or a culture."[13] He argues, therefore, that both "the unhistorical and the historical are equally essential."[14] The documentary film as audiovisual record is a memory machine, but film as record cannot itself recall. While historical events and actions recorded in archival footage can be shown again, these will appear as present-tense actions, not past tense, like flashbacks in fiction film. The past tense must be imposed through a voice-over or captioning subtitle. Documentary organizes the recorded past through a present-tense "speaking about the past" in the remembering of participants and witnesses, as well as the commentary of historians. In this it can become cultural memory. But remembering is not simply the recall of past events; it is also the reencountering of emotions attached to those past events and their losses, and in this, it is a work of memorializing that can become a process of mourning in which pastness is commemorated as the having been, which the subject is able to mourn rather than remember traumatically. Documentary remembers for us, and in doing so, it memorializes not only as a celebrating but also, perhaps, as a mourning; and it is place, I suggest, that can enable such a commemoration in documentary remembering. Mourning, and its accompanying memorials, is a form of forgetting. Ricoeur writes that "forgetting has a positive meaning insofar as having-been prevails over being-no-longer in the meaning attached to the idea of the past. Having-been makes forgetting the immemorial resource offered to the work of remembering."[15] As a result, he concludes, "the primary equivocalness of destructive forgetting and of founding forgetting remains fundamentally undecidable. In human experience, there is no superior point of view from which one could apprehend the common source of destroying and constructing. In this great dramaturgy of being, there is, for us, no final assessment."[16] What is important in the documentary memorial is the *re-presenting* and the figural associations this makes possible, for which indexed reality as factual and material nevertheless remains central, as a kind of fetish, standing in for an absence that is also a loss. My discussion here considers not only the role of affect arising in memorializing but also the implications of this for our ideas about documentary as historical record, as memory, and as art.

In contrast to time as measured, in time as duration, Bergson argued, past, present, and future are neither radically disjunct nor a continuum;

rather, each is made and re-made through the present experience of dura-
tion. This is undertaken through memory and recollection.[17] Maurice
Halbwachs, himself a student of Bergson, similarly argued that "time
does not flow, but endures and continues to exist. It must do so, for other-
wise how could memory re-ascend the course of time?"[18] He nevertheless
opposed Bergson's view of memory as an archive of "printed pages"
that could be opened at will: "In my view, by contrast, what remains are
not ready-made images in some subterranean gallery of our thought."[19]
Rather, recollection involves a re-construction in which, consciously
or unconsciously, we "find in society all the necessary information for
reconstructing certain parts of our past represented in an incomplete and
indefinite manner, or even considered completely gone from memory."[20]
Halbwachs proposes an understanding of memory not as retrieved but
as re-constructed, and this as a process that draws upon social knowl-
edge and not simply the singularity of individual experience. Halbwachs
posits *collective* memory against the individualism of Bergson, that is, a
remembering that is never simply personal but is always enacted from and
in a social context. As a result of this act of incorporation, we engage as
members of the group for whom those images *are* memories.

Collective memory is not a shared memory, however, but
the individual experience of remembering—its manifestation in
consciousness—through a shared social world that constitutes a deter-
minant for memory as the historical real that prompts and shapes the
"memories" as we recollect, and thus *produce,* for ourselves or for our
family and community. Memory for Halbwachs, as for Bergson, involves
the interplay of two aspects: On the one hand, there are the habits of
mind arising from our familiarity with the everyday world we encounter
and our learned experience. On the other hand, there is the mind's act of
recollection, a self-conscious process of reconstruction. He calls "tradi-
tion" that process by which individual recollections become integrated
into the structures of collective memory.

History is a form of memory, of remembering, that is a knowing of
the past in the present. It is a cultural "memory" handed down to us and
evoked in the exhortation to remember. What we are asked to remember
is a knowledge that while deriving from historical accounts also func-
tions as myth did for nonliterate societies, for example, "here our nation
was at its lowest ebb (or highest triumph)." Such remembering is not
a call upon our personal experience but arises through what has been
termed "invented tradition," explored notably by Eric Hobsbawm,[21] who
describes the commemorative practices of late nineteenth-century Western
Europe as "mass-produced traditions." Such traditions, as invented, were

also collectively authored both by the middle classes and by the organizations of the rising working class in their union pageants, banners, and marches, and therefore they were unlike customs that were "practices bequeathed by the past to which a society naturally had recourse for practical ends."[22] A distinction between the natural and the manufactured is introduced here that I want to resist and instead suggest that there is a single process for, Halbwachs writes: "Every group—be it religious, political or economic, family, friends, or acquaintances, even a transient gathering in a salon, auditorium, or street—immobilizes time in its own way and imposes on its members the illusion that, in a given duration of a constantly changing world, certain zones have acquired a relative stability and balance in which nothing essential is altered."[23] Memorials are physical objects in sites constructed to engage us visually and spatially in a duration that is the spectator's time; it is a contemplation that is social, because memorials instate a social other as commemorated and as available to public remembrance in collective rituals in relation to people and an event—for example, the period of collective silence on Armistice Day or the anniversary of September 11. Memorials, as commemoration, are commands to perform a remembering, either directly by the inscription of a text, or through cultural memory in our recognition of the figure or symbols. The time of the memorial itself is always past and completed—in terms of both the time of its making and the persons and events it references. In the present of its encounter by a spectator, it has no time; rather time is on the side of the spectator.[24]

The claim "I remember" is a performative that elides the difference between remembering one's own past and remembering a public past, a learned history, and both of these are distinct from memory as affect. Though memory is, like history, a selection, it is not always a conscious choice, and thus it must also be viewed as involuntary, where present perceptions produce associations that bring to mind a memory and, like a flashback, one is suddenly brought to apprehend a past experience or image in the present. An emotion, either of wishfulness or of loss surrounding an event, might lead to something—an image, phrase, or person—being remembered. The image remembered is not the "truth" of the affect it may accompany, and knowing the image or the event cannot "explain" the emotional response. Freud's psychoanalysis contains two approaches to memories: The first, which was criticized by Halbwachs, centers on the recovery of memories as a key to understanding the symptom. Another approach lies behind this, however, in which Freud focuses not on the retrieval of memory as a content with a truth but on the processes of remembering and of what brings one to remember something

incompletely and thus to remember something as forgotten.[25] To remember is to bring back to the present something of the past, but it is also to engage the pastness of the event and its meanings and emotions.

The work on memorializing pioneered by Maurice Agulhon in his study of the image of Marianne for French republicanism has, argues Patrick Hutton, "signified a shift in historiographical interest from ideology to imagery, from the history of politics to the politics of culture." "To discuss republican ideas might be edifying, he [Agulhon] allowed. But only concrete imagery could give such an abstract notion the emotional appeal needed to acquire a following."[26] Marianne, Agulhon explains, was a "name given in memory of the early secret societies," and it was remembered as the "dream in which the image was first coined."[27] To remember Marianne was to fire the popular imagination in relation to that dream of political freedom, figured as the beautiful woman. Such a commemoration involving a reification of an abstract idea is described by the anthropologist Godfrey Lienhardt in his account of a Dinka man who, having been imprisoned in Khartoum, then "called one of his children 'Khartoum' in memory of the place, but also to turn aside any possible harmful influence of that place upon him in later life. The act is an act of exorcism, but the exorcism of what, for us, would be memories of experiences. Thus also do the Dinka call children after Powers, and after the dead, who to Dinka way of thought are less likely to return to trouble the living if their place and constant presence are thus explicitly acknowledged."[28] The Dinka, Lienhardt suggests, have no conception that at all closely corresponds to our popular modern conception of the "mind" as mediating the experiences of the self, and hence they have no distinction of the conscious from the unconscious. He writes: "Hence it would be impossible to suggest to the Dinka that a powerful dream was 'only' a dream, and might for that reason be dismissed as relatively unimportant in the light of day, or that a state of possession was grounded 'merely' in the psychology of the person possessed. They do not make the kind of distinction between the psyche and the world which would make such interpretations significant for them."[29] We might dismiss as simple animism the general belief in powers shown here by this Dinka father, yet instead it strikes me, as it may have Lienhardt, that it is a process of mourning through which a traumatic past experience is being dealt with—the city Khartoum personifies the traumatic experience enacted upon the man that is acknowledged and propitiated in the giving to his child the city's name. It is a process of memorialization, as distinct from remembering, in which a different—and valued—object stands in for and thus also signifies the trauma. This might appear as grotesque and cruel if

we were to imagine an Auschwitz survivor calling her child by the camp's name. The child would perhaps seem to be burdened by an unbearable reality of which it is innocent but that continues to contaminate it. Yet this burden is indeed one that children of survivors have so lucidly pointed to as being borne by them and has been all the more terrifying insofar as it has remained unnamed, unremembered, and unowned by their survivor parents. Instead, for this Dinka father and his child, traumatic memory is made into a process of external enactment and memorialization, and it is contained and corralled in a symbolizing naming rather than made abject to return again and again.

Writing about anxiety, Lacan argues, "In my experience, it is necessary to canalize it and, if I may say so, to take it in small doses, so that one is not overcome by it. This is similar to bringing the subject into contact with the real."[30] Homeopathy—established on the principle of "let likes cure likes"—seeks to heal through the similar, prescribing a remedy that will cause the symptom in a healthy person but in the ill body will stimulate it to restore itself to health. Yet for psychoanalysis this cannot be a form of inoculation against or resistance to anxiety or the real, as if it were a pathogen that could be removed. The experiencing of "small doses" must, rather, bring about some accommodation with the real of anxiety, in a circumscribing such that it no longer floods the subject or defines every encounter with others in reality as always being in the service of the jouissance of the other.[31] Lienhardt explains that for the man who called his child Khartoum, "it is Khartoum which is regarded as an agent, the subject which acts, and not as with us the remembering mind which recalls the place. The man is the object acted upon. Even in the usual expressions of the Dinka for the action of features of their world upon them, we often find a reversal of European expressions which assume the human self, or mind, as subject in relation to what happens to it; in English, for example, it is often said that a man 'catches a disease,' but in Dinka the disease, or Power, always 'seizes the man.'"[32] This, too, is how Lacan understands the agency of the *objet petit a*, the gaze or voice that seizes us. Our memorials, as ways in which we acknowledge the dead, are also invested with a power by which we may be seized in our remembering. The now time of Nietzsche's unremembering implies both a distraction and an immersion that documentary, too, engages us in while also opening us to the historical of memory. In this movement there can emerge a cognizance of the unrememberable and of trauma, so that in the documentary art of remembering we may be enabled to apprehend the real without being overwhelmed by it.

Michel Foucault, in his conception of specific temporal "epistemes," or epochs, locates the way in which societies produce discourses of knowledge and memory, thereby defining the knowable and the citizen-subject of knowledge. He argues that in nineteenth-century Europe "a profound historicity penetrates into the heart of things, isolates and defines them in their own coherence, imposes upon them the forms of order implied by the continuity of time."[33]

The documentary film, too, presents such a historiography, a teleology, whereby what we see is organized through a causality of explanation or persuasion, such as that which we experience in Michael Moore's powerfully rhetorical films. Place and space are visible evidence for this narrative. It is, in Deleuze's terms, a "movement-image" cinema in which the unity of space and time, its continuity, in Bazin's terms, is secondary and subordinate to its role as illustration for the film's plot, theme, or thesis. Place here is a matter of picturing, including the emplacement of people within this picture. The documentary's argument is *applied* to the place and space through which we discover its truth.

Documentary's ability to show place and space as immanent—as a "time-image" as Deleuze defines this—involves a freeing of depicted time from the temporal causality of cinematic representation. (I return to Deleuze's distinctions later in the chapter.) Such a documentary time image is an anthropology of place and space, insofar as our dwelling in place and space involves our dwelling *with* both a landscape and a fellow people of neighbors and thus a community. The anthropology of place is the process of a recognition, both descriptive and analytical, of a way or ways of dwelling that is material and psychological, both physically manifest and memory.[34] Anthropology is a discipline of seeing. As a colonial project, its "frames of seeing" presumed the knowing eye of the Western anthropologist encountering the "unknown" place that was to be "read" in an understanding that also "speaks" that place to the outside, the non-placed, and to the other. But understanding is seeing through a particular approach to knowledge, such as in the assumption of a functional role for what is observed—that is, a purposefulness in fulfilling needs, and therefore the phenomena is taken to be caused by, and a response to, those posited needs. Anthropology here thus measures place as activity and movement as caused.

An anthropology of time, in Bergson's and Deleuze's sense of duration, can instead be imagined as one that is engaged in a seeing that focuses on the ways a community "endures" through its practices of memory in individual and collective remembering for which reenactment and ritual are also a remembering. Yet change is endemic. Both colonialism

and the anthropologist brought change, most simply as an external other requiring the community to include this other in their world.

Deleuze has described Europe following World War II as lacking the habits of dwelling: "The fact is that in Europe, the post-war period has greatly increased the situations in which we no longer know how to react to, in space which we no longer knew how to describe. These were 'any-spaces-whatever,' deserted but inhabited, disused warehouses, waste-ground, cities in the course of demolition or reconstruction. And in these any-spaces-whatever a new race of characters was stirring, a kind of mutant: they saw rather than acted, they were seers."[35] This "new race" might be diasporic dwellers in such "any-spaces-whatever," making space as place again. As seers they might be documentary filmmakers such as Jean Rouch, engaged (and engaging spectators) in the process of recollection images and of understanding not as a linear process of argument or causality but as a process of intersection and as present in the same time of knowledge and meaning. It is as such a "time-image" of now time that enables recollection and memorializing.

In *Maelstrom: A Family Chronicle* (1997, Netherlands), Péter Forgács uses images of the sea's stormy waves crashing onto the shore to figure the turbulence of the 1930s. These are intercut with the home movies recorded by Max Peereboom that, edited with the documentary records of contemporary newsreel and radio, become our "now time." The film is not an explanatory account of the events it presents—it simply cites key events. It enacts the particulars of remembering as we follow the lives of Max and his family—through holidays, work, marriages, births, and deaths. A different kind of remembering is introduced through the home movies of a second family: here we see another successful, proud father and doting grandfather Arthur Seyss-Inquart, the former Chancellor of Austria who joined the Nazi Party in 1938 and was appointed Reichskommissar for the occupied Dutch territories in 1940. This knowledge produces a powerful and poignant contrast between the Peerebooms, whose lives we have come to know and care about through Max's camera, and this other father and filmmaker who will ensure their annihilation.[36]

The Peerebooms have lived again for us through Max's camera and its record of events that took place over sixty years ago, commemorating this family and the living community it was a part of while also narrating their loss, for we already know the ending of the story Max himself will be unable to go on to tell. As spectators we are painfully suspended between 1942, watching Max's family packing in response to the order to leave on the awaiting trains and sharing their hopes and fears for a future

they can still imagine, and the present time of viewing and our knowledge of their fate. Through this suspense, the film's re-presenting of these fragments of family home movies enacts a "remembering" that engages the viewer in a coming to know of loss as an emotional experience summed up by the words "if only."[37] It is a personal memory of loss, even though we ourselves never knew the Peerebooms, that draws us into a work of both mourning and commemoration.

Mikhail Bakhtin recognized the importance of the space–time matrix, which he termed the "chronotope," where "time, as it were, thickens, takes on flesh, becomes artistically visible," while "space becomes charged and responsive to the movements of time, plot and history."[38] This is not, Michael Chanan notes, "so much a question of grammar, the logic of the formal temporal and spatial devices (a certain way of organizing space) or flashbacks (a way of organizing time), although this is part of it, but rather the relation of these attributes, and the way they are organized, to the cultural and historical conditions in which they arise."[39]

Documentary time and space are central to Milica Tomić's *Portrait of My Mother* (1999), which presents a work of memory and a process of memorial transformation of the space and time of the political of the public and the private, of the nation and the family, that is also a process

Portrait of My Mother (1999) installed in a gallery. Still reproduced by kind permission of the artist, Milica Tomić.

of desire. Installed in a gallery are two (or sometimes four) slide projectors showing images recapturing the past of Tomić, her national history, and her mother's life with its successive intellectual obsessions including, now, a fierce commitment to the Serbian Orthodox Church. Between these is a large screen projecting a video recording that appears to be an ordinary documentary, a journey taken by foot, by car, by tram, and by car and foot again from her own apartment to that of her mother's. Made in a single day, it is filmed entirely by handheld camera. The spectator is thereby restricted to a single optical point of view—the camera's mechanical eye—with which we travel across Belgrade and thus adopt as our own. It is a view to which, however, we may also attribute a subjectivity, namely, Tomić herself, and identify with. Yet immediately the sound track alerts us to a discrepancy, for the single view and subjectivity of our vision is opposed and replaced by the multiple voices of several people as we follow the discussion—recorded at another time and place—between Tomić, her mother, and her mother's oldest female friend. We may authorize a new controlling subjectivity, namely, that of Tomić as artist and author of the work (that she is not the cameraperson is only revealed at the end), but this will never be fully aligned with the daughter who debates stories of the past with her mother. She says, "Between her [mother's] father and my father I put a child's voice," so that the words "Mama" and "Papa" are heard intermittently between the recorded conversations and the sounds of the street of cars, footsteps, and so on. This voice embodies both the past, as the child Tomić was, and the future, in which the daughter becomes mother to her own son. Other nondiegetic sounds are heard over the black leader that intermittently interrupts the flow of images, first as a kind of explosion as her mother tells of the end of her marriage to Tomić's father, and again shortly after strange rhythmic slapping noises accompanying the voice-over when she describes their breakdown in contact, which here seem to stand in for the missing sexual relation of the parents. Later, during the taxi journey, after a long discussion of the bombing of Sarajevo, Kosovo, and now Belgrade, a louder explosion is heard and then a long sequences of noises we can begin to recognize as stone or concrete debris falling down endlessly, and we realize the reference is to the noises reported by survivors of the bombing as they crouched in a basement while the building above slowly disintegrated. *Portrait of My Mother* is a memory work, not as a recovery of memory, but as a staging, a mise-en-scène through which memory as affect is apprehended. Its temporal montage is at once personal and public in its interweaving. The meaning of the past is continually remade by Tomić in the present of remembering as a work of identity and its politics.

Portrait of My Mother (1999). The camera finds Milica's father, who has boarded a bus, while her mother's voice, heard as voice over, speaks of their relation and "the fact that I didn't feel any intimacy." Still reproduced by kind permission of the artist, Milica Tomić.

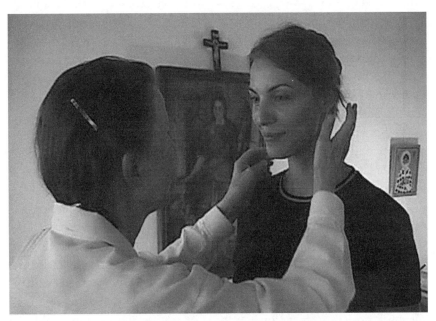

Portrait of My Mother (1999). Milica now appears on camera, embracing her mother as she arrives in her flat at the end of her journey. Still reproduced by kind permission of the artist, Milica Tomić.

Reality in Documentary Art

The traditional role of art as realism with its purpose of enabling us to know and be moved by the world was challenged by the scientific and factual possibilities of the new media of photography and cinematography that mechanically record reality with an automatic faithfulness that mimics human vision.[40] At the same time, this realism was dismissed by critics who, drawing on the claims of romanticism, saw it as merely reproduction lacking the interpretation and intervention of the artist's subjectivity. The process of perceiving the world as imaged became foregrounded in the visual arts while the representation of historical reality as such ceased to be central. To the question "Is art useful?" Baudelaire polemically replies "Yes. Why? Because it is art."[41] Rejecting art as mimesis, he argued for the autonomy of art and saw its role as imagining anew. It is not the artist alone who produces this imagining, represented in the artwork; rather a process of encounter and exchange between the work and viewer arises through which we come to engage imaginatively in a way that produces a newness. The politics of art must be found in this process of engagement.

The work of Hans Richter provides a salient example of the interrelating of art, reality, and politics. Richter was a central member of the Zurich Dada group and by the 1920s was recognized as a major avant-garde artist and filmmaker. As an artist, Richter was deeply committed to a modernism that eschewed the representational and the reproduction of apparently "objective reality." In abstractionism Richter saw the possibility of a universalism in opposition to individualism, whereby, Timothy O. Benson suggests: "The autonomous elements of art held a power of embodiment capable of transcending the particular, enabling a universality."[42] Through formal invention the bourgeois and capitalist conventions of reason and reference in realist figural art could be subverted. At the same time, as a political activist in Munich and Berlin after World War I (in which he had been wounded), he sought to relate his concept of art to his political commitment. Given the economic and political developments in the late 1920s, and influenced by the Soviet filmmakers, Richter turned to figurative representation in a series of documentary essay films, as the radical form for art necessary at that moment, as other avant-garde filmmakers, such as Luis Buñuel and Germaine Dulac, would later do.[43] Form intervened in the figurative, however, as shown by Richter's use of cinematic devices such as slow motion, fast cutting and close-ups, which abstracted the recorded reality from its immediate reference, enabling associations not conventionally given by the objects themselves.

While Richter, unlike many other Dadaists, did not embrace surrealism, he said that "I did not look at natural objects as literal elements," for in film, "every object tells a 'story' and awakens some emotional or representational association, regardless of the context in which it is experienced." Despite the illogical happenings in his films, the flow of images, he argued, would always make a story, for that "is how our mind works." But he also observed, "In addition to the emotional connotation of every object, I learned that there was an abstract, or purely visual, significance as well."[44] For Richter, form is a material element of art, and a central material of film is time. Citing Brecht's declaration that "true reality has taken refuge in the functional"[45] (quoted earlier in the Introduction), it is cinema, he argues, that can reveal the "*functional* meaning of things and events, for it has *time* at its disposal, it can contract it and thus show the development, the evolution of things."[46]

What is rejected here is the mere recording of actuality as spectacle or the beautiful, and instead the documentary is presented as an epistemological discourse that requires that we not only *see* but also are brought to *know*.[47] At the same time, in the documentary's presentation of reality, it also produces a statement or discourse by which it constitutes the recorded reality as knowable. But, as I have earlier argued, facts are not given; they must be discursively asserted, thereby constructing them *as* facts. Theodor Adorno and Max Horkheimer, in their critique of Enlightenment rationalism, demand an interpretive understanding of the presumed givenness of what is presented as the factual:

> What appears to be the triumph of subjective rationality, the subjection of all reality to logical formalism, is paid for by the obedient subjection of reason to what is directly given. What is abandoned is the whole claim and approach to knowledge: to comprehend the given as such; not merely to determine the abstract spatio-temporal relations of the facts which allow them just to be grasped, but on the contrary to conceive them as the superficies, as mediated conceptual moments which come to fulfillment only in the development of their social, historical, and human significance. The task of cognition does not consist in mere apprehension, classification, and calculation, but in the determinate negation of each im-mediacy.[48]

Facts are aspects of reality recognized and distinguished through specific regimes of criteria—scientific, legal, or historiographical. Adorno's injunction requires that we not accept facts at the "face value" of a rationality, which presumes a single premise, unmediated and derived from regimes of category not themselves examined. Adorno and Horkheimer point to the multiple in the singularity of "facts." The "facts of the matter" are established after the "event," which thus

brings the "event" into existence as the factual, halting the undecidability of the event in its contingency. An event is an action: something happens, becomes classified as an event, and is extracted from the ongoing, contingent reality of a multitude of actions and happenings. Events entail the temporal as actions that, located in time and space, become identified as timely and caused.[49] In the scientific experiment that tests a hypothesis, something happens (even if only the failure of the experiment), and "what happens" is articulated as the factual and a scientific truth by the procedures of the scientific discourse. If it enables new knowledge or changes understanding, then it becomes a scientific event. Events are thus known by the facts established about them, and they are singular and exceptional in being unrepeatable, for while the experiment can be repeated, the event of the transformation of knowledge it brought about cannot. The certainty of the event is unknown at the time of its happening, so that what comes to be an event is understood as such only afterward. Derrida writes: "The event, the singularity of the event, that's what *différance* is all about."[50] John Rajchman suggests, following Gilles Deleuze, that the event can be considered as "a moment of erosion, collapse, questioning, or problematization of the very assumptions of the setting in which the drama may take place, occasioning the chance or possibility of another, different setting."[51] It is this undecided in the contingent-to-become event that is central to documentary, which both constitutes and represents "events." For Deleuze it is the chanceness of the event, of its contingency, that is important. Alain Badiou instead emphasizes the eventness of chance, of the event as the break in the ongoing of the contingent inasmuch as it is what is experienced and discerned as difference within the same and familiar of the contingent, while this event as difference is also uncertain *because* it is not the same. It is only by chance that the possibility of discerning differently, and thus the event, arises. Chance, he says, "is, for me, the predicate of the contingency of *each* event."[52] That an event is distinct from an action is demonstrated by Duchamp's *Fountain*, a porcelain urinal laid on its back that he offered for exhibition in 1917 and that, despite being rejected—in Alfred Stieglitz's photograph—became the event by which the "readymade" was made art. The event is unrepeatable, and at the time and context of its appearance, it was unknown and unknowable as the event we now understand it to be. Not only the readymade but also the document might become an event as an "artwork,"[53] enabling a "seeing anew" such as that which Bataille proposed in *Documents* (discussed in chapter 4), as evidentiary of the contingent as well as the socially organized

worlds that, juxtaposed, bring about new connections. The surrealists' idea of the unmotivated juxtaposition anticipates the role Deleuze gives to his concept of interval in cinema.

▶ ———————————————————————————————————

The Time of Events and Being

The contingency of living becomes an experience in time only when it is correlated to an idea of a point in time marked by measurement and by the memory of place and of the material experience of sights, sounds, and smells. Walter Benjamin writes: "It is not that what is past casts its light on what is present, or what is present its light on what is past: rather, image is that wherein what has been comes together in a flash with the now to form a constellation."[54] We become aware of time through movement marked by change as distinct from repetition. Through observing the duration of movement by objects and people, we understand the time of the event. Time invokes a before and an after, and with this it invokes the possibility of causality. In a process of "afterwardsness," contingent reality in its duration becomes interpreted as moments of action that bring about change as "events." Doane notes that, for Peirce, "the ungraspability of the present is a consequence of the fact that thought (and its necessary embeddedness in signs) *takes time*." Time is a continuum, but human perception of time sees the present as a point of discontinuity in the instance of the moment, and, Doane argues: "The absolute break between past and future is a symptom of our consciousness of this discontinuity."[55] For Peirce, time is the form in which logic presents itself to our objective intuition, "and the signification of the discontinuity at the actual instant is that here new premises, not logically derived by Firsts, are introduced."[56] As a result, Doane suggests that the "instant is the condition of the possibility of newness, novelty, modernity."[57] It is the contingent, and not the event, that engages the instant and the possibility of the new.

The image, Doane says, "does not speak its own relation to time"; as a result: "Film *is*, therefore, a record of time, but a non-specific, non-identifiable time, a disembodied, unanchored time."[58] Film records indexical signs of time—clocks, shadows cast by the sun, styles of clothing or automobiles, but not time itself. It records events in time in a duration, but what we watch is not the time of the event but the event re-performed in a now time of viewing. Documentary film, however, gives a tense to each sound and image it presents to us, as time *past* insofar as it is record and not fiction. Yet, as Walter Benjamin writes,

the historical index of the images not only says that they belong to a particular time; it says, above all, that they attain to legibility only at a particular time. And, indeed, this acceding "to legibility" constitutes a specific critical point in the movement of their interior. Every present day is determined by the images that are synchronic with it: each "now" is the now of a particular recognizability. In it, truth is charged to the bursting point with time . . . It is not that what is past casts its light on what is present, or what is present its light on what is past; rather, image is that wherein what has been comes together in a flash with the now to form a constellation . . . For while the relation of the present to the past is purely temporal, the relation of what-has-been to the now is dialectical: not temporal in nature but figural (*bildlich*). The image that is read—which is to say, the image in the now of its recognizability—bears to the highest degree the imprint of the perilous critical moment on which all reading is founded.[59]

The pastness of the documentary image is not its time in the past but in the now of its subsequent encounter, which is also a reading of its time and its timeliness. Deleuze, too, presents the relation of time as figural, though he rejects the notion of a dialectic. He draws on Peirce's account of time and the virtual, as well as Bergson's understanding of duration and of being, to develop his notion of the interval—a term he takes from Dziga Vertov—and of the meanwhile that the interval gives rise to. Deleuze distinguishes a rational interval as one where the interval dividing two spatial sections serves simultaneously as the end of the first and the beginning of the second, thereby assuring continuity in space and succession in time.[60] It can do so because we infer and make sense of the time or space elided by the edit in terms of rules of continuity so that the movement in the film and the movement forward in screen time and story time of the film is a moving whole, a duration from which the image, as an edit, is "cut" from a mobile section of duration the rest of which is elided. This concept of the interval addresses the cut, the edit, whether in classical continuity editing or Eisenstein's montage. Deleuze opposes this to what he characterizes as the irrational interval that produces a dissociation rather than an association of images and times that, D. N. Rodowick suggests, "neither marks the trajectory between an action and a reaction nor bridges two sets through continuity links. Instead, the interval collapses and so becomes 'irrational': not a link bridging images, but an interstice between them, an unbridgeable gap whose recurrences give movement as displacements in space marked by false continuity."[61]

It is a juxtaposition that produces association that is not already thought and not organized to prompt a certain order of connection, but instead a "here and there," as Trinh T. Minh-ha suggests, "with no linear intent in mind . . . here and there, rather than before and after, because

there is no before and after."[62] What may arise is "thought from the outside,"[63] a becoming thought that is not internal to the juxtaposition but a potential or a virtuality. What is introduced by this outsideness of thinking is a series of possibilities, and thus a series of times in which these virtual possibles might be actualized or become. The irrational interval produces an image becoming rather than being, and thus it includes a hesitation, an uncertainty, and a suspense as to what might be possible, which can never be fully resolved by the actual thought we are led to. Deleuze thinks juxtaposition philosophically where surrealist works assert it. He writes, "Film ceases to be 'images in a chain . . . an uninterrupted chain of images each one the slave of the next,' and whose slave we are (*Ici et ailleurs*)." Instead it becomes

> the method of BETWEEN, "between two images," which does away *with* *a*ll cinema of the One. It is the method of AND, "this and then that," which does away wit*h all t*he cinema of Being = is. Between two actions, between two affections, between two perceptions, between two visual images, between two sound, between the sound and the visual: make the indiscernible, that is the frontier, visible (*Six fois deux*). The whole undergoes a mutation, because it has ceased to be the One-Being, in order to become the constitutive "and" of things, the constitutive between-two of images.[64]

The irrational interval no longer divides a before from an after but suspends the spectator in a state of uncertainty where it is impossible to know or predict in advance which direction change will take. Instead, Rodowick argues that the "chronological time of the movement-image fragments into an image of uncertain becoming."[65] The irrational interval of the time image is the meanwhile, of that during or within the time which intervenes. Deleuze and Félix Guattari write that it is "no longer time that exists between two instants; it is the event that is a meanwhile: the meanwhile is not part of the eternal, but neither is it part of time—it belongs to becoming."[66]

The visual artist Yves Lomax, drawing on Deleuze, suggests, "In the empty meanwhile nothing happens or moves in the present and this 'nothing happens in the present' could be a way to (re)think stillness. To think stillness in this way would be, at the same time, to think the 'movement,' albeit virtual, of becoming. Indeed, thinking stillness in this way does not bring my thinking to a halt; on the contrary, it invites my thinking to go with becoming in itself, which is nothing but the turning of time where chance is given a chance, which is what marks time's resistance to banality."[67] In the notion of the pregnant or significant moment in his discussion of the classical sculpture of the Trojan priest, Laocöon,

G. E. Lessing articulated an understanding of movement in stillness as, John Stezaker suggests, "an expanded moment, rather than as an inter-ruptive one . . . which allows an unfolding within the image."[68] Lessing writes, "The longer we gaze, the more must our imagination add; and the more our imagination adds, the more we must believe we see."[69] The stilled action of sculpture nevertheless signifies a future in which the movement of a gesture begun but held would be—or could be—realized. The arrested flow in the image presents a being forever halted before its becoming, which is nevertheless present because it is imaginable in a pos-sible future time. The moment held is both preserved and also lost to time. Inexorable time can only be stilled through the work of memory, and thus by representation, as a moment or instant held in the mind as depicted. It is only by no longer being that life lived can endure unchanged. Represen-tation always, therefore, involves a certain death and a certain life and, with this, a certain mourning.[70] Laura Mulvey, exploring the deferral and deferred action (*Nachträglichkeit*) of cinema's time—death twenty-four frames a second—observes that the "cinema has always found ways to reflect on its central paradox: the co-presence of movement and stillness, continuity and discontinuity . . . In the aesthetics of delay, the cinema's protean nature finds visibility, its capacity to create uncertainty that is, at the same time, certainty because its magic works without recourse to deception or dissimulation."[71] She reminds us that in his account of the punctum, Roland Barthes writes of "this vertigo of time defeated" that invokes a consciousness of death: "In front of the photograph of my mother as a child, I tell myself: she is going to die; I shudder, like Win-nicott's psychotic patient, *over a catastrophe that has already occurred.* Whether or not the subject is already dead, every photograph is this catastrophe."[72]

Walter Benjamin pointed to the importance of stillness in the move-ment of time when he asserts "the notion of a present which is not a transition, but in which time stands still and has come to a stop." He argues, "Materialist historiography . . . is based on a constructive prin-ciple. Thinking involves not only the flow of thoughts, but their arrest as well. Where thinking suddenly stops in a configuration pregnant with tensions, it gives that configuration a shock, by which it crystallizes into a monad."[73] For Benjamin, this enables what he terms the blasting open of the continuum of history and of historical time as a movement of cause and effect. The contingent historical object appears in a new setting, described by Andrew Benjamin as "the explosive 'now-time,' the instanti-ation of the present by montage; by the movement of montage (a montage effect whose determinations are yet to be fixed). It will be a montage that

involves temporality as well as objects and images."[74] It is through cinema that such a "now-time" came to be conceptualized, since, as Hans Richter suggested, it is film that "has *time* at its disposal." Most of all, it is the time to see differently.

Film—both documentary and fiction—interrelates times and thus places, showing simultaneous events and actions. These, being viewed in series, may be understood not only in terms of an already known and given causality but also in terms of the demand to think both this and that together, bringing the idea of connection, or its absence, into play in an interval that is never fully rational. Arising here is a process of becoming that cannot be represented as such but only apprehended through the imaginative work of spectatorship.[75] Historical time and the referential are subordinated to the bodily time of viewing, that is, to an experiential process of memory, cognition, and affect. While the observational documentary reproduces a lived reality of events and actions in the real time of their occurrence, the spectator sees this as a *part of* the world, juxtaposed to other remembered realities. Unplotted, the meanwhile of contingent reality pervades documentary. It is the aim of cinéma vérité and direct film, Deleuze declares, "not to achieve a real as it would exist independently of the image, but to achieve a before and after as they coexist with the image, as they are inseparable from the image."[76] The documents of the past re-presented figure both a historical reality, and the real, the uncanny, which is that moment for Freud when "the distinction between imagination and reality is suddenly effaced."[77]

Documentary art is the engagement of each in an aesthetic process in time that is an interrelationship of stillness and time, being and becoming.

▶ ──────────────────────────────────

The Document in Art and the Political in Representation

The possibility of "seeing anew" through our encounter with reality is invoked by T. S. Eliot in his poem "East Coker,"[78] for in relation to the knowledge we derive from experience, he writes,

> The knowledge imposes a pattern, and falsifies,
> For the pattern is new in every moment
> And every moment is a new and shocking
> Valuation of all we have been.

The project of opening us to the shock of the new in our experience of the world and the defamiliarization of the everyday and the taken for granted reemerged in the work of a number of engaged artists and

filmmakers in the 1970s and 1980s in Europe and America. The referential is both the documentary evidential and, re-presented, alongside its referential purposefulness, it is set in play in these works as both a materiality and an idea, a concept imaged that realizes the conceptualism implicit in Dada and prompted the term "conceptual art."

It was a development that Peter Wollen addressed in two key essays as a countercinema[79] and in terms of "two avant-gardes," one formalist and the other—that is my concern here—an engagement with both form and politics.[80] This produced an encounter with the political in relation to the represented by addressing issues of history and the social, while setting in play the contingency, specificity, and multiplicity of documentary reality through juxtapositions of the contingent realities shown and heard. Emerging from the intervals of image and image, sound and image, and sound and sound is a certain pausing in discontinuity that Deleuze's "meanwhile"—which enables a resistance to the present—gives articulation to. It is imagining anew not for us but before us, which can only become an after in the spectator's time. Evidence and the factual are, then, not only content but also form in constituting the documentary materiality deployed within the work of serial and time-based documentary art. This is seen in the work of Mary Kelly and her *Post-Partum Document*, a serial gallery installation work on motherhood (1973–1979), *The Nightcleaners Part One* (1975), both of which I discuss shortly, and a number of others in this period. In *The Song of the Shirt* (Sue Clayton and Christopher Curling, 1979), documentary, fictional enactment, and re-enactment of the documentation of nineteenth-century philanthropy is placed alongside images, photographs, and drawings that open up a questioning of the given of history and its representation. *Handsworth Songs* (1986) by the Black Audio Group addressed contemporary riots in Birmingham and the history of Britain and black emigration through its juxtaposition of present newsreel footage and interviews and a past of archive footage and photographs, using formal devices including freeze-frame, refilming, and a poetic voice-over.

The debates that concerned Richter in the 1920s are similarly confronted by these artists and filmmakers, for what is risked is that art drawn upon for political activism is subordinated to a purpose other than art, reneging on the autonomy of art.[81] In becoming form for a content, art is constrained to the space and time of the represented political event and to a specificity arising in the conjuncture of the historical moment and time, which overturns or subordinates the specificity of the art object and its potential for universalism. Moreover, political art is bound to an act of communication, to saying *this*,

whereas modernist art defined itself as engaging in a critique of rea-
son, of the knowable, and of history as narrative. It is precisely the
assumptions embodied in the characterization of these "risks" that are
challenged in order not only to represent politics but also to engage
the viewer in an experience of the political or of historical reality
and the social as a public sphere that can be contended, re-made, and
re-imagined. The romantic presumption of the sovereignty of art is
critiqued in the focus on the contingent and its specificity as such—on
this moment and event. The ways in which the referential is "played"
within the works challenges meaning and meaning systems, introduc-
ing instability and undecidability in the uprush and deferral of meaning
in the moment-by-moment movement of the film or video work. The
aesthetic effect is not a response or reaction to what we see—the thing
or object—but to our seeing of the "thingness" as an experience of the
process of the work.[82]

Mary Kelly's work both developed from and comes to critique
aspects of conceptual art. A key influence for Mary Kelly was the serial-
ism of Hans Haacke's *Real Estate Systems—Shapolsky et al. Manhattan
Real Estate Holdings, A Real-Time Social System, as of May 1, 1971*
and of his sequencing of documents together with text that functions as
counterpoint.[83] She began *Post-Partum Document* in 1973, paralleling
her involvement in the collective project *Women and Work* begun the
same year, and she notes: "There are elements from all of this activity that
condense in the *Post-Partum Document*."[84] *Women and Work* sought "in
the display of documents, the time that we took to investigate the condi-
tions in the factory, and the way that we used all the forms of information
and visual display [to] give the viewer a way of weaving through and
understanding the problem of that factory and its means of implementing
equal pay."[85] What their approach thereby missed was the women's work
at home and place of the psychical within the domestic space. It was this
that Kelly would investigate in *Post-Partum Document*, while seeking to
create in the gallery space an experience similar to the real time of the
long take in film, "drawing the spectator into a *diegetic* space: the idea of
real time or what you might call the *picture* in the expanded field."[86]

In *Post-Partum Document*,[87] Kelly created an aesthetic work of the
mother–child relationship—itself a proper and familiar art theme. Here,
however, the artwork is the documenting of their relationship constituted
by the six key material traces she deploys, each the instantiation of a
separation on the part of both mother and child, together with accom-
panying records and charts that articulate these traces as facts through
a specific social or scientific discourse. A framed title introduces each

series, beginning in "Documentation I: Analyzed Faecal Stains and Feeding Charts, *Experimentum Mentis I Weaning from the breast*," which is accompanied by a diagram on human metabolism in the first year of life and a diary of the correlation of Kelly Barrie's nutritional intake with his stools and his weight gain overall. There follows a series of his used diapers, and below these are the details of the food he ingested and the time of feeding. Kelly concludes each section with a discussion of the social and psychical context of the desire and subjectivity—conscious and unconscious—of both mother and child. This is prefaced by Lacan's schema "R," which represents the subject's position within the fields of the imaginary, the symbolic, and the real, a different aspect being emphasized each time, together with an adaptation of Lacan's algorithm of "S signifier over s subject" in which Kelly introduces the mother's voice:

$$\frac{\text{(WHAT HAVE I DONE WRONG?)}}{\text{S}}$$

In subsequent sections, Kelly directly incorporated her own voice in the narratives of her diary observations, which constitute documents of the subjective voice of maternal desire. The last section, "Documentation VI Pre-writing alphabet, exerque and diary (*Experimentum Mentis VI On the insistence of the letter*)," addresses the process of learning to read and write, in which the positioning of the mother and child becomes finally and fully social, though its Oedipal drama is never complete. Here, the child's first attempts at letter shapes are placed in the upper portion of the slate, under which is the mother's print-script commentary, and finally her type-script narrative (diary), together forming three registers analogous to the Rosetta stone. The acquisition of written language in literate societies marks the definitive accession of the child into symbolic relations, thus her son's entry into culture, and so the "slates" mark the end of the project itself, as well as the inevitable though incomplete ending of this stage in the mother–son relationship.

The series of presented signs and traces, stains and scribblings, words and memorabilia appear to offer a discourse of rational knowledge narrating the child's development and his mother's relation and response to the separation it imposes. But this narration is incomplete and obscure, baffling both the mother and the spectator. The scientific diagrams, while being signs of the claim to truth of science, are not simply or sufficiently explanatory. It is not the facts of nutrition or the issues of schooling that are documented here but the discursive construction of the mother by an

Post-Partum Document (1973). Documentation VI, Pre-writing
Alphabet, Exerque and Diary, 1978. Detail, 1 of 18 units, 20 x 25.5 cm each.
Perspex unit, white card, resin, slate. Collection, Arts Council of Great Britain.

authorized knowledge that always poses the subject as insufficient, giving
rise to her anxious appeal, "What have I done wrong?" Her address is
to an other who knows, to science in the position of the master and also
to the viewer; it is a miming of the mother's dilemma, and the spectator
might respond, "You're telling me this, but what are you really saying?" If
we are caught by the poignancy and resonance of these signs and objects
that are equally powerful fetishes supporting the mother's—and now our
own—desire, then we are also engaged by its impossibility. In the last
section, the reference within the "Documentation" notes to "an insistence
of the letter in the discourse of the unconscious" places Lacan's psycho-
analysis itself as a discourse of "knowledge" along with political economy
and statistics, just as nutrition, botany, and so on figured in earlier sec-
tions.[88] We are moved between a documented reality and the discourses
of the university—science—as master, of the hysteric, and the analyst.[89]
Therefore, it is a psychical and social reality that is documented, while the
real is traced in the course of a mourning of repeated loss across the six
sections. Psychoanalysis is not exempt from such fetishizing, yet because
it can never fully narrativize desire, in Kelly's deployment of its discourse,
its aporias are also made apparent.

The continuing aesthetic and political achievement of *Post-Partum Document* lies both in its feminist critique—which appears both historical and uncannily contemporary—and its pleasurable exploration of motherhood and its mementos in the framed objects. Its aesthetic power also arises from the progressive coming to know that it engages the viewer in, but this remains incomplete while also engaging us in a conceptual and emotional understanding of the interposing of subjective desire and social determinations as we encounter the anxiety of the limits and limitations of knowledge.

The Nightcleaners Part One (1975) by the Berwick Street Collective is a key British film of the 1970s, influenced by the work and ideas of Bertolt Brecht, as well as the new accounts of ideology and the subject.[90] The collective was a group of artists and filmmakers that included Mary Kelly, Marc Karlin, James Scott, and Humphrey Trevelyan. From 1970 to 1972, the collective filmed a group of office night cleaners, mostly women undertaking their isolating and repetitive routines of work, and recorded through interviews the stories of individual women. Each is involved in balancing their need to earn for their families and to take care of their children; night work enables them to do both, but at the cost of their health. *The Nightcleaners Part One* began as a campaign film for the women who were struggling for better working conditions; for feminists, the night cleaners were emblematic of the position of women, confined to low-paying work and responsible at home for unpaid domestic work and child care. The inherent difficulties of unionizing among isolated groups of office cleaners, and the indifference of the male-dominated union, meant that these initiatives were finally unsuccessful despite the extensive financial and moral support of the London Women's Liberation Movement. During filming, the collective adopted a documentary style of observational camera and interviews; in the editing process, following the end of the campaign, a different film began to be conceived that would reflect upon the process of political struggle and consciousness raising for the workers, feminist activists, and filmmakers, as well as audiences in a specifically Brechtian project. From this emerged an aesthetically radical film that remains politically important.[91]

In *The Nightcleaners Part One*, we are brought to apprehend, and thereby understand, the repetition, arduousness, and ritual of the cleaning work. Every night involves the same routine around awkward office spaces, moving heavy vacuum cleaners among filing cabinets and desks that must be dusted without disturbing the papers left on them. One shot, tightly framed and in close-up, reveals a cleaner bent over the toilet basin she is scrubbing. Such scenes are edited with extracts from interviews

with male managers and a company owner, one of whom asserts that all that is asked of the women is that they "clean here as she does at home." The "found ironies" are all too apparent. From the stories of these women, the film opens out onto the story told by feminism of the contradictions of sexuality, work, and motherhood experienced by women, presented through voice-over by feminist activists (including Sally Alexander and Sheila Rowbottom, both now major British social historians). Nevertheless, their discourse does not fully contain the images; instead they reflect upon feminist practice and the history of women's struggles. We are shown activist meetings, discussions with union leaders, marches, and, poignantly, a sequence in which May—the night cleaner's leader— begins to realize that the struggle might not be winnable.

The Nightcleaners shows us visual evidence and personal testimony, but these are wrested from their temporal and spatial continuity. Its rhetorical use of filmic devices does not, however, impose a hierarchy of discourses with a dominant meaning that is closed and complete. A process of abstraction is introduced through a series of devices that alternate with conventional editing yet, importantly, the film's formalism is never systematic, and it does not become a separate and distinct system so that the formal and referential multivoicing is integral. Sound and image are often separated, with the image being shown silent or with an

The Nightcleaners Part One (1975). A woman cleans an office toilet.

unrelated voice (e.g., one of the women cleaners is heard counting across a series of discontinuous shots until, finally, she concludes with the total of "49 offices and 9 toilets" for which they are responsible). Black leader is interposed between shots, interrupting a gesture or statement. Often there is no sound, or, as between shots of the cleaners working, a piano—reminiscent of music hall or the music performed with silent movies—can be heard. Sometimes there is a voice-over, but it is discontinuous with the images it nestles with. As the image is slowed, the sound is also changed so that we are surprised when, for example, on resuming normal film speed, the noise of a vacuum cleaner suddenly becomes very loud.[92]

Interviewed, the women appear feisty, aware, and perceptive, but not as victims. The film repeatedly uses as a central visual motif shots in which the camera comes to rest on a woman's face and the image is held and reworked. For example, the face of one cleaner, Jean Mormont, an image that opens and closes the film as well as appearing in it, becomes abstract through refilming in slow motion and zooming into very big close-ups of her eyes, nose, or mouth, the grainy image set within a black frame. Almost stilled, the woman's image appears sculptural, her head tilted; the materiality of the photographic image and the woman herself are made palpable, while the pose cinematically held for our contemplation evokes those in the pictorial tradition of images of the Christian madonna. Although her image is extracted from the ongoing moment of recorded reality, this reality is present in the sound track, as another cleaner explains that she continues to do night cleaning, despite her doctor's warning that it is destroying her health, for the sake of her children, saying, "I think if I'm going to die I might as well die happy, mightn't I, so I'm back." The issues of women, mothering, and work are neither narratively nor aesthetically resolved in *The Nightcleaners Part One* but instead leave the spectator with haunting images recalled long after that become a remembering not only of these particular women at this moment in time, during a strike, but also of any women at all, any place at all, in the now time of my viewing that might be either a re-seeing of the film or a mental reflection.

Form and the political engage memory and reflection in James Benning's *El Valley Centro* (2000), on California's Central Valley, 550 miles long and 60 miles wide, which together with *Los* (2001), on greater Los Angeles, and *Sogobi* (2002), a study of the Northern California wilderness, constitute his "California trilogy." Each consists of 35 shots lasting 2.5 minutes, filmed from the same fixed position camera setup, while all three films conclude with a final titles sequence lasting 150 seconds, identifying the subject matter, its owner, and its location. The first shot of *El*

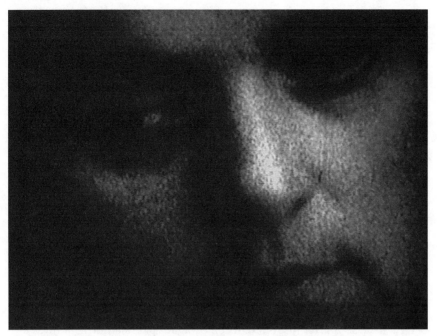

The Nightcleaners Part One (1975). The face of Joan Mormont refilmed in slow motion in a zoom that finishes in very big close-up.

Valley Centro (which is also the last shot of *Sogobi*), for instance, is titled "spillway/Department of Water Resources/Lake Berryessa." For shots 5, 6, 18, and 27, the titles read, "hay raker, Tejon Ranch, Arvin," "freight train, Southern Pacific, Bakersfield," "dredge, Delta Dredging Co., the Delta," and "freighter ship, Naviera de Chile, Stockton Deep Water Channel." Benning has said that he "wanted to code and then cause a rereading of the whole film by naming what you see and exposing ownership. Like, you might not know that this was a cotton picking machine, and almost all of the land is owned by the large corporations, like railroads, or oil companies, banks, causing a political reading . . . Not only do I want to bring out the politics, but I want the viewer to recall the whole film, to play with memory."[93] This information, displaced from its referent, the filmed sequence, becomes a deferred that is not missed until we arrive at it on each film's conclusion. It thereby becomes, retrospectively, suspended information that circumscribes the seen and heard in terms of a named subject represented, a specific location that could be revisited and an ownership that introduces relations of the propertied and the propertyless into the landscape. We must superimpose, in our memory, this language-based information upon the uncaptioned sounds and images of the thirty-five shots. The intervals between the shots that were, before, a series only by

virtue of their sequence in the time of our viewing become afterward gaps for the missing title that we can now insert. Are we successful? What will this process displace and what will it add? Prior to the titles sequence we have been viewing a series of landscape portraits whose closed and formal structure allowed quiet contemplation, enabling us to look around the scene, knowing the duration, awaiting the changes we expect within a landscape we are becoming familiar with that will nevertheless give rise to the quite unexpected. There is surprise when a freighter ship enters rear frame and passes horizontally across, followed by a sailboat, each traveling on the Stockton Deep Water Channel that we later can put a name to but that we cannot discern within the view Benning has chosen for us. The frame becomes dynamic through such movements across and within the frame; in one, a hay raker begins as just a small speck in the distance that, having traveled forward toward us in the frame, abruptly turns offscreen right but is still present to us in the sounds of its engine until it reemerges elsewhere in the field (prompting the memory of another cornfield, in Hitchcock's *North by Northwest*, 1959). The freight train entering the shot after just a few seconds, again passing horizontally, fills up the image, evacuating the landscape it occupies, and creating a rhythm of movement and vision in the repetition but also differences between cars, while its enormous length begs the question, will it cross before the end of the shot, or not? Sounds of noise or voices, their source often unseen, open up the framed space to the continuousness of a world beyond yet not visually included. The camera is an observing eye, unacknowledged except, perhaps, in the apprehensive glances that seem to to be addressed to us by migrant fruit pickers working beside an overseer. Our pleasure is in seeing with the camera, in a seeing again, and seeing what Benning could not necessarily know might happen and what he might only later—reviewing—have seen as we do now. All this is placed in parenthesis by the final titles that, in naming what we saw, challenge our own "naming," our cognitive perception, in a kind of sadistic joke that asks, did we get the point? Well, yes and no. What is cited as the content of the shot is partial, a selection, and hence an assertion, for the hay raker exists within a field and a sky, and it has a driver. The captioning reduces a polysemy we had enjoyed and now remember perhaps guiltily while suffering our failure—indeed the impossibility—to remember and re-make the film with this new information. The process of mental review the film demands is also a political act that makes representation, and our apprehension of the represented, an always incomplete process in an engagement with the on-going of the contingent and the time of mental reflection as a duration that transforms our understanding.

In *Father* (2002), Doron Solomons introduces a formal play not only in relation to the political but also in relation to trauma. What role might the artwork play in relation to the traumatic remembered? It is by enabling the apprehension of the real in dreadful anxiety without losing oneself as a subject in which one confronts—but is not overwhelmed by— the limits of one's existence.[94] The anxiety of the artwork as traumatic does not therefore involve a remembering of a past trauma as a kind of recovery of an experience. It *is* the experience, and as such it may produce a "remembering" or *Nachträglichkeit*, afterwardsness, that can become translated and symbolizable, enabling us to move beyond imaginary captivation. It is a symbolization that bears the trace of the real that it renders into the reality of its sounds and images. The artwork enables us to come up close to the real and apprehend it in its deferral of time that opens us to such afterwardsness.

Father, while showing television news footage documenting bomb attacks in Israel, presents this not in a continuous time but in a complex montage of sights and sounds that is both deeply moving and highly challenging, both conceptual and poetic. It is an "interval" film in which time stops—that is, "historical" time—and becomes the "now-time" of juxtaposed images and sounds, of series and not chronology. Across the film, a number of motifs are introduced: innocence, victims, technology and its promise to protect, violence—both human and inhuman or robotic—the magic of film and imagination, daughters lost or at risk of being lost, and terror.

The film opens with the carnage of a bomb attack, shown out of focus but with direct ambient sound audible, then Solomons's voice-over is heard saying, "You once asked me, 'Daddy, if I die—will you make magic?'" and we then see the magician-father taking back—in a literal swallowing—the word "Death." Then follows the image of his daughter jumping up and down on a "bouncy house," her movement slowed, the zoom-in losing focus to create a lyrical sense of innocence, physical enjoyment, and a loving gaze, before the film cuts to news footage of a different aftermath—a failed suicide bombing. Here, an extraordinary spectacle unfolds as we see the wounded would-be attacker approached and grasped by the mechanical arm of a robot mounted on a tanklike platform that tugs him back, away from the watching crowds gathered behind security barriers. Heard over this scene are the evocative sounds of a Bach recital. The image becomes the fuzzy lines of an interrupted television broadcast before it cuts to show the daughter seated, watching something intently, but surely, we may ask, she is not watching the images we have been seeing? A mental image of risk erupts of a possible future of not only

the little girl's bodily risk but also the risk of a traumatizing terror in the anxiety we imagine for her, to which the film answers, "in my arms you are safe." These are the words we hear in the next shot, which shows a promotional video demonstrating the safety of its car design as robots "die" testing its robustness in controlled crashes. Is this enough, the film seems to ask when it cuts to another vehicle, a child's toy truck, hurtling toward a wall and, crashing, smashing its "driver"—an egg?

Reality and play, the mechanical and the organic, interchange across the film. In the next shot we see found footage of a training camp for Palestinian "fedeeyan" (fighters) that shows two women practicing unarmed combat. The black and white film is re-worked in tones of pink, while wind instruments play over, as another father's voice is heard saying, "I always loved to watch you dance . . . fresh and flexible movements." The film cuts abruptly to an anguished father and a superimposed image of a baby girl that we may connect to the dancing (fighting) women and a death that is their future. The film's story lies in what we make of its juxtapositions produced by the father and filmmaker of reality's mechanics of contingency as he attempts to realize his role as father-magician. The poignancies of this family make-believe butt up against the constructed realities producing the terror of contested land and the contesting other so that we confront what Barthes observed as arising in the punctum: "*This will be* and *this has been*; I observe with horror an anterior future of which death is the stake."[95] It is not that time stands still through the interval of juxtaposition in *Father*; rather the relations of causality of past and present time are questioned along with our struggles for time future. The robotic spectacle is also the specter, the trace of what has and has not yet occurred; of terror experienced and of justice hoped for by two peoples, Palestinian and Israeli, for whom the film demands a different future.[96]

Documentary art is a kind of making and unmaking of history in a "now" time of remembering that is a forgetting in its memorializing, producing a transformation in the remembered. It is thus a certain practice of sublimation in which the nonsense of the sublime remains, producing not a catharsis of resolution in the work but a confrontation for the viewer in a way that opens to a real that is not sublimated as a "domestication" in or though the images and sounds but, instead, penetrates her. In these films and artworks, the "before and after" that is absent but inseparable from the images we see can become thought and thus enable an understanding that is not redemptive but rather brings us to imagine in these landscapes and places a time of being that is different.

As a kind of hoping, it is a human time, and it also makes palpable a

Father (2002). Refilmed newsreel footage of a robot tractor pulling a failed suicide bomber in Israel, while a Bach recital is heard on the sound track. Still reproduced by kind permission of the artist, Doron Solomons.

certain impossibility that thereby constitutes what, in *The Parallax View*, Žižek has called a "parallax gap" in the "confrontation of two closely linked perspectives between which no neutral common ground is possible."[97] Arising here is an "inherent 'tension,' gap, non-coincidence of the One itself"[98] that Žižek relates to the "minimal difference" of the non-coincidence of the one with itself, citing Derrida's neologism, *différance*, which Žižek describes as having "unprecedented materialist potential."[99] Such an irreducible gap disturbs presumptions of causality and the commensurable and thus demands that we imagine the incommensurable and difference as radical otherness.

Crucial for Žižek, and the wager of his book, is his argument that, rather than being an irreducible obstacle to dialectics, "the notion of the parallax gap provides the key which enables us to discern its subversive core."[100] He argues: "To put it in Kierkegaard's terms: the point is not to overcome the gap that separates thought from being, but to conceive it in its 'becoming.'"[101] It is a fissure or gap in the sensible that Rancière calls dissensus, as a gap in the sensible itself; it is such a gap that enables art as politics, in the eruption of the apprehension of a fissuring produced by the art work. Such a gap presses upon us, demanding a thinking otherwise

that in art can then be political as "the aesthetic anticipation of the future,"[102] through sensible forms and material structures that can figure our encounter in a future becoming.

Deleuze, rejecting dialectics, nevertheless develops a series of binaries that are counterintuitive yet utterly seductive reversals that confront our assumptions about reality in a philosophizing that is a kind of "parallaxing"—to use Žižek's term. These binaries include: the virtual versus the actual; the nonorganic or crystalline versus the organic; active versus reactive forces; nomadic versus sedentary distribution; molecular versus molar processes; body without organs versus organized body; and deterritorialization over re-territorialization.[103] Yet, insofar as for Deleuze the virtual is most salient, a hierarchy is introduced that puts at risk the possibility for the deployment of these terms to radically re-organize our thinking and virtualities; a risk only averted through the concept of a becoming that is endured. For Žižek, the gap between virtual and actual, thought and being is a negativity that enables a suspension of the movement of living in a nonact of reflexive distance.[104]

Jean-François Lyotard also addressed the issue of an irreconcilable gap in his concept of the "differend," namely, where the terms of a discourse, or language game, afford no agreed procedures for what is different—whether an idea, an aesthetic principle, or an injustice.[105] What results is that one party to speech is silenced, for discourses always involve power. Enabling the incommensurable to be heard and seen is, therefore, an ethical act that requires both a voice to speak or show and an interlocutor who cognizes not only through identifying "that's me" or "that's not me" but also through a recognition that is indifferent to such identification that declares, "Here I am, for another."[106] Such an ethical position, or politics of the third in Žižek's words,[107] is not without risk, for it brings us up close to the real and to the lack in the other. Neither form nor content, as either art or politics, can ensure such an encounter; instead it surprises us in the gaps of documentary's representation as it engages us in its art of reality and spectacle of the real.

Notes

INTRODUCTION

1. Quoted by Hans Richter in *The Struggle for the Film*, trans. Ben Brewster (Aldershot: Scolar Press, 1986), 47. Quoted by Walter Benjamin in "A Little History of Photography," in *Walter Benjamin: Selected Writings*, vol. 2, trans. Edmund Jephcott and Kingsley Shorter, ed. Michael W. Jennings, Howard Eiland, and Gary Smith (Cambridge, Mass.: Harvard University Press, 1999), 526. Bertolt Brecht in "Der Dreigroschenprozess, ein soziologisches Experiment," in *Gesammelte Werke in 20 Bänden* (1930/1931) (Frankfurt-am-Main: Suhrkamp Verlag, 1976), 161.
2. For example, in the writings of Walter Benjamin, Hans Richter, Sergei Eisenstein, Dziga Vertov, Paul Rotha, and of course, John Grierson.
3. This is not the same as desiring to know the true functioning of social reality, for if, as Slavoj Žižek argues, "we come to 'know too much,' to pierce the true functioning of social reality, this reality would dissolve itself. This is probably the fundamental dimension of 'ideology': ideology is not simply 'false consciousness,' an illusory representation of reality, it is rather this reality itself which is already to be conceived of as 'ideological.'" *The Sublime Object of Ideology* (London: Verso, 1989), 22–21. The role of ideology is considered further in chapter 1 of this volume.
4. Bill Nichols, *Representing Reality* (Berkeley: University of California Press, 1991), 3. Nichols argues that "these systems assume they have instrumental power; they can and should alter the world itself, they can effect action and entail consequences." Such discourses are opposed to the world of make-believe; instead they assume a relation to reality that is direct and transparent. Documentary, he suggests, "despite its kinship, has never been accepted as a full equal" (3–4).
5. Jean Baudrillard, *The Evil Demon of Images*, trans. Paul Patton and Paul Foss (Sydney: Power Institute of Fine Arts, University of Sydney, 1987), 28. Evil and immorality are invoked not in relation to morality versus sinfulness but in a Manichean opposition of rational and irrational ("Interview," 43, ibid.).
6. Mary Ann Doane, "Real Time: Instantaneity and the Photographic Imaginary," in *Stillness and Time: Photography and the Moving Image*, ed. David Green and Joanna Lowry (Brighton: Photoworks/Photoforum, 2006), 38.
7. Jacques Rancière, *The Politics of Aesthetics*, trans. Gabriel Rockhill (London: Continuum, 2004), 12.
8. Gilles Deleuze, *Bergsonism*, trans. Hugh Tomlinson and Barbara Habberjam (New York: Zone Books, 1988), 97.
9. Brian Winston, *Lies, Damn Lies, and Documentaries* (London: BFI Publications, 2001).
10. Daguerre first established himself as a theater designer and was famous for the realistic spectacle he portrayed through his sets. He later constructed the diorama in 1822—a room entered through a dark corridor in which was displayed painted scenes on transparent cloth that, as a result of the manipulation of light, appeared to change from day to night or sun to storm. He entered into a partnership with Joseph Nicéphore Niépce, a printer who produced the first permanent photograph (known as a Heliograph) in the same year as the diorama, but who died suddenly in 1933. By contrast, Talbot recounts that he was drawn to discover a

means by which to chemically record the image produced by the camera obscura as a result of his frustration with his efforts to record the image by his own hand. I am grateful to Jon Carritt for pointing out the connections between Daguerre's work in the theater, his dioramas and his painting, and his development of the daguerreotype.

11. In the context of cinema, the desire for reality re-presented has been described most forcefully in the writings of André Bazin: "Only a photographic lens can give us the kind of image of the object that is capable of satisfying the deep need man has to substitute for it something more than a mere approximation, a kind of decal or transfer. The photographic image is the object itself, the object freed from the conditions of time and space that govern it. No matter how fuzzy, distorted, or discolored, no matter how lacking in documentary value the image may be, it shares, by virtue of the very process of its becoming, the being of the model of which it is the reproduction; it is the model." *What Is Cinema?* vol. 1, essays selected and trans. Hugh Gray (Berkeley: University of California Press, 1967), 14.

12. Jean-Louis Comolli, "Machines of the Visible," in *The Cinematic Apparatus*, ed. Stephen Heath and Teresa de Lauretis (New York: St. Martin's Press, 1980), 123.

13. As Jonathan Crary has noted in his account of the emergence of a new scientific account of the optics of the eye and its transformation of the place of subjectivity, "whether it is Berkeley's divine signs of God arrayed on a diaphanous plane, Locke's sensations 'imprinted' on a white page, or Leibniz's elastic screen, the eighteenth-century observer confronts a unified space of order, unmodified by his or her own sensory and physiological apparatus, on which the contents of the world can be studied and compared, known in terms of a multitude of relationships." *Techniques of the Observer* (Cambridge, Mass.: MIT Press, 1993), 55.

14. Comolli, "Machines of the Visible," 123–24.

15. Bazin, *What Is Cinema?* 1:15. It was this split that Bazin valued, for by encountering the objectivity of the photograph, human vision could be brought to see anew, to see again, what convention and daily cares caused to be overlooked. Crary, however, characterizes this split in terms of two opposed subjectivities: first, an embodied seer arising from the "multiple affirmations of the sovereignty and autonomy of vision derived from this newly empowered body' as a result of the subjectivization of vision," and second, a disciplined observer emerging as a result of the new knowledge of human optics, which led to "forms of power that depended on the abstraction and formalization of vision" (*Techniques*, 150).

16. Mary Ann Doane, "Technology's Body: Cinematic Vision in Modernity," *Differences: A Journal of Feminist Cultural Studies* 5, no. 2 (1993): 5. A revised version appears as chapter 3 in her book *The Emergence of Cinematic Time* (Cambridge, Mass.: Harvard University Press, 2002).

17. Lewis Hine, the pioneer of social and documentary photography, writing in 1909, in "Social Photography: How the Camera May Help in the Social Uplift," argued for its special role as evidence of reality: "Whether it be a painting or a photograph, the picture is a symbol that brings one immediately into close touch with reality . . . the picture continues to tell a story packed into the most condensed and vital form. In fact, it is often more effective than the reality would have been, because, in the picture, the non-essential and conflicting interests have been eliminated. The picture is the language of all nationalities and all ages." Hine concludes, "The photograph has an added realism of its own; it has an inherent attraction not found in other forms of illustration. For this reason the average person believes implicitly that the photograph cannot falsify." But he also observes that "while photographs may not lie, liars may photograph." In *Proceedings: National Conference of Charities and Corrections*, June 1909, reprinted in *Classic Essays on Photography*, ed. Alan Trachtenberg (New Haven, Conn.: Leete's Island Books, 1980), 111.

18. I am referring here to the large installations that were common at seaside resorts and spectacular locations where several people at a time could enter and view the reflected images of the scenes and people outside.

19. This is the questioning arising in the discourse of the hysteric, explored further in chapter 3.

20. Unlike photography, the stereoscope was an invention of a scientist, Sir Charles Wheatstone, later developed by Sir David Brewster with the aim of democratizing knowledge of real phenomena and opposing illusory magic. The stereograph comprises two drawings or photographs of a scene with a variation equivalent to that produced by the small distance between the human eyes. Once placed together in a viewer that again approximates this distance, the two images will be read as one as the slight differences of angle in each image provide the information for the mind to read the scene in true perspective, and the objects and people will appear three dimensional. Viewers might be large upright boxes containing a series of cards that could be rotated in front of the binocular lenses, or they might be smaller handheld viewers on the model of opera glasses.

21. Crary, *Techniques*, 124. In contrast to Crary's skepticism, the nineteenth-century American writer Oliver Wendell Holmes, inventor of the Holmes stereoscopic viewer, presents

an enthusiastic case for the stereograph: "The first effect of looking at a good photograph through the stereoscope is a surprise such as no painting ever produced. The mind feels its way into the very depths of the picture. The scraggy branches of a tree in the foreground run out at us as if they would scratch our eyes out. The elbow of a figure stands forth so as to make us almost uncomfortable. Then there is such a frightful amount of detail, that we have the same sense of infinite complexity which Nature gives us." In "The Stereoscope and the Stereograph," *Atlantic Monthly*, 1859, reprinted in *Classic Essays on Photography*, 77.

22. Quoted by Crary, ibid., 24. Herman von Helmholtz, *Treatise on Physiological Optics*, trans. J. P. C. Southall, third German edition (1909–11) (New York: Dover 1924–25, 1962), vol. 3, 303.

23. For Crary, photography is "a form that preserved the referential illusion more fully than anything before . . . it recreated and perpetuated the notion that the 'free' subject of the *camera obscura* was still viable" (*Techniques*, 133). Yet, contrary to Crary's claim, the stereograph remained the primary form in which the photographed world was circulated and consumed in the second half of the nineteenth century, especially after the introduction of mass-production methods, continuing well into the twentieth century. Reese V. Jenkins claims that "[t]he stereoscope viewer and box of cards were as common a feature of the post-Civil War American home as the television set is today" (in *Images and Enterprise: Technology and the American Photographic Industry 1939–1925* [Baltimore, Md.: The Johns Hopkins University Press, 1975], 50).

24. The photograph as fetish is contrasted to cinema's voyeurism by Christian Metz in "Photography and Fetish," *October* 34 (Fall 1985): 81–90.

25. The tangibility of the stereoscope, described by David Trotter as "the visualization of the tangible," engages us kinesthetically, in a spatial relation and in a haptic relation, in a feeling of touching with one's eyes. ("Stereoscopy: Modernism and the 'Haptic'" *Critical Quarterly*, 46, no. 4 [2004]: 38–58). Trotter emphasizes that while the stereoscope offers the distancing of the tableau, just as important is our absorption by its image, which engages by its tactility (42).

26. Crary, *Techniques*,133.

27. The concept of disavowal was developed by Freud in his analysis of fetishism in "Fetishism," *The Standard Edition of the Complete Works of Sigmund Freud*, vol. 21, ed. and trans. James Strachey (1921; London: Hogarth Press, 1974). Hereafter cited in text as *SE*.

28. It is also central to performative popular forms, such as carnival and religious processions.

29. Edmund Burke, *A Philosophical Enquiry into the Origin of our Ideas of the Sublime and the Beautiful*, ed. Adam Phillips (Oxford: Oxford University Press, 1990), 122–23.

30. Immanuel Kant, *Critique of Judgement*, trans. Werner S. Pluhar (Indianapolis: Hackett Publishing Company, 1987), para. 25, 106.

31. Hans Richter, *The Struggle for the Film*, 41. Richter first drafted this book in the 1930s.

32. Spectacle, the primary characteristic of the "primitive mode of production" of early cinema, is nonnarrative and is valued because it opposes the closure and transparency of the "institutional mode of production." Nöel Burch, "A Primitive Mode of Representation," in *Early Cinema: Space–Frame–Narrative*, ed. Thomas Elsaesser (London: British Film Institute, 1990), 220–27. Burch also introduces here the notion of "primitive externality," which emphasizes the spectacle, and early film as confronting the spectator as an externality.

33. Tom Gunning, "The Cinema of Attractions: Early Film, Its Spectator and the Avant-Garde," in Elsaesser, *Early Cinema: Space–Frame–Narrative*, 58.

34. As a result, Gunning distinguishes the exhibitionism of the cinema of attractions, with its solicitation of the audience's look, from the voyeurism of narrative film, in which the spectator overlooks a scene of action apparently unknown to the characters. The opposition between the drive to narrative in film and the cinematic playing for spectacle cannot be aligned with a division between voyeurism as narrative pleasure and some nonvoyeuristic, nonnarrative pleasure. Neither fetishism nor exhibitionism can fulfill this role. I have discussed this more fully in *Representing the Woman* (Minneapolis: University of Minnesota Press, 1997).

35. The term "actualities"—drawn from the French term—is now used to refer to these early forms of nonfiction.

36. Seen, for example, in *Prigionieri della guerra* (*Prisoners of War*) (Italy, Yuervant Gianikin and Angela Ricci Luchi, 1995), made with the Museo Storico di Trento and the Museo della Guerra di Rovereto and Commune di Rovereto using Russian and Austro-Hungarian film footage from World War I.

37. Actuality and documentary film, while "attractions," are not necessarily exhibitionist, since the "attraction" may be seeing as such, such as in "overlooking," for example, the voyeurism of the close-up.

38. Scopophilia and epistemophilia are, for Freud, components of the human drive, that is, the force that impels the subject in relation to objects of desire. The wish to see may be active— voyeurism—or, as Freud emphasizes, it may be passive in the wish to be seen—exhibitionism. "The Development of Libido and the Sexual Organizations" (1917), *SE* 16:327. The passive wish

is satisfied in the cinema through identification with the seen in what is displayed to us, so that the spectator becomes the seen image. Here arises the pleasure of that psychical engagement summed up by the term "identification." This is explored in chapter 3.

39. For Freud, the uncanny is the emotion associated with the return of the repressed and, specifically in his analysis of Hoffman's tale "The Sandman," of the Oedipal wishes involved in the castration complex. The uncanny confronts the subject—unconsciously—with the impossibility of its desire and the terror of its losses as a "castration." For Lacan, the disturbance in the image or story is a little bit of the real, of the senseless, intruding into the picture or narrative that disturbs its ordering (Sigmund Freud, "The Uncanny" [1919], SE 17: 217–52).

40. See, for example, Trinh T. Minh-ha, "The Totalizing Quest of Meaning," in *Theorizing Documentary*, ed. Michael Renov (London: Routledge, 1993), 95; and Brian Winston, *Claiming the Real: The Documentary Revisited* (London: British Film Institute, 1995), 205–18.

41. This history is reviewed in *Understanding Reality TV*, ed. Sue Holmes and Deborah Jermyn (London: Routledge, 2004).

42. John Corner, "Performing the Real: Documentary Diversions," *Television and New Media* 3, no. 3 (August 2002): 266.

43. Corner, ibid., 261–62.

44. Annette Hill, *Restyling Factual TV: Audiences and News, Documentary and Reality Genres* (London: Routledge, 2007), 110. Hill's audience research presents extraordinary insights enriched by her own subtle analysis.

45. As Corner notes, "The term *documentary* is always much safer when used as an adjective rather than a noun," so that we may ask how the work is documentary in its project. "Performing the Real," 258.

46. In an interview Watson comments, "Channel after channel showing reality TV. It's predictable. It doesn't inquire, it doesn't upset, it just creates more of the same and makes our film-makers lazy." *The Guardian*, November 20, 2006, http://www.guardian.co.uk/media/2006/nov/20/mondaymediasection4

47. Tara Conlan, *The Guardian*, September 21, 2007, http://www.guardian.co.uk/media/2007/sep/21/ITV.television2

1. Narrating the Real

1. John Grierson, "The Documentary Producer," *Cinema Quarterly* 2, no. 1 (1933): 8. In his review of Robert Flaherty's film *Moana* (1926, United States), written anonymously for the *New York Sun* (February 8, 1926), Grierson described *Moana*'s record of the life of a Samoan community, and its project of filming actuality, as "documentary," thus giving the English-speaking world a new film genre. Grierson later wrote, "Documentary is a clumsy description, but let it stand. The French who first used the term only meant travelogue," which Grierson sarcastically calls "shimmying exoticisms." He suggests that the term "documentary" has gone on to "include dramatic films like *Moana*, *Earth* and *Turksib*." "First Principles of Documentary," in *Grierson on Documentary*, ed. F. Hardy (New York: Harcourt, Brace and Co., 1947), 99.

2. Winston, *Claiming the Real: The Documentary Revisited* (London: British Film Institute, 1995), 14.

3. Comolli, "Détour par le direct—Un corps en trop," *Cahiers du Cinéma* 278 (July 1977), 5–16, trans. Diana Matias, Christopher Williams, ed., *Realism and the Cinema* (London: Routledge, 1980), 226–27. Comolli is invoking here in relation to documentary Christian Metz's comment that a certain *unrealization* "is at the heart of every narrative act" because narrating orders events. In *Film Language: A Semiotics of the Cinema*, trans. Michael Taylor (New York: Oxford University Press,1974), 21. Metz, however, saw documentary as a nonnarrative genre (94).

4. Grierson, *Grierson on Documentary*, 84.

5. Vaughan, *For Documentary* (Berkeley: University of California Press, 1999), 154.

6. Charles Baudelaire, *Art in Paris 1845–1862*, trans. Jonathan Mayne (London: Phaidon, 1965), 162. Baudelaire therefore rejected photography, as it too embodied such a desire for a realism that might portray the world as if without interference.

7. Giving rise to the "direct" film movement of observational cinema, drawing on the work of Flaherty, and Vertov; it is also referred to as cinéma vérité, but this, in the films of Jean Rouch, for example, *Chronique d'une été*, also involved participation and provocation.

8. Bazin, *What Is Cinema?* vol. 1, essays selected and trans. Hugh Gray (Berkeley: University of California Press, 1967), 12.

9. Freud, "Formulations on the Two Principles of Mental functioning," (1911) in *The Standard Edition of the Complete Works of Sigmund Freud*, vol. 12, 213–26, ed. and trans. James Strachey (1921; London: Hogarth Press, 1974). Hereafter cited in text as *SE*.

10. Lacan, *Écrits, A Selection*, trans. Alan Sheridan (London: Tavistock Publications, 1977), 197. The real in representation is explored further in chapters 3 and 4.

11. A key text in film studies here is Jean-Louis Baudry, "Ideological Effects of the Basic Cinematographic Apparatus," trans. Alan Williams, *Film Quarterly* 27, no 2 (Winter 1974–75): 39–47.

12. Louis Althusser, "Ideology and Ideological State Apparatuses," in *Lenin and Philosophy and Other Essays*, trans. Ben Brewster, 127–88 (London: New Left Books, 1969).

13. Jacques Lacan, *Écrits, A Selection*, 1–7.

14. Paul Hirst has questioned the epistemological assumptions of Althusser's theory of the relative autonomy of ideology in *On Law and Ideology* (London: Macmillan, 1979). Althusser drew upon the work of Gaston Bachelard (under whom he studied), who argued that the objectivity of the subject was impeded by what he termed the imaginary of the subject, which Althusser located in Lacan's concept of the imaginary as the miscognition of the subject as a unified subject. Joan Copjec's invaluable discussion in "The Orthopsychic Subject" retraces this history (*Read My Desire: Lacan Against the Historicists* [Cambridge, Mass.: MIT Press, 1994], 15–38). Mladen Dolar has shown the opposition between Althusser's and Lacan's accounts of the subject and the imaginary in "Beyond Interpellation," *Qui Parle* 6, no. 2 (1993): 75–96.

15. Christian Metz, in his major study *Psychoanalysis and Cinema: The Imaginary Signifier*, also drew on Lacan's account of the mirror stage to argue that the cinema is imaginary insofar as the spectator subject takes up as its own—that is, identifies with—the omniscient look of the camera on the scene the camera records, and thereby the spectator misrecognizes itself as the origin of the seeing that the film affords (London: Macmillan, 1977). Metz's account follows Althusser's in failing to acknowledge that the mirror stage produces a split subject, not a unified subject. The imaginary engenders the fantasy of unity, not its enactment. I have addressed Metz's account more fully in *Representing the Woman: Psychoanalysis and Cinema* (London: Macmillan, 1997).

16. Slavoj Žižek, *The Sublime Object of Ideology* (London: Verso, 1989), 28–29.

17. Slavoj Žižek, "The Spectre of Ideology," in *Mapping Ideology*, ed. Slavoj Žižek (London: Verso, 1994), 17.

18. *The Encyclopaedia Britannica*, vol. 19, 11th ed., ed. Edmund Gosse, s.v. "Novel." Geoffrey Day, in *From Fiction to the Novel*, has pointed out that eighteenth-century writers of the literary works now seen as novels resolutely rejected this term for their books, preferring instead to refer to them as "fiction" in contrast to the novel, which was associated with the romance (London: Routledge, 1987).

19. Henry James, "The Art of Fiction," *The Art of Fiction and Other Essays by Henry James*, introduced by Morris Roberts (London: Oxford University Press, 1948), 5–6.

20. Peter Lamarque and Stein Haugom Olsen, in *Truth, Fiction, and Literature: A Philosophical Perspective* (Oxford: Clarendon Press, 1994), oppose the view of some philosophers (e.g., Bertrand Russell and Nelson Goodman) that literary fiction is falsehood. They argue instead that that account must be taken of the context and how this is construed by the reader, and thus facts presented in literary fiction may be construed contextually as relating to the fictional world or noncontextually as universal truths or facts about historical reality (53).

21. Discussed, for example, by Janet Montefiore, *Men and Women Writers of the 1930s: The Dangerous Flood of History* (London: Routledge, 1996).

22. *Oxford English Dictionary*, 2nd edition (Oxford: Oxford University Press, 1989).

23. Paul Rotha, *Celluloid: The Film Today* (London: Longmans, Green & Co., 1931), 46.

24. *Oxford English Dictionary*.

25. Edward Branigan, *Narrative Comprehension and Film* (London: Routledge, 1992), 204–6.

26. Carl Plantinga, "Defining Documentary: Fiction, Non-fiction, and Projected Worlds," *Persistence of Vision*, no. 5 (Spring 1987): 52–53. He discusses this further in *Rhetoric and Representation in Nonfiction Film* (Cambridge: Cambridge University Press, 1997), 24–25.

27. Trevor Ponech, *What Is Non-Fiction Cinema? On the Very Idea of Motion Picture Communication* (Boulder, Colorado: Westview Press,1999), 13; Noël Carroll, in "Fiction, Non-Fiction, and the Film of Presumptive Assertion: A Conceptual Analysis," similarly argues for documentary as "films of putative fact" or "films of presumptive assertion," in *Philosophy of Film and Motion Pictures: An Anthology*, ed. Noël Carroll and Jinhee Choi (Oxford: Blackwell's, 2005), 154–72.

28. Lamarque and Olsen suggest, "What sets the fictive story-teller apart are the conditions governing the way the descriptions are presented, the purposes they seek to fulfil, the responses they elicit, and so on; in other word the practice within which they play their part," but, they ask, "What makes (propositional) content fictional or otherwise?" The answer "must be something about its origin" and not is truth value, since fictional utterances can have truth value. With the fictive utterance, the storyteller presents her account for "a particular kind of attention," namely, for the attention of a reader who adopts the fictive stance, broadly so that the account is "as if" it were the author's views, testimony, and so on but may not be. (*Truth, Fiction, and Literature*, 41, 42). The fictive stance produces a cognitive distance in the reader,

who does not receive the account as factual testimony to the author's own experience of reality or her account of other's experience of reality.

29. Bill Nichols, *Representing Reality* (Berkeley: University of California Press, 1991), 115. Michelle Citron's film *Daughter Rite* (1980), notwithstanding its fabrication, is not simply fiction because its stance toward its reworked visual and auditory material is nonfiction, for we are asked to understand it as about the world, not as a world.

30. Lamarque and Olsen, *Truth, Fiction, and Literature*, 277.

31. Philosophers more commonly address this as an issue of the "truth value" of a statement. My discussion here follows both "Correspondence Theory" and the "Semantic Theory" accounts of the truth of a proposition as arising out of a relationship between that proposition and features or events in the world. My argument also follows "Coherence" theories that account for the truth of a proposition as arising out of a relationship between that proposition and other propositions that are accepted as true. The succinct and useful entry on truth by Bradley Dowden and Norman Swartz in the *Internet Encyclopedia of Philosophy* argues that what these theories of truth, as well as the "Pragmatic and Postmodern," have in common is the assumption that a proposition is true just in case the proposition has some property or other—correspondence with the facts, satisfaction, coherence, utility, and so on. In contrast to these approaches, are "deflationary theories" that reject or displace the role of truth. "The Redundancy Theory," advocated by Frege, Ramsey, and Horwich, argues that nothing is added to the content of a statement by the addition of the phrase "it is true that" (http://www.iep.utm.edu/truth).

32. For Emmanuel Kant, R. Hanna suggests, "truth just is agreement or correspondence, which can then be further unpacked as a relation between a judgment and an object such that (i) the form or structure of the object is isomorphic with the logico-syntactic and logico-semantic form of the proposition expressed by the judgment, (ii) the judger cognitively orients herself in the world by projecting the object under specific 'points of view' (*Gesichtspunkte*) or modes of presentation that would also be typically cognitively associated with the constituent concepts of the judgment by any other rational human animal in that context, and (iii) the object represented by the judgment really exists" (in "Kant, Truth, and Human Nature," *British Journal for the History of Philosophy* 8, no. 2 [2000]: 225–50).

33. Jacques Lacan, *Écrits: The First Complete Edition in English*, trans. Bruce Fink (New York: Norton, 2006), 684.

34. Ibid.

35. Bradley Dowden and Norman Swartz write, "Instead of saying, 'It is true that snow is white,' one could substitute 'I embrace the claim that snow is white.' The key idea is that saying of some proposition, P, that it is true is to say in a disguised fashion 'I commend P to you,' or 'I endorse P,' or something of the sort. The case may be likened somewhat to that of promising. When you promise to pay your sister five dollars, you are not making a claim about the proposition expressed by 'I will pay you five dollars'; rather you are performing the action of promising her something." In *The Internet Encyclopedia of Philosophy* (http://www.iep.utm.edu/truth). The "Performative" theory of truth" is another example of the "Redundancy" theory of truth.

36. Lacan, *The Ethics of Psychoanalysis: The Seminar of Jacques Lacan* (London: Routledge, 1992), 12.

37. Jeremy Bentham, "Essay on Language," in *The Works of Jeremy Bentham, published under the superintendence of his executor, John Bowring* (Edinburgh: William Tate, 1843) vol. 8, 325. "To language, then—to language alone—it is that fictitious entities owe their existence; their impossible, yet indispensable existence." (198). Elsewhere he writes, "There are no real entities that are not species of fictitious entities: there are no fictitious entities that are not species of real entities," in "Draft letter to d'Alembert," unpublished manuscript (UC clxix, 59), cited in "The Place of Jeremy Bentham's Theory of Fictions in Eighteenth-century Linguistic Thought," Emmanuelle de Champs, author's translation, at http://eprints.ucl.ac.uk/647. This is discussed by Žižek in *Tarrying With the Negative: Kant, Hegel and the Critique of Ideology* (Durham: Duke University Press, 1993), 83–89.

38. Colin Tyler, "Jeremy Bentham, Social Criticism & Levels of Meaning," *UCL Bentham Project*, http://www.ucl.ac.uk/Bentham-Project/journal/Tyler1.htm.

39. Ponech, *What is Non-Fiction Cinema?*, 85.

40. Carl Plantinga, "What a Documentary Is, After All," *Journal of Aesthetics and Art Criticism* 63, no. 2 (Spring 2005): 111.

41. The creation of a perfect illusion was considered an aim of painting, that is, where the spectator is deceived into taking the image for reality. In the very famous classical tale of Zeuxis and Parrhasios, the triumph of Parrhasios lies in deceiving Zeuxis when he turns to him and asks to see behind the veil that Parrhasios has painted, as if it were real.

42. Bazin, *What Is Cinema?*, 1:13. Gregory Currie makes a similar case in "Visible Traces: Documentary and the Contents of Photographs" (*Journal of Aesthetics and Art Criticism* 57, no. 3 [Summer 1999]), where he notes, "By virtue of being traces of things, they offer us special epistemic and emotional access to the things they are documentaries of" (289).

43. Charles Sanders Peirce, *Elements of Logic*, in *Collected Papers of Charles Sanders Peirce*, ed. Charles Hartshorne, Paul Weiss, and Arthur Burks (Cambridge, Mass.: Harvard University Press, 1932), 2:159.

44. Charles Sanders Peirce, *Peirce on Signs: Writings on Semiotic*, ed. James Hoopes (Chapel Hill: University of North Carolina Press, 1991), 25.

45. Mary Ann Doane argues in *The Emergence of Cinematic Time: Modernity, Contingency, and the Archive* (Cambridge, Mass.: Harvard University Press, 2002) that indexicality "can and must be dissociated from its sole connection to the concept of realism, the reflection of a coherent, familiar, and recognizable world. Indexicality is a function that is essentially without content—in language it is allied with the pure denotation of 'this' or 'here it is'" (25). My discussion here and throughout this chapter is indebted to her subtle and illuminating consideration of Peirce, time, and cinema.

46. The icon has firstness in that it represents the object in terms of perception; the index has secondness in that it presents the object in terms of its relations, or causality; the symbol has thirdness (as well as firstness and secondness) in that it presents the object referentially.

47. Ponech claims rather more, saying that it is sometimes appropriate to identify the content of films with a natural interpretation in that "few films contain only this kind of interpretation. But so long as it is photographically made, any motion picture will have natural meaning in relation to external objects. Provided that the image (and sound) is recognizable, part of this natural meaning will be a description of the visual (and aural) features of a real situation, in addition to whatever these visible features themselves happen to indicate about that situation" (86). He excludes here "its mental significance" for the interpreter (81), but all cognition involves memory and thus learned knowledge, in addition to being affectual. I return to this in relation to Comolli's claim about documentary's "fiction effect."

48. Dai Vaughan, in *Television Documentary Usage* (London: British Film Institute, 1976), has called this the "putative event," since it must be imagined (41).

49. Beginning in 2004, accounts of abuse, rape, killing, and torture of prisoners held in the Abu Ghraib prison in Iraq (also known as the Baghdad Correctional Facility) came to public attention as a result of the filming of acts. The acts were committed by some personnel of the 372nd Military Police Company of the United States, the U.S. Central Intelligence Agency, and possibly additional American governmental agencies. Errol Morris recently made *Standard Operating Procedure* (2008) on these events. For a fuller account and images, see http://www.antiwar.com/news/?articleid=2444 and http://www.salon.com/news/abu_ghraib/2006/03/14/introduction.

50. Philip Rosen, "Document and Documentary: On the Persistence of Historical Concepts," in *Theorizing Documentary*, ed. Michael Renov (London: Routledge, 1993), 62.

51. The *Oxford English Dictionary* cites Harriet Beecher Stowe's *Uncle Tom's Cabin* (1852).

52. See Maureen Turim, *Flashbacks in Film* (London: Routledge, 1989).

53. Katherine Bigelow's *Strange Days* (1995) presents the science-fiction fantasy of a memory apparatus—the "squid"—that allowed the wearer to experience in the present her own or another's recorded past as a lived present of interaction.

54. Peter Goldie, "Narrative, Emotion, and Perspective," in *Imagination and the Arts*, ed. M. Kieran and D. Lopes (London: Routledge, 2003), 56. Richard Allen, in *Projecting Illusion: Film Spectatorship and the Impression of Reality* (Cambridge: Cambridge University Press, 1995), shows how compelling our experience of what he characterizes as the "projective illusion" in cinema is, where our belief in the reality of the object and people seen supports our emotion response, and he argues that this explains the paradoxical effect of fiction's ability to engender our belief or, rather, our emotional response, which is not necessarily the same thing (118–19).

55. Ibid., 55.

56. Such imagining has been explored as "side-shadowing" versus the presumption of "foreshadowing," which historical narration often draws upon by Gary Saul Morson in "Essential Narrative: Tempics and the Return of Process," in *Narratologies: New Perspectives on Narrative Analysis*, ed. David Herman (Columbus: Ohio State University Press, 1999), 277–314.

57. The phrase was coined by Samuel Taylor Coleridge, who added that it also "constitutes poetic faith." In *The Complete Works of Samuel Taylor Coleridge* (New York: Harper Row, 1854), 3:365.

58. Colin Radford formulated this paradox in "How Can We Be Moved by the Fate of Anna Karenina?" *Proceedings of the Aristotelian Society*, Supplementary vol. 49, 1975, 67–80.

59. Paul Ricoeur, *Time and Narrative*, vol. 1, trans. Kathleen McLaughlin and David Pellauer (Chicago: University of Chicago Press, 1984), 176.

60. Paul Lazarsfeld and Robert K. Merton, "The Psychological Analysis of Propaganda," in *Writers' Congress: The Proceedings of the Conference Held in October 1943 under the Sponsorship of the Hollywood Writers' Mobilization and the University of California* (Berkeley: University of California Press, 1943), 378–79. Their conclusions remain highly salient and equally pertinent to documentary film that aims to persuade with regard to the facts it seeks to inform us of.

61. To be believable as nonfiction, a documentary must also be recognizable as such by drawing on generic expectations, such as voice-over explanatory narration, direct-to-camera address by participants and "experts," as well as handheld camera and direct sound recording, the roughness and indistinctness of which comes to connote raw reality recorded. Conventions become hackneyed, however, so new stylistic devices must emerge to renew the effect of realism, such as observational documentary and the multivoiced, multiview of direct address, which are often made possible by not only new technologies, such as tiny hidden cameras or infrared devices but also stylistic characteristics, such as rapid montages and slow motion. See Roman Jakobson, "On Realism in Art," in *Language in Literature*, ed. Krystyna Pomorska and Stephen Rudy (Cambridge, Mass.: Belknap Press, 1987), 19–27; and Gérard Genette, "Vraisemblance et Motivation," in *Figures II* (Paris: Seuil, 1969), 71–100. The "mockumentary," too, draws on such conventions, but in its comic parody, it also reveals the verisimilitude of documentary as conventional; see, for example, *The Office* (BBC 2001, NBC 2004). *Crossing the Great Sagrada* (Adrian Brunel, 1924) is an early parody of the travelogue. See Jane Roscoe and Craig Hight, *Faking It: Mock-Documentary and the Subversion of Factuality* (Manchester: Manchester University Press, 2001); Alexandra Juhasz and Jesse Lerner, eds., *F Is for Phony: Fake Documentary and Truth's Undoing* (Minneapolis: University of Minnesota Press, 2006).

62. Comolli is attacking the claims for direct cinema as simply reality, emphasizing the manipulation inevitably involved, notably editing, which he identifies with fiction as distinct from the fiction effect. "Détour par le direct—Un corps en trop," 226–27.

63. Indeed, Gosse suggests *A Journal of the Plague Year* nevertheless fails to use the devices of the novelistic, for it lacks a principle agent, or protagonist, who acts in relation to the events (*The Encyclopaedia Britannica*, s.v. "Novel").

64. Peirce, *Scientific Metaphysics*, vol. 6 of Hartshorne, Weiss, and Burks, *Collected Papers*, 66.

65. By plot and story I am referring to the distinction introduced by Shklovsky between *syuzet* and *fabula* and formulated as *discours* and *histoire* by Gérard Genette. See William Guynn, *Writing History in Film* (London: Routledge, 2006).

66. William Guynn, *A Cinema of Non-Fiction* (New York: Associated University Presses, 1990), 16–17. Many documentary film devices, such as the effacement of the camera's look in direct cinema or the use of eyeline matching (as in Robert Flaherty's work), are also used by the classical fiction feature film, but others are not, such as the use of direct address. See Branigan, *Narrative Comprehension and Film*, 204–6.

67. Hayden White, in "The Question of Narrative in Contemporary Historical Theory," (in *The Content of Form* [Baltimore, Md.: The John Hopkins University Press, 1987]), makes clear that narrative writing is not itself fiction (57).

68. Jacques Derrida and Bernard Stiegler, *Echographies of Television: Filmed Interviews*, trans. Jennifer Bajorek (Cambridge, UK: Polity Press, 2002), 41, 52.

69. Director Brian Blake, made for the Granada *World in Action* series, first broadcast November 1976, 8:30 P.M., on UK Independent Television.

70. Stephen Heath and Gillian Skirrow, "Television, a World in Action," *Screen* 18, no. 2 (Summer 1977): 58–59.

71. This view of novelistic realism thus differs from that outlined by Georg Lukács in "To Narrate or Describe," in *Writer and Critic, and Other Essays*, ed. Arthur D. Kahn (London: Merlin, 1970), where he argues for a narrative perspective that gives an orientation—necessarily ideological—that shapes the historical material, whereas description merely offers a series of moments, unintelligible in their causal significance. Outlined here, of course, is the problem of a controlling "perspective" for the novelistic, whether fiction or documentary.

72. Paul Ricoeur, in *Time and Narrative*, explores the mediating role of plot and the emplotment of events and actions in time in a relation of cause and effect (1:31–51).

73. Such performing is learned and mimetic, and cinema's contribution here was very early recognized, for example by Marcel Mauss, "The Notion of Body Techniques," in *Sociology and Psychology: Essays*, trans. Ben Brewster (London, Routledge, 1979), 100.

74. For example, *Who Bombed Birmingham*, a drama documentary about the wrongful conviction for this atrocity of the "Birmingham Six" and the efforts of British Member of Parliament Chris Mullen to obtain justice for these Irishmen, fails to be properly novelistic. On docudrama, see Derek Paget, *No Other Way to Tell It* (Manchester: Manchester University Press, 1998); and Steven N. Lipkin, *Real Emotional Logic: Film and Television Docudrama as Persuasive Practice* (Carbondale: Southern Illinois University Press, 2002).

75. Dai Vaughan, *For Documentary* (Berkeley: University of California Press, 1999), 154.
76. The two-DVD edition of the film presents additional material including interviews not used in the film. Arnold Friedman committed suicide in prison in 1995, leaving his life insurance benefit to Jesse. New evidence brought to light by the film enabled Jesse Friedman's appeal against his conviction, following his release in 2001 after serving thirteen years. This was rejected on technical grounds but the federal judge for the Second Circuit Court of Appeals in 2010 agreed that he was probably wrongfully convicted. See http://www.wisconsin appeals.net/?p=2436. Following this, Nassau County District Attorney Kathleen Rice announced that she would appoint a committee of her own assistants to re-examine the case and will compile a panel of experts in law enforcement, law, and social science to oversee the prosecutors' panel. http://www.huffingtonpost.com/2010/08/18/kathleen-rice-will -review_n_686044.html.
77. Debbie Nathan, "Complex Persecution," *Village Voice*, May 20, 2003, http://www.villagevoice .com/2003-05-20/news/complex-persecution.
78. On the role of home video in this film, see Marsha Orgeron and Devin Orgeron, "Familial Pursuits, Editorial Acts: Documentaries after the Age of Home Video," *The Velvet Light Trap— A Critical Journal of Film and Television*, no. 60 (Fall 2007): 47–62.

2. Working Images

1. Christine Buci-Glucksman, *Baroque Reason—The Aesthetics of Modernity* (London: Sage, 1994), 75.
2. Quoted by Hans Richter in *The Struggle for the Film*, trans. Ben Brewster (Aldershot: Scolar Press, 1986), 47. Quoted by Walter Benjamin in "A Little History of Photography," in *Walter Benjamin: Selected Writings*, vol. 2, trans. Edmund Jephcott and Kingsley Shorter, ed. Michael W. Jennings, Howard Eiland, and Gary Smith (Cambridge, Mass.: Harvard University Press, 1999), 526. Bertolt Brecht in "Der Dreigroschenprozess, ein soziologisches Experiment," in *Gesammelte Werke in 20 Bänden* (1930/1931) (Frankfurt-am-Main: Suhrkamp Verlag, 1976), 161.
3. These include, for example, German expressionism, and, French impressionist film, and later surrealism as well as the films of artist's such as Fernand Leger.
4. See the writings of, for example, Béla Balázs, Rudolf Arnheim, Paul Rotha, and John Grierson himself, who drew upon the theoretical writing of Soviet filmmakers such as Lev Kuleshov, Sergei Eisenstein, and Vsevolod Pudovkin, and the Russian formalists in journals such as *Lef* and *Novy Lef*.
5. John Grierson, "The Documentary Producer," *Cinema Quarterly* 2, no. 1 (1933): 8. He continued, "and every development of technique or new mastery of theme has to be brought quickly into criticism. In that respect it is well that the producer should be a theorist: teaching and creating a style; stamping it, in greater or less degree, on all the work for which he is responsible."
6. In "Two Paths to Poetry," *Cinema Quarterly* 3, no. 4 (Summer 1935), Grierson writes, "in our realistic cinema all roads lead by one hill or another to poetry. Poets they must be all—or stay forever journalists" (196).
7. Grierson, "The Story of the Documentary Film," *Fortnightly Review*, August 1939, cited by Forsyth Hardy in his introduction to his edited collection of Grierson's writings, *Grierson on Documentary* (New York: Harcourt, Brace and Co, 1947), 9. Here Grierson gives priority to the social rather than the aesthetic in the documentary idea.
8. Germaine Dulac, "The Educational and Social Effects of Newsreels," in "Germaine Dulac and Newsreel: 3 Articles," trans. Sian Reynolds, *Screening the Past* no. 12 (March 2007): 3, http:// www.latrobe.edu.au/screeningthepast/classics/cl0301/gdcl12a.htm.
9. Georg Lukacs, "Narrate or Describe?" in *Writer and Critic*, trans. A. D. Kahn (1936; New York: Gross & Dunlap, 1970).
10. Grierson, *Grierson on Documentary*, 103.
11. As S. Tretyakov observed, "It seems to me that the apparently sharp demarcation line between the 'play' film and the 'unplayed' film is in fact extremely relative. The question of the 'play' film versus the 'unplayed' film is the question of preference for fact as against fiction, for contemporaneity as against the past." Tretyakov, "Notes of Discussion," *Novy Lef* 11–12 (1927), trans. Diana Matias, *Screen Reader I* (London: Society for Education in Film and Television, 1977), 305.
12. Grierson, *Grierson on Documentary*, 103.
13. Michel Foucault, *The Archeology of Knowledge*, trans. A. M. Sheridan Smith (New York: Harper, 1972), 117.
14. Rudi Visker, *Michel Foucault: Genealogy as Critique*, trans. Chris Turner (London: Verso, 1995), 119.
15. Foucault, *Archaeology*, 167.

16. Ibid., 118, emphasis in original.
17. Visker, *Michel Foucault*, 119, quoting Foucault, *Archeology*, 109 and 129.
18. Visker, *Michel Foucault*, 120; quoting Foucault, "History of Systems of Thought," in *Language, Counter-Memory, Practice: Selected Essays and Interviews*, ed. Donald Bouchard (Ithaca, N.Y.: Cornell University Press, 1977), 199.
19. Henry Krips, in *Fetish: An Erotics of Culture*, describes the construction of the "virtual witness" through the specific rhetorical style of writing adopted by Robert Boyle, the seventeenth-century scientist, to describe, explain, and propagate his scientific discoveries as contemporary knowledge. Krips, *Fetish* (Ithaca, N.Y.: Cornell University Press, 1999), 119–32.
20. See Winston, *Lies, Damned Lies, and Documentaries* (London: BFI Publications, 2001).
21. This is explored further in relation to an early medical film in chapter 4.
22. Foucault, *Archeology*, 47.
23. Foucault, *Histoire de la folie à l'âge classique* (Paris: Gallimard, 1972), 94.
24. Visker, *Michel Foucault*, 118.
25. Foucault, *Archeology*, 47.
26. Visker, *Michel Foucault*, 121. Quoting Foucault, "The Order of Discourse," in *Untying the Text: A Post-Structuralist Reader*, ed. R. Young (London: Routledge, 1981), 67
27. Foucault, *Archeology*, 167.
28. Ibid.
29. Ibid., 36.
30. Visker, *Michel Foucault*, 119.
31. Foucault, "Truth and Power," in *Michel Foucault: Power*, Essential Works of Foucault, 1954–84 vol. 3, ed. James D. Faubion (London: Allen Lane, 2000), 131. He continues: "'Truth' is to be understood as a system of ordered procedures for the production, regulation, distribution, circulation, and operation of statements" (132).
32. Ibid., 131.
33. Ibid. Further: "The essential political problem for the intellectual is not to criticize the ideological contents supposedly linked to science, or to ensure that his own scientific practice is accompanied by a correct ideology, but that of ascertaining the possibility of constituting a new politics of truth. The problem is not changing people's consciousnesses—or what's in their heads—but the political, economic, institutional regime of the production of truth" (132–33).
34. Ibid.
35. Slavoj Žižek, "Four Discourses, Four Subjects," *Cogito and the Unconscious* (London: Verso, 1998), 78.
36. Foucault, "The Subject and Power," in Foucault, *Power*, 327.
37. Ibid., 327.
38. Foucault "Interview with Michel Foucault," in Foucault, *Power*, 255.
39. Peter Miller, *Domination and Power* (London: Routledge, 1987), 119.
40. Foucault, *Histoire de la folie*, 400, cited by Miller, *Domination and Power*, 119.
41. Foucault writes, "Everything was organized so that the madman would recognize himself in a world of judgment that enveloped him on all sides," ibid., 214.
42. Foucault, *Madness and Civilization: A History of Insanity in the Age of Reason*, trans. Michael Howard (New York: Vintage, 1973), 200.
43. Ibid., 201.
44. Ibid., 200.
45. Martin Jay, *Downcast Eyes: The Denigration of Vision in Twentieth-Century French Thought* (Berkeley: University of California Press, 1993), 414.
46. Ibid., 416.
47. Ibid., 221.
48. A question of activity versus passivity haunts Foucault's work, however these are not simple oppositions for the subject acts in relation to the constraints and regulation of disciplining. In the psyche, Jean Laplanche argues that the drive is first an activity of primary passivity, in the wish to be pleasured, see "The Drive and its Object-Source," in *Jean Laplanche—Seduction, Translation, and the Drives* (London: Institute of Contemporary Art, 1992), 179–95.
49. Foucault, *The Care of the Self: The History of Sexuality, Vol. 3*, trans. Robert Hurley (New York: Pantheon, 1986).
50. James D. Faubion, "Introduction," in *Michel Foucault: Aesthetics, Method, and Epistemology*, vol. 2, ed. James Faubion (New York: The New Press, 1998), xxxvii.
51. Ibid.
52. Foucault, *The Uses of Pleasure: The History of Sexuality, Vol. 2*, trans. Robert Hurley (New York: Pantheon, 1985), 28.
53. Paul Rabinow, "Introduction," in *Michel Foucault: Ethics, Subjectivity, and Truth*, ed. Paul Rabinow (New York: The New Press, 1998), xxxviii.

54. Judith Butler, *Gender Trouble: Feminism and the Subversion of the Identity* (London: Routledge, 1990), 25.

55. Gilles Deleuze, *Foucault*, trans. Sean Hand (London: Athlone, 1988), 97.

56. I have drawn here on Vikki Bell's insights in her discussion in "Performative Knowledge," *Theory, Culture & Society* 23, nos. 2–3 (2006): 214–17. She shows how the problem of the origin of subjectivity continues to haunt, notwithstanding Judith Butler's later work that incorporates an account of melancholia, of a lost object. Bell argues, "To interrogate the performative nature of these productions is to lay emphasis on the detail of power's operations, as well as its fragility. Subjectification is always incomplete and always threatened therefore by the sense in which its accomplishment is also its ability to be undone" (215). I suggest that the issue here of an original activity—or an original passivity—of a subjectivity that is nevertheless constructed in response to the world always rests on a temporal relation that invokes causality and a scenario of the automaton subject, or the resisting subject. "Becoming" in time as duration, however, implies not an objective subjectivity made but a continual making of subjective subjectivity.

57. Faubion, "Introduction," xxxviii.

58. Jacques Rancière, *The Politics of Aesthetics*, trans. Gabriel Rockhill (London: Continuum, 2004), 12.

59. Ibid., 52. The concepts are more fully explored in his *Aux bords du politique* (Paris: La Fabrique Éditons, 1998), 128–47.

60. In *Power*, Foucault identifies three modes of control that accompanied the emergence of the modern "worker" in the nineteenth century: First, in relation to time, transforming living time into labor time. Second, in relation to the body for "it was not just a matter of appropriating, extracting the maximum quantity of time but also of controlling, shaping, valorizing the individual's body according to a particular system." Where earlier this involved inscribing actions upon the body, as tortured and punished, later the body came "to be something molded, reformed, corrected, something that must acquire aptitudes, receive a number of qualities, become qualified as a body capable of working." The body was transformed thereby into labor power. Third, there was "the creation of a new and peculiar type of power" (82), economic, political, juridical, and epistemological.

61. Mary Ann Doane explores this relation in "Temporality, Storage, Legibility: Freud, Marey and the Cinema," *The Emergence of Cinematic Time* (Cambridge, Mass.: Harvard University Press, 2002), 33–68.

62. A painter and a poet as well as a filmmaker and photographer, Jennings was associated with the surrealists and was a cofounder of Mass-Observation (see note 85 in this chapter). For many of Jennings's contemporaries as well as for later viewers and critics, *Spare Time* represents an alternative to the mainstream of British 1930s documentary in its lyricism as well as its concern with images of people and their experience of the everyday and the popular.

63. Richter, *The Struggle for the Film*, 47.

64. The film was shot silent. The sound track of voice-over commentary and music (Brahms) was only added by Buñuel in 1936 after the ban on the film was lifted.

65. William Rothman—commenting in *Documentary Film Classics* (Cambridge: Cambridge University Press, 1997) that the film has been alternately taught as a social documentary and as a parody of documentary, a mock documentary—suggests that it both documents and "estranges" the reality it records (37–38).

66. Roland Barthes, *Camera Lucida* (New York: Hill and Wang, 1981), 27.

67. Quoted by Stuart Hood, "The Documentary Film Movement," in *British Cinema History* ed. James Curran and Vincent Porter (London: Weidenfield and Nicolson, 1983), 107 and 86.

68. Robert Colls and Philip Dodd, "Representing the Nation: British Documentary Film, 1930–45," *Screen* 26, no. 1 (1985): 25.

69. Ibid.

70. Andrew Higson, *Waving the Flag: Constructing a National Cinema in Britain* (Oxford: Oxford University Press, 1997), 186.

71. Ibid., 184.

72. Ibid., 185.

73. Grierson, "The Story of the Documentary Film," cited by Forsyth Hardy in *Grierson on Documentary*, 9.

74. Paul Rotha, *Documentary Film* (London: Faber and Faber Ltd., 1935), 115.

75. Higson, *Waving the Flag*, 185.

76. Ibid., 197.

77. Mayhew was a journalist, playwright, and advocate of reform who carried out extensive interviews in the 1850s with the whole range of London's poor—laborers, sweatshop workers, market traders, beggars, and prostitutes—whom he categorized in terms of whether "they will

work, they can't work," or "they won't work." These appeared as articles, later collected in four volumes as *London Labour and the London Poor* (London: Dover Publications, 1968). *The Song of the Shirt* (1979, dir. Susan Clayton and Jonathan Curling, British Film Institute) explores the problems of work for women in the 1850s and 1970s through a reenactment of some of these interviews, a fictional storytelling, and contemporary documentary.

78. "Modernity" for the Western world arises from the seventeenth century with the European Enlightenment project and the industrial revolution in the eighteenth century in Britain.

79. This is explored further in chapter 3.

80. This is discussed further in relation to *Spanish Earth* in chapter 1.

81. The movement remains a strong retailing and banking organization in the UK—see http://www.co-operative.coop/corporate/widermovement. It included film societies and filmmaking. See http://www.co-op.ac.uk/our-heritage/national-co-operative-archive/.

82. Dr. John Bowlby, a child psychotherapist at the Tavistock Clinic, London, was influenced by the work of the psychoanalysts Melanie Klein and David Winnicott in developing his view of the importance of the early mother-child relationship. Bowlby produced the study *Maternal Care and Mental Health* in 1951 for the World Health Organization (New York: Colombia University Press). See Denise Riley, *War in the Nursery* (London: Virago, 1983) on Bowlby's role.

83. This is explored in films such as *Women of the Rhondda* (1973, made by the London Womens' Film Group, with filmmakers Mary Capps, Mary Kelly, Margaret Dickinson, Esther Ronay, Brigid Segrave, Humphrey Trevelyan, Susan Shapiro) and more recently in *Shifting Times* (1998, dir. Lucy Jago, BBC Community Programme Unit), which I discuss in "Working Images: The Representations of Documentary Film," in *Work and the Image II—Work in Modern Times: Visual Mediations and Social Processes*, ed. Valerie Mainz and Griselda Pollock (Aldershot: Ashgate, 2000), on which this chapter draws.

84. Two contrasting approaches to the representation of work in contemporary works are, first, the BBC series *Trawlermen* (2006–2008), which, with its dramatic filming of fishing boats at sea and the perilous conditions for their crews, constructs its particular way of knowing through a dominant voice-over. This episode is available to view on the BBC Web site at http://www.bbc.co.uk/iplayer/episode/b00d4xny. The second is Paul Watson's earlier observational series, *The Factory* (Granada TV, first screened in 1995).

85. Mass-Observation was formed following a letter in The *New Statesman* published January 30, 1937, by Jennings and Madge responding to Mr. Geoffrey Pyke, who had written asking for "that anthropological study of our own civilization of which we stand in such desperate need" (The *New Statesman*, December 12, 1936) in which they announced an "anthropology at home . . . a science of ourselves" and requested that volunteers collect observations of everyday life—speaking for themselves. Anthropologist Tom Harrisson saw the correspondence and joined with Jennings and Madge. One of the first investigations they undertook was a study of Bolton and Blackpool covering the years 1937 to 1940, which became known as the Worktown Study. Madge, a published poet, was then a journalist with *The Mirror*, later becoming the first professor of sociology at the University of Birmingham, and subsequently involved in the creation of the Centre for Cultural Studies at the university.

86. Charles Madge, "They Speak for Themselves: Mass-Observation and Social Narrative," *Life and Letters Today*, 17, no. 9 (1937): 37–42. Reprinted in *The Everyday Life Reader*, ed. Ben Highmore (London: Routledge, 2002), 146–52.

87. During the war, she worked on government films such as *Choose Cheese* (1940) and *They Also Serve* (1940). She died in 1940 at the age of thirty-six, during the filming of British child evacuees, when the ship on which they were travelling was torpedoed and sunk en route to Canada.

88. Her younger sister, Marion Grierson, was also a filmmaker and married to John Taylor.

89. Humphrey Jennings, Charles Madge, letter to the *New Statesman*.

90. Charles Madge and Humphrey Jennings, "Preface," in *May the Twelfth, Mass-Observation Day-Surveys 1937 by over two hundred observers*, ed. Humphrey Jennings and Charles Madge, with T. O. Beechcroft, Julian Blackburn, William Empson, Stuart Legg, Kathleen Raine, et al. (London: Faber & Faber, 1937), iii. The co-editors include some of the major figures in the arts of the time.

91. Charles Madge and Tom Harrisson, eds., *First Year's Work* (London: Penguin, 1938), 66.

92. This is discussed in the Introduction.

93. According to Paul Rotha it was Ruby Grierson's ability to win people's confidence that "gave a spontaneity and an honesty to the 'interviews' that contrasted sharply with the previous, romantic, method of handling people." Rotha, *Documentary Film* (London: Faber, 1952), 195. Basil Wright later referred to these as "cinéma vérité," interviewed in Elizabeth Sussex, *The Rise and Fall of British Documentary* (Berkeley: University of California Press, 1975), 62.

94. Higson, *Waving the Flag*, 200.

95. John Corner, *The Art of Record* (Manchester: Manchester University Press, 1996), 68. He rightly concludes, "The effect is one of powerful immediacy and engagement." Corner refers here to the "access project" of the film (69) and its "reportorial naturalism" that has made it be recognized as a forerunner of much contemporary television documentary (56).

96. Drawing on Mass-Observation's project, in 1993, Chris Mohr and Mandy Rose of the Community Programmes Unit, BBC, started the TV series *Video Nation* using a series of cameras distributed across the United Kingdom. The contributors were given their Hi-8 camera for one year, during which time they filmed their everyday lives. See these at BBC's *Video Nation* Web site (http://www.bbc.co.uk/videonation/archive).

3. Documentary Desire

1. For Freud, the "reality principle" is not primarily the imposition of material external exigencies that must be recognized by the subject. Rather it is what opposes the pleasure principle as something the subject must accede to as a result of an external imperative, not only a voiced account of the world as a material, but also as an internal moral exigency, a voice of the super ego or conscience. See *An Outline of Psycho-Analysis* (1938), in *The Standard Edition of the Complete Works of Sigmund Freud*, ed. and trans. James Strachey (London: Hogarth Press, 1974), 23:139–208. Hereafter cited in text as *SE*. Lacan replaces this binary opposition with his tripartite characterization of the real, the imaginary, and the symbolic, where "reality" is constructed in our imaginary or symbolic relations to the other.

2. Lacan, *The Ethics of Psychoanalysis 1959–1960: The Seminar of Jacques Lacan*, ed. Jacques-Alain Miller, trans. Dennis Porter (London: Routledge, 1992), 131–32.

3. Paul Lazarsfeld and Robert K. Merton, "The Psychological Analysis of Propaganda," in *Writers' Congress: The Proceedings of the Conference Held in October, 1943 under the Sponsorship of the Hollywood Writers' Mobilization and the University of California* (Berkeley: University of California Press, 1943), 377. Propaganda here, as for Grierson, is a neutral term, though the authors note that such a tool, like any medium, can be abused, and "the pseudo fact may supplant the fact" (380).

4. Ibid., 378, and 380.

5. Ibid., 378.

6. Character identification is often termed a "folk theory" in cognitive and analytic philosophy approaches, thus the affectual impetus of the commonsense idea of identification is set against a "proper" knowledge and understanding. Noël Carrol writes that "identification . . . is not the correct model for describing the emotional responses of spectators," in *The Philosophy of Horror, or Paradoxes of the Heart* (London: Routledge, 1990), 96. Berys Gaut, summarizing these debates in "Identification and Emotion in Narrative Film," draws on Richard Wolheim to defend the concept of identification as sympathy or empathy. In *Passionate Views*, ed. Carl Plantinga and Greg M. Smith (Baltimore: The Johns Hopkins University Press, 1999), 200–216.

7. Lacan, "The mirror stage as formation of the function of the I as revealed in psychoanalytic experience," in *Écrits, A Selection*, trans. Alan Sheridan (London: Tavistock Publications, 1977), 1–7. See chapter 1 on this. Here arises what Freud termed the ideal ego, as well as, Lacan argues, aggressivity.

8. We identify with the desire of the other, to be what the other wants (us to be), which corresponds to Freud's ego ideal, as the image the other desires. See Elizabeth Cowie, *Representing the Woman: Cinema and Psychoanalysis* (London: Macmillan, 1997), 166–221.

9. John Corner has discussed the self that is displayed in documentary and reality television as a process of "selving," performing, or becoming a self, as well as the recognition of a "true self" by the participant and the viewer. "Performing the Real: Documentary Diversions," *Television and New Media* 3, no. 3 (August 2002), 261.

10. Freud characterized the disavowal central to fetishism as a splitting of the ego, and one that is merely "an exceptional case" of a process of warding off unacceptable demands of reality. *In An Outline of Psycho-Analysis, SE*, 23:203–4.

11. In Lacanian terms, this is an affirmation that the Big Other knows and thus that it does not lack; this is termed by Lacan an imaginary relation, whereby lack in the other, though not in the subject herself or himself, is disavowed. This is discussed more fully shortly.

12. Slavoj Žižek, "The Interpassive Subject," *The Symptom*, no. 3 (2002), http://www.lacan.com/zizek-pompidou.htm. Žižek develops here the idea of an "interpassivity" as the "other side" of the spectator's interactive engagement with media, whereby "it is the object itself which 'enjoys the show' instead of me, relieving me of the superego duty to enjoy myself." The processes of splitting and projection that arise are themselves a very interactive engagement with the medium as object, made into an agent that "takes from me" or "endures for me." Žižek shows that interpassivity is a form of interacting with the other and distinguishes

between the belief, knowledge, or enjoyment that the other is supposed to undertake "for me."

13. Walter Benjamin, "The Work of Art in the Age of Mechanical Reproduction," in *Iluminations*, trans. Harry Zohn (London: Fontana, 1968), 230. This view has also been adopted by later theorists, including Laura Mulvey and Christian Metz.

14. Two psychical processes are in play that are distinct: We see as if we were there ourselves, with the same view, eliding the camera as agency of our view separate from us. In addition, our active drive to see is satisfied in our identification with the all-powerful inquisitorial look of the camera, which is thus separate from our own limited access of sight.

15. I've drawn here on Frances Guerin's work in *Through Amateur Eyes: Film and Photography in World War II Germany* (Minneapolis: University of Minnesota Press, forthcoming).

16. Jacques Lacan, "The Mirror Stage," 5. More recently the phenomenon has been identified as a specific neurological process, termed the "mirror neurone."

17. Gilles Deleuze and Félix Guattari, *What Is Philosophy?*, trans. Graham Burchell and Hugh Tomlinson (London: Verso, 1994), 17.

18. Gilles Deleuze, *Difference and Repetition*, trans. Paul Patton (New York: Columbia University Press,1994), 139.

19. Joan Copjec, *Imagine There's No Woman* (Cambridge, Mass.: MIT Press, 2002), 76. This, however, presents a trap for our reading of the face Copjec suggests, namely, of "believing in a world that is elsewhere, in a place to which one can withdraw in solitude to safeguard the precious core of one's being," (78), the space of narcissism, as might seem the case for Elisabeth in Deleuze's example of *Persona* (Ingmar Bergman,1966).

20. Richard Rushton, "What Can a Face Do? On Deleuze and Faces," *Cultural Critique* 51 (Spring 2002): 234.

21. Deleuze, *Cinema 1: the Movement-Image*, trans. Hugh Tomlinson and Barbara Habberjam (Minneapolis: University of Minnesota Press, 1986), 87. Deleuze discusses the face as an "affection-image" that arises between the "perception-image" and "action-image" in the interval as "what occupies it without filling it in or filling it up," but that involves a certain indeterminacy. It is the way the subject "feels itself 'from the inside'" as a qualitative experience (65).

22. For Bela Belázs, in a film, "the precipice over which someone leans may perhaps explain his expression of fright, but it does not create it. For the expression exists even without justification." In *Theory of the Film: Character and Growth of a New Art*, trans. Edith Bone (New York: Dover, 1970), 136; cited in Deleuze, ibid., 102. The close-up for Deleuze is not part of the scene, an enlarged detail within its narrative account, but rather, as Copjec emphasizes, "it opens onto a different dimension . . . that is not of the spatiotemporal order" (*Imagine There's No Woman*, 75).

23. Peirce, "A Guess at the Riddle," *Collected Papers of Charles Sanders Peirce*, ed. Charles Hartshorne, Paul Weiss, and Arthur Burks (Cambridge, Mass.: Harvard University Press, 1932), vol. 1, 356–57) and Commens Peirce Dictionary http://www.helsinki.fi/science/commens/dictionary.html.

24. Language is also encountered within the image-track as writing, where, disembodied but nevertheless material, it signifies as words as such: in their physical appearance as subtitles over the image; or as documents and letters presented for view; or as found elements within documentary footage, such as posters, store signs, and so on.

25. For *The Life and Times of Rosie the Riveter*, for example, Connie Fields refers to having talked to seven hundred women on the phone and two hundred in person; thirty-five were video-taped and five were eventually filmed. In Barbara Zheutlin, "The Politics of Documentary: A Symposium," in *New Challenges for Documentary*, ed. John Corner and Alan Rosenthal, *New Challenges for Documentary* (Manchester: Manchester University Press, 2005), 160.

26. Leger Grindon explores this further in "Q & A: Poetics of the Documentary Film Interview," *The Velvet Light Trap* 60 (Fall 2007), 4–12.

27. Trinh T. Minh-ha further comments, "Direct speech does not transcend representation. To a certain extent, interviewees choose how they want to be represented in what they say as well as in the way they speak, dress, and perform their daily activities." In *Framer Framed: Film Scripts and Interviews* (London: Routledge, 1992), 193–94.

28. Michel Chion, *The Voice in Cinema*, trans. Claudia Gorbman (New York: Columbia University Press, 1999), 18.

29. Nichols, *Representing Reality* (Berkeley: University of California Press, 1991), 43. While the term "observational cinema" is associated with the development of direct sound recording in documentary in 1960, the camera as unseen onlooker was already part of silent classical cinema, and these conventions were adopted by Robert Flaherty in his early documentaries, particularly *Moana* (1926).

30. Heath and Skirrow, "Television, a World in Action," *Screen* 18, no 2 (Summer 1977), 58–59.

31. Manuals on documentary filmmaking emphasize the importance of this: for example, Sheila Curran Bernard's *Documentary Storytelling for Video and Filmmakers* (Oxford: Focal Press, 2004).

32. Berys Gaut, "Identification and Emotion in Narrative Film," in *Passionate Views: Film, Cognition, and Emotion*, ed. Carl Plantinga and Greg M. Smith (Baltimore, Md.: The Johns Hopkins University Press, 1999), 206–7.

33. Kaja Silverman, *The Threshold of the Visible World* (London: Routledge, 1996), 26.

34. The ego ideal is that image of the self that one should be or become in order to be likeable and valued. Renata Salecl has described this aspect of caring as the "second tear," drawing on Milan Kundera's discussion of kitsch in *The Unbearable Lightness of Being*: "Kitsch causes two tears to flow in quick succession. The first tear says: How nice to see children running on the grass! The second tear says: How nice to be moved, together with all mankind, by children running on the grass! It is this second tear which makes kitsch kitsch." (London: Faber, 1986), 250–51. Salecl comments, "To paraphrase Kundera, in the case of the Bosnian refugee girl, one could say that the first tear runs when we see the picture of the poor girl and the second tear runs when we, together with all mankind, are moved by the fact that we are compassionate." *The Spoils of Freedom: Psychoanalysis and Feminism after the Fall of Socialism* (London: Routledge, 1994), 139.

35. Brian Winston has addressed the "victim" tradition in documentary in "Documentary: I Think We Are in Trouble," in *New Challenges for Documentary*, ed. Alan Rosenthal (Berkeley: University of California Press, 1988), 30.

36. Hill, *Restyling Factual TV: Audiences and News, Documentary and Reality Genres* (London: Routledge, 2007),142.

37. This point is made by Hill's interviewees, and Hill argues: "A grammar for citizenship can be located in the spaces in-between the public and private" (ibid., 166–67).

38. Ibid.,108.

39. Ibid., 110.

40. Henri Bergson, *Time and Free Will*, trans. F. L. Pogson (New York: Harper & Row, 1960), 105.

41. Ibid., 19. Bergson suggests here a very complex view of "true pity" as consisting not in a fear of suffering but in a desire for it by which one both avoids complicity in causing it and feels raised in one's self-estimation.

42. Deleuze draws on Bergson's account here and develops a further elaboration of duration and the form our encounter of duration in representation in his concept of the rhizome or the crystalline, considered further in chapter 6.

43. Bergson, "The Idea of Duration," in *Henri Bergson: Key Writings*, ed. Keith Ansell Pearson and John Muillarkey, trans. Melissa McMahon (London: Continuum, 2002), 73.

44. Hill, *Restyling Factual TV*, 137.

45. Lacan, *The Other Side of Psychoanalysis: The Seminar of Jacques Lacan Book XVII*, trans. Russel Grigg (New York: Norton, 2007). Lacan introduced this theory in the seminar of 1969 to 1970, "L'envers de la psychanalyse," developing these points in "Radiophonie," *Scilicet*, nos. 2–3 (1970): 55–99, and in his following seminar, "Du'un discours qui ne serait pas du semblant." A further elaboration is given in *Encore*, the seminar of 1972 to 1973 (Paris: Seuil, 1975).

46. Ibid., 29.

47. Paul Verhaeghe, "From Impossibility to Inability: Lacan's Theory on the Four Discourses," *The Letter: Lacanian Perspectives on Psychoanalysis* (Spring 1995): 82. I am indebted here to Verhaeghe's valuable account of the "Four Discourses," which he describes as "a condensation of Lacan's evolution" of his theoretical intervention in psychoanalysis" (80). He has developed this account in *Does the Woman Exist?* (London: Rebus Press, 1997), 95–122.

48. Verhaeghe observes that these two disjunctions "condense a major Freudian discovery, namely the ever-present failure of the pleasure principle . . . Man can never return to what Freud called 'die primäre Befriedigungserlebnis,' (in *Project for a Scientific Psychology, SE* 1:317–20) the primary experience of satisfaction. He is unable to operate this return because of the primary Spaltung, the division of the subject due to language. Nevertheless, he keeps on trying, and during this process he gets stuck on the road, and that's where he experiences the impossibility" (86).

49. In *The Other Side of Psychoanalysis*, Lacan desigates the *objet petit a* as an enjoyment or jouissance that is "extra," or "*plus-de-jouir*," because it is marked by lack (19). A further account of the *objet petit a* is given in chapter 4.

50. Ibid., 5.

51. Ibid., 34.

52. Slavoj Žižek, *Cogito and the Unconscious* (Durham, N.C.: Duke University Press, 1998), 76.

53. Lacan, *The Other Side of Psychoanalysis*, 90. Lacan suggests that mathematics similarly "represents the master's knowledge insofar as it is constituted on the basis of other laws than those of mythical knowledge" (ibid.).

54. Ibid., 148.

55. Ibid., 90.

56. Ibid., 90.

57. Slavoj Žižek, "The Interpassive Subject."

58. Mladen Dolar, "Hegel as the Other Side of Psychoanalysis," in *Jacques Lacan and the Other Side of Psychoanalysis*, ed. Justin Clemens and Russel Grigg (Durham, N.C.: Duke University Press, 2006),148.

59. Lacan, *The Other Side of Psychoanalysis*, 148.

60. Alenka Zupančič, "When Surplus Enjoyment Meets Surplus Value," in Clemens and Grigg, *Jacques Lacan and the Other Side of Psychoanalysis*, 168.

61. This was a bullying participated in by Jo O'Meara and Danielle Lloyd as well. Goody appeared on *Big Brother* in 2003, initially receiving considerable media derision as a result of her lack of knowledge of Britain, which led to her being seen as ignorant (she had in fact trained as a dental assistant), but she become a celebrity as a result of public fascination with her, as well as successful and wealthy through a later television show and other appearances. The 2007 *Big Brother* house sought to promote tension between the participants, playing on the features that had drawn public interest in Goody: her impoverished background, her difficult relationship with her mother, and so on. Goody vigorously denied that she was a racist, and it was on a visit to India shortly afterward to redeem her image that she learned she had cervical cancer. She died in 2009.

62. Verhaeghe, *Does the Woman Exist?*, 113.

63. Lacan, *The Seminar of Jacques Lacan XX: Encore* (1992), trans. Cormac Gallagher (London: Karnac, 2004), 3:5. This is, Verhaeghe writes, "the possibility for grasping the determination from object a to *S*" (*The Letter*, 99).

64. Lacan, *The Other Side of Psychoanalysis*, 147.

65. Foucault, *Madness and Civilization: A History of Insanity in the Age of Reason*, trans. Michael Howard (New York: Vintage, 1973), 248. See also my earlier discussion in chapter 2. Foucault introduced his concept of discourse in December 1970 during his inaugural speech at the Collège de France.

66. Produced by Chris Bryer and Roger Finnigan. A DVD version is available from Films Media Group: Films for the Humanities & Sciences, USA, http://ffh.films.com/ContactUs.aspx.

67. Another example is the melodramatic use of radio host and New Orleans resident Garland Robinette, who breaks down, unable to continue, as he covers his face, crying, when he recalls Mayor Ray Nagin's interview with him and his outburst regarding the failure of state and federal help to arrive. This contrasts with Nagin's bland composure in the next shot.

68. Documentary autobiography, such as Jonathan Caouette's *Tarnation* (2003), similarly presents a repetitive returning in its attempt to say through the documenting of his filming who he is, which also leads to questions of what he is for his mother and what she was for her parents, his grandparents. It is to ask what they want, the question of their desire. Michael Renov explores the film as "domestic ethnography" in "First-person Films: Some Theses on Self-inscription," in *Re-thinking Documentary*, ed. Thomas Austin and Wilma de Jong (Maidenhead, U.K.: Open University Press, 2008).

4. Documenting the Real

1. Max Hernandez, "Winnicott's 'Fear of Breakdown': On and beyond Trauma," *Diacritics* 28, no. 4 (Winter 1998): 139 and 140. Hernandez is referring here to the work of Alvin Frank in "The Unrememberable and the Unforgettable: Passive Primal Repression," *The Psychoanalytic Study of the Child* 24 (1969): 48–77.

2. Available to view on line at the website of British Pathé at http://www.britishpathe.com/results .php?search=war+neuroses.

3. I am drawing here on Martin Stone's excellent reevaluation of British psychiatry and the development of modern psychiatric practices as a result of the unprecedented medical requirements of the war neuroses of soldiers in his chapter "Shellshock and the Psychologists," in *The Anatomy of Madness: Essays in the History of Psychiatry* (Cambridge: Cambridge University Press, 1985), 242–71.

4. Freud, *Beyond the Pleasure Principle*, *The Standard Edition of the Complete Works of Sigmund Freud*, vol. 8, ed. and trans. James Strachey (1920; London: Hogarth Press, 1974). Hereafter cited in text as *SE*. See especially Freud's discussion of the *fort-da* game (14–17). This is addressed by Lacan in his re-consideration of the death drive in *Écrits: The First Complete Edition in English*, trans. Bruce Fink (New York: Norton, 2006), 262.

5. Lorenzo Chiesa, in *Subjectivity and Otherness: A Philosophical Reading of Lacan* (Cambridge, Mass.: MIT Press, 2007), reviews the development of the concept of the real in Lacan's thinking that, firstly, "locates itself in a 'beyond' with respect to everyday reality; secondly, it has been there 'from the beginning.'" This beginning "should be identified with primordial frustration" (129).

6. Ibid., 132.

7. Slavoj Žižek argues that "reality" is a fantasy construction that enables us to mask the "real" of our desire, *The Sublime Object of Ideology* (London: Verso, 1989), 45.

8. Walter Benjamin, "Little History of Photography," Selected Writings vol. 2. ed. Michael W. Jennings, Howard Eiland, and Gary Smith, trans. Edmund Jephcott and Kingsley Shorter (Cambridge, Mass.: Harvard University Press, 1999), 510.

9. Mary Ann Doane, *The Emergence of Cinematic Time: Modernity, Contingency, and the Archive* (Cambridge, Mass.: Harvard University Press, 2002), 100.

10. Peirce, *Scientific Metaphysics*, in *Collected Papers of Charles Sanders Peirce*, ed. Charles Hartshorne, Paul Weiss, and Arthur Burks (Cambridge, Mass.: Harvard University Press, 1935), vol. 6:234.

11. Doane, *Emergence*, 101; Peirce, *Exact Logic* (1933); *Collected Papers* 3:226.

12. Freud, *The "Uncanny,"* (1919) *SE* vol. 17, 219–52.

13. Lacan, *The Four Fundamental Concepts of Psycho-Analysis* (Harmondsworth: Penguin Books, 1977), 53.

14. Ibid., 55.

15. Chiesa, *Subjectivity and Otherness*, 135.

16. Ibid., 135–36. Supporting his argument, Chiesa notes that "the notion of the real 'Thing,' around which the entirety of Seminar VII [*The Ethics of Psychoanalysis*] revolves, disappears almost completely from later Seminars" (131). It is this view of sublimation to which I will return in chapter 6.

17. This gives rise to what Lacan, in his later work after 1968, called a "surplus jouissance," or "plus-de-jouir" that he identifies with the object "*a*" in *The Other Side of Psychoanalysis*, trans. Russell Grigg (New York: Norton, 2007), 19.

18. Freud, "An Outline of Psycho-Analysis," (1938), *SE* vol.23, 204. See also chapter 5 of Elizabeth Cowie, *Representing the Woman: Psychoanalysis and Cinema* (London: Macmillan, 1997).

19. Produced by the U.S. Army Signal Corp Pictorial Service. Huston is also credited as the screenwriter.

20. Hal Foster comments in relation to repetition in Andy Warhol's works are also apt here: "Somehow in these repetitions, then, several contradictory things occur at the same time: a warding away of traumatic significance and an opening out to it, a defending against traumatic affect and a producing of it." *The Return of the Real* (Cambridge: MIT Press, 1996), 132.

21. Cathy Caruth, *Unclaimed Experience* (Baltimore, Md.: The Johns Hopkins University Press, 1996), 6. Caruth does, however, write of trauma as "experiences not yet completely grasped" (56).

22. Ibid., 7.

23. Translated by Strachey in the *Standard Edition* of Freud's work as "deferred action," which Laplanche suggests is better understood in English as "afterwardsness," in *Essays on Otherness* (London: Routledge, 1998), 265. See also John Fletcher and Martin Stanton, eds., *Jean Laplanche: Seduction, Translation, Drives* (London: Institute of Contemporary Arts, 1992), especially Andrew Benjamin's illuminating essay, "The Unconscious: Structuring as a Translation," 137–57.

24. Laplanche describes this as a process of translation–detranslation–retranslation, arguing that his theory of seduction "affirms the priority of the other in the constitution of the human being and of its sexuality. Not the Lacanian Other, but the concrete other: the adult facing the child. A perverse adult? Yes, one must say; but intrinsically perverse because his messages are 'compromised' by his own unconscious" (*Essays on Otherness*, 212).

25. In *Hiroshima mon amour* (Alain Resnais, 1959), trauma is addressed as an issue of the unknown in the commemorated and remembered as a repeated return and re-finding of what cannot be understood, but it also institutes a forgetting that enables trauma to pass into memory and thus some level of resolution. See also Elizabeth Cowie, "Traumatic Memories of Remembering and Forgetting," in *Between the Psyche and the Polis: Refiguring History in Literature and Theory*, ed. A. Whitehead and M. Rossington (Aldershot: Ashgate, 2000), 191–204.

26. W. H. Rivers accounted for this difference by referencing the different training procedures of the two groups of men, likening the drill training of the ordinary soldier to hypnosis, whereas the men of the officer class—educated in the main at public school (i.e., in the English system, privately)—came into the army "with a long course of training behind him which enables him successfully to repress, not only expressions of fear, but also the emotion itself." "War Neurosis

and Military Training," in *Instinct and the Unconscious: A Contribution to a Biological Theory of the Psycho-Neuroses* (Cambridge: Cambridge University Press, 1920), 209.

27. British neurology up to this time had been predominantly materialist, so that the soldier's symptoms were understood as a neurological response to the physical effects of shell blast. But symptoms of shell shock, as it was subsequently but misleadingly called, were also arising in men who had not been directly exposed to physical factors such as shelling, and only a small proportion of shell shock victims had suffered organic damage to the central nervous system. In response, such traditionalists marshaled the second account of mental illness in the nineteenth century, namely, that of "tainted" heredities. Shell shock, however, occurred so widely, even among the "volunteers" and officers considered to be the "'best" genetically, that such an approach was fundamentally discredited. Martin Stone argues, therefore, that the process of "medicalization of the mind" characterized by the concept of "war neuroses" that emerged in medical discourse at this time was a response to the problem shell shock confronted the medical establishment with (*The Anatomy of Madness*, 248).

28. The treatment at Netley and Seale Hayne was described by Drs. Hurst and Symns in "The Rapid Cure of Hysterical Symptoms," *Lancet*, August 3rd, 1918: 139–41. The technique of suggestion, or persuasion, produced spectacularly rapid results, as *War Neuroses* demonstrates, and at the time of their article—a few months after the film—they claimed that there were few relapses among the soldiers treated. That the effects of trauma continued to be felt and to incapacitate is indicated by the number of pensions paid for these symptoms. Hypnosis was also used, but the curative effects were often not long-lived and the technique was difficult for doctors to learn, while patients were frequently not suitable subjects.

29. Such scenes are possibly a convention of war documentaries at the time; a similar scene of soldiers off duty appears in *British Troops in Italy* (United Kingdom, 1918), involving the comic plucking of a chicken for cooking.

30. The final shots of the film are missing, but probably these conclude the battle.

31. Stone, *The Anatomy of Madness*, 246, 248.

32. This suggests the extent to which conventions for the representation of such scenes were already established, for example by *The Battle of the Somme* (filmed by two official war cinematographers, Geoffrey Malins and John McDowell, 1916), which Michael Hammond has suggested draws upon the battle scenes in D. W. Griffith's *Birth of a Nation* (1915). Michael Hammond, *The Big Show: British Cinema in the Great War, 1914–18* (Exeter: Exeter University Press, 2006), 98–128.

33. http://www.tate.org.uk/modern/exhibitions/cinema/gordon.htm. Also held by the British Council, see http://collection.britishcouncil.org/collection/artist/5/17554/object/39639.

34. The concept of the poetic as a dominant aspect of the communication process is outlined by Roman Jakobson in "Closing Statement: Linguistics and Poetics," in *Style in Language*, ed. T. Sebeok (New York: Wiley, 1960).

35. The Bible, verse 3, Genesis, King James version, describes God's creation of light out of Earth's darkness and formlessness. Voice over written by John Huston, narrated by his father, Walter.

36. Huston said, "I think it boils down to the fact that they wanted to maintain the 'warrior' myth, which said that our American soldiers went to war and came back all the stronger for the experience, standing tall and proud for having served their country well. Only a few weaklings fell by the wayside. Everyone was a hero, and had medals and ribbons to prove it. They might die, or they might be wounded, but their spirit remained unbroken. When speaking of the War Department I say 'they,' because in that bureaucratic morass it is impossible to pin down responsibility." John Huston, *An Open Book* (New York: Alfred A. Knopf, 1980), 125–26.

37. Raffaele Donato and Martin Scorsese, "Docufictions: An Interview with Martin Scorsese on Documentary Film," *Film History: An International Journal* 19, no. 2 (2007): 199–207.

38. Huston and his crew spent three months at the hospital documenting the intensive eight-week program of therapy the soldiers underwent.

39. Richard Ledes, "*Let There Be Light*: John Huston's Film and the Concept of Trauma in the United States after World War II," Après-Coup Psychoanalytic Association, http://www.apres-coup.org/mt/archives/title/2005/01/let_there_be_li.html.

40. This approach suggests that the doctors may have drawn upon the work of Donald Winnicott. Winnicott had published a number of major papers in the 1930s and early 1940s in the *International Journal of Psycho-Analysis*.

5. Ways of Seeing and the Surreal of Reality

1. Bazin, *What Is Cinema? Volume 2*, essays selected and trans. Hugh Gray (Berkeley: University of California Press, 1971), 30.

2. Lacan, *The Four Fundamental Concepts of Psycho-analysis*, trans. Alan Sheridan (Harmondsworth: Penguin, 1977), 197. See on this Maire Jaanus, "The Démontage of the Drive," in *Reading Seminar XI: Lacan's Four Fundamental Concepts of Psychoanalysis*, ed. Richard Eldstein, Bruce Fink, and Maire Janus (Albany: State University of New York, 1995), 119–36.

3. Charles Baudelaire, *Art in Paris 1845–1862*, trans. Jonathan Mayne (London: Phaidon, 1965), 162.

4. Regarding events that Flaherty was unable to capture in *Man of Arran* (1934), Bazin writes, "How much more moving is this flotsam, snatched from the tempest, than would have been the faultless and complete report offered by an organized film, for it remains true that this film is not made up only of what we see—its faults are equally witness to its authenticity. The missing documents are the negative imprints of the expedition—its inscription chiseled deep" (*What Is Cinema? Volume One*, essays selected and trans. Hugh Gray (Berkeley: University of California Press, 1971), 162.

5. Serge Daney, "The Screen of Fantasy (Bazin and Animals)," in *Rites of Realism*, ed. Ivone Margulies (Durham, N.C.: Duke University Press, 2005), 34. Bazin, *Qu'est-ce que le cinema?* (Paris: Editions du Cerf, 1958), 1:57; Daney, "The Screen of Fantasy," 35.

6. Daney, "The Screen of Fantasy," 35.

7. Marcel Mauss, "Real and Practical Relations between Psychology and Sociology," *Sociology and Psychology: Essays*, trans. Ben Brewster (1950; London: Routledge, 1979), 32.

8. Lacan was very active in the world of French surrealism. He was influenced by Salvador Dalí in the 1920s and was associated with André Breton, Georges Bataille, and Pablo Picasso. He attended the Mouvement Psyché founded by Maryse Choisy. Several of his articles were published in the surrealist journal *Minotaure*, and he was present at the first public reading of James Joyce's *Ulysses*. Lacan was the last private owner of Gustave Courbet's provocative painting *L'Origine du monde* (The origin of the world), a surrealist variant of which he had his stepbrother, André Masson, paint.

9. Jean Rouch with Enrico Fulchignoni, "Ciné-Ethnography," in *Ciné-Ethnography*, ed. Steven Feld (Minneapolis: University of Minnesota Press, 2003), 185.

10. Jeanne DeBouzek, "The 'Ethnographic Surrealism' of Jean Rouch," *Visual Anthropology* 2, nos. 3–4 (1989): 303.

11. Quoted by André Breton in his 1924 "Surrealist Manifesto," reprinted in *Manifestoes of Surrealism*, trans. Richard Seaver and Helen R. Lane (Ann Arbor: University of Michigan Press, 1969), 20. Also cited by Jean-Luc Godard in his film *JLG/JLG: Self-Portrait in December* (1994) and by Paul Stoller in *The Cinematic Griot: The Ethnography of Jean Rouch* (Chicago: University of Chicago Press, 1992), 202. Breton comments, "These words, however sibylline for the uninitiated, were extremely revealing, and I pondered them for a long time. But the image eluded me. Reverdy's aesthetic, a completely a posteriori aesthetic, led me to mistake the effects for the causes" (20–21).

12. Breton, "Surrealist Manifesto," 37. He continues, "The principle of the association of ideas, such as we conceive of it, militates against it. Or else we would have to revert to an elliptical art, which Reverdy deplores as much as I. We are therefore obliged to admit that the two terms of the image are not deduced one from the other by the mind for the specific purpose of producing the spark, that they are the simultaneous products of the activity I call Surrealist, reason's role being limited to taking note of, and appreciating, the luminous phenomenon" (37). For Breton, surrealism was, in its challenge to rationalism and traditional literature, a highly political project, and this is an aspect in Rouch's work as well. Breton was a member of the Communist Party between 1926 and 1933.

13. Such objects are not bizarre or strange until they strike us thus, that is, their bizarreness is a quality of perception in the viewer and not of the object itself. Hal Foster addresses this and the fantasy as well as fetishism implicated in the formed and deformed surrealist image in *Compulsive Beauty* (Cambridge, Mass.: MIT Press, 1995), 57–100.

14. That is, documentation using a wide variety of media, which emerges from long-term fieldwork involving not only immersion in the culture but also "initiation" through dialogue with informants as "wise teachers." See Stoller, *The Cinematic Griot*, 19.

15. James Clifford, *The Predicament of Culture* (Cambridge, Mass.: Harvard University Press, 1988), 146.

16. Jean Rouch with Enrico Fulchignoni, "Ciné-Ethnography," in *Ciné-Ethnography*, 148–49.

17. Ibid., 112, 155–56.

18. Ibid., 155.

19. Ibid., 156.

20. Ibid., 156 and 111–14. Griaule's account with Germaine Dieterlen of Dogon cosmology has been questioned for its reliance upon a single Dogon informant—albeit one who was a spiritual leader within his community—while inspiring diverse accounts of how the Dogon

came to "know" about the companion to Sirius. See Walter E. A. van Beek, "Dogon Restudied: A Field Evaluation of the Work of Maracel Griaule," *Current Anthropology* 32, no. 2 (April 1991), 139–67. Uncannily, Sirius itself is subject to anomalies in our knowledge of it, not only in relation to its companions—for a third companion has been hypothesized to account for the aberrant trajectory of Sirius B—but also because in relation to the accounts of the star in classical writing, in Europe and elsewhere, that speak of a red star, while Sirius for us to day is whitish-blue. Dieterlen's comment, in her introduction to *Conversations with Ogotemmêli*, restates the dilemma here, of the clash of occidental logic and systems of thought "in which analogies and the power of symbols have the value of facts," which leads us not only to misrecognize the complexity and subtlety of the religious systems but also to denigrate the people's systematizing of knowledge of their practices and environment. (First published as *Dieu d'Eaud'eau: entretiens Entretiens avec Ogotemmêli* in 1948, and in English, Oxford: Oxford University Press, 1965), xiii).

21. Dominique Le Coq, "Documents, Acéphale, Critique: Bataille autour des revues," in *Georges Batailles, Actes du colloque d'Amsterdam*, June 21–22, 1985, ed. Jan Versteeg (Amsterdam: Rodopi, 1987), 117–30. Cited by Alastair Brotchie in his introduction to *Encyclopaedia Acephalica, a Selection of Works from Documents and Encylopaedia Da Costa* (London: Atlas Press, 1995), 11, on which I have drawn for my summary here. The project of Mass-Observation developed from similar concerns. Michel Leiris, another highly important influence for Rouch, collaborated with Bataille on *Documents* and contributed to the later surrealist journal *Minotaure* in 1934.

22. André Breton, *Le Surréalism et la peinture* (Paris: Gallimard, 1936, 1969), 279, cited in Haim N. Finkelstein, *Surrealism and the Crisis of the Object* (Ann Arbor, University of Michigan, 1979), 59–65.

23. Le Coq, quoted by Brotchie, *Encyclopaedia Acephalica*, 11.

24. David Bate, *Photography and Surrealism: Sexuality, Colonialism, and Social Dissent* (London: I. B. Taurus, 2004), 23. His excellent discussion of the photograph in surrealism explores the ideas of the surrealists in the context of psychoanalysis, drawing on Laplanche's concept of the enigmatic signifier.

25. For Rosalind Krauss, the surreal photographic object is a reality deformed and not simply found, since only in this way can the referentiality of the "documentary" photograph be displaced (in "The Photographic Conditions of Surrealism," *October* 19 [Winter 1981]). This view preserves the role of the artist-author, but the visual record is never simply referential; it has always "added" to the reality it shows. Moreover, if the referent is unfamiliar, it no longer simply affirms a reality but risks appearing uncanny. The real in contingent historical reality must always be made into reality.

26. Buñuel described not just the tone of the voice-over but also the text itself—written by the surrealist Pierre Unik—as deliberately neutral: "Pay attention to the end: 'After so much time in Las Hurdes, let's now return to Madrid.' That's how the commentary is, very dry, very documentary-like, without literary effects" (in *Imagining Reality*, ed. Kevin Macdonald and Mark Cousins [London: Faber and Faber, 1996], 88). Rouch, who was strongly influenced by Buñuel's earlier films in collaboration with Salvador Dalí, spoke of *Las Hurdes* as an example of an ethnographic film "where the commentary is in direct counterpoint to the images . . . [the] violently subjective text brings the necessary oral cruelty to match the unbearably cruel visuals" (*Ciné-Ethnography*, 142). Rouch reports that on seeing *Les mâitres fous*, Buñuel "was fascinated and afraid" (ibid., 142).

27. Buñuel, *Imagining Reality*, 88.

28. Tom Conley's very fine analysis of *Las Hurdes* and the "the disquiet of its documentary" focuses on the visual organization by which it conveys this in relation to "1. the compositional ensemble and its overall visual effects; 2. the very cursive use of the lap-dissolve; 3. the uncanny framing that both conceals and manifests a cinema of sacrifice . . . 4. the breakdown of illusory space through the presence of writing or scripture in the cinematic frame, and 5. the nagging presence of a latently Spanish painterly tradition foregrounding the representation of the Hurdano population." "Documentary Surrealism: On *Land without Bread*," in *Dada and Surrealist Film*, ed. Rudolf E. Kuenzli (Cambridge, Mass.: MIT Press, 1998), 176.

29. Rouch, *Ciné-Ethnography*, 132.

30. Ibid., 133.

31. Breton, "Surrealist Manifesto," 14.

32. Breton visited Freud in Vienna in 1921 and corresponded with him in 1932 about *The Interpretation of Dreams*, but Freud never lent his support to the surrealists, for the dream as interpretable remained at the center of his psychoanalytic work. The discussion here draws on my essay "The Cinematic Dream-Work of Ingmar Bergman's *Wild Strawberries*," in *The Couch and the Silver Screen: Psychoanalytic Reflections on European Cinema*, ed. Andrea Sabbadini (London: Brenner-Routledge, 2003).

33. Rouch, *Ciné-Ethnography*, 132.

34. Freud writes that "there is at least one spot in every dream at which it is unplumbable—a navel, as it were, that is its point of contact with the unknown." *The Interpretation of Dreams* (1900), *The Standard Edition of the Complete Works of Sigmund Freud*, ed. and trans. James Strachey (1921; London: Hogarth Press, 1974), 4:111n1. Cited hereafter as *SE*.

35. Breton's found object has been distinguished from the readymade of Duchamp by Finkelstein (*Surrealism and the Crisis of the Object*, 59–65). Margaret Iverson argues that Breton's found object is the model for Lacan's rethinking of Freud's object of desire in his concept of the *objet petit a* by which the subject is enabled to separate from the real but that is thereby marked by the real at the same time as enabling desire. "Readymade, Found Object, Photograph," *Art Journal* 63 no. 2 (Summer 2004): 49. See also Bate, *Photography and Surrealism*, on the relation of Lacan's thinking to surrealism and, in particular, to Breton's work (in the chapter titled "The Automatic Image," 54–87).

36. Buñuel writes in his autobiography, "I brought dreams directly into my films, trying as hard as I could to avoid any analysis." *My Last Sigh* (New York: Vintage Books, 1984), 92.

37. Rouch says of Buñuel, "His ability to cross the barrier between dream and reality is incomparable: the sudden switch to the other side of the mirror. The dream is just as real, maybe more so, than reality. It's what I tried to do in *Moi, un noir*—or in *La pyramide humaine*—jumping between the two" (*Ciné-Ethnography*, 143).

38. Rouch, drawing on Vertov, *Ciné-Ethnography*, 98–99.

39. On the interactivity of Flaherty's filming, see Jay Ruby, "A Re-examination of the Early Career of Robert J. Flaherty," *Quarterly Review of Film Studies* 5 no. 4 (Fall 1980), 431–57.

40. Rouch, *Ciné-Ethnography*, 185.

41. Rouch's comment appears in several interviews. Ibid., 100, 184.

42. Rouch argues that the Songhay–Zarma people he films are used to him and his camera such that "my person is altered before their eyes just as the person of the possession dancers is altered, to the point where it is the *cinè-transe* of one filming the real trance of the other." Ibid., 184.

43. Filming in a single take, as Rouch advanced into the dance area, the long shot becomes a medium shot. His main interest and focus are the musicians; however, his weaving movements as he follows first one and then another mimic those of the dancer Sambou. When the drumming suddenly stopped, Rouch was about to turn off his camera, but the lute player started up again, for he had seen a spirit—Sambou had become possessed.

44. Ibid., 183. See also Rouch's more extended discussion, (Ibid., 87).

45. The Songhay–Zerma, who are also Muslims, hold that this parallel world does not extend beyond death to the realm of the hereafter, managed by God.

46. Rouch, *Ciné-Ethnography*, 96.

47. Sigmund Freud, "Fetishism" (1927), *SE* 21, 147–58.

48. Directed by Rouben Mamoulian, it is set around 1820, starring Tyrone Power as the son of a California nobleman returning from Spain to find his native land under a villainous dictatorship and who then undertakes a double role as both effete fop and as the masked avenger, Zorro, a fearless swordsman who defends the peasants, thereby overturning the tyranny of his fellow Spanish colonial absentee landowners. The inclusion of the poster within the setting of the ritual itself references both doubling and transgression, as well anticolonialism that, as a U.S. film, relates not only to Spanish but also, implicitly, to British colonial rule.

49. Rouch, *Ciné-Ethnography*, 218.

50. Paul Henley, "Spirit-Possession, Witchcraft, and the Absent Presence of Islam: A Re-Appraisal of *Les mâitres fous*," *Journal of the Royal Anthropological Society* 12, no. 4 (2006): 751. The essay is a valuable review of the ethnography of the *hauka* and the debate the film gave rise to.

51. Rouch, *Ciné-Ethnography*, 217. Jean Genet's *Les Nègres* was published in 1958 and first performed in a production directed by Roger Blin at the Théatre de Lutèce in Paris, which opened on October 28, 1959.

52. Paul Henley, "Spirit-Possession," 755.

53. Ibid., 752.

54. Rouch, *Ciné-Ethnography*, 189.

55. Ibid., 218.

56. Henley is here adapting Clifford Geertz's expression, "thick description."

57. DeBouzek, "The 'Ethnographic Surrealism' of Jean Rouch," 308. The poetic nature of Rouch's voice-over arising from the rhythmic pace and repetitive structure that DeBouzek suggests is less apparent in the voice-over in English that Rouch recorded. Diane Scheinman, in "The 'Dialogic Imagination' of Jean Rouch: Covert Conversations in *Les mâitres fous*," argues that the shift between the music and speech of the adepts and Rouch's voice-over allows a certain dialogism to emerge in the film, as the directly recorded sounds come to be dominant.

"Subverting his apparently monologic control of the film," other voices are heard that, she argues, "in a Bakhtinian sense, call upon a 'responsive listener' to react to, and participate in, the developing and dialogic 'text.'" *Documenting the Documentary: Close Readings of Documentary Film and Video*, ed. Barry Keith Grant and Jeannette Sloniowski (Detroit: Wayne State University Press, 1998), 196.

58. Rouch, *Ciné-Ethnography*, 218.

59. Prerana Reddy, "The Poesis of Mimesis in *Les maîtres fous*: Looking Back at the Conspiratorial Ethnography of Jean Rouch," *African Film Festival, Inc.*, 2001, http://www.african filmny.org/network/news/T01m2reddy.html. Ted Nannicelli takes a similar view in "From Representation to Evocation: Tracing a Progression in Jean Rouch's *Les magiciens de Wanzerbé, Les maîtres fous*, and *Jaguar*." He critiques what he sees as Rouch's Orientalist romanticization, not only in the final commentary, but also in the "journey" structure and montage editing of the film in which the *hauka* become objectified and other. (*Visual Anthropology* 19 [2006]: 190).

60. Rouch, *Ciné-Ethnography*, 191.

61. Ibid., 191.

62. His approach to fiction, Rouch declared, was the same as the way he sought to treat reality. "Inspiration changes sides, it is no longer solely up to the filmmaker to improvise his shots and his movements, it is also up to the actors to invent the action that they are as yet unaware of, dialogues that are born of the preceding retort. This means that the atmosphere, the humor, and the caprices of this capricious little devil I call 'grace' play an essential role in the reaction, and inter-reaction, which can only be irreversible." (*Ciné-Ethnography*, 186–87). *Jaguar* had a significant influence on the directors of the French New Wave, as well as, Rouch claimed, on Roberto Rossellini (164).

6. Specters of the Real

1. Slavoj Žižek, *The Metastases of Enjoyment: Six Essays on Woman and Causality* (London: Verso, 1994), 194. Jacques Derrida and Bernard Stiegler, *Echographies of Television: Filmed Interviews*, trans. Jennifer Bajorek (Cambridge: Polity Press, 2002), 117 and 115, quoted from *Ghost Dance* (1983), the film made by Ken McMullen where Derrida observes that "Film is 'phantomachia.' Let the ghosts come back."

2. Walter Benjamin, "The Work of Art in the Age of Mechanical Reproduction," in *Illuminations*, trans. Harry Zohn (New York: Schocken Books, 1969), 227.

3. Walter Benjamin, "On Some Motifs in Baudelaire," in *Illuminations*, 174–75.

4. This changed with the development of magnetic video tape recording in 1956.

5. My discussion here draws upon Mary Ann Doane's important insights in her essay "Real Time: Instantaneity and the Photographic Imaginary," in *Stillness and Time: Photography and the Moving Image*, ed. David Green and Joanna Lowry (Brighton: Photoworks/Photoforum, 2006), 23–38.

6. The digital has enabled a new democracy of audiovisual production and communication—mobile phones, MP3 formats, as well as films and video art—and, as importantly, new modes of interaction. The public sphere is extended and changed with the development of Internet blogs, MySpace, and YouTube, while campaign sites are transforming the space of political debate and the structures of knowledge definition.

7. Peirce writes that the mind is virtual for "no present actual thought (which is a mere feeling) has any meaning, any intellectual value; for this lies not in what is actually thought, but in what this thought may be connected with in representation by subsequent thoughts; so that the meaning of a thought is altogether something virtual" (Charles Sanders Peirce, *Pragmatism and Pragmaticism* (1935), in *Collected Papers of Charles Sanders Peirce*, ed. Charles Hartshorne, Paul Weiss, and Arthur Burks (Cambridge, Mass.: Harvard University Press, 5, para. 289). "At no instant in my state of mind is there cognition or representation, but in the relation of my states of mind at different instants there is." Further, "What I say is that the mind is virtual, not in a series of moments, not capable of existing except in a space of time–nothing in so far as it is at any one moment" (*Letter to the editor of Journal of Speculative Philosophy* in *Collected Papers* 8, para. 248).

8. Deleuze discusses the relation of the virtual and the actual in *Bergsonism*, trans. Hugh Tomlinson and Barbara Habberjam (New York: Zone, 1988), 97.

9. Mladen Dolar, in *A Voice and Nothing More* (Cambridge, Mass.: MIT Press, 2006), writes of the acousmatic voice, the voice-off of cinema, that "combines two levels, the voice and the gaze, for the voice, as opposed to the gaze, does not conceal, it is given in a seeming immediacy and immediately penetrates interiority, it cannot be quite held at bay. Thus the deception lies in the inability to find its match in the visible, in the gap which always persists between the

two, in the impossibility of their coordination, so that *the visible as such can start to function as the veil of the voice*" (78; emphasis in original).

10. Jacques Derrida and Bernard Stiegler, *Echographies*, 38–39. He notes that where previously only the material support of the forms of inscription was preserved, now it is also the moment of inscription that—recorded—will be relived as "live."

11. Ibid.,129.

12. Friedrich Nietzsche, *The Use and Abuse of History*, trans. Adrian Collins (New York: The Liberal Arts Press, Bobbs-Merrill, 1957), 6.

13. Ibid.

14. Ibid., 8.

15. Paul Ricoeur, *Memory, History, Forgetting*, trans. Kathleen Blamey and David Pellauer (Chicago: University of Chicago Press, 2004), 443.

16. Ibid.

17. Such a notion of time is of course central to Gilles Deleuze's discussion of film in *Cinema 2, The Time-Image* (Minneapolis: University of Minnesota Press, 1989), 116–25.

18. Maurice Halbwachs, *The Collective Memory* (1950), trans. Francis J. Ditter Jr. and Vida Yazdi Ditter (New York: Harper & Row, 1989), 125.

19. Ibid., 75.

20. Ibid.

21. Hobsbawm, "Inventing Traditions" *The Invention of Tradition*, ed. Eric Hobsbawm and Terence Ranger (Cambridge: Cambridge University Press, 1983), 1–14.

22. Patrick H. Hutton, *History as an Art of Memory* (Hanover: University of Vermont Press, 2003), 5.

23. Halbwachs, *The Collective Memory*, 126.

24. Similarly, in the art gallery, the duration of viewing is determined by the spectator who may glance at a work or stay and contemplate; the serial work and the video installation are equally liable to such indeterminate time of viewing, and such contingency is intrinsic to their processes as art. I have explored this further in "On documentary Sounds and Images in the Gallery," *Screen* 50, no. 1 (2009), 124–34.

25. Ricoeur, *Memory, History, Forgetting*, 412–56.

26. Hutton, *History as an Art of Memory*, 3.

27. Maurice Agulhon, *Marianne into Battle: Republican Imagery and Symbolism in France, 1789–1880*, trans. Janet Lloyd (Cambridge: Cambridge University Press, 1981), 9.

28. Godfrey Lienhardt, *Divinity and Experience: The Religion of the Dinka* (Oxford: Oxford University Press, 1961), 149.

29. Ibid.

30. Lacan, *The Four Fundamental Concepts*, trans. Alan Sheridan (Harmondsworth: Penguin, 1979), 41.

31. Ibid., 41. My discussion here draws on my more extended consideration of the horror of the horror film in "The Lived Nightmare: Trauma, Anxiety, and the Ethical Aesthetics of Horror," in *Dark Thoughts: Philosophic Reflections on Cinematic Horror*, ed. Steven Jay Schneider and Daniel Shaw (Lanham, Md.: Scarecrow Press, 2003), 25–46.

32. Lienhardt, *Divinity and Experience*, 150.

33. Foucault, *The Order of Things: An Archeology of the Human Sciences* (London: Tavistock Publications, 1970), xxiii.

34. Edward S. Casey, in *Getting Back into Place*, argues against a view of place as a point in space and hence also time. He cites Heidegger: "The relationship between man and space is none other than dwelling, strictly thought and spoken." (Bloomington: Indiana University Press, 1993), 109.

35. Deleuze, *Cinema 2*, xi.

36. Seyss-Inquart was condemned to death following his conviction for war crimes at the Nuremberg tribunal. He was executed in 1946. Our knowledge of this judgement reasserts the rule of human rights and justice against Nazi inhumanity.

37. Forgacs said, "It is like the suspense of a Hitchcock film. We know ahead of time that the innocent victim will fall into the hands of the killer. We want to warn her/him: watch out! And our palms are sweating. We can't help, and here—in my films—it anticipates real blood, real suffering." In contrast to a Hitchcock film, it is not play-acting. Péter Forgács, in an interview with Bill Nichols, "The Memory of Loss: Saga of Family Life and Social Hell," *Film Quarterly* 56, no. 4 (2003): 9.

38. Mikhail Bakhtin, *The Dialogical Imagination: Four Essays*, ed. Michael Holquist, trans. Caryl Emerson and Michael Holquist (Austin: University of Texas Press, 1982), 84.

39. Michael Chanan, "The Documentary Chronotope," *Jump Cut, A Review of Contemporary Cinema*, no. 3 (July 2000): 56–57. See also Michael Chanan, *The Politics of Documentary* (London: British Film Institute, 2007).

40. The creation of a perfect illusion had been seen as an the aim of painting, but photography challenged its role as realism and the realistic.

41. Charles Baudelaire, *L'art romantique*, ed. J. Crepet (Paris: Louis Conard, 1925), 284. For Baudelaire, it is the artist's imagination that "decomposes all creation, and with the raw materials accumulated and disposed in accordance with rules whose origins one cannot find save in the furthest depths of the soul, it creates a world, it produces a sensation of newness." In *Art in Paris 1845–1862*, trans. Jonathan Mayne (Oxford: Phaidon, 1965), 156. As a result, the beauty of art can involve what elsewhere in everyday life we might experience as the ugly, and we are moved not to pleasure but to an engagement with the imagined new of art.

42. Timothy O. Benson, "Abstraction, Autonomy, and Contradiction in the Politicization of the Art of Hans Richter," in *Hans Richter: Activism, Modernism and the Avant-garde*, ed. Stephen C. Foster (Cambridge, Mass.: MIT Press, 1998), 30.

43. Documentaries made by Richter include: *Alles drecht sich, Alles bewet sich!* (Everything Revolves, Everything Moves, 1929, his first sound film); *Neues Leben* (New Living, 1929), promoting Bauhaus ideas; *Metal* (1931–33, unfinished), on Nazi strike-breaking. See Marion von Hofacker, "Richter's Films and the Role of the Radical Artist 1927–1941," in Foster, *Hans Richter*, 138.

44. Hans Richter, "My Experience with Movement in Painting and in Film" in *The Nature and Art of Motion*, ed. Gyorgy Kepes (New York: George Braziller, 1965), 155. Cited by Marion von Hofacker, "Richter's Films," in Foster, *Hans Richter*, 135.

45. Quoted by Hans Richter in *The Struggle for the Film*, trans. Ben Brewster (Aldershot: Scolar Press, 1986), 47. Quoted by Walter Benjamin in "A Little History of Photography," in *Walter Benjamin: Selected Writings*, vol. 2, trans. Edmund Jephcott and Kingsley Shorter, ed. Michael W. Jennings, Howard Eiland, and Gary Smith (Cambridge, Mass.: Harvard University Press, 1999), 526. Bertolt Brecht in "Der Dreigroschenprozess, ein soziologisches Experiment," in *Gesammelte Werke in 20 Bänden* (1930/1931) (Frankfurt-am-Main: Suhrkamp Verlag, 1976), 161.

46. Richter, *Struggle for the Film*, 47.

47. Philip Rosen offers a further exploration of this in "Document and Documentary: On the Persistence of Historical Concepts," in *Theorizing Documentary*, ed. Michael Renov (London: Routledge, 1993), 58–89.

48. Theodor Adorno and Max Horkheimer, *Dialectic of Enlightenment*, trans. John Comming (London: Verso, 1979), 26–27.

49. The *Oxford English Dictionary* cites the following uses of the term: In 1919 by A. N. Whitehead, "The 'constants of externality' are those characteristics of a perpetual experience which it possesses when we apprehend it. A fact which possesses these characteristics, namely these constants of externality, is what we call an 'event.'" In 1920 by A. S. Eddington, "A point in this space-time, that is to say a given instant at a given place, is called an 'event.' An event in its customary meaning would be the physical happening which occurs at and identifies a particular place and time. However, we shall use the word in both senses." (*Oxford English Dictionary*, Oxford: Oxford University Press, 2nd edition 1989).

50. Derrida and Stiegler, *Echographies*, 10.

51. John Rajchman, *Philosophical Events: Essays of the Eighties* (New York: Columbia University Press, 1991), viii.

52. Badiou continues, "For Delueze, chance is the play of the All, always replayed as such; whereas I believe that there is the multiplicity (and rarity) of chances, such that the chance of an event happens to us already by chance, and not by the expressive univocity of the One." In *Deleuze: The Clamor of Being*, trans. Louise Burchill (Minneapolis: University of Minnesota Press, 1999), 76.

53. Duchamp had used the term earlier, in 1915, and previous works in 1913 and 1914 had deployed found objects. In 1917, he submitted the *Fountain* for exhibition by The Society of Independent Artists, with which Duchamp had been associated, but it was apparently rejected, for no record of its appearance in the exhibition exists. Alfred Stieglitz, however, had photographed it for the cover of the art journal, *The Blind Man*, and it was this photograph that enabled the *Fountain* to become an "event." The "original" urinal disappeared, but in 1964, Duchamp authorized a number of replicas based on the photographic record.

54. Walter Benjamin, *The Arcades Project*, trans. Howard Eiland and Kevin McLaughlin (Cambridge, Mass.: Harvard University Press, 1999), 464.

55. Mary Anne Doane, *The Emergence of Cinematic Time: Modernity, Contingency, and the Archive* (Cambridge, Mass.: Harvard University Press, 2002), 101, 99.

56. Peirce, *Scientific Metaphysics, Collected Papers* (1935), vol. 6, para. 66. Peirce writes, "The immediate present, could we seize it, would have no character but its Firstness. Not that I mean to say that immediate consciousness (a pure fiction, by the way), would be Firstness, but that the quality of what we are immediately conscious of, which is no fiction, is Firstness." "Lowell Lectures" *Collected Papers* (1932), vol. 1, para. 343.

57. Doane, *The Emergence of Cinematic Time*, 100.

58. Ibid., 163.

59. Benjamin, *The Arcades Project*, 463–64.

60. D. N. Rodowick notes that the concept of "rational interval" is derived from what modern mathematics conceives as a "rational" division. In *Gilles Deleuze's Time Machine* (Durham, N.C.: Duke University Press, 1997), 3.

61. Ibid., 143.

62. Trinh T. Minh-ha, *The Framer Framed* (London: Routledge, 1982),195.

63. Rodowick, *Gilles Deleuze's Time Machine*, 17.

64. Deleuze, *Cinema 2*, 182. Delueze refers here and in the next quote to films by Godard and Mieville, *Ici et ailleurs* (1976) and *Six fois deux* (1976).

65. Rodowick, *Gilles Deleuze's Time Machine*, 15.

66. Deleuze and Guattari, *What Is Philosophy?*, 158.

67. Yve Lomax, "Thinking Stillness," in Green and Lowry, *Stillness and Time*, 61.

68. John Stezaker, "The Film Still and Its Double: Reflections on the 'Found' Film-Still," in Green and Lowry, *Stillness and Time*, 125. See also Raymond Bellour, "The Film Stilled," *Camera Obscura* 24 (1990): 99–124.

69. G. E. Lessing, *Laocöon*, trans. E. C. Beasley (London: Longman, 1853), 17.

70. Leo Bersani has suggested that art plays with the oscillation between art as being (for death) and art as becoming, a dying that moves us from the individual and singular to the universal in a being that is more than the individual. In *The Culture of Redemption* (Cambridge, Mass.: Harvard University Press, 1990), 10.

71. Laura Mulvey, *Death 24x a Second: Stillness and the Moving Image* (London: Reaktion Books, 2006), 12.

72. Roland Barthes, *Camera Lucida*, trans. Richard Howard (New York: Hill and Wang, 1981), 96.

73. Walter Benjamin, "Theses on the Philosophy of History," in his *Illuminations*, 262–63.

74. Ibid., 235.

75. For Deleuze, Eisenstein's cinema is "action-thought," open and spiral in a circuit of author, image, viewer, and sensory shock so that the "whole forms a knowledge, in the Hegelian fashion" (*Cinema 2*, 161). Yet Deleuze—drawing on Jean-Louis Shefer—finds, in the mists of Odessa (despite Eisenstein's analytical account), a suspension of organic event that opens a time of becoming visible of thought "not as an object, but as an act which is constantly arising and being revealed in thought" (169).

76. Deleuze, *Cinema 2*, 38.

77. Freud, "The Uncanny," *The Standard Edition of the Complete Works of Sigmund Freud*, ed. and trans. James Strachey (1919; London: Hogarth Press, 1974), vol. 17: 247.

78. "East Coker" was first published in 1940, and later appeared as one of the *Four Quartets* (1943), quoted here from *The Complete Poems and Plays of T. S. Eliot* (London: Faber, 1969), 179.

79. Peter Wollen, "Godard and Counter Cinema: *Vent d'est*," in *Movies and Methods*, vol. 2, ed. Bill Nichols (Los Angeles: University of California Press, 1985), 500–508.

80. Peter Wollen, "The Two Avant-gardes," *Readings and Writings: Semiotic Counter-Strategies* (London: Verso, 1982), 92–104.

81. Adorno's emphasis on, and specific account of, the aesthetic experience and the autonomy of art led him to doubt the value of politically engaged art. For Adorno, the technical and formal innovations of modern art makes it critical of and relatively autonomous from the political and socioeconomical system it arises in.

82. The notion of process here is drawn from Christoph Menke's account of Adorno in *The Sovereignty of Art: Aesthetic Negativity in Adorno and Derrida* (Cambridge, Mass.: MIT Press, 1999), where he notes: "Aesthetic meanings are only formed in a processual linking of signifying elements, which, at the same time, only arise as such elements by means of this processual linking" (88). He later comments, "A process of aesthetic experience that has suspended pregiven judgments on what it signifies aesthetically and on what its meaning consists in has to subject itself to the indirect route of the mimetic spelling out of its processuality and transitional character" (96).

83. Mary Kelly in her interview with Douglas Crimp, *Mary Kelly*, ed. Margaret Iverson, Douglas Crimp, and Homi K. Bhabha (London: Phaidon Press, 1997), 15. Peter Wollen also refers to this work as important for his approach, with Laura Mulvey, in making *Riddles of the Sphinx* (1976). Peter Wollen, "Thirteen Paragraphs," in *Social Process/Collaborative Action: Mary Kelly 1970–1975*, ed. Judith Mastai (Vancouver: Charles H. Scott Gallery, Emily Carr Institute of Art and Design, 1997), 25. Wollen also made with Laura Mulvey, *Penthesilea* (1974), *The Bad Sister* (1983), *Frida Kahlo & Tina Modotti* (1983), and on his own, *Friendship's Death* (1987).

84. Kelly, in Iverson, et al., *Mary Kelly*, 13.

85. Ibid., 12.

86. Ibid.,13. Concurrently she was part of the Berwick Street Collective that was making *The Night-cleaners Part One* and also involved in making *Women of the Rhondda*.

87. Mary Kelly, *Post-Partum Document* (London: Routledge, 1983), I discussed the work more fully in my introduction to the publication of the "Documentation VI" section in *m/f*, nos. 5–6 (1981): 115–23, reprinted with a postscript in *Modern Art Culture: A Reader*, ed. Francis Frascina (London: Routledge, 2009), 303–11.

88. Ibid., 167.

89. Ibid., 38–39. Parveen Adams first made the case for such an approach to Kelly's work in "Mary Kelly's *Interim* and the Discourse of the Analyst," *The Emptiness of the Image: Psychoanalysis and Sexual Differences* (London: Routledge, 1996),71–89.

90. No "part two" film was made. Instead *36 to 77* (1978) was made as a sequel by Marc Karlin, Jon Sanders, James Scott, and Humphrey Trevelyan. A clip from the film can be accessed on YouTube.

91. On these films, see Griselda Pollock's valuable discussion, "The Pathos of the Political: Documentary, Subjectivity, and a Forgotten Moment of Feminist Avant-garde Poetics in Four Films of the 1970s," in *Work in Modern Times: Visual Mediations and Social Processes*, ed. Valerie Mainz and Griselda Pollock (Aldershot, U.K.: Ashgate, 2000),193–223.

92. Dave Douglass, a miner, National Union of Mineworkers activist, and member of the Cinema Action film collective from 1971, commenting on the screening of the film to large audiences of working-class women in Doncaster, United Kingdom, said: "They responded very well" to its radical style. Cited in *Rogue Reels: Oppositional Film in Britain*, ed. Margaret Dickinson (London: British Film Institute, 1999), 274.

93. Cited by Jonathan Rosenbaum in his review in *Chicago Reader*, March 14, 2002, and http://www.chicagoreader.com/chicago/california-trilogy/Content?oid=907971.

94. This idea is explored in Philippe Van Haute's "Death and Sublimation in Lacan's Reading of *Antigone*" in *Levinas and Lacan: The Missed Encounter*, ed. Sarah Harasym (Albany: State University of New York Press, 1998), 115–16.

95. Barthes, *Camera Lucida*, 62.

96. Derrida and Stiegler write: "As soon as one calls for the disappearance of ghosts, one deprives oneself of the very thing that constitutes the revolutionary movement itself, that is to say, the appeal to justice, what I call 'messiancity'" (*Echographies*, 128). They reference here Derrida's discussion in *Specters of Marx*, trans. Peggy Kamuf (London: Routledge, 1994).

97. Slavoj Žižek, *The Parallax View* (Cambridge, Mass.: MIT Press, 2006), 4. The concept parallels that of Lyotard's "differend," whereby the terms of language (language game) afford no agreed on procedures for what is different (be it an idea, an aesthetic principle, or a grievance) within the discursive domain of discourse, such that one party to speech is silenced: for example, the differend marks the silencing by the impossibility of phrasing an injustice that will be recognized by the other.

98. Ibid., 7.

99. Ibid., 11.

100. Ibid., 4.

101. Ibid., 6.

102. Jacques Rancière, *The Politics of Aesthetics*, trans. Gabriel Rockhill (London: Continuum, 2004), 29.

103. As developed with Félix Guattari in, Gilles Deleuze and Félix Guattari, *A Thousand Plateaus: Capitalism and Schizophrenia*, trans. Brian Massumi (London and New York: Continuum, 2004), 1980.

104. Žižek, *The Parallax View*, 6.

105. Jean-François Lyotard, *The Differend: Phrases in Dispute*, trans. Georges Van Den Abbeele (Manchester: Manchester University Press, 1988).

106. I am drawing here on Eric Santner's argument for the necessity to move from identification in a transition from "that's me," to "here I am" that "can take place only by way of a 'recognition' of oneself not in the identification proposed/mandated by way of ideological interpellation, but rather in its 'objectal' leftover that persists in the formations of fantasy." In "Miracles Happen: Benjamin, Rosenzweig, Freud, and the Matter of the Neighbor," in *The Neighbor: Three Inquiries in Political Theology*, ed. Slavoj Žižek, Eric L. Santner, and Kenneth Reinhard (Chicago: The University of Chicago Press, 2005), 132.

107. Žižek, "Neighbors and Other Monsters: A Plea for Ethical Violence," in Žižek, et al., *The Neighbor: Three Inquiries in Political Theology*, 182.

Index

Ace of Cakes (The Food Network), 16
actualities, industrials, topicals, 12, 17, 64, 189n35
Adorno, Theodor and Max Horkheimer, 6, 211n81
Airport (BBC), 16, 99
Althusser, Louis, 22, 54, 191n14, 191n15
American Chopper (Discovery Channel), 16
American Family, An (PBS), 16
American Hot Rod (Discovery Channel), 16
A propos de Nice (About Nice) (Jean Vigo), 48

Barthes, Roland, 66–67, 172, 184
Bates, David, 141
Baudelaire, Charles, 20, 135, 166
Baudrillard, Jean, 2
Bazin, André, 21, 29, 49, 135–36, 161, 205n4, 188n15
BBC: The Voice of Britain (Stuart Legg), 83
Belázs, Bela, 93, 200n22
Benjamin, Walter, 90, 122, 153, 169–70, 172
Bergson, Henri: on duration, 3, 92, 101, 154–56
Berlin—Symphony of a City (Walter Ruttman), 64
Beyond a Reasonable Doubt (Fritz Lang), 43
Big Brother (Channel 4), 17, 42, 99, 107–8, 202n61
Brecht, Bertolt, 1, 47, 167
British documentary film movement, 5, 64; class struggle and, 69–76
Burch, Nöel, 12
Burke, Edmund, 11
Bus 174 (José Padilha, codirector Felipe Lacerda), 17
Butler, Judith, 58

camera obscura, 6–8, 188n10, 189n23
Candid Camera (CBS), 14
Capturing the Friedmans (Andrew Jarecki), 43–45, 116–17
Caruth, Cathy, 125
Celebrity Big Brother (Channel 4), 100
Chiesa, Lorenzo, 123
Children's Hospital (The WB), 100
Chion, Michel, 95

Chronique d'une été (Chronicle of a Summer) (Jean Rouch), 152
chronotope, 163
cinema of attractions, 12, 14, 66. *See also* Gunning
cinéma vérité. *See* direct cinema
Coal Face (Alberto Cavalcanti), 63, 65, 67–73, 75
cognition: belief and, 38; discursive assertion of facts and, 46, 167; expectation and, 37; incoherence of vision and, 10; speech and, 26; strangeness of reality and, 144–52; the sublime and, 11
Comolli, Jean-Luc, 6–8, 19; reality–fiction effect and, 38
Copjec, Joan, 93, 191n14, 200n19
Cops (20th Century Fox Television), 14
Corner, John, 16
Crary, Jonathan, 9, 10, 12, 79

Dada, 166–67, 174
daguerreotype, 6–7, 187–88n10
Daney, Serge, 136
Daughter Rite (Michelle Citron), 43
Day in the Life of a Coalminer, A (Kineto Films), 64–71
Deadliest Catch (Discovery Channel), 16
Deleuze, Gilles: on actual vs. virtual, 3, 58, 154, 186; on event, 168–73; on the face, 92–94; on movement-image, 161; on rational–irrational interval, 170–71, 173, 211n60; on time-image, 93, 161–62; on the virtual, 3–4, 154, 170, 186, 208n8
Derrida, Jacques, 4, 135; on artifactuality, 40; on *différance*, 4, 155, 168, 185
desire: anxiety and, 9, 20–21, 86; in experience of past and present, 7; for the hidden, 13, 68; for the knowable, 23, 38–39, 50, 61, 86, 103; mise-en-scène of, 89–95; for the ordinary, 78; spectator and, 5
différance, 4, 155, 168, 185. *See also* Derrida
direct address, indirect address, interview, 12, 42, 69, 73–74, 94–96, 116, 132, 194n61, 194n66
direct cinema, 17, 19, 38, 85, 144, 190n7, 194n62

Disaster at Hillsborough (Yorkshire Television), 19, 110–14
disavowal, splitting of the ego, 10, 101, 123, 136, 144–46, 189n27. *See also* fetishism
discourse: coherent mediation and, 31–32; Foucauldian discursive practice, 50–59; Lacan's four discourses, 5, 103–12; power and, 53–54, 186; representation as historical information, 46; shifting of, 109–10; showing vs. telling and, 28–29, 40, 50, 87, 155; truth and, 5, 20, 26
dissensus, 59, 185. *See also* Rancière
Doane, Mary Ann, 3, 8, 122, 169
docudrama, 24, 78, 194n74
Documents journal, 140–41, 168, 206n21
dreams: Rouch and, 139, 143; surrealism and, 137, 143–44, 206n32, 207n36. *See also* Freud
Drifters (John Grierson), 64
drive, 119–23, 189n38, 196n48, 202n4
Dulac, Germaine, 48–49, 166
duration, 6, 101–2, 125, 130, 153–56, 169–70, 197n56, 201n42, 209n24. *See also* Bergson; time

Eisenstein, Sergei, 48–49, 94, 170, 211n75
El Valley Centro (James Benning), 180–82
emplotment, 21, 37–40, 43, 194n72. *See also* Ricoeur
Enlightenment, the, 54, 167, 198n78
Enough to Eat? (Edgar Anstey), 72, 75, 110
ethics: engagement and, 31, 36, 97; Foucault and, 57, 86
event, the, 168–73

face, the: as image, 91–94; in speech, 94–96
facticity, evidence, 45, 118; authenticity and, 7–8, 31–36, 25–29; directorial intentionality and, 44, 81; form and, 58–59; the sensible and, 58–59; (un)scientific discourses of, 2, 110–16, 124–27
Family, The (Paul Watson and Franc Roddam), 16
fantasy, 2, 21–23, 118–21, 123, 136, 144, 191n15, 203n7; traversing the fantasy, 108
Father (Doron Solmons), 183
feminism: political consensus and, 70–71; sexuality and, 67–68; work and, 72–76, 175–76, 178–80, 197–98n77, 200n25, 212n92
fetishism: disavowal and, 10, 90, 101, 105; evidential records and, 31. *See also* Freud
fiction, 23–29; fiction-effect, 34–35, 37–40, 194n62; fictive stance, 191n28; flashback and, 33–34, 156; generic origin of, 23; hybridity and, 24; nonfiction and, 2, 12–13, 16, 23–26, 39, 41–43, 86, 99–100, 137, 169–70, 191n28, 192n29, 195n11; paradox of, 36; quasi-emotion and, 35, 193n54; Jean Rouch on, 128, 138, 143–46, 152; in subjective remembering, 34; truth and, 19–21, 26–29, 96, 107, 143; verisimilitude and, 38
Fire Call and Rescue by Fire Escapes (Warwick Trading Company), 15
Five and Under (Donald Alexander), 75
Flaherty, Robert, 19

flashback, 33–34; fiction of, 34
Foucault, Michel, 3, 5; on discursive practice, 50–59, 109; on ethics, 57, 86; on history, 51–54, 57; on power, 53–58, 86, 161; on temporal epochs, 161; on truth, 52–53, 90. *See also* discourse; knowlege; the political; truth
found object (*objet insolite*), 131, 139, 143–44, 147, 207n35, 210n53
Freud, Sigmund, 3, 10; on disavowal, 90, 101; on scopophilia vs. epistephilia, 13; on speech vs. hearing, 104; on the uncanny, 14, 72, 122, 155, 173, 190n39; on the unconscious, 21, 118–20, 141

genre, 1, 20–24, 37, 64
Give the Kids a Break (Donald Taylor), 83–85
Goldie, Peter, 35, 193n54
Gosse, Edmund, 23
Grierson, John, 19, 23–25, 45; on documentary as art, 48–49; public education and, 70; workers and, 64
Grierson, Ruby, 5, 77–80, 82–84, 198n93
Gunning, Tom, 12, 14, 66
Guynn, William, 39–40

Halbwachs, Maurice, 157–59
Heath, Stephen, 40–41, 97
Hell Unlimited (Norman Maclaren and Helen Biggar), 71
Herzog, Werner, 41
Higson, Andrew, 70–71
history: fiction and, 36, 39, 65; Foucault on, 51–54, 57; memory and, 157–59, 184; the political and, 79, 159, 173–74; trauma and, 118, 125. *See also* Foucault; Ricoeur
Helmholtz, Hermann von, 9
Hoop Dreams (Steve James), 42
Hospital (Frederick Wiseman), 96
Housing Problems (Arthur Elton and Edgar Anstey), 72, 78, 80–82, 84, 110
How Green Was My Valley (John Ford), 64
Huston, John, 5, 118, 131–34, 204n36
hypnosis, 134, 151, 203n26, 204n28
hysteria: discourse of hysteric and, 103, 105–16, 127–28, 145, 177; symptoms and, 42, 119–20, 124–26, 130

Ice Road Truckers (The History Channel), 16
identification, 3, 88–103; affective responses and, 34–36, 56, 77–79, 84, 156; belonging and community and, 5, 76; close-up of face and, 91–94; complicity and, 12, 16, 65–67; desiring subject and, 88–90; duration and, 101–2; expectation and, 25; with the other of knowledge, 89–90, 102; public values and, 5, 20, 68–70; self and other, 17, 88, 103, 149–50, 186; sympathy and empathy and, 97–101, 130–31; trauma and, 110–17
ideology, 21, 88, 187n3; Althusser on, 22, 191n14; Foucault on, 53, 55, 196n33; Žižek on, 22–23
index. *See* Peirce
Industrial Britain (Robert Flaherty), 64, 69
interval. *See* Deleuze

interview. See direct address
Ivens, Joris, 76, 31, 48

Jaguar (Jean Rouch), 152
James, Henry, 24, 37
Jerry Springer Show (NBC Universal Television), 16

Kant, Immanuel, 11, 27, 192n32
Kelly, Mary, 174–78
knowledge: belief and, 38, 45, 96; contradictory, 135–37, 144, 150–52, 171; epistemological discourse and, 167; Foucauldian observation and, 54; impossibility of mastery and, 14; intention and, 27; objectivity and, 1–4; optics and, 7; organization and, 13, 21, 40; versus pleasure, 13; social ramifications of, 20, 72–73; spectacle and, 11

Lacan, Jacques, 3, 5; on anxiety, 160; on Big Other, 23; the four discourses and, 5, 103–12; on imaginary in ideology, 21–23; on mirror stage, 22, 88, 92, 120, 191n15; on objet petit a, 104–9, 124, 160, 207n35; on real, imaginary, symbolic, 120–21, 176; on the Thing, 123, 203n16; on truth, 27; on tuché, 125, 128. See also real; sublimation
Lady in the Lake (Robert Montgomery), 96
Laplanche, Jean, 125, 183, 203n24
Las Hurdes (Land without Bread) (Luis Buñuel), 62–63, 138, 142–43, 206n26
Lazarsfeld, Karl, 36
Les mâitres fous (The mad masters) (Jean Rouch), 146–52
Let There Be Light (John Huston), 5, 42, 118, 124–25, 131–34
Lienhardt, Godfrey: Khartoum and, 159–60
Life and Times of Rosie the Riveter, The (Connie Field), 76, 200n25
Life of an American Fireman, The (Edwin S. Porter), 15
Little Dieter Needs to Fly (Werner Herzog), 41
London (Patrick Keiller), 24
look: as disruptive, 66; as mediated or embodied, 20–21, 31, 91; pleasure and, 3, 11, 68, 78; as subject or object of, 12
Lorentz, Pare, 19, 76
Los (James Benning), 180
Lumière, Louis, 2, 73, 118
Lyotard, Jean-François, 186, 212n97

Maelstrom: A Family Chronicle (Péter Forgács), 162
Malcolm and Barbara: Love's Farewell (Paul Watson), 17
Man with a Movie Camera (Dziga Vertov), 48
Manhatta (Paul Strand), 48
Marey, Etienne-Jules, 13, 61, 118, 130
Mass-Observation, 5, 77
Mauss, Marcel, 137, 140, 194n73
memory, 6, 33, 114, 161–63, 173–80; collective memory and, 157–58; forgetting and, 156–64, 183; memorializing and, 6, 9, 155–60,

162, 184. See also plot; political, the; re-presentation; time
Merton, Paul, 36
Metz, Christian, 189n24, 190n3, 191n15, 200n13
Miami Ink (The Learning Channel), 16
mimesis: art and, 66; diegesis and, 41; plot and, 38
Misère au Borinage (Poverty in Borinage) (Joris Ivens), 48
mock documentary, the, and mockumentary, 51, 194n61, 197n65
modernism, 1, 47; Dada and, 166
modernity, 1, 17, 20; knowledge and, 26; work and, 46–47; 79, 105, 152, 198n78
Moi un noir (Me, a Black) (Jean Rouch), 152
mourning, 6, 114, 156–60, 172, 177. See also re-presentation
Mulvey, Laura, 172, 200n13
Muybridge, Eadweard, 13, 61, 130

Nachträglichkeit, 125, 134, 172, 183, 203n23; translated as afterwardsness, 125, 129, 169, 203n23; as deferred action, 203n23
narration: fiction and, 23–29; mimesis vs. diegesis in film and, 29, 41; as opposed to trauma, 125–26; order and, 4, 12, 21; testimonial as imagined space and, 80–82; verisimilitude and, 38–40; voice and, 95–96; voice-over and, 10, 21, 62, 77, 80–82, 94–95, 97, 102–3, 110, 137, 142–47, 150, 156, 194n61, 197n64, 206n26, 207n57
narrative, defined, 39
neorealism, Italian, 39
Nichols, Bill, 1, 25, 96
Niépce, Joseph Nicéphone, 7, 187–88n10
Nietzsche, Friedrich, 155–56
Nightcleaners Part One, The (The Berwick Street Collective), 94, 174, 178–80
Night Mail (Harry Watt and Basil Wright, 1936), 63, 70, 83
nonfiction: anxiety over authenticity and, 51, 73, 80–83, 135; authorship and, 25; intentionality and, 25; knowledge and, 27; novelization of social reality and, 65–66, 72–75, 131; skepticism and, 36, 107
novelizing, 24, 40–45, 96–101, 127
Nuit et brouillard (Night and Fog) (Alain Resnais), 91

objet petit a, 104–9, 123, 154, 160, 201n49, 207n35. See also Lacan
observational style, 4, 14, 38, 178
Oprah Winfrey Show, The (HBO Films), 16

Peace and Plenty (Ivor Montagu and B. Megarry), 71
Peirce, Charles Sanders: on Firstness, 93–94, 169, 193n46, 210n56; on the icon, 30, 193n46; on index, 4, 28–30, 38, 87, 93–94, 122, 154, 169; on the mind as virtual, 208n7; on natural signs, 30; on the symbol, 29–30
People Who Count, The (Geoffrey Colyer), 73

performance, performativity, 17, 19, 41–42, 58–59, 80–81, 149–51. See also Butler
Petit à petit (Jean Rouch), 152
photography, 6–8, 29031, 46, 153, 166, 188n17 and n23, 189n24, 190n6; Rouch and, 138
Plantinga, Carl 25, 28
plot: in fiction and documentary, 37–39; memory and, 161–63; 194n65; narrative and, 40–42
Police, Action, Camera (ITV), 14
politics, political, the: agency and, 79; art and, 62, 159, 166, 174–75, 181, 185–86; class struggle and, 69–76; collective memory and, 157–58; documentary as public service and, 70–71; evidence in ethics and, 31, 186; Foucauldian will to truth and, 57–58; master discourses and, 110; memory and, 173–80; performativity and, 59; radicalism and, 6, 17; representation and, 131; seeing reality anew and, 130–31, 140–42, 182; social criticism and, 47–48; social ramifications of reality and, 20
Ponech, Trevor, 25, 28, 193n47
Portrait of My Mother (Milica Tomić), 163–65
post-documentary, 16
Post-Partum Document (Mary Kelly), 174–78
power: discourse and, 53–54, 109; Foucault on, 53–58, 86, 161; ritual and, 147, 149–52, 197n56; sublime and, 11; Žižek on, 22–23, 53, 186, 187n3
Power and the Land, The (Joris Ivens), 76–77
Primary (Albert Maysles and D. A. Pennebaker), 97
punctum. See Barthes, Roland

Rancière, Jacques: on dissensus, 185; on sensible, 3, 58–59
real, the: documentary as nonfiction and, 29, 107–8; grotesque and, 124, 130; Lacan's concept of, 5, 59, 121–26; the surreal of reality and, 5, 137; trauma and, 114–16, 127–31, 183; tuché and, 122–25. See also Lacan; objet petit a
realism, 1–7; challenge to tradition, 166; emotion and, 34; possibility of, 46; truth and, 19–20; verisimilitude and, 37, 78, 96, 151
reality television, 4, 128; as "infotainment," 14–17; 42; transference and, 100
reality effect, 38
real-time, now-time, 32–33, 155, 172–73, 155, 183
Reassemblage (Trin T. Minh-ha), 1, 95
reenactment: authenticity and, 38, 107; time and, 20–21, 161; verisimilitude and, 41, 43, 128–30
re-presentation: as evidence, 26; feigned reality and, 32; as flashback, 33, 94, 135; inclusion vs. exclusion and, 19–21; memory and mourning and, 156–64, 183; surrealism and, 141–43
Richter, Hans, 11, 62, 166
Ricki Lake Show, The (Columbia TriStar Television), 16
Ricoeur, Paul, 36, 156; on emplotment, 39, 41, 194n72
Rien que les heures (Nothing But Time) (Alberto Cavalcanti), 48
River, The (Pare Lorentz), 76

Rodney King beating, 26
Rosen, Philip, 31, 210n47
Rotha, Paul, 24, 70, 198n93
Rouch, Jean, 5, 128, 138–52, 162; direct cinema vs. participatory camera and, 144–45; on fiction, 128, 138, 143–46, 152; hauka and, 145–51
Rushton, Richard, 93

Samson Unit, The (Channel 4), 15
Sans Soleil (Chris Marker), 137
scopophilia, 3, 8, 189n38; epistephilia and, 13; mastery and, 14; 189n38. See also desire
Seashell and the Clergyman, The (Germaine Dulac with Antonin Artaud), 48
Secrets of Nature, The (British Instructional Films), 13
sensible, the, 3, 58–59. See also Rancière
shell shock, 33, 132, 137, 204n27. See also War Neuroses
Silverman, Kaja, 97–98
Skirrow, Gillian, 40–41, 97
Spanish Earth (Joris Ivens), 31, 76
Spare Time (Humphrey Jennings), 62
spectacle, 2, 4, 10–18; the cinema of attractions and, 12, 14; class and, 70–75; culture and, 10; documentary discourse and, 50–52; the hidden revealed and, 13–15
Sogobi (James Benning), 180
Stagefright (Alfred Hitchcock), 34
stereoscope, 9–10, 188n20, 188–89n21, 189n23, 189n25
Stone, Martin, 119, 128, 202n3, 204n27
subject: Foucaudian power and, 53–58, 161; identity and, 4, 88–90; interpassivity and, 199n12; knowledge and, 7–14, 22–23, 26, 49–52, 54–59, 86–89, 94, 102–10, 144–46, 167, 174–77; Lacan's four discourses and, 103–110; Mass-Observation and, 78–79; origin of subjectification and, 197n56; trauma and, 98–101, 118–26, 157, 183–84, 204n28; work and, 76–85
subject-position: embodiment and, 32–33; mechanized modes of vision and, 8; subjects of knowledge, 3, 5; the true self and, 17
sublimation, 87, 93, 123, 184
sublime, the: knowledge and, 11, 14; nonsense and, 184. See also Kant
suggestion. See hypnosis
Supernanny (American Broadcasting Company), 100
surrealism, 139–42; found objects or cultures and, 139, 143; interpretation and, 139; possession or spirits and, 149; surreal of reality, 5, 137
Sylvania Waters (Paul Watson for ABC/BBC), 16
sympathy, empathy, pity, 35, 56, 97–99, 130, 199n6, 201n41

Talbot, Henry Fox, 6, 7
technology: camera obscura and, 6–8, 188–89n10, 189n23; daguerreotype and, 6–7, 187–88n10; the digital and, 4, 154; the Internet and, 17, 85, 154; in modernity, 46–47; optical devices and, 13,

91, 20; real-time communications and, 32, 154; 16mm cameras and, 20; specialist cameras and, 14–15; stereoscope and, 9–10, 188n20, 188–89n21; understanding and, 7–8

10ms–1 (Douglas Gordon), 130–31

Thin Blue Line, The (Errol Morris), 42

Thing, the, 123, 203n16. *See also objet petit a;* sublimation

time: anthropology of, 161–62; duration of sympathy and, 101–2; emplotment and, 41–42; event and, 168; experience as duration, 6, 125, 153; flashback and, 33–34; historical, 6, 78, 153; irrational interval and, 169–71; memory and, 6, 33; now vs. past time, 155, 180–84; space and, 163–65, 179; stillness and, 172–73; work and, 61

Today and Tomorrow (John Taylor, codirectors Ralph Bond and Ruby Grierson), 78

Today We Live (Ruby Grierson), 78

Tourou et Bitti: Les tambours d'vant (Tourou and Bitti: The Drums of the Past) (Jean Rouch), 145

trauma, 33, 35, 98–101, 114, 118–29, 156, 159, 183–84, 203n20, 203n25, 204n28

Trinh T. Minh-ha, 1, 95, 170, 200n72

Triumph of the Will (Leni Reifenstahl), 83

truth: discourse and, 5, 20, 26; documentary truth, 4, 20, 25–26, 31, 36–38, 49, 51–54, 86–88, 96–99, 107, 117, 161; Foucault on, 52–53, 57, 90; Kant on, 192n32; Lacan on, 27–28, 103–9; modernity and, 26, 53, 105

Truth, Duty, Valour (Outdoor Life Network), 16

tuché, 125, 128

uncanny, 14, 72, 122, 155, 173, 190n39, 206n25, 206n28

unhistorical. *See* Nietzsche

Undercover Britain (Channel 4), 15

Vaughan, Dai, 20, 42

Verhaeghe, Paul, 104, 108

Vertov, Dziga, 19, 48–49, 170

video art, 130–31, 208n6, 209n24

video diary, and Video Nation (BBC), 85

virtual space, 154, 171, virtual witness, 196n19

Visker, Rudi, 50, 51

voice: the ordinary and, 78; political engagement and, 77–82; speaking subject, 3, 5, 82, 94–96

voice-over. *See* narration

War Neuroses: Netley, 1917, Seale Hayne Military Hospital 1918 (Pathé), 5, 42, 118–31

When the Levees Broke: A Requiem in Four Acts (Spike Lee), 34, 114–16

Wife Swap (Channel 4), 99–100

Winston, Brian, 4, 19, 201n35

Wiseman, Frederick, 25

work, 59–77; class struggle and, 69–76; the co-operative ideal and, 72–75; as focus of film movement, 64; ideology and, 64, 68, 77; possibility of representation, 46; women and, 68, 74–76

Workers Leaving the Lumière Factory (Louis Lumière), 73

Would Like to Meet (BBC), 99

You've Been Framed (ITV), 14, 100–101

Žižek, Slavoj: identification and, 90; ideology and, 22–23, 53; parallax and, 185–86

(series page continued from ii)

Volume 9 :: Alexandra Juhasz, Editor
Women of Vision: Histories in Feminist Film and Video

Volume 8 :: Douglas Kellner and Dan Streible, Editors
Emile de Antonio: A Reader

Volume 7 :: Patricia R. Zimmermann
*States of Emergency: Documentaries, Wars,
Democracies*

Volume 6 :: Jane M. Gaines and Michael Renov, Editors
Collecting Visible Evidence

Volume 5 :: Diane Waldman and Janet Walker, Editors
Feminism and Documentary

Volume 4 :: Michelle Citron
Home Movies and Other Necessary Fictions

Volume 3 :: Andrea Liss
*Trespassing through Shadows:
Memory, Photography, and the Holocaust*

Volume 2 :: Toby Miller
*Technologies of Truth:
Cultural Citizenship and the Popular Media*

Volume 1 :: Chris Holmlund and Cynthia Fuchs, Editors
*Between the Sheets, In the Streets:
Queer, Lesbian, Gay Documentary*

ELIZABETH COWIE is professor of film studies at the University of Kent. Her books include *Representing the Woman: Cinema and Psychoanalysis* (Minnesota, 1997).